Character Animation Fundamentals

Developing Skills for 2D and 3D Character Animation

Character Animation Fundamentals

Developing Skills for 2D and 3D Character Animation

Steve Roberts

Routledge
Taylor & Francis Group

LONDON AND NEW YORK

First published 2011
This edition published 2013 by Focal Press

Published 2017 by Routledge
2 Park Square, Milton Park, Abingdon, Oxon OX14 4RN
711 Third Avenue, New York, NY 10017, USA

First issued in hardback 2017

Routledge is an imprint of the Taylor & Francis Group, an informa business

British Library Cataloguing-in-Publication Data
A catalogue record for this book is available from the British Library.

Library of Congress Number: 2011933090

ISBN 13: 978-1-138-40309-3 (hbk)
ISBN 13: 978-0-240-52227-2 (pbk)

TABLE OF CONTENTS

Chapter 2 Matter and the Animation of Inanimate Objects ... 63

Chapter 3 The Construction of a Simple Character, its Articulation and Balance 95

Chapter 4 Timing, Anticipation, Overshoot, Follow-Through and Overlapping Action with an Animated Character 159

Chapter 5 Animation of Human Walks and Runs .. 223

Chapter 6 Animation of Animal Walks and Runs 245

Chapter 7 Animation of Acting – Body Language.................................. 275

Chapter 8 Animation of Acting – Facial Expressions .. 329

ACKNOWLEDGEMENTS

This book would not have been possible without the following people.

Dee Honeybun for going through my unintelligible notes and turning them into something worth reading.

Marie Hooper for commissioning the book in the first place and putting up with every missed deadline.

Katy Spencer of Elsevier for commissioning the revised version of this book and putting up with even more missed deadlines.

Claudia Lester for being my 'best man' and persuading me that function curves are my friends.
Kevin Rowe for help with Maya and acting.
Birgitta Hosea for making time for me.

Bob Godfrey for getting me into animation in the first place – I was bought his book *The Do-It-Yourself Film Animation Book* at the age of 10.

Paul Stone and Mal Hartley for being my animated best mates.
Central St Martins College of Art and Design for their support and the use of Maya.
Cavendish College for their support and the use of 3D Studio Max.
Kent Braun for the use of DigiCel FlipBook.

Nick Manning of Autodesk, Inc. for permission to use images from Maya and 3D Studio Max. Screen shots and models are used with the permission of Autodesk, Inc.

Vasco Carou for the wonderful footage of his horse Inato (a thoroughbred Lusitano).

All of the students I have ever taught animation to (nearly 1000!) – believe me, I've learnt as much from you as you have from me. A very big thank you to all the students who replied to my inane email questions.

All the people I've known, argued with, watched, listened too, agreed with, ignored and generally experienced that have made me the animator I am today.

My mum and dad who had faith in me getting a job that involved scribbling all day.

But most of all Dee, Felix and Emily, who haven't seen nearly as much of me as they should have done for the past few years but have loved me all the same.

This book is the culmination of nearly 20 years of teaching drawn animation techniques to 3D computer animators.

You may think, 'why on earth does a 3D computer animator need to learn how to do drawn animation?' The answer to this question is that the basics of animation are the same regardless of the medium and often you can get an idea of the movement far more quickly using pencil and paper. A computer can take a lot of the drudgery out of animating, but you can end up doing a piece of animation without quite understanding how it happened and whether it works or not.

One of the most valuable things I have learnt over the past 25 years of animating is to keep things simple. The main value of an animation teacher is to cut to the chase and tell you the fundamental things that you need to know. You can then elaborate on them in your own way. I have kept the examples and the animation exercises in this book as simple as possible so that you are able to build a firm foundation of skills on which you can develop your animation further.

The form of the book is as follows. In each chapter I will go through the fundamentals of a given topic, following them with a drawn animation exercise to complete. Then and only then can an identical animation exercise be attempted using the software package of your choice.

The fundamentals, the drawn animation exercises and guidance on how to do the same exercises in 3D are in the book. Have a look at the website that accompanies the book: www.charactermation.com. It includes .pdf files with bigger images and also movies showing how to do the exercises or how to build models as well as movies of the animations, plus lots of models, all fully rigged and ready for you to load onto your computer to do the exercises. There are also lots of tip and tricks about animation and film making. I also have a YouTube channel (www.youtube.com) called charactermation, where I will be uploading tutorials on a regular basis.

The most important thing to do when animating is to do your research. If you need to animate an elephant, go and look at an elephant moving. If you need to animate somebody playing basketball, go and look at somebody playing basketball (or, better still, play it yourself!). If you find out how it feels to do a certain movement, you will always animate it better. The web is great for research but nothing beats experiencing the real thing. This is one of the things that I love about animation: it makes you find out about the world around you.

I have been in love with animation since the age of seven when my mother took me to see Disney's *Sleeping Beauty* at the cinema. Compared to the little Murphy black and white television we had at home, I found the colors, the huge size of the screen and the wonderful sound almost overwhelming. I still always think of an animated film as something special.

I became obsessed with becoming an animator at the age of 10 when I saw a television show called *The Do-It-Yourself Film Animation Show* presented by Bob Godfrey. If there is anybody to thank (or blame) for my being involved with animation it is Bob. It is wonderful to have worked with him and to be regarded by him as a friend. Other great inspirations to me have been

Tex Avery and Chuck Jones: my favorite cartoon characters as a kid were Screwy Squirrel and Droopy (both Tex Avery creations), closely followed by Daffy Duck and Bugs Bunny (generally the incarnations of these characters in Chuck Jones' films).

The list of animators I'm in awe of is almost endless: Brad Bird, John Lasseter, Hayao Miyazaki, Nick Park, Joanna Quinn, Jan Svankmajer – I could go on and on.

Hopefully this book will inspire you.

FOREWORD

Animators are fortunate: not for them the limitations of the theatrical stage or the many hazards of a live-action film location shoot! Their only limitations are their imaginations and the size of their checkbooks. With the cosmos at their disposal, plus all the colors and sounds in the universe, animation can be a daunting prospect! Small wonder some take up gardening or DIY. Steve Roberts (the first time I saw him was at Farnham's Animation course – he was remaking *Snow White and the Seven Dwarfs* as a satire) is not easily daunted. He has written and illustrated a remarkable book that actually makes animation easy to understand. Using simple illustrations, he takes the reader through every situation they are likely to come across in their progress towards believable animation. The key to this book is *simplicity*. Keep it simple! Parting the Red Sea is for Cecil B. DeMille.

Bob Godfrey MBE

CHAPTER ONE

Introduction to Animation Working Practice

In this chapter I'll take you through two things: the equipment needed to make a basic animation studio and some simple animation. We will look at X-sheets and how they help timing, flipping, flicking and rolling; how to use a line tester; and how to put the lessons learnt from your drawn exercises onto a 3D computer animation program. By the end of the chapter you will have learnt how to organise yourself and how to plan and execute a piece of animation.

I make no apologies for taking you right back to basics. You may know much of this but bear with me – it is worth refreshing your knowledge and reinforcing the basic principles behind animation.

How Animation Works

The Basics

2D drawn animation consists of a series of drawings shot one after another and played back to give the illusion of movement. This animation can be played back in a number of ways:

- In the form of a 'flipbook' (basically a pile of drawings in sequence, bound together and flipped with the thumb).

- Shot on film one drawing at a time with a movie camera and played back using a cinema projector.
- Shot on a video camera and played back with a video player.
- Shot with a video camera attached to a computer and played back on the same computer using an animation program.
- Scanned into a computer and played back.

Frames per Second

Animation shot on film and projected is played at 24 frames per second. Animation for television in Europe, Africa, the Middle East and Australia is played at 25 frames per second. These countries use a television system called PAL, which plays at 50 fields (frames) per second. Animation that plays at 25 frames per second is compatible with PAL, but if we played an animated film at 24 frames per second on a television we would see a black bar rolling up the screen. The Americas, the West Indies and the Pacific Rim countries use NTSC, which runs at 60 fields per second. This means that for this system you should be animating at 30 frames per second (60 is divisible by 30). Quite often some sort of digital converter is used to transfer one speed of film to another speed of video, allowing 24-frames-per-second film to be shown on a 60-fields-per-second (NTSC) television. If you stop-frame through a video of an animated film, you will find there are points at which one frame will blur into another. This is how the incompatibility of the two systems is overcome. (Stop-framing through animated movies is a very good way of learning about animation.) The most important thing to find out when animating something is what speed the animation will be played back at. All the animation taught in this book will be played back at 25 frames per second.

What You Need for Your Studio

In order to complete the drawn exercises in this book, you will need the following things (all of which are available from the professional animation equipment suppliers listed at the back of this book):

- Animation paper
- Peg bar
- Light box
- X-sheets
- Line tester
- Pencils

Animation Paper

When animating, you often find that you are working with four or more layers of paper. A level of translucency is necessary in order to see all of the drawings. Professional animation paper is made with this in mind.

It also comes in different sizes, which are referred to as field sizes. 12-field and 15-field are the most popular. 15-field is 15 inches wide and 12-field is 12 inches wide. (I'll elaborate on this later in the chapter when I refer to field guides, the grids that measure field sizes.)

Most professional animation paper comes with three punched holes. It is possible to buy the paper with no holes (which is cheaper, but you will need a specialist animation punch, which is very expensive). Used with a peg bar, the holes allow accurate placing of each piece of paper with the next. This is important, as the slightest movement in a drawing will show when the sequence is shot.

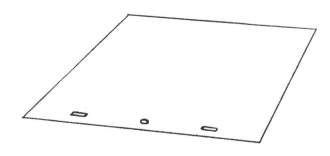

It is possible to use A4 paper with standard ring-binder punched holes and a peg bar with two pins that fit the holes. This will work out far cheaper than professional animation paper.

Peg Bars

Professional peg bars, used with professional animation paper, are made up of a strip of steel or plastic with three pins. They are made to an industry standard. They are used to register each piece of animation paper against the next.

It is possible to buy two-pin peg bars – these are often called 'junior peg bars'.

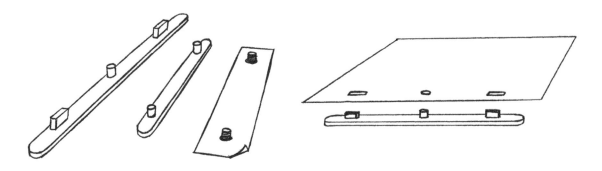

It is equally possible to make your own, using a strip of wood with two pieces of dowel that correspond to the holes in your paper, or even to tape two 5 mm counter-sunk bolts onto your light box. These can then be used with ring-binder punched A4 paper.

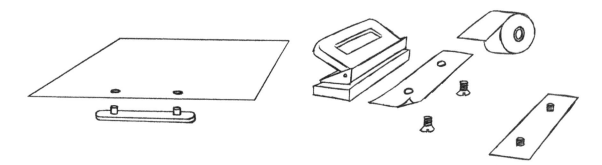

As with the paper, bear in mind that, if you want to use your animation professionally, it is advisable to buy a three-pin peg bar.

Light Boxes

In its most basic form, a light box is a flat sheet of opal Perspex over a light. Professional light boxes use a rotating disk. They should also have the ability to change the angle of the drawing surface. This makes drawing easier on both the wrist and the back.

Simple light boxes are relatively straightforward to make. You could use a wooden storage box with the top part cut off at an angle, mount a neon bulb inside and then fasten a piece of 6 mm opal Perspex to the top with screws.

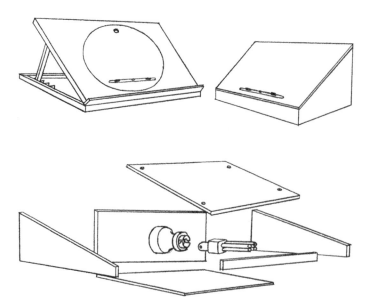

X-sheets

ANIMATOR;									
PRODUCTION;									
SCENE NO;		SEQUENCE NO;		LENGTH;			SHEET NO;		
NOTES;									

			LEVELS;							
ACTION	SOUND	FRM NO	6	5	4	3	2	1	B.G.	CAMERA
		1								
		2								
		3								
		4								
		5								
		6								
		7								
		8								
		9								
		10								
		11								
		12								
		13								
		14								
		15								
		16								
		17								
		18								
		19								
		20								
		21								
		22								
		23								
		24								
		25								
		26								
		27								
		28								
		29								
		30								
		31								
		32								
		33								
		34								
		35								
		36								
		37								
		38								
		39								
		40								
		41								
		42								
		43								
		44								
		45								
		46								
		47								
		48								
		49								
		50								

ANIMATOR;											
PRODUCTION;											
SCENE NO:		SEQUENCE NO:		LENGTH;				SHEET NO:			
NOTES;											

ACTION	SOUND	FRM NO	LEVELS;						B.G.	CAMERA
			6	5	4	3	2	1		
		1								
		2								
		3								
		4								
		5								
		6								

ANIMATOR;	STEVE ROBERTS										
PRODUCTION;	BOUNCING BALL										
SCENE NO: 3		SEQUENCE NO: 2		LENGTH; 3 SECS				SHEET NO: 1			
NOTES; BALL BOUNCES INTO SCREEN, HITS GROUND AND BOUNCES OUT!											

ACTION	SOUND	FRM NO	LEVELS;						B.G.	CAMERA
			6	5	4	3	2	1		
		1							BG 1	
		2								12
		3							2	FIELD
		4								CENTER
		5							3	
		6								
		7							4	

X-sheets are also referred to as dope sheets or exposure sheets. They are used by the animator to record all the necessary information relating to how the animation should be shot. A standard X-sheet consists of several columns that run from top to bottom and 100 rows that run from left to right (the illustration shows 50). Each row represents one frame of animation. If the animation is to be played back at 25 frames per second, 100 frames will equal 4 seconds of animation (or 2 seconds on the X-sheet shown).

The columns on an X-sheet are used as follows.

Sound

This column contains the sounds that are relevant to the animation. Very often this is the dialog spoken by the characters. For animation the dialog is recorded first. It is then 'broken down'. This means that someone, usually an editor, goes through the sound track frame by frame. They work out where each word starts and ends and where each of the major vowel and consonant sounds are. These are then marked on the X-sheet in the sound column, frame by frame. You then know that at a certain frame in a scene a particular sound is made.

SOUND	FRM NO
H	1
E	2
	3
L	4
O	5
	6
	7
////////	8
	9
H	10
O	11
W	12
////////	13
	14
A	15
R	16
////////	17
	18
Y	19
O	20
O	21
	22
////////	23
	24
	25

Action

This contains instructions on when a given piece of animation will start and end. An experienced animator will fill out this part of the X-sheet before they start animating. Sometimes the director will fill this out. The process is often referred to as 'slugging out'.

Frame Numbers

As the name suggests, this is where the number of each frame is inserted. One of the main ways of 'cheating' in drawn animation is to do your animation on 'twos'. This means that each of your drawings is shot for two frames. This saves a huge amount of work; for example, if you have to animate 4 seconds you only have to do 50 drawings, rather than 100, which you would have to do if you did a drawing for each frame (assuming a rate of 25 frames per second).

At times you will find that you want to 'hold' your animation. For example, at a given point in the action a character may move into a position where they stand still for a second or so. At this point you could just have one drawing 'held' for however many frames are needed.

There are two ways to number your drawings. The first way is to number them by the drawing. This means that drawing number one is numbered 1, drawing number two is numbered 2 etc. The other way is to number them by the frame. This means that the drawing on frame one is numbered 1, the drawing on frame three (if the sequence is shot on twos, this is the second drawing) is numbered 3, the drawing on frame five is numbered 5 etc. Each method has its advantages and disadvantages. As an aspiring computer animator, it is probably better for you to number drawings by the frame so that when you look at your drawings in order to copy their position with your computer model you know exactly what frame that pose should be on. All the exercises done in this book will be numbered by the frame.

The columns show the order in which the levels are placed: background at the bottom level (right on the X-sheet) and foreground at the top (left on the X-sheet) with the character in the middle.

Each drawing will have its own number. Each unit represents a frame. The drawing number is inserted to show where that frame of animation will be in the sequence. This varies depending on how many frames per second each drawing represents. The example right shows a sequence that is shot on twos; that is, each drawing is shot for two frames. When something is on twos, the first row has a number and the second is left blank. It is not necessary to fill in every frame. At the end of the sequence, the last drawing is held for 10 frames; that is, the drawing is shot for ten frames. This is indicated by the line that runs from the bottom of the drawing number to the last frame that the drawing is held for. If the drawing is held for more than two frames, it is necessary to insert a line to show how long the drawing is held for.

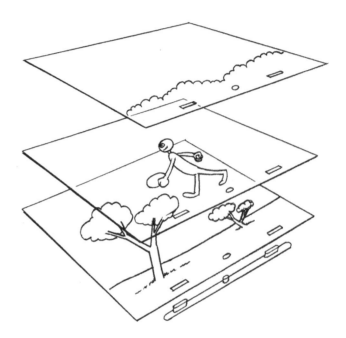

Levels

When a sequence is animated, even if there is only one character, the drawing for one frame of animation may be on several levels of paper. If the body remains still during the sequence but the head and arms are moving, there will be only one drawing of the body for the whole sequence. If the head is moving at a different rate to the arms, the head will be on a separate piece of paper and the arms on a further piece. If there is a background and the character is stood in front of a tree, for example, these will again be on separate pieces of paper. However accurate the final drawings are, if you have to re-trace exactly the same drawing 20 times or more (your background with a tree, for example), there will be variations between the drawings that will show when the animation is played. It also is an unnecessary use of time. Before the use of computers, the finished drawings were traced and colored onto Cel (cellulose acetate, or clear plastic sheets). This allowed for a maximum of six levels before the thickness of the cell made the colors on the lower levels look muddy. Today, each of these levels would be painted and they would then be assembled with programs such as DigiCel FlipBook or Toon Boom. This allows for infinite levels without any loss of quality.

LEVELS;							
10 6	5	4	3	2	1	B.G.	
				OL I	A I	BG-I	
					A 3		
					A 5		
					A 7		
					A 9		

Camera

Information in this column instructs the camera on how you want the scene to be shot and pinpoints the area within the artwork that needs to be in frame. The most important piece of information is the field size. The most popular paper is 12-field, which means that the camera at its maximum setting will shoot an oblong area that is 12 inches wide.

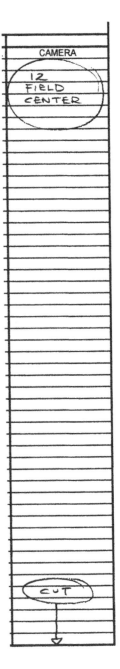

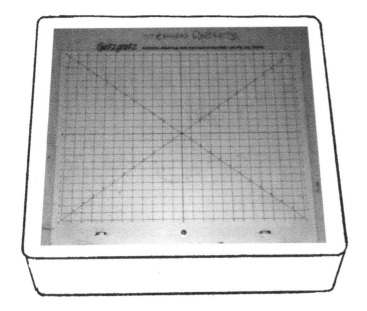

Traditional 2D animators use a field guide, also called a graticule, to work out the position of the shot. For example, for animation to be shot using the full size of the paper, '12-field center' is marked at the top of the camera column. As a 3D computer animator, you won't be using field sizes. However, it is worth understanding how they are worked out.

The field guide has 'North', 'South', 'East' and 'West' printed at the top, bottom, right and left. It consists of 24 columns and 24 rows in a grid. The columns are half an inch wide. By using these compass points and grid references you can specify any area on your paper that you want to be shot.

The illustration right shows an oblong area at the top right of the paper that is 5 inches wide. This would be 5 field at 7 east/ 7 north of 12-field center. Using the field guide, you work out where the center of the oblong is in relation to 12-field center (the cen-

ter of the field guide). To find the center you would count along seven lines east and seven lines north from the center of the field guide (12-field center).

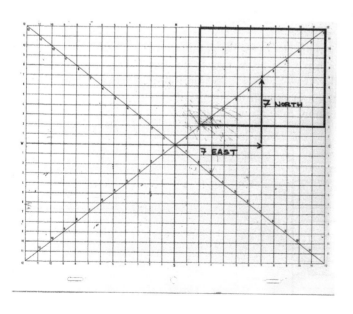

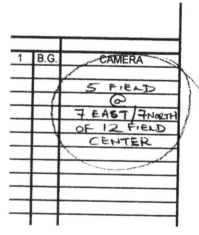

Using this method, you can place a field of any size in any area.

All exercises in this book are at 12-field center (or, if you are using A4 photocopy paper, 10 field at 2 south of 12-field center).

Line Testers

A line tester is a device that captures your drawings and plays them back. It is a quick and easy way to see whether the roughly drawn sequence works. There are a number of ways to set up a line tester. You could use a film camera, a video recorder that can record single frames or a line testing software program and a computer. The movie examples on the website were produced using a program called DigiCel FlipBook, which can be downloaded from www.DigiCelinc.com (you can start with the free watermarked version but I would recommend upgrading to the basic version for a small fee). Alternatives are available. I would suggest looking for a program that contains an X-sheet, as this is best for working out timing.

The simplest and cheapest way of setting up a line tester is to use a webcam together with a computer and the line testing software. Set the camera to point down onto the table. The camera could be mounted on a tripod or even stuck to a steel rule that is then attached to the top of your computer. Stick your peg bar to the table, put a piece of your animation paper onto it and align it under the camera. The peg bar is important for the accurate placing of drawings. It is also possible to scan drawings into the computer using a flat bed scanner, but it takes an awful lot longer than using a camera.

Now would be a good time to load a copy of DigiCel FlipBook onto your PC and familiarise yourself with its operation.

Pencils

When doing drawn animation it is always best to work in rough with a Col-Erase blue pencil (which can be easily erased) and then 'clean up' your drawings afterwards with a graphite pencil. This means you can define the correct lines of the character and add details in graphite pen-

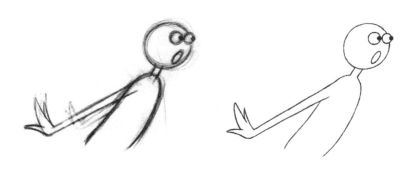

cil on top of the rough Col-Erase lines. (Also, when you line test your animation the graphite line will show up more distinctly than the blue lines underneath.)

Let's Get Animating

There are two ways to animate a sequence using traditional 2D animation: 'straight ahead' and 'key-to-key' (also known as 'pose-to-pose').

Key-to-Key Animation

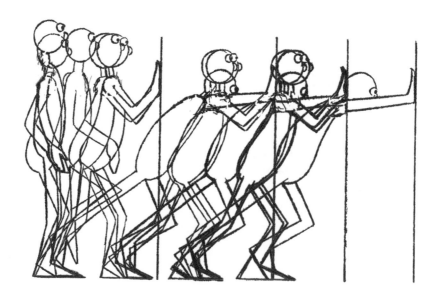

'Key drawings', also referred to as 'keys', are important drawings that sum up the essence of the action during a scene.

In key-to-key animation, 'key positions' or 'poses' in a sequence are drawn before completing the sections between them ('in-betweening'). I always like to think of the key positions as the plot or a précis of a scene. They give a rough overall feel of the animation. The in-between drawings provide the characterisation or detail.

Animating key-to-key allows for a large degree of control over your animation. It can prevent the character or object from changing size or distorting where you don't want it to. It also means you have control over the timing of your animation and can more easily predict what action will happen when and where. By line testing the keys you can see the basic movement of a sequence before completing the full animation.

In the end, though, all the frames of your animation are important and if you put too much emphasis on the key positions the animation can look clunky and stiff.

Below is an example of key-to-key animation. In this example, a man sits at a table with a glass of liquid on it. He picks up the glass and drinks from it.

- Key number 1 – He looks at the glass.
- Key number 2 – He grasps the glass in his hand.
- Key number 3 – He raises the glass to his lips.
- Key number 4 – He tips the contents of the glass into his mouth.

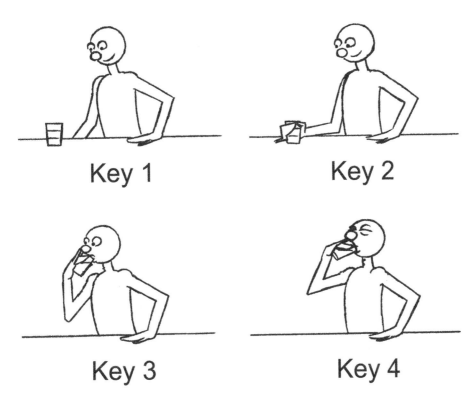

Key 1　　　　Key 2

Key 3　　　　Key 4

The number of in-betweens and where they are positioned (the timing) depend on the character and the mood of the man. If he was thirsty, he would quickly grab the glass (only a few in-between drawings, spaced far apart), put the glass swiftly to his lips (maybe spilling some liquid), pull back his head and tip the drink straight down his throat. To create the illusion of speed you have less in-betweens with larger gaps between each drawing.

If he was an alcoholic he might pick up the glass carefully, to avoid spilling any liquid (a lot of in-between drawings, positioned close together). Just before the glass reaches his lips he might dip his head, so as to avoid spilling any liquid if his arm fails. He would then drink long and slowly. To show slower movements there are more in-betweens and smaller gaps between the drawings.

If the man were hesitant about drinking the liquid, he might pull his hand back just before grasping the glass and, holding it with the tips of his fingers, bring it slowly and delicately to his lips so that he could take a small sip.

Animating Straight Ahead

In straight-ahead animation, images in the sequence are drawn directly one after the other. This method can produce a more vibrant form of animation with more energy and exuberance. Unfortunately there is far less control with straight-ahead animation and distortion and changes in size are more likely. It is also more difficult to work out the timing because you can only check the animation with a line tester when it is all done and then it may be wrong, in which case you would have to throw away a lot of drawings and redo them.

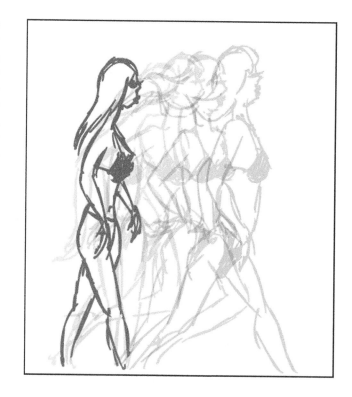

Flipping, Flicking and Rolling

There are three skills that are invaluable when animating with pencil and paper: flipping, flicking and rolling. They allow you to see the drawings moving while you are animating. To practice these skills, we are going to animate a ball bouncing into the screen, hitting the ground and then bouncing out of the screen. Each of these bounces describes an arc, which is referred to as a parabola.

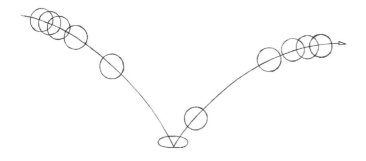

This is a good example of timing in animation. To create the dynamics of the movement of the ball, the drawings are spaced at different intervals. As the ball bounces, it accelerates towards the ground in an arc, pulled by the force of gravity. At the fastest point, the drawings are furthest apart. At the highest point of the bounce (the apex), the ball is travelling more slowly. Here the drawings are closer together. To create acceleration as the ball falls to the ground, the drawings of the ball are placed further and further apart. As the ball hits the ground, it squashes down, absorbing the energy of the fall. It then un-squashes and accelerates into the next bounce, slowing down as it reaches the apex of this next bounce.

This principle of timing is relevant to all animation. The closer the drawings are together, the slower the movement; the further apart they are, the quicker the movement.

Flipping

Grab an old exercise book, sketchbook or block of Post-it notes: we are going to make a flipbook. We are going to use this flipbook to bounce a ball across the page using straight-ahead animation.

With the spine furthest away from you, lift the pages until the bottom page is facing you. Draw the ball in the top left-hand corner of the bottom page of your flipbook. Following the above illustration, draw one ball on each subsequent page. When the ball hits the ground, remember to squash it so that it is almost flat. As it leaves the ground, stretch the ball along the arc it is following.

When you have completed the sequence, hold the flipbook at the spine with your right hand and place your left thumb at the bottom of the flipbook with your left-hand index finger and forefinger at the top page of the flipbook. Bend the flipbook up towards you with your left hand and allow the pages of the flipbook to slide away from your thumb. All being well, you should see your ball fall in an arc from the top left of the page to the center bottom of the page, where it squashes and bounces up to the top right of the page. Open 'flipook.avi' in chapter 1 on the website for a demonstration of how to do this.

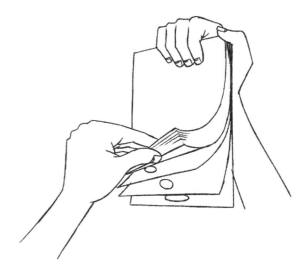

You have just created a piece of 'straight-ahead' animation; that is, where images are drawn one after the other.

This exercise should have given you an idea of timing and spacing. Try experimenting with the distance between one ball and the next; for example, if the balls are very close together they will move slowly and appear to float.

When you are using animation paper, flipping is a good way to see how your animation is working. Arrange your drawings with the first drawing of the sequence at the bottom of the pile and the last drawing at the top. This is called the 'flipping order'. Hold up your drawings with your right hand at the top of the pile and your left hand at the bottom. As with the flipbook, pull

the drawings towards you and let them slide off your left-hand thumb one at a time as they fall flat. If this is too awkward (your pile of drawings is too thin), try putting some blank pages on top of these drawings to make the pile thicker. (Open 'flipping.avi' in movies001, Chapter 1 on the website.)

Flicking

Flicking is a technique used to look at your animation while you are sitting at your light box. When mastered, it allows you to see how your animation is moving and to adjust your animation accordingly by re-drawing.

For this next exercise we will use the punched paper, peg bar and light box. Put your light box on the table in front of you in a comfortable position. Always animate with the peg bar at the bottom of your piece of paper. It is much more difficult to flip and flick with the peg bar at the top.

We are going to animate a piece of key-to-key animation using the same sequence as for the flipping exercise (the bouncing ball). We will be numbering these drawings by the frame and each drawing will be shot for two frames (twos).

Place your first sheet of paper onto the peg bar. At the bottom right-hand corner of the paper, label this drawing no. 1. This is our first key drawing.

Place a second sheet on top, using the peg bar to register it. Draw a squashed ball and label it drawing number 11. This is our second key drawing.

Lastly, place a third sheet over the previous two and draw a ball at the top right-hand corner. Call this drawing number 17. This is our third and final key drawing.

Remove drawing number 21. We will 'in-between' drawings 1–11. This means we will draw the drawings that go between 1 and 11.

The first in-between we draw will be number 9. This is half way between numbers 1 and 11. This may seem rather odd, but it will help give the impression of the ball speeding up as it hits the ground. If we look at the 'timing chart' (on page 18), we see that, because the ball was at its slowest on the apex, there are more drawings and they are closer together at this point. As the ball falls out of the sky, the drawings get further and further apart. This is why the drawing half way between 1 and 11 is number 9.

The first drawing you do as an in-between is often referred to as a 'breakdown' drawing. This is the major in-between.

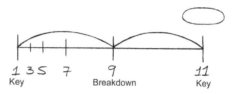

Timing charts (also known as breakdown guides, in-betweening guides, or telegraph poles) are used to show where the in-between images should be drawn. They are generally placed at the bottom of the key drawing and should relate to the drawings between that key and the next. They consist of a horizontal line with a vertical line at each end representing the key drawings. The 'breakdown' (major in-between) drawings are indicated by a vertical line and by a couple of arcs between them and the key drawings. The remaining in-between drawings are represented by shorter vertical marks. The illustration (right) shows the breakdown guide for drawings 1 to 11.

Drawing 7 is half way between numbers 1 and 9, drawing 5 is half way between numbers 1 and 7 and drawing 3 is half way between numbers 1 and 5.

When we in-between our sequence, we need to 'flick' our drawings. Place drawing 11 over drawing 1 with a

clean sheet over them. Label this drawing number 9. Hold drawing 9 with your left thumb and forefinger. Slip your index finger underneath drawing 11. Leave drawing 1 flat on the light box.

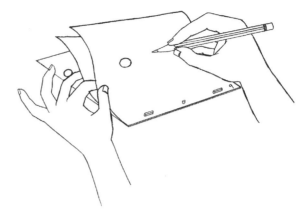

Now draw the ball on drawing 9. Remember the ball is moving through an arc and that it should be half way between the balls on drawings 1 and 11.

In order to see how the ball is moving, fold back drawings 11 and 9 towards you (while still attached to the peg bar) and look at drawing 1.

Fold drawings 11 and 9 flat against the light box and look at drawing 9.

Then fold drawing 9 up towards you and look at drawing 11.

When this is done in quick succession, the ball will move along the arc. You are now 'flicking'. Sometimes it helps to put a rubber band over the pins on the peg bar to stop the paper slipping off. If the ball in drawing 9 doesn't appear to be in the correct position, rub it out and re-draw it. Keep flicking and drawing until it looks right. (See 'flicking.avi' in movies001, Chapter 1 on the website.)

Repeat the 'in-betweening' process for drawing 7

(between drawings 1 and 9), drawing 5 (between drawings 1 and 7) and drawing 3 (between drawings 1 and 5). Once you have drawn all these you can have a go at rolling.

Rolling

Place the first five drawings of the sequence onto the peg bar with drawing 1 at the bottom and drawing 9 at the top. Interleave each of these drawings between the fingers of your left hand. You can only ever roll with five drawings.

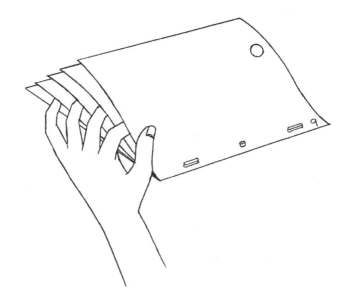

Fold all the drawings towards you and look at drawing 1. By moving your little finger forwards, allow drawing 3 to fall flat over drawing 1 and look at this.

Let drawing 5 fall flat over drawing 3. Look at this. Let drawing 7 fall flat over drawing 5. Look at this. Lastly, allow drawing 9 to fall flat onto drawing 7 and look at this. Bring your hand back and repeat the process. Make sure your fingers stay interleaved with the paper at all times. When this is done in quick succession, you will see the

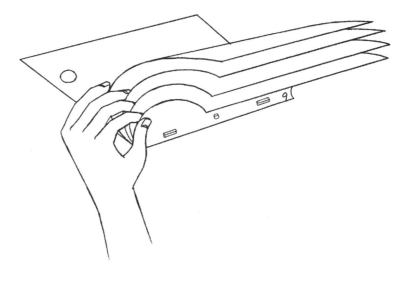

ball falling from the top left of the page and hitting the ground, accelerating as it falls. You are now rolling. (See 'rolling.avi' in movies001, Chapter 1 on the website.)

Complete the exercise by in-betweening drawings 11 to 21. Below is the timing chart for drawing 11, showing how you should in-between the drawings between numbers 11 and 21.

The X in the chart shows that the distance has been divided into three. The first in-between you will do is drawing 15. This is the breakdown drawing. It is one third closer to 21 and two thirds further away from 11. (The X is there to show the relative position of drawing 15.) The next drawing to do is number 17. This is half way between 15 and 21. Then do drawing 19. This is half way between 17 and 21.

There is no drawing at position X. The next drawing to do is number 13. This is half way between X and number 11. By using this spacing, the ball will accelerate from drawing 9 and decelerate as it reaches drawing 17. Make sure the ball follows the arc through the sequence. When you have

completed all the drawings, have a go at flipping them. Pick up all the drawings you've animated with the first number at the bottom and the last at the top. Hold them up with your right hand and flip with your left.

Finally, shoot the sequence with a line tester to see accurately how the animation moves. Each drawing should be shot for two frames. If you haven't worked out how to use a line tester yet, never fear! I'm going to take you through how to use one in the next section. (See 'ball_bounce. avi' in animations001, Chapter 1 on the website.)

How to Use a Line Tester to Help Your Animation

In the previous exercise we looked at the timing of a ball bouncing across the screen. Learning the timing for the key positions is one of the hardest things to do in animation. Using a line tester enables you to see how the timing is working and will hopefully help you to learn timing skills more quickly.

For the next exercise we will make a ball drop into screen, fall straight to the ground and bounce a few times before coming to a halt.

The first thing to do is to animate and shoot the key drawings on the line tester. The resulting movie is called a pose test or a key test. The number of frames that each of the key drawings is played back for can be adjusted on the X-sheet part of the program. When this is working satisfactorily, the drawing numbers are marked onto a paper X-sheet and from this the timing for the in-between drawings is worked out. Work out timing charts for where the in-betweens will go. Do the in-betweens and finally shoot the entire sequence on the line tester.

Exercises

Every exercise in the book will follow the basic format below. Animate the exercise in 2D and then use the drawings as a guide to how the animation will move in 3D. By the time you are half way through the book you could only be doing rough thumbnail sketches to be prepared for an exercise in 3D. Remember, though, it's always a good idea to have a go at animating all of the exercises in both 2D and 3D.

A Bouncing Ball in 2D

Draw the following key positions onto pieces of paper and number them as shown.

Open up DigiCel FlipBook on your computer. Click **Create New Scene**. Specify a **Frame Rate** of 25, **# of Frames** as 44 and **# of Levels** as 2. Select 'PAL (768 × 576)'. Then click **OK**.

If you are going to be using a video camera, click on the **Capture** icon. Hopefully, up will come a live screen of what your camera is seeing and a **Video Capture** toolbar.

We need to play the key drawings back at roughly the same speed and length as the finished sequence. (Remember that we have yet to do all the in-betweens for this piece of animation.) We do this by 'holding' each of the key drawings for the estimated number of frames between each of the keys. The line test helps us to work out the number of frames needed. We need to see this sequence as a series of keys that demonstrate the main positions for the correct timing. In DigiCel FlipBook you can specify how many frames each key drawing is captured for (the **Hold** box on the **Video Capture** toolbar) and you can also adjust the number of frames the drawing is held for on the X-sheet part of the program.

We now need to capture your key drawings. For this exercise we will start by capturing each drawing for one frame each.

On the **Video Capture** toolbar set the **Frame** box to 1 and the **Hold** box to 1. This means that when they are captured your drawings will be numbered in the same way that you numbered them. These are referred to as the key numbers. Set the **Level** box to 1.

Place key drawing 1 under the camera and, when it is positioned correctly on the peg bar, click on the **Capture** button. Place key drawing No 2 under the camera and click the **Capture** button. Repeat this process for all eight key drawings. When you have captured all your keys, click **Quit**. Now click the **Play Forwards** button at the bottom of the DigiCel FlipBook window. It's running a bit fast, isn't it? That's because it's running on 'singles'. This means that each drawing is being played back for one frame. The way to correct the timing and slow it down is to make each of the key drawings 'hold' for longer than one frame. To do this we need to drag each of the key drawings down the X-sheet for the appropriate number of frames.

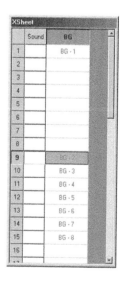

If you look at the X-sheet panel you will see that the drawings are called BG-1 to BG-8. This is because they are on the background level. In the X-sheet window, click onto BG-2. Click on it again while holding down **Alt** on your keyboard and drag it down the X-sheet until BG-2 is next to frame 9 on the X-sheet window.

This means that key 1 (BG-1 on the X-sheet window) is now held for eight frames; when it is played back your audience will see it for eight frames. Click on BG-3 and (while holding **Alt**) drag it down to frame 17. This means that key 2 (BG-2) is held for eight frames. Next, drag BG-4 down to frame 23, BG-5 down to frame 29, BG-6 down to frame 33, BG-7 down to frame 37 and BG-8 down to frame 41. (You can compare your key sequence with 'ball_drop_keys.avi' in animations001, Chapter 1 on the website.)

When you have adjusted the X-sheet, click the **Play Forwards** button on the main screen. How does your animation look? It will be jerky, but at this stage that doesn't matter. The important thing is to work out the timing. You have to imagine what it will look like when it has all the in-between drawings included. (This is a skill that comes with experience. The more you animate and look at pose tests, the more adept you become at working out the correct timing.)

If any of your key drawings appear to be playing for too long or too short a period, 'hold' them for less or more frames. With DigiCel FlipBook, highlight the drawing on the X-sheet by clicking on the image that you want to change the frame value of. Then click on it a second time and hold the mouse button down while holding down **Alt** on your keyboard. Drag the column up or down, depending on whether you want to increase or decrease the number of frames.

When you are happy with the result, mark the key positions onto a paper X-sheet (photocopy the one included earlier or print one from the folder X-SHEETS in Chapter 1 on the website). Use the far-left Level column and a pencil. (These keys are marked here for temporary reference.) If key drawing 1 (BG-1) starts on frame 1 of the DigiCel X-sheet, mark it into frame 1 of the paper X-sheet. If key drawing 2 (BG-2) starts on frame 9 of the DigiCel X-sheet, mark it onto frame 9 of the paper X-sheet, and so on. If the animation is on twos we need to know where these will be during the sequence. In the far-right Level column, mark in the correct drawing numbers; that is, drawing 1 on frame 1, drawing 3 on frame 3 etc.

You can now re-number your key drawings by the

FRM NO	6	5	4	3	2	1	B.G.	CAMERA
1	k1					1		12
2								FIELD
3						3		CENTER.
4								
5						5		
6								
7						7		
8								
9	k2					9		
10								
11						11		
12								
13						13		
14								
15						15		
16								
17	k3					17		
18								
19						19		
20								
21						21		
22								
23	k4					23		
24								
25						25		
26								
27						27		
28								
29	k5					29		
30								
31						31		
32								
33	k6					33		
34								
35						35		
36								
37	k7					37		
38								
39						39		
40								
41	k8					41		CUT
42								
43								
44								
45								
46								
47								
48								
49								
50								

DigiCel X-sheet (left panel), Sound / BG columns: BG-1, BG-2, BG-3, BG-4, BG-5, BG-6, BG-7, BG-8.

frame number they correspond to. Key drawing 2 corresponds with frame 9 so it becomes drawing 9. Key 3 becomes drawing 17, key 4 becomes drawing 23, key 5 becomes drawing 29, key 6 becomes drawing 33, key 7 becomes drawing 37 and key 8 becomes drawing 41. Draw a ring around each of the key drawing frame numbers. Erase the key numbers in the far-left Level column. Re-number your key animation drawings as per the frame number.

FRM NO	LEVELS;						B.G.	CAMERA
	6	5	4	3	2	1		
1						①		12
2								FIELD
3						3		CENTER
4								
5						5		
6								
7						7		
8								
9						⑨		
10								
11						11		
12								
13						13		
14								
15						15		
16								
17						⑰		
18								
19						19		
20								
21						21		
22								
23						㉓		
24								
25						25		
26								
27						27		
28								
29						㉙		
30								
31						31		
32								
33						㉝		
34								
35						35		
36								
37						㊲		
38								
39						39		
40								
41						㊶		CUT
42								
43								
44								
45								
46								
47								
48								
49								
50								

The next stage is to work out the in-between drawings and place a timing chart at the bottom of each key. Remember that, to show increased speed as the ball is dropped, the drawings will be further and further apart.

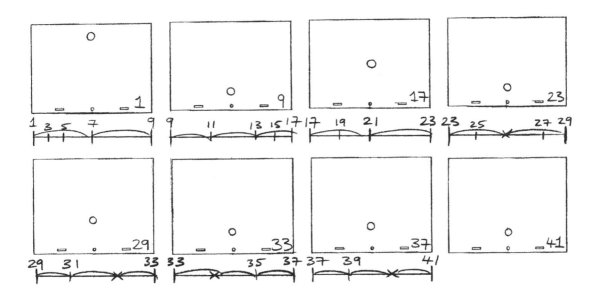

The above illustration shows the timing charts for all the keys and the correct numbering. As the ball bounces up, it will accelerate to the maximum speed and then start to slow as gravity takes over and it reaches the apex of the bounce. As the ball hits the ground for the second time, it will squash slightly less (having fallen from a lower height). This pattern is repeated for the remaining bounces. Each bounce will be lower and lower until the ball comes to a stop.

Complete the in-between drawings for the sequence by following the timing charts and then line test it (shoot each drawing for two frames each). You may have or may want to work out your own timing for the sequence. The finished piece of animation should be similar to 'ball-drop.avi' in animations001, Chapter 1 on the website.

How to Relate Your 2D Animation to Your 3D Animation

Once you've worked out the basic timing of your animation in 2D, you can go on and do the animation in 3D. The basic premise is the same: you create key positions in the 3D program just as you would in 2D, and then you let the computer do the in-betweening for you. Sounds easy? If only it were that simple! You will probably have to adjust the way in which the computer in-betweens the object you have moved. Usually this is done by adjusting the animation curves (more about this later).

First you need to know 13 basic things about your 3D program.

The 13 Things You Need to Know About Maya

1 Maya Screen Basics

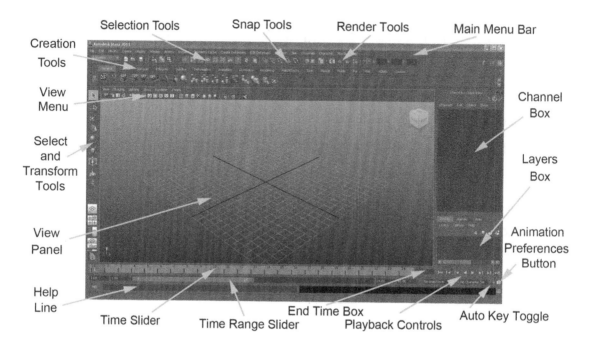

2 Maya Keyboard Shortcuts

Views Shortcuts

Alt + Left mouse button = Tumble (only in perspective view)

Alt + Middle mouse button = Track

Alt + Left mouse button + Middle mouse button = Dolly

Alt + **Ctrl** + Left mouse button and drag a box = Box dolly

A = Frame all

D = Rough, medium and fine display of model

Space bar (quick tap) = Takes you from one set of view panels to full screen on the selected view panel

Animation/Manipulation Shortcuts

S = Set key

E = Rotate tool

R = Scale tool

W = Translate tool

Playback Shortcuts

Alt + **V** = Playback animation

K + Left mouse button + drag = Scrub animation

• + **Alt** = Move one frame forwards

, + **Alt** = Move one frame back

• = Go to next key

, = Go to last key

3 Setting Up Animation Preferences in Maya

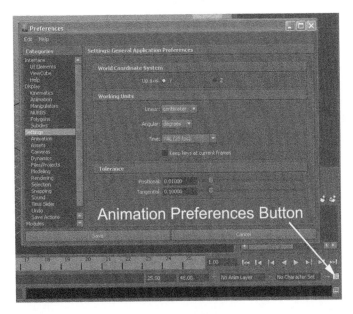

Click the **Animation Preferences** button (bottom right of screen) and up will come the **Preferences** window. In the **Categories** section select **Settings** and set **Time** to 'PAL (25 fps)'. Then, in the **Categories** section go to **TimeLine** and specify a **Playback Speed** of 'Real-Time' (25 fps).

4 Creating Basic Objects in Maya

Go to the main menu and select **Create** and then select the sort of object that you want to create. For example, **NURBS Primitive > Sphere**. This will then create a sphere of a default radius of 1

in the view panel. You can change the size of the object by double clicking its name in the **Inputs** section of the **Channel** box and typing in a new dimension for your object.

5 Moving Objects in Maya

Select either the **Move**, the **Rotate** or the **Scale** tool button in the **Select and Transform** section on the left-hand side of the screen. Select the object in the view panel and transform it by clicking and dragging.

6 Setting Keys in Maya

Click the frame you want to set a key on in the Time Slider. Move your object to the position you want and press **S** on your keyboard. Otherwise you can select the **Auto Keyframe** toggle. This means that, whenever something is moved, a key frame will be set on that movement. Once you are used to this, it can be a much faster and more efficient way of working. At various points throughout the book I will recommend working with this button on.

7 Using Graph Editor in Maya

To open Graph Editor go to the main menu and then **Window > Animation Editors > Graph Editor**. Select the object in the view panel. Then select the movement of the object in the **Outliner** area of Graph Editor to see relevant animation curves in the animation curve area. Use the buttons at the top of Graph Editor to manipulate or move around animation curves. To change the property of curves (stepped, linear, spline etc.) go to the Graph Editor main menu and select **Tangents > Spline** (or the property you want).

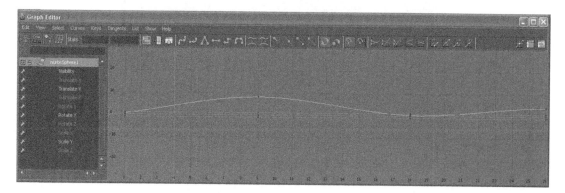

8 Creating a Preview in Maya

Select a view panel (make it full screen) and go to the main menu. Click **Window** and then **Playblast**. A low-resolution .avi of your animation will be rendered. Windows Media Player or Quick-Time will come up and play your animation, which will be saved to your hard drive.

9 Hierarchies in Maya

Select the object that is to be the child, press **Shift** and then select the object that is to be the parent. Press **P** on your keyboard. You should now have a parent and a child. To remove the relationship, select the child then go to the main menu and select **Edit > Unparent**.

To constrain, select the constraining object and then press **Shift** and select the constrained object; then go to the main menu, select **Constrain** and choose your constraint. For example, if you are making a control for an eye, select the locator first and then the eye, and then go to the main menu and select **Constrain > Aim**. Your eye should now follow your locator.

10 Creating Objects and Putting Bones in them in Maya

Create an object by going to the main menu then selecting **Create > Primitives** and choosing whatever object you want. To put bones in it select the **IK Joint Tool** button (IK stands for 'inverse kinematics') or in the main menu select **Skeleton > Joint Tool**. Click in the object to create joints. To bind them to the object, select both the object and the joint (*in that order*) by **Shift**-clicking and then in the main menu select **Skin > Bind Skin > Smooth Bind** or **Rigid Bind**. Another method is to parent objects to joints, so that when you select and move the bone the object moves with it.

11 Giving Your Characters Color in Maya

In Maya, select the object in the viewport, click **Window > Attribute Editor** and then click the rightmost tab and click on the box next to **Color**. Choose your color from the **Color Chooser** window. Click **Accept**. This will make all objects you create this color.

For a more specific color and texture select **Window > Rendering Editors > Hypershade**. Select a material. In the work area a sphere will appear. Double click and choose a color from the sphere's Attribute Editor. Right click on your object and from the menu select **Assign Existing Material > Blinn1** (for example). Your object should now have a new color/surface. To add a texture in the Attribute Editor, click the black-and-white box next to **Color**.

12 Importing Sound into Maya

Go to the main menu and select **File > Import**. In the **Import** window, find your sound file, select it and click the **Import** button.

To get the sound to play back in the timeline, right click on the timeline and select **Sound** from the menu that comes up. Follow the arrow next to **Sound** and select the recently imported sound file. The sound file should appear in the timeline as a waveform. If Maya is set to the correct playback speed when you play the timeline (and when you scrub through it) the sound should play back.

13 Rendering a Scene in Maya

You can output either an .avi or an image sequence, which can be taken into an editing program such as Premiere.

Go to the main menu and click **Render > Render Current Frame**. Up will come the **Render View** window. In the **Render View** window menu select **Options > Render Globals** and up will come the **Render Globals** window.

Fill in the columns in accordance with how you want to output your rendered scene. Give it a name in **File Name Prefix**. **Frame/Animation Ext** is for an image sequence and how you want it numbered (use either 'name#.ext' or 'name.#.ext'). **Start Frame** and **End Frame** are for the first and last frames that you want to render. **Frame Padding** is for numbering an image sequence and should be set to 3 if you have less than 1000 frames. **Image Format** is the output you want to produce, either an image sequence or an .avi. **Renderable Objects** should be set to **All**. For **Camera**, choose the view you want to render from. In **Resolution**, set **Presets** to '320 × 240'. When you have finished inputting the settings, close the **Render Globals** window. Then go to the main menu and select **Render > Batch Render**. Your scene should now render. It will be saved to your hard drive.

The 13 Things You Need to Know About 3D Studio Max

1 3D Studio Max Screen Basics

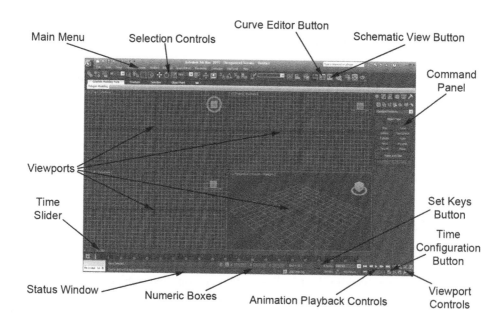

2 3D Studio Max Keyboard Shortcuts

Views Shortcuts

Ctrl + P + Left mouse button (or middle mouse button) = Pan

Z + Left mouse button (or roll middle mouse button) = Zoom

Alt + Middle mouse button = Orbit

Ctrl + **W** + Left mouse button and drag a box = Box zoom

Ctrl + **R** = Rotate view

Ctrl + **Alt** + **Z** = Frame all in one view

Ctrl + **Shift** + **Z** = Frame all in all views

W = toggles selected viewport full screen (**Alt** + **W** in 3D Studio Max 5)

Ctrl + **X** = Professional mode

Animation/Manipulation Shortcuts

Manipulation shortcuts need to be custom set.

Playback Shortcuts

/ = Playback animation

Home = Go to first frame

End = Go to last frame

• = Go to next key

, = Go to last key

3 Setting Up Animation Preferences in 3D Studio Max

Click the **Time Configuration** button at the bottom right of the screen and up will come the **Time Configuration** window. Set the **Frame Rate** to the speed that you want your animation to play back at (the default is 30 fps so change this to 25 fps by clicking **Custom** and typing in '25').

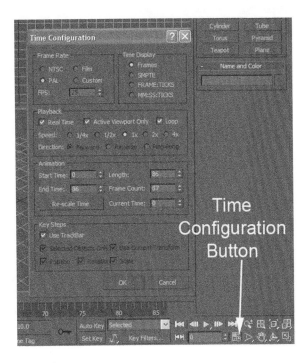

4 Creating Basic Objects in 3D Studio Max

In the Command Panel select the **Create** tab and then select the object you want to create. With the **Geometry** button selected, you can chose various sorts of objects from the dropdown menu. Select one of the object buttons, for example **Sphere**, and create the object by clicking and dragging in one of the viewports and then pressing **Enter**. You can also type the size you require in the section of the Command Panel titled **Keyboard Entry** (e.g. **Radius**: 1.0) and then click the **Create** button and a sphere will be created in the viewport.

5 Moving Objects in 3D Studio Max

Click either the **Select and Move**, the **Select and Rotate** or the **Select and Scale** button at the top of the screen. Then select the object you want to move and move it by clicking and dragging.

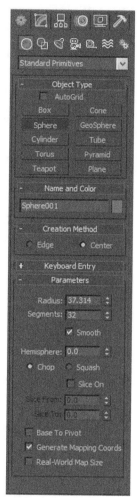

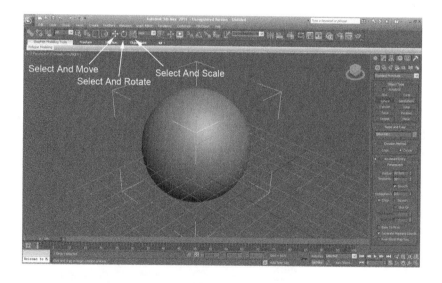

6 Setting Keys in 3D Studio Max

To create a key in 3D Studio Max click the **Set Keys** button (which will turn the surround of the viewport red). Click either the **Select and Move**, the **Select and Rotate** or the **Select and Scale** button and move the object that you want to move. Then click the **Set Keys** button again. This will set a key position on the Time Slider for your object. Move the Time Slider along to the next frame in which you wish a key position to be added. Move your object and click the **Set Keys** button.

To set keys automatically click **Auto Key** and move your object, and a key will be set automatically. You can also right click the Time Slider to set keys or set them in the **PRS Parameters** area within **Motion** on the Command Panel.

7 Using Track View in 3D Studio Max

Open up Track View by going to the main menu and selecting **Graph Editors > Track View > Open Track View – Curve Editor**. Select the curve from within the hierarchy tree (follow the path **Objects > Specific object > Transform > Position Rotation** or **Scale**).

To get handles on a key point on a function curve, select the key point (right click) and up will come the **Position** window. Select the **Handles** buttons for both **In** and **Out**. Move the handle with the left mouse button. Only the **Show Tangents** and **Move Keys** buttons should be selected at the top of the **Track View** window.

To break handles, click on the **Advanced** button and click **Lock** against X, Y or Z. Move handles with the left mouse button.

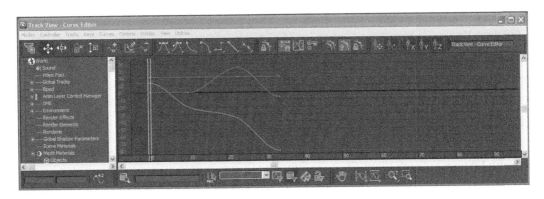

8 Creating a Preview in 3D Studio Max

Select a viewport, go to the main menu and click **Rendering** and then click **Make Preview** and up will come a panel with settings for various parameters such as start and end frames, size, frames per second etc. Click **Create** and an .avi movie will be rendered for you.

9 Hierarchies in 3D Studio Max

Open up Schematic View (on the main menu, **Graph Editors > Open Schematic View** or **New Schematic View**) and up will come the **Schematic View** window. Select one object (which will turn yellow) in Schematic View, then select the **Link** button (top left of the **Schematic View** window). Click and drag from the selected object to the object that you want to be the parent and let go. You should now have two linked objects. To unlink them select them both (click one object then select the other object with **Ctrl** pressed) and then click the **Unlink Selection** button (next to the **Link** button). The objects should now be unlinked.

10 Creating Objects and Putting Bones in them in 3D Studio Max

To make an object, go to the main menu and select **Create > Standard Primitives** or **Extended Primitives**.

To create bones, go to the Command Panel and select **Create > Systems > Object Type > Bones**. Alternatively, go to main menu and select **Animation > Create Bones** (or **Character > Bone Tools > Create Bones** in 3D Studio Max 5) and left-click in the scene. Press **Esc** to leave the mode.

To add an IK solver, select the top bone and in the main menu go to **Animation > IK Solver > Hi Solver** and select the next bone but one.

To skin the bones, select the object to be skinned and from the main menu choose **Modifiers > Animation Modifiers > Skin**. In the Command Panel **Parameters** box under **Edit Envelopes** select the **Add Bone** button. Up will come the **Select Bone** window. Click the bones in the list that you want to be associated with your skin and click the **Select** button, and the bones will now move your skin very badly. To change weighting, click the **Edit Envelopes** button and spend days and days trying to get the damn thing to move properly. Alternatively, parent an object to a bone (much easier).

11 Giving Your Characters Color in 3D Studio Max

Right-click on the object, click on **Properties**, click on the colored box next to **Name**, choose a color and then click **OK** twice.

12 Importing Sound into 3D Studio Max

Right-click on the Time Slider and select **Configure > Show Sound Track**. Go to the main menu and click **Graph Editors > Track View**. Click the **Function Curves** button at the top of the Track View in 3D Studio Max 4 or go to the main menu and select **Graph Editors > Track View > Open Track View – Curve Editor** in 3D Studio Max 5. Select **Sound** by right-clicking in the hierarchy tree and select **Properties** from the list that comes up. This will open the **ProSound** window. Select **Add** and from the **Open** window find your sound, select it and click **OK**. Click **OK** in the **ProSound** window and you should now have your sound in the hierarchy tree. It should also appear in the Time Slider and in the Track View. If you play back the Time Slider with the playback controls you will hear your sound playing.

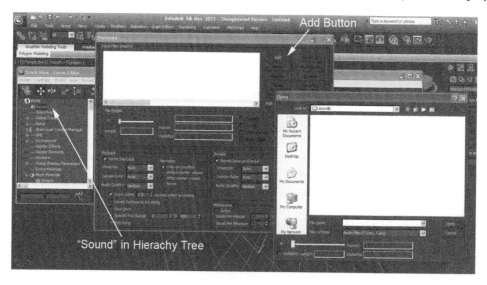

13 Rendering Your Work in 3D Studio Max

Go to the main menu and select **Rendering > Render Setup** and up will come the **Render Setup** window.

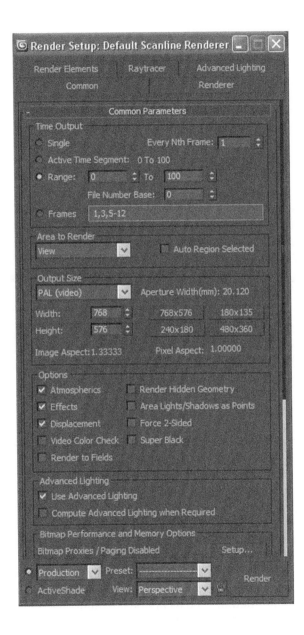

Make sure you select the **Range** radio button and make sure the start and end frames are correct. Make sure your **Output Size** is correct (e.g. 768 × 576). In the **Render Output** section (you may have to scroll down to find this section) click **Files** and up will come the **Render Output File** window.

Give your movie a name in the **File name** box and choose how you want it to be saved in the **Save as type** box. If you choose .avi the program will ask you what codec to compress your .avi with. Close the **Render Output File** window. Click the **Render** button at the bottom of the **Render Scene** window. With any luck you should be rendering your scene!

Overview of the 'Ball Drop' Exercise in 3D

Open up your 3D computer program and take out your 'balldrop' animation drawings and the related X-sheet (or look back at the illustration showing the eight drawings with timing charts). Create a ball. Make sure that the Time Slider or Frame Slider is at the first frame and move the ball to a position similar to drawing 1 of your 2D animation. Set a key position. Then move the Frame/Time Slider to frame 9 and position the ball as in drawing number 9 (the second key position).

Copy each of the key positions from your animation onto the computer in this way and set keys at the key positions of your drawn animation.

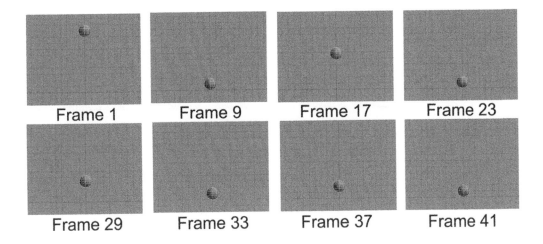

| Frame 1 | Frame 9 | Frame 17 | Frame 23 |

| Frame 29 | Frame 33 | Frame 37 | Frame 41 |

Play back your animation (or have a look at 'ball_drop_keys_3D.avi', animations001, Chapter 1 on the website). It will look odd because of the way the program in-betweens the key positions. It does this by accelerating out of one key and decelerating into the next. In order to adjust this we need to manipulate the curves (called either 'animation curves' or 'function curves') that relate to the animation of the ball. In all 3D computer animation program, the movement is broken down into a graph-like mathematical interpretation. If you take the up and down movement of the ball as the vertical value and the time it takes to do it as the horizontal value, you will end up with a series of points on a graph that correspond to where you have set your key frames. The computer program will join these points together to produce a curve and this will provide the in-between movement of your object. The default type of line linking the curves is called a 'spline'.

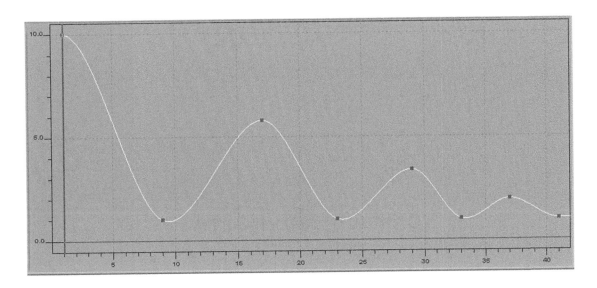

You can change the way the computer in-betweens your key positions by adjusting these curves. There are a number of different options. 'Linear' is a straight line between each key. A 'stepped' or 'constant' line continues at the same value as the first key before jumping to the value of the next key.

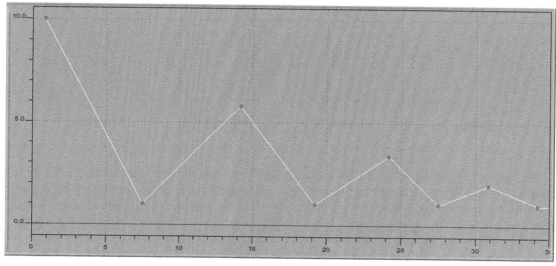

Linear Curves.

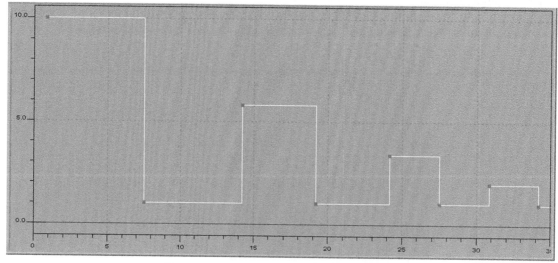

Constant or Stepped Curves.

The key points can also be given 'handles', making it possible to adjust the angle of the curve. (Curves with handles can be called 'Bézier splines').

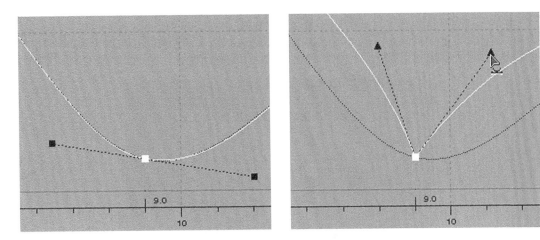

For our bouncy ball we need to 'break' the curve at the key position where the ball hits the ground. This means we need to make the curve ascend and descend between the keys in a nice parabola. From here we need to have a second parabola for the second bounce, a third parabola for the third bounce and so on.

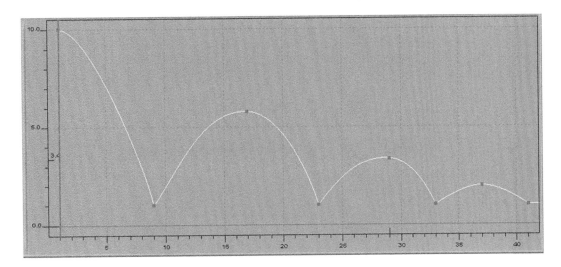

Take a look at 'ball_drop_3D.avi' in animations001, Chapter 1 on the website. The ball is now bouncing more like a ball should!

Of course, I'm not suggesting that you should always start by working in 2D, but while you are learning to animate it will help you pick up timing all the quicker. By the end of the book you will only need to work out the basic key positions in 2D (in a very rough form) before animating in 3D.

How to Animate a Basic Bouncy Ball in Maya

How to Create Your Ball

Open up Maya and make the screen turn into four view panels by pressing the space bar on your keyboard quickly once. Make the mouse pointer hover over the front view panel and press the space bar quickly again to make the front view panel full screen.

To create a ball, go to the main menu and select **Create > NURBS Primitives > Sphere** (alternatively click the **Sphere** icon on the shelf above the view panel). Then click and drag in the view panel. This will create a ball.

You can rename your ball by going to the top of the Channel Box and under **SHAPES** clicking on 'NURBSSphere1' (the current name of your ball), which will turn blue. Type in a new name; let's be imaginative and call it 'ball'. Press **Enter**. The position of the ball can be controlled by typing in the upper part of the Channel Box. Next to **Translate X** and **Translate Y**, type '0'. This will bring the ball to the center of the viewport.

The size and shape of the ball can be altered by going to the **Inputs** section of the Channel Box and clicking on 'MakeNurbsSphere1'. This will open a series of input boxes: **Radius** (the radius of the sphere) – type '1' to give it a radius of 1 unit; **Start Sweep** and **End Sweep** (by adjusting the figures in these boxes you can end up with a sphere that looks a bit like an orange with a few segments missing); **Degree** (this will change the ball from the low-resolution look to the high-resolution look); **Sections** (this controls the number of lines running up and down the sphere); **Spans** (this controls the number of lines running from side to side across the sphere); and **Height Ratio** (I haven't got a clue what this does so I keep it at 2).

Have a play at changing the inputs on the ball. If you mess up, delete it and create another. When you have adjusted the ball to something that you like, it's always a good idea to delete its history. Do this by selecting the ball and from the main menu selecting **Edit > Delete by Type > History**. This 'sets' the ball to the new shape.

How to Animate Your Ball

Take out your drawn animation of a ball dropping (or have a look at the ball dropping illustration earlier in this chapter). Click the **Animation Preferences** button at the bottom right of the screen. Up will come the **Preferences** window. In the **Categories** box select **Settings** and in the box next to **Time** select 'PAL (25 fps)' (unless you are in a country that uses NTSC, in which case choose 'NTSC (30 fps)'). Alternatively, keep it at 24 fps (film speed); this is easier to work with mathematically (it is more easily divisible than 25). Click **Save** to close the **Preferences** window.

Press **Alt** and 'pan' the view with the middle mouse button so that the thick horizontal line on the grid is near to the bottom of the view panel.

Make sure the Time Slider is at frame 1. Move the ball to the top of the view panel by clicking the **Move** tool and then clicking and dragging the green arrow that emerges from the top of the ball. This will move the ball in the Y axis (up and down). (You could type a number – let's say 10 – next to **Translate Y** in the Channel Box and press **Enter**). When the ball is in the correct position hit **S** on your keyboard. You have now saved your first key in Maya! Alternatively, you could click the **Auto Keyframe** toggle and with it activated a key will be set when you move the ball.

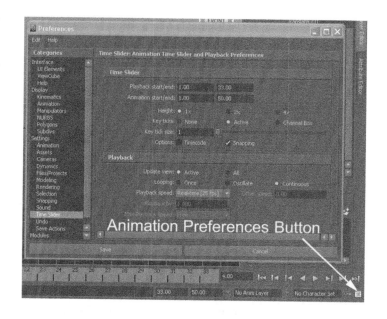

Move the Time Slider to frame 9 and then drag the ball down so that it is sitting on the thick horizontal line running through the grid. Set your second key (or, if you are using **Auto Keyframe**, a key will be set automatically).

Follow this procedure for all remaining keys (at frames 17, 23, 29, 33, 37 and 41).

Play back your animation (or take a look at 'ball_drop_keys_3D.avi', animations001, Chapter 1 on the website). It bounces in a rather strange way. This is because the ball is accelerating out of and then decelerating into each of the key positions. It should decelerate into and accelerate out of the key positions at the apex of each bounce (17, 29 and 37) but should keep accelerating into the keys where it hits the ground and then accelerate out of these key positions (9, 23, 33 and 41).

Adjusting the In-Betweens

Open up the Graph Editor by going to the main menu and selecting **Window > Animation Editors > Graph Editor**. In the **Outliner** area of the Graph Editor select **Translate Y** and a green curve will be illustrated in the **Animation Curve** area of the Graph Editor.

Each of the points on the curve is one of the key frames that you set. On the graph, horizontally they will correspond to the frame number they were set at, and vertically to the value in **Y** (up and down). These values can be adjusted using various tools (more later). The highest key points on the curves are the highest parts, in the animation, of each of the bounces. The lowest key points on the curves are the parts, in the animation, where the ball touches the ground. The program has linked these key points together in a way that makes the curve gracefully swoop in and out of each key point.

These curves are referred to as 'spline' curves. (You can also set the curves to 'linear', 'clamped', 'stepped', 'flat' or 'fixed'. Go to the Graph Editor menu and select **Tangents** and select each of these curve types in turn. Play back your animation and see what effect they have on the ball's movement and then return the curves to 'spline' to continue with the exercise.)

The effect of 'spline' curves is to accelerate the movement out of one particular key point and decelerate into the next key point and so on through the piece of animation. Sometimes this works fine, as with the apex of each bounce of the ball, and sometimes it doesn't, as with the parts of the animation where the ball hits the ground. At these points we need to 'break' the curves.

You can adjust each of these key points by selecting them (click on a key point or click and drag a box around a key point) and then selecting the **Move Nearest Picked Key Tool** button (top left of the Graph Editor window). When selected, the key points will grow handles, and middle clicking and dragging one of the handles while pressing **W** on your keyboard will affect the shape of the curve and thus affect your animation.

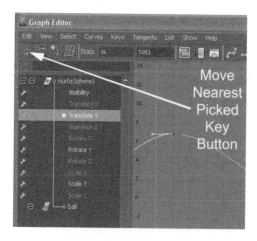

The handles work in unison with each other when using this method of adjustment. You can also make the handles work independently of each other by 'breaking' the key point. To do this select a key point and the select the **Break Tangents** button. The left handle will turn dark blue.

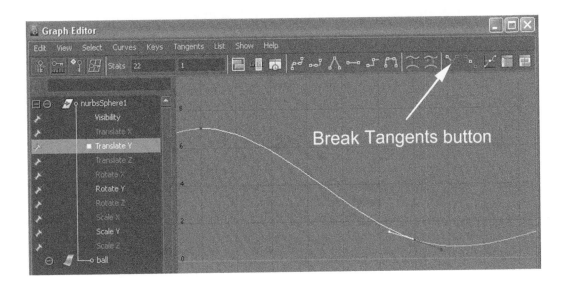

Click one of the handles to make it active and then middle click and drag to adjust it. Drag it up so that you get a nice sharp curve arcing into the key point. Do the same for the second arm.

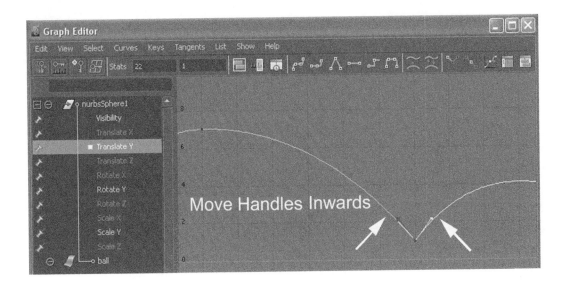

Repeat this procedure for each of the key points where the ball bounces on the ground (frames 9, 23, 33 and 41). You should end up with a curve that looks like the one below.

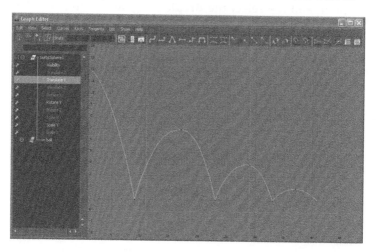

Make a preview of your animation by selecting a view panel (it goes blue around the edge) and go to the main menu. Click **Window** and then click **Playblast**. Maya will now render a low-resolution .avi of your animation. Windows Media Player or Quick Time will come up and play your animation.

Hopefully your ball will be bouncing a bit more like a real ball now. Have a look at ball_drop_3D. avi, animations001, Chapter 1 on the website.

How to Animate a Basic Bouncy Ball in 3D Studio Max

How to Create Your Ball

Open up 3D Studio Max and switch the screen from showing four viewports to having the **Front** viewport full screen. To do this select the **Front** viewport by clicking in it and press **Alt** + **W** on your keyboard (just **W** for 3D Studio Max 4).

To create a ball go to the Command Panel and select the **Create** tab. In the dropdown menu make sure that **Standard Primitives** is displayed and in the **Object Type** section select 'Sphere'. Go down to the **Keyboard Entry** section and type '10.0' in the box next to **Radius**. Then click **Create** and a sphere will appear in the center of the viewport.

The ball should be solid rather than wireframe, but, if it's wireframe, click on **Wireframe** in the top left corner of the viewport and select **Smooth + Highlight** from the menu that comes up.

How to Animate Your Ball

Take out your drawn animation of a ball dropping (or have a look at the illustration of the ball dropping earlier in this chapter).

Click the **Time Configuration** button at the bottom right of the screen. Up will come the **Time Configuration** window. In the **Frame Rate** section select **Custom** and in **FPS** type 25, then select 'PAL' (unless you are in a country that uses NTSC, in which case choose 'NTSC (30 fps)'). Click **OK** to close the **Time Configuration** window.

Click the middle mouse button and move the mouse to pan the view so that the thick horizontal line on the grid is near to the bottom of the viewport.

Make sure the Time Slider is at frame 1. Move the ball to the top of the view panel by clicking the **Select and Move** button and then clicking and dragging the green arrow that emerges from the top of the ball. This will move the ball in the Y axis (up and down). When the ball is in the correct position, select **Create a Key**. Select the **Set Keys** button (the surround of the viewport goes red) then click the **Set Keys** button (the button with the key on it). You could use **Auto Key**. To do this, select the **Auto Key** button, then move the ball to its first position. It will set a key for you automatically.

You have now created your first key in 3D Studio Max! Alternatively, you could select the **Auto Key** button. Then, whenever you move the ball, a key is automatically set.

Move the Time Slider to frame 9 and then drag the ball down so that it is sitting on the thick horizontal line running through the grid. Set your second key (or, if **Auto Key** is selected, a key will be set automatically).

Follow this procedure for all remaining keys (at frames 17, 23, 29, 33, 37 and 41).

Play back your animation (or take a look at 'ball_drop_keys_3D.avi', animations001, Chapter 1 on the website). It bounces in a rather strange way. This is because the ball is accelerating out of and then decelerating into each of the key positions. It should decelerate into and accelerate out of the key positions at the apex of each bounce (17, 29 and 37) but should keep accelerating into the keys where it hits the ground and then accelerate out of these key positions (9, 23, 33 and 41).

Adjusting the In-Betweens

Open up the Track View by going to the main menu and selecting **Graph Editors > Track View – Curve Editor**. In the hierarchy tree area of the Track View select **Objects**, then **Sphere 01**, then **Transform**, then **Position** and also **Z Position**. This will all be selected for you if the ball is selected in the viewport. A blue curve will be illustrated in the **Animation Curve** area of the **Curve Editor**.

Each of the points on the curve is one of the key frames that you set. On the graph, horizontally they will correspond to the frame number they were set at, and vertically to the value in **Y** (up and down). These values can be adjusted using various tools (more later). The highest key points on the curves are the highest parts, in the animation, of each of the bounces. The lowest key points on the curves are the parts, in the animation, where the ball touches the ground. The program has linked these key points together in a way that makes the curve gracefully swoop in and out of each key point.

These curves are referred to as 'spline' curves. (You can also set the curves to 'linear', 'stepped', 'flat' and others. Right click on one of the key points on the curve and in the **Position** window. Play back your animation and see what effect 'linear', 'stepped' and 'flat' curve have on the ball's movement and then return the curves to 'spline' to continue with the exercise.)

The effect of 'spline' curves is to accelerate the movement out of one particular key point and decelerate into the next key point and so on through the piece of animation. Sometimes this works fine, as with the apex of each bounce of the ball, and sometimes it doesn't, as with the parts of the animation where the ball hits the ground. At these points we need to 'break' the curves.

You can adjust each of these key points by selecting them (right click on a key point) and in the **Position** window selecting the **Handle Spline** button for the **In** curve. When selected, the key points will grow handles and left mouse clicking and dragging on one of the handles will affect the shape of the curve and thus affect your animation.

The handles work in unison using this method of adjustment. You can also make them work independently of each other by 'breaking' the key point. To do this, right click a key point to bring up the **Position** window and the select the **Advanced** button. In-between the **In** and **Out** sections is a padlock icon. Click on this.

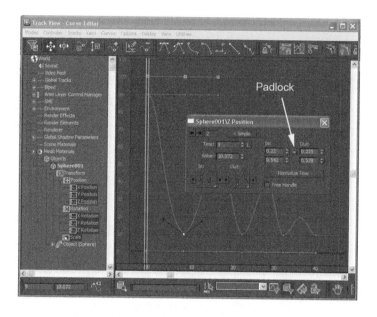

Click one of the handles and drag to adjust it. Drag it up so that you get a nice sharp curve arcing into the key point. Do the same for the second handle.

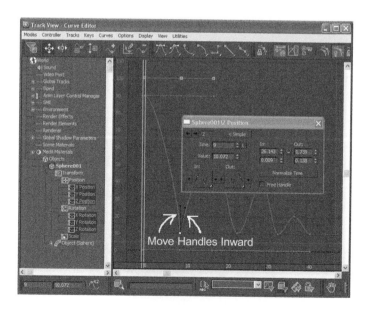

Repeat this procedure for each of the key points where the ball bounces on the ground (frames 9, 23, 33 and 41). You should end up with a curve that looks like the one below.

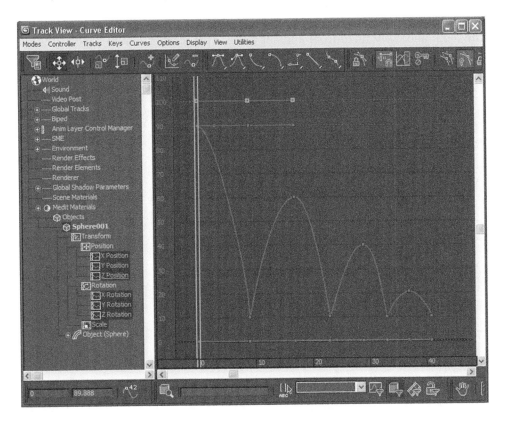

Now make a preview of your animation. Select a viewport, go to the main menu and click **Tools > Grab viewport > Create Animated Sequence File** and up will come the **Make Preview** window. In the **Preview Range** section specify the start and end frame. In the **Frame Rate** specify 1 for **Every Nth Frame** and 25 for **Playback FPS**. In **Image Size** type in a number in the **Percent of Output** to get the frame size you want. In the **Output** section specify 'AVI' and click on the **Top** button to choose the codec that will compress your movie (**Cinepak by Radius** is a good one to use). Click the **Create** button and 3D Studio Max will render an .avi movie for you.

Hopefully your ball will be bouncing a bit more like a real ball now. Have a look at ball_drop_3D. avi, animations001, Chapter 1 on the website.

Drawing

A good animator (whether 2D or 3D) should be able to sketch out a pose for a key frame of an animation in a simple, concise form. You don't have to be brilliant at drawing; however, drawing is the best way there is to interpret the world around you. So, draw as much as possible. Drawing

something that is moving (an animal, say) means that you need to observe it intensively and this will help you to understand the way it moves.

Attend life drawing classes and focus on short poses (less than 10 minutes). If the model is going to pose for an hour or two, draw them from one angle for a short period of time and then move around the room and draw them from another angle. This teaches you to capture the essence of a pose with a few simple lines. Concentrate on getting the structure, weight and balance correct.

Go to zoos and sketch the animals. You'll have to draw quickly in order to capture an animal on the move! This will be far more informative that drawing from books, the television or the Internet.

Sit at street cafés or in parks and draw the people around you. This is a great way to find out about human nature. How do people talk to each other? How do they walk, sit, run and play?

The most important thing about drawing is that it makes you sit down and look at the world around you in detail. Things that you would not normally notice – the way people pick things up, the faces they pull, the body language they adopt – become more apparent to you. A sketchbook is valuable reference material for your animation.

The 12 Principles of Animation

These basic principles were worked out a very long time ago by the pioneering animators of the 1920s. They are still wholly relevant today for *all* animators.

Squash and Stretch

Objects and characters will squash and stretch depending on their construction and what forces are inflicted on them or movements that they do. Squashing and stretching must be controlled and done for a reason: a football will squash when dropped but a bowling ball won't. Squashing and stretching also depend on the construction of the character: the lower half of a person's face around the jaw and cheeks will squash and stretch but the cranium won't.

Anticipation

Any major movement is preceded by a minor anticipatory movement. This anticipatory movement prepares the audience for the major movement to happen and makes them look at the right place on the screen. It also seems to 'wind the character up' and give them energy to do the action they are going to do. For example, if a character is going to throw a ball, they will pull their arm back first before throwing. The amount of anticipation depends on the action that is going to happen and whether you want to surprise your audience. Always vary the intensity of the anticipatory movements during a scene to stop them becoming monotonous.

Staging

Stage the action in a scene so that it is obvious what is happening to an audience. This principle is similar to staging in theater and film. Have good, strong silhouettes (if the character were completely blacked in, could you tell what it was doing?). Make sure nothing else in the scene distracts from what the audience is looking at and make the composition lead the audience's eye to the important part of the shot, through perspective, color, lighting and/or shadow.

Straight-Ahead Action and Pose-to-Pose

As discussed above, these are two different approaches to the animation process. 'Straight-ahead' animation involves producing the scene frame by frame from beginning to end (drawing one drawing after another or positioning a puppet or computer model one frame at a time), while 'pose-to-pose' animation involves starting with a few key positions and then filling in the intervals later (known as 'in-betweening' or 'tweening'). Straight-ahead animation creates a more fluid, dynamic illusion of movement and is better for producing realistic action sequences. However, it is hard to maintain proportions and to create exact, convincing poses along the way. Pose-to-pose animation works better for dramatic or emotional scenes, where composition and relation to the surroundings are of greater importance. A combination of the two techniques is often used.

3D computer animation tends to use pose-to-pose with the software doing the in-betweens for the animator. However, it generally doesn't do these in-betweens particularly well, so the animator has to adjust and correct this in-between movement.

All puppet animation is straight-ahead, but modern techniques mean that an animator will do a dummy run (or 'pop through') of their animation first and use editing techniques to work out the timing. This will then be noted down on an exposure sheet so that, when the animator animates the scene in earnest, they know at which frame their character should be doing what.

Follow-Through and Overlapping Action

These closely related techniques help render movement more realistic and give the impression that characters follow the laws of physics. 'Follow-through' refers to the fact that different parts of a body will continue moving after the character has stopped. 'Overlapping action' is the tendency for parts of the body to move at different rates (the timing of an arm will differ from that of the head, and so on).

A third technique that can be employed is 'drag', where a character starts to move but parts of him take a few frames to catch up. These parts can be inanimate objects, such as clothing or the antenna on a car, or parts of the body, such as arms or hair. On the human body, the torso is the core and the arms, legs, head and hair are appendices that normally follow the torso's movement. Body parts with a lot of tissue, such as large stomachs and breasts or the loose skin on a dog, are more prone to independent movement than bonier body parts. Again, exaggerated use of the technique can produce a comical effect while more realistic animation must time the actions exactly to produce a convincing result.

There is also the idea of the 'moving hold'. A character may have a fixed facial expression as they do a fast movement so that the audience registers that expression.

Slow In and Slow Out

Any movement of a character will accelerate to an maximum speed and slow to a stop. Animation will look more believable if it follows this rule. There are exceptions to this, for example when an object falls down and hits the floor. It often pays to animate this acceleration unevenly, for example by having a movement accelerate slower than it decelerates or vice versa. Constant acceleration and declaration can look robotic.

Arcs

Most human and animal movement occurs in arcs. They way in which we are constructed means that we move our outer extremities is arcs related to joints closer to the body. There is a whole part of our brain that is dedicated to observing and analysing movement and it wants to see living things moving in arcs. Mechanical movement tends to follow circular or straight trajectories and, when you move a human or an animal like this, it looks mechanical.

Secondary Action

Adding secondary actions to the main action gives an animated character more believability and can make them more delightful to watch. Secondary animation should emphasise a character's movements rather than distract from it, and could be the way the arms drag as the body moves, the way another character follows a first character or the flow of drapery or cloth. Try to avoid 'twining', which is movement of different parts of the body in similar ways (e.g. arms moving simultaneously in the same way). When a character comes to rest, have different bits stopping at different times.

Timing

Timing refers to the points during a scene when various things an audience registers happen. Each of these key points happens with a given number of frames or drawings between them and the amount of frames or drawings that each of these key points is 'held' for. It pays to vary the timing of the key positions during a scene and to also work to a beat or rhythm. Show your work to as many people as possible. Give them the minimum they need to understand what's going on and then play with them. Slow things down before something major happens. Move things according to the mood at the time. There is no easy way to learn time – just animate, animate, animate.

Exaggeration

All animation is artifice and exaggeration makes animation more believable. An action or expression that works in live action won't necessarily work in animation. The level of exaggeration depends on how realistic your characters are. Live-action actors in a movie do not behave like real-life people and nor do animated characters.

Solid Drawing

An understanding of drawing in 3D space gives volume and weight to a character. An animator needs to have an understanding of anatomy, weight, balance, light and shadow. All animators should take life drawing classes and also do location sketching of humans and animals. An animator who fills up several sketchbooks a year will be better than one who doesn't.

Appeal

An animated character should be appealing to an audience. This would be described as charisma in an actor. Your audience has to be interested in the character in order to keep watching the movie they are in.

Matter and the Animation of Inanimate Objects

Chapter Summary

- Inanimate Objects
- How to Animate Inanimate Objects
- The Animation of Solids
- The Animation of Liquids
- 2D Exercises
- 3D Exercises

If you can cast your mind back to your first ever physics lesson at school, you will probably remember being told that the world is divided into three states of matter: solid, liquid and gas. At some point you're going to animate all three of these. And, just to make life difficult, there are also energy sources you'll need to animate: electricity, fire and explosions. The animation of liquids, gasses, electricity, fire and explosions is the preserve of the special-effects animator and, although I will touch on how it is done, it is not really in this book's remit. However, knowledge of the movement of solid inanimate objects is vital to the understanding of character animation and that's primarily what this chapter is about.

One thing that will always help your animation is to study real life. We are going to be spending most of this chapter looking at how balls bounce. Almost anything we need to know about the movement of matter can be condensed to its most basic form in the movement of bouncing balls. So, get some balls and start bouncing them!

This chapter is also about familiarising yourself with the 3D program you are using. I will go into a lot of detail about how to use your chosen program.

Inanimate Objects

My definition of an inanimate object is any object that does not display 'life'. These fall into two categories. The first are objects that do not move by themselves: things that have to be dropped, pushed, pulled or propelled by a character. The second are inanimate objects that are able to move: cars, motorbikes, ships, aircraft, machines, engines etc. I would still describe these things as inanimate objects because they are not alive and they show no character or emotion.

In animation there are many examples of previously inanimate objects that do display life. Cars, gas boilers, yoghurt pots, toilet cleaners, gherkins and so on have all been given the breath of life by sticking a couple of eyes, a mouth, some arms and some legs on them and animating them displaying emotions. These have all ceased to be inanimate objects.

When animating any inanimate object we must take the following things into consideration.

Weight

How heavy is the object? A bowling ball will fall differently from a balloon.

Environment

A plank of wood on land may be very heavy but the same plank of wood floating in water will appear to be much lighter. Another consideration is interaction with other objects; for example, a person bowling a bowling ball. The ball rolls along, gathering momentum, before coming into contact with skittles. As it hits the skittles, the force from the bowling ball is transferred into the skittles, causing them to fall over or leave the ground while the ball itself loses energy and therefore slows.

Solidity

How solid is your object? A brick when dropped will not display any squash and stretch as it hits the ground – if anything, bits may fall off it as a result of the impact. It has no inherent elasticity. In contrast, a rubber ball will stretch as rubber has a lot of give. The force of the impact will cause the ball to squash down as it hits the ground before stretching as it rebounds into a bounce.

Force

What type of force is being applied to the object? A shot putter throwing a heavy ball will cause the ball to move in a different way from a cannon firing it!

Construction

How is your inanimate object constructed? A balloon full of water will move differently from a solid box full of water. A feather will float gently down whereas a bowling ball will fall with great speed straight to the ground.

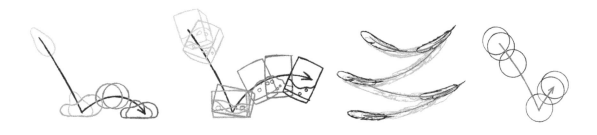

How to Animate Inanimate Objects

It's always best to base your animation on real life. Even the most cartoon-like animation will have one foot in reality to make it believable. If your animation involves dropping a bowling ball, find a bowling ball and drop it. This way you can observe the motion. Bear in mind that, to make the action more convincing for your audience, you will have to exaggerate the way the ball moves. All animation can be thought of as a performance, in the same way that an actor will produce a performance that is an exaggerated version of real life. If you make the animation too 'realistic' it can often look stiff or insignificant. Exaggerating the movement can make a piece of animation more convincing.

A good example of this can be seen in many live-action films that feature explosions. The explosion will usually be shown in slow motion, emphasising its power and force and drawing your attention to the smoke and debris flying through the air. Think of all animation as being an exaggerated version of real life.

The Animation of Solids
A Bowling Ball

This is a good example of a heavy object. Once dropped, the bowling ball will accelerate rapidly to its maximum speed (deriving its energy from gravitational pull). It will then bounce (with no squash and stretch, because it is a solid, rigid object) as it hits the ground (unless it smashes straight through the floor, in which case it will keep going). The maximum speed is reached just before the ball hits the ground. The weight of the ball combined with its rigidity means that the curve (or angle) of the bounce will be steep. As it accelerates away from the ground and decelerates into the apex, the movement will be short and quick before the ball accelerates back towards

the ground as gravitational pull takes over. This could be repeated a couple of times. The apex of the bounce will be lower each time. Each successive bounce will be increasingly closer to the previous bounce, while the curves of the bounces will remain quite sharp.

To animate this sequence, start with a still picture of the ball being held. When the ball is dropped, the time elapsed between each drawing rapidly increases until you reach maximum speed, at which point the drawings will be an equal distance apart. This means that each subsequent ball will be further and further from the previous one on the drawings.

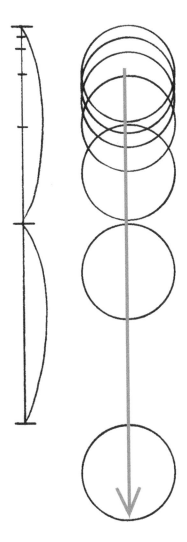

When the ball hits the ground it will bounce. The reason it bounces is that when the ball hits the ground the energy contained within the ball has nowhere to go but back up, lifting the ball into a bounce. The ground absorbs a small amount of energy, which gives each bounce less power. The

height of the first bounce will be lower than the height from which the ball was initially dropped. As more energy is absorbed by the ground, each successive bounce will be lower than the last.

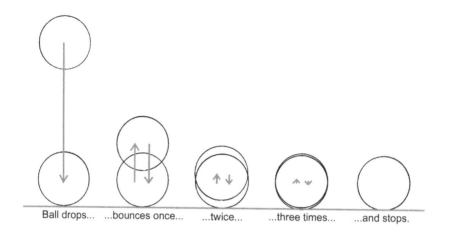

Ball drops... ...bounces once... ...twice... ...three times... ...and stops.

As another example, when you propel a bowling ball forwards, the acceleration is slow as you transfer energy from your hand to the ball. It is as if the ball is reluctant to take on the energy. You need to give it a very hard shove to get it going. The ball will be at its maximum speed as you stop pushing. Once it gets going, the weight of the ball combined with the energy from the push gives the ball the momentum to keep travelling and it will decelerate very slowly before stopping.

When animating a bowling ball being bowled, the first drawings, of the hand propelling the bowling ball, are close together, giving the impression of the initial thrust of speed. The time spacing between the drawings then increases gradually until the maximum speed is reached (the point at which the hand stops pushing the ball). The drawings gradually become closer and closer to each other as the speed of the ball slowly decreases and it comes to a graceful stop. It must be remembered that a lot of energy has been passed to the ball to get it rolling. It has a great deal of momentum, so it will take considerable force (or a very strong object) to stop it prematurely.

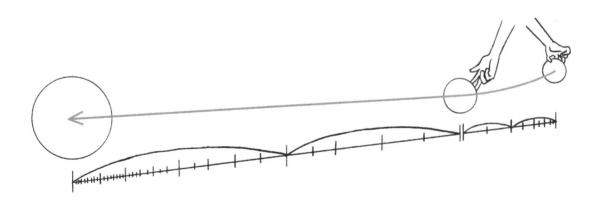

A Soccer Ball

A soccer ball, when dropped, will accelerate at a slightly slower pace than a bowling ball. It will squash slightly as it hits the ground. This is because a football is flexible: it consists of a membrane holding in compressed air. As the ball hits the ground, the energy contained in the ball is forced outwards (i.e. the ball squashes) and not upwards because there is still energy at the top of the ball that will prevent the energy at the bottom of the ball from bouncing straight up. Only when the energy at the top of the ball has reached its lowest limit will the ball bounce up. Because a soccer ball is lighter than a bowling ball, it is affected less by the pull of gravity as it bounces and will bounce higher (assuming they are dropped from the same height). A membrane filled with compressed air has a certain amount of give, making it springier. This means that a soccer ball will also bounce more times than a bowling ball before coming to a stop.

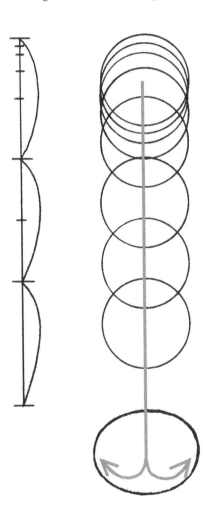

A soccer ball being kicked is far easier to move than a bowling ball (it is a soccer ball, after all). The energy is passed easily from the foot to the ball, which will probably travel further than the bowling ball. It will be easier to stop, though, because it is flexible and will squash against any object in its path, and also won't contain as much kinetic energy as a shoved bowling ball.

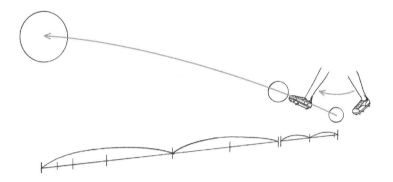

A Balloon

When dropped, a balloon will accelerate very slowly to maximum speed, squash slightly, bounce slowly a couple of times (each time a smaller bounce) and come to a stop. The reason it squashes less than a football is that it has gained far less momentum from its fall, so there is less energy to push outwards at the point at which it hits the ground. It will also slow down just before it hits the ground. This is because a balloon is so light that a cushion of air above the ground gives a small amount of resistance and adds to the impression of the balloon's lightness.

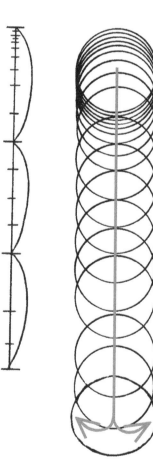

A balloon being pushed along the ground requires very little energy to get it moving, so it will accelerate rapidly to its maximum speed while some of the energy is absorbed by the balloon squashing against the hand as it is pushed. Very little energy is passed to the balloon from the hand so it contains very little forwards momentum. As such, as it leaves the hand it will decelerate to a stop rapidly.

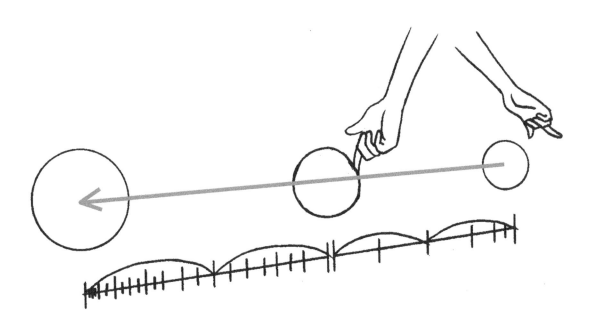

A Water-Filled Balloon

A balloon full of water, when dropped, will accelerate rapidly because it is heavy. It will also adopt a tear shape as it falls. This is because the balloon is a flexible membrane and all of the water wants to be at the bottom of the balloon because of gravity. The membrane will flex to a certain limit at the bottom of the balloon and any water that can't fit at the bottom will stay at the top. When it hits the ground, the water at the top of the balloon will push the membrane outwards to the sides. When the water has pushed the membrane out as far as it will go (without bursting), the water is forced upwards, all around the inner surface of the balloon's membrane. When it meets at the top, whatever energy there is will lift the balloon. As the balloon reaches the top of its apex, the water will fall back down within the middle of the balloon. As the balloon hits the ground again, the water is forced outwards, again causing the balloon to squash. This time, because the force of the fall is smaller, the balloon will squash less. As before, the water is forced upwards by the membrane, meets at the top and is then forced down. The balloon does not take off this time.

The water circles round within the balloon and pushes the membrane out into another squash, this time even smaller than the last. This action can be repeated several times, with the extent of the squash and the height to which the water travels within the balloon becoming less and less. Finally, the balloon will come to rest in a slightly squashed position.

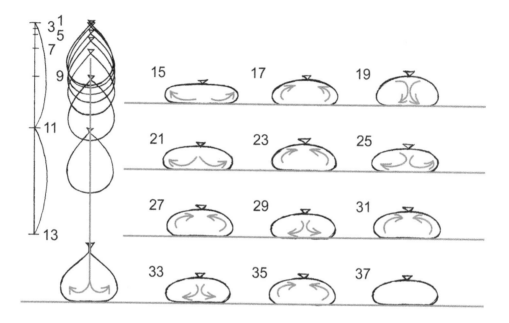

Depending on the force of the fall, the balloon will ether burst, if dropped from a great height (because it will be travelling faster than if it were dropped from a lower height), or will not bounce into the air at all, if dropped from a low height. All that will happen will be the flexing-upwards action.

If you were to try to push this water-filled balloon along the ground, the water would absorb a huge amount of the energy passed to it and the balloon would rapidly come to a halt. The water within the balloon would rotate faster than the balloon's rotation along the ground, producing a forwards-moving, undulating effect across the top of the balloon. The basic principle of what happens is as follows. The water flows forwards, pushing the membrane at the front of the balloon until it reaches its elastic limit. This stretches the balloon out so that it is flatter. When this occurs, the water flows under itself towards the back of the balloon. When the water reaches the back of the balloon, it is prevented from flowing back by the rear part of the balloon's membrane. The water then goes up and over itself towards the front of the balloon, pushing the membrane at the top of the balloon upwards as it goes. Finally, to complete this cycle, the water pushes against the front part of the balloon, producing forwards momentum. As this cyclical action is repeated, the water loses energy and is able to push against the membrane of the balloon less and less. So, when the water is at the top of the balloon it will push up the membrane to an increasingly smaller degree

and, in turn, when the water is at the front of the balloon, it will push the membrane forwards less and less. You can see a very simplified version of what is happening in the diagram below.

When the balloon comes to a stop, the water within the balloon will still be rotating within it. The water does not have the force to push the balloon forwards any more but it can still affect the outer membrane shape. With the balloon no longer rolling, the water pushes the membrane as far forwards as it can go and then flows under itself, towards the back of the balloon. At the back of the balloon the membrane stops the water going back any further and forces the water up over the top of itself, pushing the membrane up. It flows toward the front of the balloon and pushes the membrane forwards. As the water has less energy than when it was last at the front of the balloon, it will not push the membrane out as far as it did last time. The water will again flow under itself, towards the back of the balloon, and repeat the same action as before but with less force. After this process has been repeated a few times, each time with less exaggeration, the balloon will come to rest in a slightly squashed position.

These examples of how a water-filled balloon will move are animated at a much slower rate than a water-filled balloon would move in real life. This is because an audience tends to understand what's going on in an animated film more slowly than they do in a piece of live-action film. Consequently, a lot of animated movement has to be slightly slower than movement in real life.

The Animation of Liquids
A Drip

Liquids, unlike solids, have the ability to break apart and reform easily. As it falls, a drop of liquid takes on a tear shape (a bit like a balloon). Surface tension creates a 'membrane', which holds the majority of the water at the bottom of the drop. When the drop hits the ground, the surface tension is broken and the water breaks apart. As the first amount of water hits the ground it bounces outwards and upwards at an angle. It is prevented from bouncing directly upwards by the water that follows.

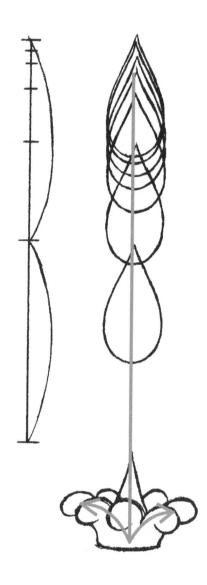

The water caught in the bounce separates from the main body and creates smaller drops. As each of these smaller drops bounce they follow a parabola like a bouncing ball. The smaller drops radiate outwards from the central point of impact and, as each reaches the apex of its bounce, it slows down. As each comes out of its apex, it speeds up and breaks away from the middle. The water behind these smaller drops may form other drops that continue to radiate outwards in arcs or, as they run out of energy and become unable to complete a full arc, they may fall back on themselves.

Depending on the momentum of the water, this sequence may continue for a number of bounces or the drops may run out of energy as they hit the ground, causing the water to flow forwards over the surface. See 'drip. avi', Chapter 2 on the website.

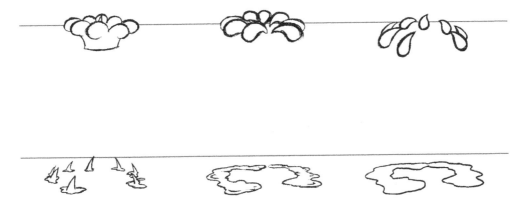

A Splash

Splashes follow the same principles as drips, but they consist of a lot more water. To help visualise this, I always think of the water bouncing off the ground as looking like sheets folding over on themselves. For the first bounce, the sheet of water remains in a mass as it radiates outwards before separating into smaller drops during further bounces or running out of energy and flowing over the ground. See 'splash. avi', animations002, Chapter 2 on the website.

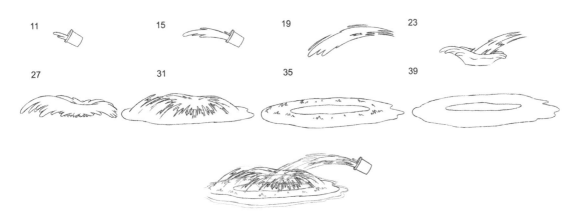

An Object Falling into Water

When an object is dropped into water, the object penetrates the surface, forcing a splash to rise up at the outside edges of the object.

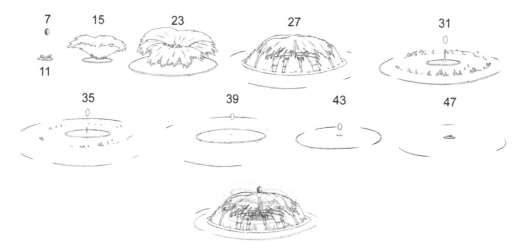

In the above illustration, you will notice that a column of water bounces up in the middle of the splash. This happens because, as the object sinks, it leaves a hollow column. The water surrounding this hollow fills in. It meets in the middle with equal force and wants to rebound. It can't bounce back because of the following water. It can't go down because the object below is in the way, so the water is propelled up. When the column of water reaches a certain height, it runs out of energy and gravity takes over. The water at the very top has the most energy. As the water below it runs out if energy, it breaks away and falls back on itself. This leaves a blob of water floating in the air that, as gravity takes over, then starts its descent to the water surface. It may also cause another smaller splash when it hits the water surface. See 'pond splash.avi', animations002, Chapter 2 on the website.

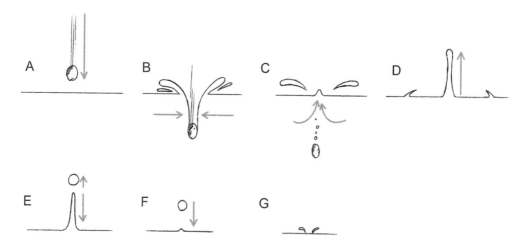

2D Exercises

These exercises look at the principles behind the movement of inanimate objects. Using the examples from earlier we will animate five different balls rolling off the roof of a shed and bouncing on the ground before rolling to a stop. These exercises look at momentum, the force of gravity and how different objects react when hitting the ground.

We will animate a bowling ball, a soccer ball, a beach ball, a ping-pong ball and a water-filled balloon. Each of the balls should be 1 cm in diameter.

The Background Level

First draw a shed at the side of your paper in the same position as in the illustration below. Draw it in black felt pen to make the lines as dark as possible, so that when you combine it with the animation it will be as clear as possible. Make the shed 5 cm wide, 5 cm tall at the highest point and 4 cm tall at the lowest point. (These same dimensions are going to be used in your 3D computer animation.)

You will only need to draw this once. This is your background. When you are animating your balls, keep this background on your peg bar on the light box. Name it 'BG 1' in the bottom right-hand corner.

I will go through the bowling ball exercise in detail. The method is the same for all five balls and can be used as a reference for the other exercises.

Animating a 2D Bowling Ball

Here is the rough trajectory of a bowling ball and the key positions that should be drawn first. Note that a bowling ball will not demonstrate any squash or stretch. Keep it solid!

Draw each of the following key positions on separate pieces of paper.

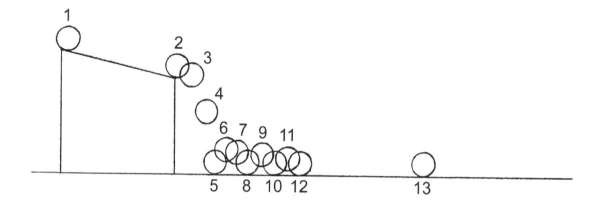

Open up DigiCel on your computer and input the following settings: **# of Frames**: 75, **Frame Rate**: 25 and **# of Levels**: 2.

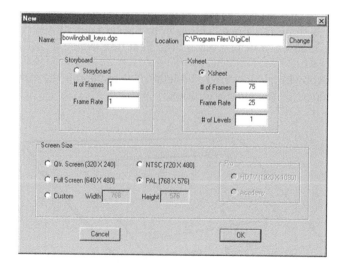

Place the background on the peg bar under the camera, then lay your first drawing of the bowling ball over the top. Hopefully you should be able to see the background through the animation drawing. (Later, when all the in-betweens are done, we'll capture two levels, the background and the animation.) Click on the **Capture** button.

Set **Hold** to 1, **Frame** to 1 and **Level** to 1 or 0 before you begin. Then capture your bowling ball key drawings.

When you've finished capturing, click **OK** and the X-sheet will look like this.

	Sound	BG
1		BG · 1
2		BG · 2
3		BG · 3
4		BG · 4
5		BG · 5
6		BG · 6
7		BG · 7
8		BG · 8
9		BG · 9
10		BG · 10
11		BG · 11
12		BG · 12
13		BG · 13
14		
15		

Click **Play**. A bit quick, isn't it? So, we have to give our drawings extra frames. Experiment with prolonging the number of frames that each of the drawings is held for.

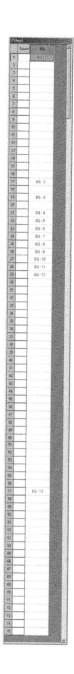

As a guide, arrange your drawings on the X-sheet as shown below. Note down in the 'action column' what is happening and where. If the ball hits the ground at frame 22, write 'ball hits ground' in the row that corresponds with frame 22. This is called 'slugging out' and is good to do so that you get a feel for the timing. After a while you will be able to fill in the column before you even start animating!

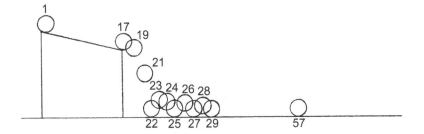

Play your key animation back. How does it look? If it looks like the animation in 'bowlingball_keys.avi' (Chapter 2 on the website), you're doing OK. If not, adjust the number of frames that each of the key drawings is played for until you are happy with it. Show it to other people: friends, loved ones or complete strangers. If they identify it as a bowling ball falling off a shed, you know you are on the right track. Above is an illustration of the bowling ball with the correct drawing numbers (the frame numbers that each of these balls should be captured on).

Now you have to do the 'in-between' drawings. We will follow the same procedure as in Chapter 1 to change the preliminary numbering sequence for the key drawings to the correct sequence that includes the in-betweens. Note down the numbers for the key drawings on a paper X-sheet in column 6. In column 1, write the animation drawing numbers in every other frame. These will be the correct animation drawing numbers (we are going to be numbering our drawings by the frame). Transfer the correct animation drawing numbers across to the key drawings. So, key drawing 1 will now be animation drawing 1 (corresponding with frame 1); key drawing 2 will become animation drawing 17 (corresponding with frame 17); key 3 will become 19; key 4 will become 21; and so on. Once you have renumbered your key drawings with the correct animation drawing numbers, rub out the key drawing numbers on the paper X-sheet. See the illustration right.

Note that the drawings between key drawing 4 (animation drawing 21) and key drawing 12 (animation drawing 29) are 'singles'. This means they are shot for one frame only.

The next stage is to put timing charts onto each of your key drawings. These help you plan the positions for the in-between drawings. The timing chart is drawn at the bottom of your key between the peg bar holes. The first timing chart will be drawn on the bottom of key 1 and relates to the in-betweens from key drawing 1 (renamed animation drawing 1) and key drawing 2 (renamed animation drawing 17). As the ball rolls down the shed roof, it speeds up, so in each of the following drawings the ball drawings should be further and further apart.

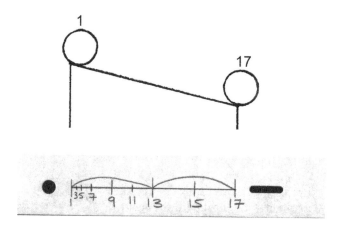

You will notice that there is a looped line between drawings 1 and 13 and between drawings 13 and 17. This is to indicate that drawing 13 is exactly half way between drawings 1 and 17: the ball on drawing 13 should be half way between the balls on drawings 1 and 17. Follow the timing chart, each time completing the next half way drawing. Drawing 15 is half way between 13 and 17, drawing 9 is halfway between 1 and 13, etc.

You've done all the animation necessary between animation drawings 17 and 29 (where the ball is bouncing on 'singles'), so the only other timing chart to do is between animation drawings 29 (formally known as key drawing 12) and 57 (key drawing 13).

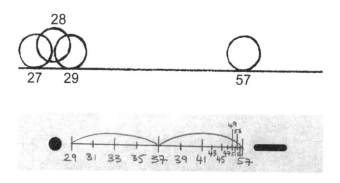

Once you've completed your in-between drawings, capture them with your line tester, as follows. When setting up DigiCel, specify 2 in # **of Levels**.

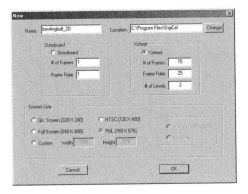

Click the **Capture** button and the **Video Capture** box comes up. Capture the background. Change the **Level** box to 0 and click **Capture**.

To play the drawings on top of the background, change the **Level** box to 1 and change the **Frame** box to 1. Drawings 1–19 will be captured for two frames each. Set the **Hold** box to 2.

Drawings 21–28 will be captured for one frame each. Set the **Hold** box to 1.

Drawings 29–57 will be captured for two frames each. Set the **Hold** box to 2.

When you've finished, click **OK**. Your X-sheet should look something like the illustration below. When you play the drawings back, your animation should look like 'bowlingball_2D.avi' (animations002, Chapter 2 on the website).

FRM NO	6	5	4	3	2	1	B.G.
1	①					①	
2							
3						3	
4							
5						5	
6							
7						7	
8							
9						9	
10							
11						11	
12							
13						13	
14							
15						15	
16							
17	②					⑰	
18							
19	③					⑲	
20							
21	④					21	
22	⑤					22	
23	⑥					23	
24	⑦					24	
25	⑧					25	
26	⑨					26	
27	⑩					㉗	
28	⑪					㉙	
29	⑫					㉙	
30							
31						31	
32							
33						33	
34							
35						35	
36							
37						37	
38							
39						39	
40							
41						41	
42							
43						43	
44							
45						45	
46							
47						47	
48							
49						49	
50							
51						51	
52							
53						53	
54							
55						55	
56							
57	⑬					�57	
58							
59							
60							
61							
62							
63							
64							
65							
66							
67							
68							
69							
70							
71							
72							
73							
74							
75							
76							

Animating a 2D Soccer Ball

Below is the rough trajectory for the soccer ball, showing the key positions. A soccer ball will undergo a certain amount of squash and stretch. As the ball hits the ground, it squashes. As it flies through the air, it stretches at the fastest point of each arc.

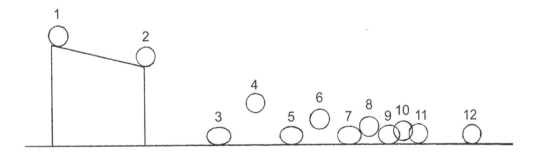

Draw the 12 key positions of the soccer ball and capture them. Number each key by the drawing: 1, 2, 3, 4 etc. The sequence will be 120 frames long (in DigiCel, use the following settings: # **of Frames**: 120, **Frame Rate**: 25 and # **of Levels**: 2). Play the keys back and adjust the frames until you are happy with the timing of the sequence (hold down **Alt** while clicking and dragging down). Use the illustration below for reference. Check out 'soccerball_ keys.avi', animations002, Chapter 2 on the website.

Once you are happy with the sequence, re-number the key drawings by the frame number. You then know how many in-between drawings are needed. Mark them up on a paper X-sheet.

FRM NO	6	5	4	3	2	1	B.G.
1	(1)					1	BG1
2							
3						3	
4							
5						5	
6							
7						7	
8							
9						9	
10							
11						11	
12							
13						13	
14							
15						15	
16							
17						17	
18							
19						19	
20							
21	(2)					(21)	
22							
23						23	
24							
25						25	
26							
27	(3)					(27)	
28							
29						29	
30							
31						31	
32							
33	(4)					(33)	
34							
35						35	
36							
37						37	
38							
39	(5)					(39)	
40							
41						41	
42							
43						43	
44							
45	(6)					(45)	
46							
47						47	
48							
49						49	
50							

FRM NO	6	5	4	3	2	1	B.G.
51	(7)					51	BG1
52							
53						53	
54							
55						55	
56							
57	(8)					(57)	
58							
59						59	
60							
61						61	
62							
63	(9)					(63)	
64							
65						65	
66							
67						67	
68							
69	(10)					(69)	
70							
71						71	
72							
73						73	
74							
75	(11)					(75)	
76							
77						77	
78							
79						79	
80							
81						81	
82							
83						83	
84							
85						85	
86							
87						87	
88							
89						89	
90							
91						91	
92							
93						93	
94							
95						95	
96							
97						97	
98							
99						99	
100							

FRM NO	6	5	4	3	2	1	B.G.
101						101	BG1
102							
103						103	
104							
105						105	
106							
107						107	
108							
109						109	
110							
111	(12)					(111)	
112							
113							
114							
115							
116							
117							
118							
119							
120							
21							
22							
23							
24							
25							
26							
27							
28							
29							
30							
31							
32							
33							
34							
35							
36							
37							
38							
39							
40							
41							
42							
43							
44							
45							
46							
47							
48							
49							
50							

Work out the timing charts for each key drawing. Use the illustration below for reference. Complete the in-betweens. All the drawings in this piece of animation are on twos.

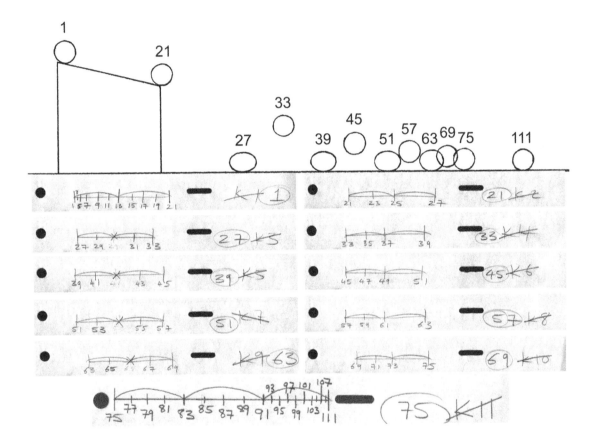

You may notice that on the timing chart between drawings 29 and 31 there is an X. This means that the ball half way between frames 27 and 33 has no drawing. The two inbetween drawings are positioned half way between the key drawings and the mythical X. So, drawing 29 is positioned a quarter of the distance nearer to drawing 27 and three quarters of the distance away from drawing 33. Drawing 31 is positioned a quarter nearer to drawing 33 and three quarters further away from drawing 29. This will give the appearance of the ball moving faster in the middle of the movement.

When you have drawn all the in-betweens, capture them and play them back. If your animation looks like 'soccerball_2D.avi', animations002, Chapter 2 on the website, well done. If not, try to find where you've gone wrong. For example, if the ball spends too much time in the air, take a drawing out or hold one of the drawings for a single frame rather than a double. Don't be afraid to experiment.

Animating a 2D Beach Ball

The beach ball sequence will be 120 frames long (in DigiCel, use the following settings: # of **Frames**: 120, **Frame Rate**: 25 and # of **Levels**: 2).

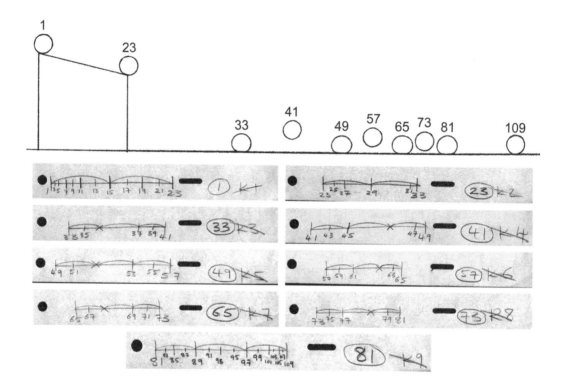

Follow the sequence for the bowling ball and soccer ball. This time, experiment with the timing. A beach ball will travel more slowly through the air than a football. It might roll slightly as it bounces on the ground and not bounce as high. It will crumple at the bottom when it hits the ground rather than squash like a soccer ball. Have a look at 'beachball_keys.avi' and 'beachball_ 2D.avi', animation002, Chapter 2 on the website. As the beach ball bounces, there will be an

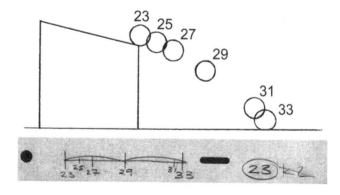

in-between drawing just before it touches the ground. This slows the beach ball down. The reason we do this is to emphasise the lightness of the beach ball, suggesting that the air above the ground gives a small amount of resistance to such a light ball.

Animating a 2D Ping-Pong Ball

A Ping-Pong ball will bounce quite high with fairly short distances between the apex of each bounce. It will not squash or stretch at all. The upwards bounce is quite quick. When it reaches the apex it slows before almost floating down to hit the ground. Adjust your in-betweens accordingly. Below is an illustration of the trajectory of a ping-pong ball. Once it hits the ground it bounces very quickly. To show this, the drawings between 19 and 56 will be on singles.

Follow the sequence for the bowling ball and the soccer ball. The ping-pong ball sequence will be 100 frames long. In DigiCel, use the following settings: **# of Frames**: 100, **Frame Rate**: 25 and **# of Levels**: 2. (Have a look at 'ping-pongball_keys.avi' and 'ping-pongball_ 2D.avi', animations002, Chapter 2 on the website.)

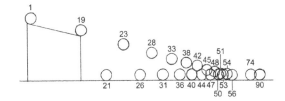

Animating a 2D Water-Filled Balloon

This is probably the most difficult sequence to animate but it is also the most fun to watch when it's working well.

Work out the basic trajectory. Think of the water flowing around the inside of the balloon as it moves, pushing the balloon forwards.

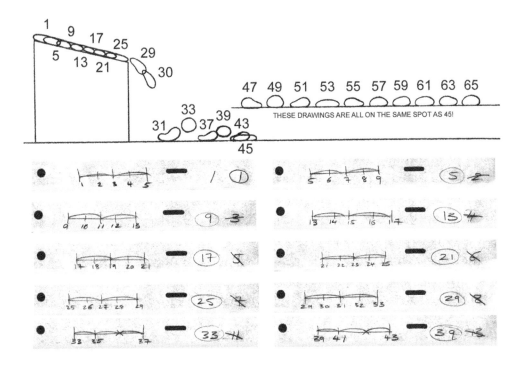

THESE DRAWINGS ARE ALL ON THE SAME SPOT AS 45!

The sequence will be 75 frames long. In Digi-Cel, use the following settings: **# of Frames**: 75, **Frame Rate**: 25 and **# of Levels**: 2.

Start with the basic key positions of the balloon rolling down the shed roof. The in-between drawings of this sequence should be on singles. The illustration (right) shows the in-betweens from key 1 to key 5. The rest of the sequence of the balloon rolling down the roof will follow this pattern.

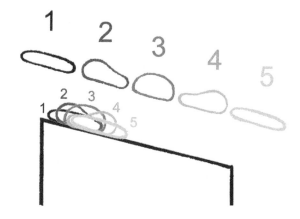

Try to make sure the balloon doesn't slide down the roof. Most forwards movement occurs at the point at which the balloon is most stretched. When stationary, the water rotating inside the balloon stretches the rubber slightly backwards, upwards, then ahead. As the water inside the balloon moves forwards it stretches the balloon and pulls it onward. Have a look at 'waterballoon_keys.avi', animations002, Chapter 2 on the website.

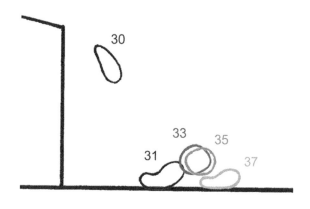

The water-filled balloon will fall quickly when it leaves the edge of the roof because it is very heavy. When it lands it will squash slightly more on one side than the other because of the slight angle at which it leaves the roof.

When you have animated the full sequence capture the drawings and the background and see how it looks. Take a look at 'waterballoon_ 2D.avi', animations002, Chapter 2 on the website.

When you're happy with the five different sequences and it is easy to identify what sort of balls they are, you are ready to do them all again in 3D!

3D Exercises

The 3D exercises for this chapter can be found on the book's website, www.charactermation.com.

To animate the five different balls in 3D, we will follow a similar approach to that for the 2D exercises. First we need to make a background. This consists of a cube that has been given a sloping top. It is built to the same proportions as the shed in our 2D background (5 units × 5 units × 4 units).

We also need to make a floor for the ball to bounce on. This consists of a grid that is the same width as our shed and is long enough to fit all of our ball bounces on (5 units × 40 units). This only has to be built once. It can be reused for each ball we animate.

Then we need to make our balls. These will all be the same size! We want an audience to be able to tell what sort of ball they are from their movement rather than their size. The balls will always be 1/5 the size of the width of the shed.

Each of the balls will have to be constructed with a 'hierarchy'. A hierarchy is an abstract graphical interpretation of how a model is constructed. It consists of a 'parent' that could then be linked to any number of 'children'. Let's say we have two objects on screen, a big cube and a smaller cube. They will be linked together in a hierarchy. The large cube is the parent and the smaller cube is the child. When you select the large cube (the parent) and move it, the small cube (the child) will move with it. But, when you select and move the small cube (the child), it will move on its own, leaving the large cube (the parent) behind.

Select large cube and rotate... ...and small cube will follow... ...but the small cube will rotate independently

Movement given to the parent will affect all of the children, but movement given to a child will work independently of the parent.

The ball hierarchy will consist of three parts: a parent, a child and a child of the child. The parent and the first child will be invisible objects and the second child (grandchild?) will be the ball. These invisible objects are devices that do not render in the final version of your animation (they are called 'point helpers' in 3D Studio Max and 'locators' in Maya). The first two parts of the hierarchy will have different movements ascribed to them. The parent object will deal with the movement (or 'translation') of the ball and the first child will deal with the rotation. In order to save confusion it's a good idea to rename these invisible objects 'movement' and 'rotation'.

First we work out the key positions of the movement (or translation) of the ball and set keys on the movement part of the hierarchy (this will take the other parts of the hierarchy with it). We do this by following the key positions of our drawn animation. The first key position will be at the top of the shed. This will be on frame 1. So, select the movement part of the hierarchy and set key positions on it. The second key position will be just as the ball reaches the end of the shed roof. The frame number of this key position depends on which ball you are animating (with the bowling ball it's frame 17). The key position where the ball leaves the roof is on frame 19. The remaining key positions are worked out by measuring the height and the distance travelled by each of the drawn key balls and then putting the ball, in the 3D computer animation program, in the same position and at the same frame number as the drawn key ball. Take all your measurements from the center of the block for the distance and the height of the ball above the ground.

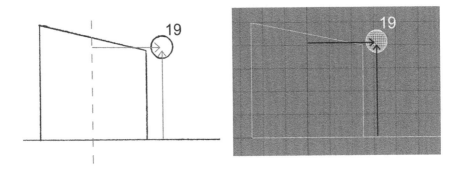

Stick a clear acetate sheet on your monitor screen and draw on it with a whiteboard marker (I accept no responsibility for any damage that you may do if you draw directly onto the screen. Don't draw on a LCD screen until you've tested that the mark can be cleaned off). I will suggest that you use this technique at various points throughout the book. Acetate is a clear plastic sheet that can be bought from stationers and art material shops. Draw the rough positions onto the acetate sheet over the screen of where the ball looks like it should go according to your drawn keys and then position the 3D ball underneath.

Once the movement key positions are in place, the computer will do the in-betweens for us. As we saw in Chapter 1, the in-betweening that the computer does will not be correct. We have to tell it where to put the in-between balls. We do this either by putting in all the in-between balls ourselves or by manipulating the animation curves, as in Chapter 1.

3D Studio Max Track View.

Maya Graph Editor.

Once the movement is done we can go back over our animation and set keys for rotation on the rotation part of the hierarchy. Select the rotation part of the hierarchy and set a key at the very start of the piece of animation. Work out how much the ball will rotate over the length of the scene by measuring the distance travelled in relation to the circumference of the ball. Then, go to the very end of the scene, rotate the ball by the correct amount and adjust the curves to make it looks right.

THREE

The Construction of a Simple Character, its Articulation and Balance

Chapter Summary

- Basic Human Anatomy
- Joints
- Movement in Arcs
- Line of Action
- Designing a Basic Human Character
- How to Design a 3D Character

- Overview of How to Build and Rig a Simple 3D Character
- Planning a Scene
- Animating Your Characters (Using the Left and Right Sides of the Brain)
- Exercises

Animating inanimate objects such as bouncy balls gives you an idea of weight, timing, spacing, and squash and stretch. However, they are not the most interesting things to animate. During this chapter, we will animate something with life, something that initiates movement and has forces imposed upon it: the human character.

Our first task is to design our character. Before doing this we need a basic understanding of human anatomy. I will go through the construction of the skeleton and types of joints. As well as looking at the structure of these, I will also explain how they move and the importance of arcs when animating.

Basic Human Anatomy

A whole book could be (and likely has been) written on animating human and animal anatomy, so I'm going to stick to the absolute minimum that we need to know. Let's start with the main part of the human skeleton: the spine.

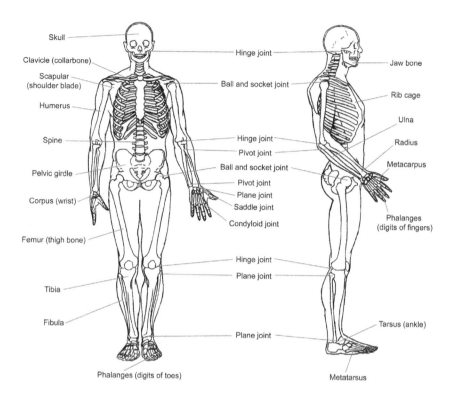

The Spine

At the center of the human skeleton is the 'S'-shaped spine. It is made up of 24 individual bones, called vertebra, which are linked by discs of cartilage. This combination gives the spine great flexibility, allowing forwards and backwards and side-to-side movement and a degree of twisting.

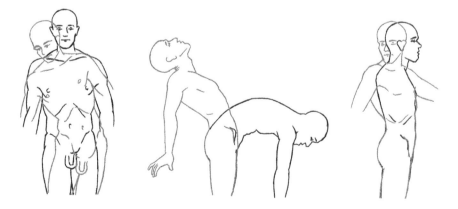

At the top of the spine are the seven vertebrae that make up the neck.

The Rib Cage

Attached to the next twelve vertebrae are 24 ribs (two per vertebra), which constitute the rib cage. The role of the rib cage is to protect the heart, lungs and internal organs. At the bottom of the rib cage is the diaphragm; this, in conjunction with the rib cage, controls breathing. The rib cage restricts the bending and twisting movement of the 12 vertebrae that the ribs are attached to. The lower five vertebra make up the lower spine. Most of the twisting and bending of the spine during the body's movement occurs between these five vertebra.

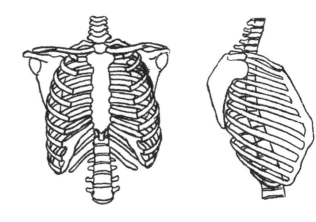

The Pelvic Girdle

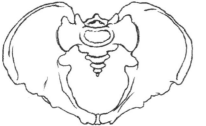 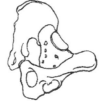 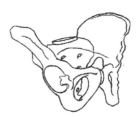

At the base of the spine is the pelvic girdle. This solid set of bones plays a role in keeping us upright. Attached by ball and socket joints are the two femurs of the upper legs. The largest muscle in the body (the gluteus maximus) is attached to the upper thigh bone (the femur) at one end and the pelvic girdle at the other end. This muscle is used to hold the body upright when stationary and moves the femur during walking. It is used when picking things up and jumping. It also helps with the balance of the body.

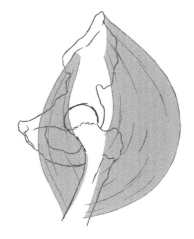

The Skull

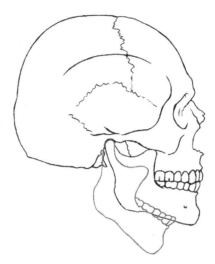

At the top of the spine is the skull. Attached to the scull is the jaw bone, which hinges from the point at which it meets the skull. It has up and down and side-to-side movement.

Between the skull and the rib cage is the neck. This also displays a large amount of twisting and bending, giving about 90 degrees backwards and forwards movement (combined).

The neck also gives about 180 degrees of twist.

The Shoulders

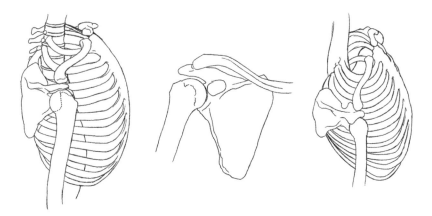

At the top of the rib cage are the two collarbones (clavicles) at the front and two shoulder blades (scapulas) at the back. The collarbones are connected to the front of the rib cage at their inner ends and to the shoulder blades at their outer ends. When viewed from the top, these form a triangle that holds the upper arm (humerus) in place at a ball and socket joint.

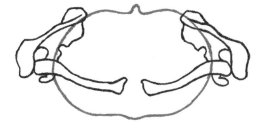

The shoulders blades are almost free-floating and can move in a number of directions: up and down, inwards so that they are almost touching at the spine and outwards to the edge of the rib cage. The main things restricting their movement are the collarbones.

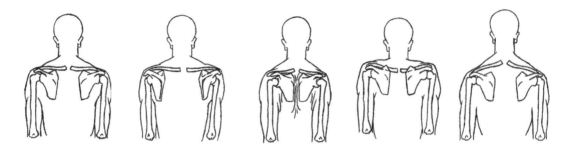

The movement of the shoulder blades affects the position of the arms. For example, by raising the shoulder blades, the arms raise and give the body the appearance of a shrug. When picking up a heavy object, the shoulder blades and collarbones will be lowered, lowering the position of the arm. Much of the character and mood of a person is conveyed by the positions of the shoulders. See 'shoulderjoint.avi', Chapter 3 on the website.

Joints

The limbs of the skeleton are linked by joints, of which there are six types. These are:

1. Plane joints

2. Pivot joints

3. Hinge joints

4. Ball and socket joints

5. Saddle joints

6. Condyloid joints

Understanding how these joints work gives us a clue to understanding movement.

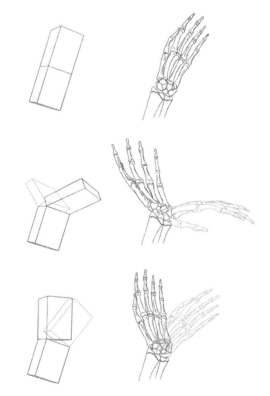

Plane Joints

The surfaces that meet at a plane joint are flat or slightly curved. This allows only a small amount of movement: about 90 degrees backwards and forwards and approximately 45 degrees from side to side. Examples are the wrist and ankle. See 'plane-joint.avi', Chapter 3 on the website.

Pivot Joints

Pivot joints consist of a cylindrical bone twisting within a complete or partial ring. The best example of this is the joint just below the wrist between the two bones of the forearm, the radius and the ulna. This movement combined with the plane joint of the wrist produces the very expressive movement of the wrists. See 'pivotjoint.avi', Chapter on the website.

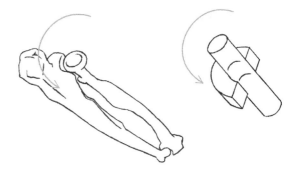

Hinge Joints

The hinge joint, as its name suggests, moves in one plane, like a hinge. The end of one bone ends in a cylinder, the other in a cylindrical excavation. Depending on the joint, it will give up to 160 degrees of movement. Examples include the knees, elbows, fingers and toes (excluding the first knuckle of the fingers). See 'hingejoint.avi', Chapter 3 on the website.

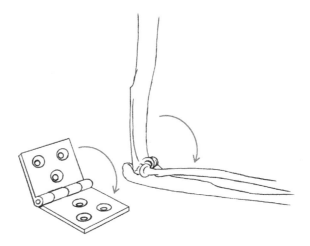

Ball and Socket Joints

The ball and socket joint allows a huge amount of circular movement in most directions. A sphere at the end of one bone fits into a spherical excavation at the end of the other bone. Examples include the hip and the shoulder. See 'ballandsocketjoint.avi', Chapter 3 on the website.

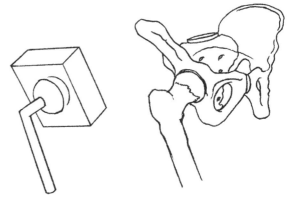

Saddle Joints

The saddle joint is almost a combination of a hinge joint and a ball and socket joint. It is a hinge joint that allows for a certain amount of side-to-side movement. The main example is the joint between the hand and the thumb. See 'saddlejoint.avi', Chapter 3 on the website.

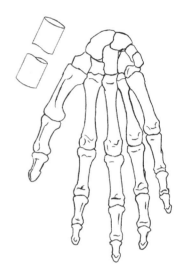

Condyloid Joints

The condyloid joint is a bit like the saddle joint but with more circular movement. Examples of this joint are the first row of knuckles (where the fingers join the hand). See 'condyloidjoint.avi' on the website.

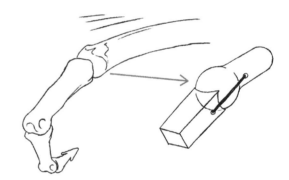

Movement in Arcs

Most movements undertaken by the human body describe arcs. For example, if you keep your arm straight and raise it above you head your hand will move in an arc.

When we watch someone walking, we are aware of how the joints of the body are moving. Subconsciously we see how they move in arcs in relation to each other and from this we deduce that this creature is a human being. Anything that doesn't move in this way will look strange.

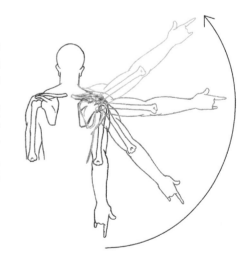

As an experiment, I built a human character in 3D. Rather than giving it skin, I put a white ball at each of the joints. Set against a black background, all you see is a collection of white spheres. I then animated a basic walk cycle, with the character walking on the spot. When the animation plays, all you can see are some white balls moving through space. Despite the abstract nature of the sequence, it is surprisingly easy to work out that it is a human character walking on the spot. This emphasises how important it is to be mindful of reality when moving human characters. Take a look at 'arcs. avi' in Chapter 3 on the website and see if you can work out whether it's a person walking or not.

When somebody looks to the side, their head will bob down through an arc. When somebody jumps in the air, his or her trajectory will describe an arc. Almost all movements made by any living thing will follow an arc. If the character doesn't follow arcs with its movement, your animation can look stiff and robotic.

Line of Action

Your character should always have a design that suggests movement is passing through it. This can help with the design and flow of the movement and also the composition of the scene and the character within it. The line of action can also be thought of as the first, fast, simple mark – or two – that conveys the extent and direction of the pose in life drawing.

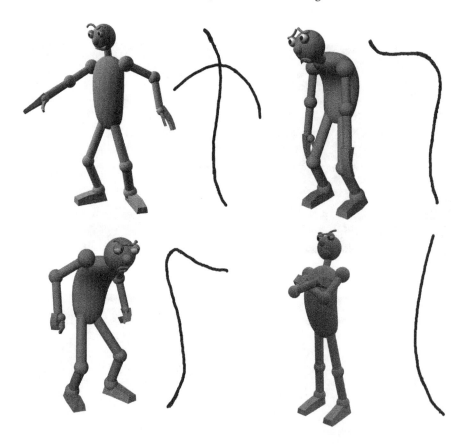

Designing a Basic Human Character

Human beings are one of the most difficult things to animate convincingly. From the moment we are born, we are interacting with other humans. This gives us a subconscious knowledge of how they move. Having this knowledge gives us something to compare the animated character with: the real thing!

When designing a character it is often preferable to simplify and slightly stylise it. The more realistic the character, the more the audience expects it to move realistically. The whole point of

animation is to make the character look believable rather than real. Real people have many subtle nuances in the way they move that are difficult if not impossible to animate. Just watch a real human being and see how much their face moves when they talk. Remember that you want your audience to follow the story rather than thinking that there is something a bit weird about your character. This is equally true of 2D and 3D animation.

It's always good to make a model sheet of your character. This is a collection of drawings on one page (or several pages) that show front, back, side and three-quarter views of the character. It could also include head shots of the face showing different emotions.

A good way of working in drawn animation is to divide your character up into a series of simple 3D shapes: an oval for the head, a bean shape for the body and sticks for the arms and legs. Animate these shapes first. Then, when you are happy with the movement, start adding the details.

For the 2D animation exercises outlined in the book, we will be using a very simple character, like the one below.

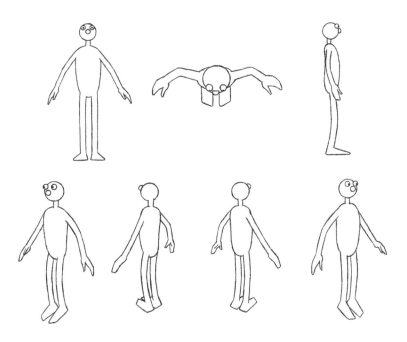

For the 3D animation exercises outlined in the book, we will be using a very simple character, like the one below.

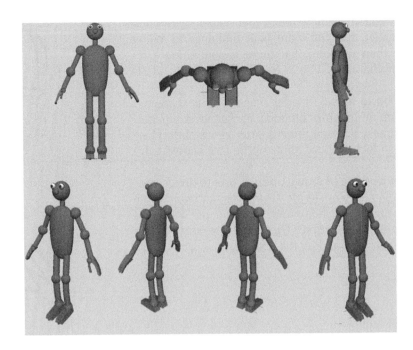

The character is made up of two arms, two legs, a sphere for the head, a body like a bean and basic mittens for hands. The feet have joints at the ankles and toes.

You can design your own character, but bear in mind that it is easier to do the exercises and then apply the timing and spacing learnt to a 3D character that is similar to the 2D drawn one.

When designing a character, there are a number of points to look at:

1. Complexity

2. The 'graphic' nature of the character

3. Strong silhouettes

4. Weight and balance

How to Design a 3D Character

The main thing to bear in mind when designing and building a 3D animated character is to *keep it simple*! You could build the most complicated character in the world, but if it's very complexity makes it awkward to animate the object of the exercise is defeated. Internally, think of your character as being like a racing car. All the controls are cut down to a minimum and are easily accessible. There won't be any cup holders, electric windows, climate control or the 101 other gadgets that you might find on

a standard road car. This simplicity will speed up the workflow of your animation and mean that you don't have to save as many keys on each part of your model. It will also make life a lot easier when it comes to controlling the animation curves of your scene. Less keys, less curves, less wasted time.

Also think about keeping the 'look' of your character simple. The more complicated the design of the character, the longer it takes an audience to take a character in and the slower you need to animate your character – and slow animation usually leads to boredom on your audience's part. Every fold in the drapery, every pimple and hair, every button and pinstripe, every wrinkle and texture will distract the eye of the audience and make the animation look stilted. All of this 'clutter' takes away from your character's performance. It's also much more difficult to 'stage' a complicated character. One of the most important parts of animating a scene is producing good, strong 'silhouettes' at all your key poses.

It is vital to remember that, the more realistic you make your character, the more the audience will demand that your character moves in a realistic way. A real human being sat in front of you has hundreds of tiny, almost imperceptible movements occurring across their face and body, even when they are not doing anything. It's virtually impossible for an animator to replicate all of these movements convincingly without spending a huge amount of time and effort. This is why almost every photo-realistic human character I've seen in movies has looked a bit creepy. Only a fraction of the muscles of the face are moving, the joints are not following graceful arcs and the eyes never seem to be looking in the right place. They end up looking like a shop dummy that's come to life. In the end, rather than make a photo-realistic human model and animate it, wouldn't it be better to film a real human being?

There is certainly a place for photo-realistic human models – in particular, as digital stunt doubles in live-action films. But generally the scene in which the girl is being saved by the superhero as she plunges to her death is done in long shot and inter-cut with live-action close-ups. The strength of the animation is down to the scene planning and the editing.

Photo-realistic animals are a different case in point. An animal's face has far fewer muscles with which to pull facial expressions, so there is less for the animator to do. Also, as soon as an animal talks we are into the world of fantasy and this will kick off something in your audience's head that allows you to get away with more stylised animation.

Making your character simpler and more stylised means that your audience is more forgiving when viewing your animation. They will not be demanding perfectly realistic movement, which means that you can get away with exaggerating and making the movement more fantastic than you can with a realistic character.

In the end, the movement is more important than the model (but then I would say that – I'm an animator). The best-looking character in the world will look terrible if it is animated badly, whereas a stick figure animated well can engage and delight an audience. It's the same in live action: if you take the most beautiful catwalk model in the world and put her in a movie but she can't act, she won't have a very long movie career.

When it comes to designing your character, first draw, draw, draw! Draw your character from as many different positions as you can think of. Make it pull as many faces as possible. Fill up an entire sketchbook if you can. Stick all of these pictures up above your desk so that they are staring down at you. Put together a 'mood board'. A mood board is a large piece of cardboard onto which you stick all of your reference material. This could include photographs and illustrations that you've cut out of magazines or printed up from the Internet, or examples of colors and textures, fabric, rocks and anything that you think will help with the design of your character. Again, stick your mood board above your desk.

It's a good idea to have a go at sculpting your character first in modelling clay. This way you can get a good 'feel' for your character and you can also save a hell of a lot of time selecting and moving points on your model. Look at it from all sides. Hold it up in front of a strong light source. Does it throw up good silhouettes? Have a go at sculpting all the facial expressions you think your character will pull.

A texture map is a flat piece of artwork that is wrapped around your model. For example, it could be the skin of your character's face with areas around the eyes and cheek bones shaded and stubble on the chin. When it comes to applying textures to your character, think about the texture map's construction. If your character's trousers are separate objects from its torso, using a texture map makes it a lot easier to color them different colors. Painting a texture map for an entire character is a lot more difficult. So, the head could be one object. The torso and arms another. The hands would be separate objects, as would the legs and feet.

Try to avoid the 'Christmas wrapping paper' effect. This is where a texture bares absolutely no relation to model it has been applied to. It ends up looking like a gift very tightly wrapped in highly patterned paper.

Lastly and most importantly, make sure your model will do everything that is required of it to act out the script of your movie. In other words, write the script first. If your character is required to reach up and grab something off a tall shelf, make sure their arms are long enough to reach. For some reason, taller thinner characters seem to be easier to animate than shorter, fatter ones. Maybe it's because they can produce stronger silhouettes, which means you can get a pose over to an audience quicker. Maybe it's because you can't fit as much 'clutter' onto a thinner character so there's less to distract from the movement.

Complexity

Decide how much animation you wish to do. In 'full' animation (the kind of animation that you will see in feature films, where the character is moving all the time) the characters tend to be simpler. There will be few buttons, frills or details. Too many details will distract the eye and can cause 'full' animation to look clumsy. It also takes a considerable amount of time to animate a waistcoat full of buttons throughout an entire film. Disney knew this in the 1930s. It was estimated that each button on a character would cost several thousand dollars for the length of a feature film.

For limited animation (the kind of animation that you see in television series, where the characters tend to stop and start or jump from one strong pose to another), characters can be more complicated, mainly because they won't be moving as much.

This is also true of 3D animated characters. The more textures and details you add to your model, the more difficult it is to 'read' what the character is doing. Also, the more complicated the character, the more difficult it is to achieve elegant animation.

The Graphic Nature of the Character

The more complex the character is, the slower the animation has to be. A simple, flat graphic character that consists of blocks of color will 'read' (the audience will understand what it is doing) more quickly than a complicated 3D one. For the same reason that adding lots of details affects the speed at which you can animate a character, the flat, graphic character can be moved at a faster pace than the complicated 3D one. This is because there is so much more to look at. With a 3D character, you've got shadows and highlights, color and texture, and various details that you've may have added as well as the animation.

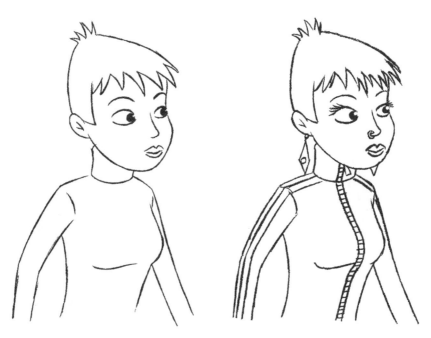

Line drawings also need more time to 'read' than colored animation. When animating for a black and white sequence (or if you are going to convert the movement to 3D), make the animation for the line test slightly slower than you think it should be. If the line test is going to be colored using flat colors, make the line test slightly faster.

The shapes of the character will also affect how it animates. Characters made from rounded shapes tend to be easier to move in 3D and easier to make strong poses with. The rounded shapes also suggest softness. Angular characters made from hard, sharp shapes look clumsier when moving and tend to look more aggressive.

The type of animation used also influences the pace of the animation. 2D drawn animation is suited to a fast, frenetic pace. It is not very good for slow-moving, subtle close-ups of a character's face. However, clay or puppet animation works better with subtle, slower, close-up movements and is not so good at the fast, frenetic stuff. Computer 3D animation has both the advantages and disadvantages of these two disciplines. It can move faster, with more fluidity than clay or puppet animation, but is not as good with the subtle, close-up work. It is better at close-up work than 2D drawn animation, but is not as good with fast, fluid or aggressive movements.

Please remember that these are very general rules and there are many brilliant exceptions to them.

Strong Silhouettes

When drawing your key positions, make sure they have good silhouettes. If you were to black out the character, would you still be able to understand what the character was doing? If the answer is yes, this will help the audience to understand what is happening faster.

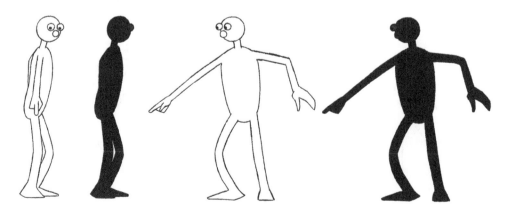

When animating in 3D, always think of the camera angle that your final animation will be viewed from and make sure that you have good, strong silhouetted poses that work from that angle. Don't do the animation and then sort the camera angle out later. If you want to do a flying camera move, make sure that every frame is well-composed during the sequence.

Weight and Balance

For your audience to believe that your character is a living, breathing being (rather than graphite scraped onto paper or a collection of pixels on a screen), you need to follow a few basic rules. Two of these are: give your character weight and ensure your character is balanced correctly.

Gravity

Assuming we are animating a character on planet Earth, the first thing it has to deal with is gravity. In the same way that our bouncy ball falls to the ground and bounces when rolled off the roof, so our character will fall to the ground and bounce (though rather less) if it jumps off the roof. Similarly, if the character jumps into the air, this takes effort and will always result in the character falling back to earth.

Every object (including our character) has a center of gravity. With our balls this would be in the exact center. With a character it will be roughly at the bottom of the rib cage (about the center of the body). If the object or character is taller, the center of gravity will be higher. If the character is shorter, the center of gravity will be lower.

A character's center of gravity is not always in the same place. It will change position as the character changes its body posture.

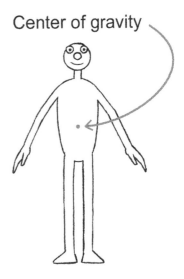

Center of gravity

Balance

The stability of an object is affected by its shape. The wider the base, the more stable it will be. For example, a cube is a very stable object. It is difficult to push over or roll down a slope.

A ball, on the other hand, is much less stable. It is easy to push along or roll down a slope. Because of this instability, it is much more susceptible to the forces of gravity.

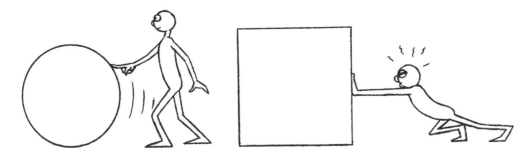

Our character maintains stability by spreading its legs. The wider the legs are spread, the lower the center of gravity and the more difficult it is to knock over the character.

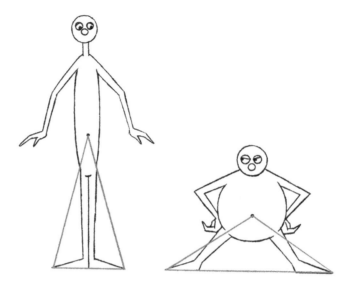

To ensure that your character looks balanced, imagine a plumb line (a weight on the end of a string) running top to bottom through the center. There should always be an equal amount of weight on either side of this line.

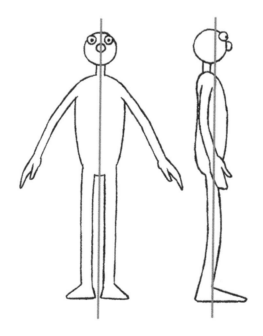

As the character leans in one direction, the plumb line will move with the center of gravity. If it swings far enough to reach a leg, other parts of the body will need to be moved to maintain balance and to stop the character from falling over. For example, if a person leans forwards, to maintain their balance they need to stretch their arms out behind them. If they lean further, they will need to stretch one leg out behind them.

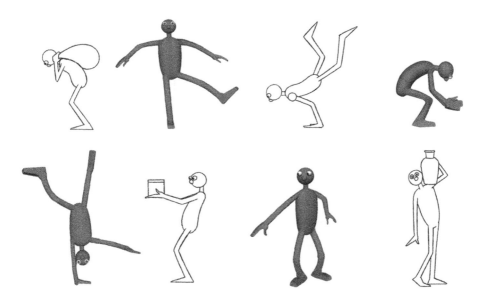

If a person holds a heavy bucket of water, they will lean their body at the opposite angle to the arm holding the bucket.

Someone who is overweight will need to lean back to balance his or her large stomach.

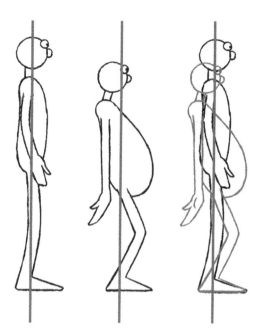

Overview of How to Build and Rig a Simple 3D Character

This character is built and ready and waiting for you to animate it. Have a look in the folder 'man_models' in the Chapter 3 folder on the website. However, if you want to have a go at building him (and doing so will give you a better idea of how to animate him later), following are some basic instructions. There are lots of ways to build and rig a 3D animated character. I have deliberately kept him very simple so that he is easy for a beginner to build.

A 3D character's skeleton will consist of a series of bones (or joints) that are linked together and rotate in relationship to each other (you will hardly ever move or translate these bones). These will, in turn, move the skin (or envelope) that surrounds them. The bones need to be linked to the skin. There are several ways of doing this, two of which are the 'skin and bones' and 'child of the joint' methods.

Skin and Bones

The most sophisticated way of constructing a character is to build a complete skin and then insert bones within it and link them to the skin. This is referred to as 'skinning' or 'enveloping'. You then need to modify the skin so that different parts of it move correctly in relation to the bones. This is achieved by 'weighting'. All 3D animation programs have slightly different ways of weighting a character. The basic idea is that you select points on the surface of the skin and assign them a differing degree of influence, depending on how each part of the skin should move in relation to the

bone. A good demonstration of this is the way in which the skin of an arm moves with the upper and lower arm bones. If the bones are inserted into the arm without any weighting and then you bend the arm, you will get a rubber hose effect at the elbow. If, however, the arm is correctly weighted to the bones, the skin at the elbow will move correctly.

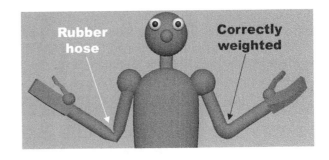

You could go even further and insert muscle groups that expand and contract with the movement of the arm. The possibilities are endless.

What you do need to remember, though, is that an animated character in a feature film will have had several artists involved in its construction. First a sculptor will have made a model out of clay, which will then have been scanned into a computer. Then a digital artist will have cleaned up this model on the computer to simplify the mesh. After this a rigger will have inserted the skeleton and weighted the model to make sure it moves correctly. He will also have worked out things like muscle groups, facial expressions and place handles on the important bones to ease the animation process. After this a texture artist will have worked out the coloring of the character and a technical director will have assigned the texture to the skin. This could take weeks if not months. We'll be looking at how to build a more sophisticated character in Chapter 9.

Child of the Joint

The other way of building a character is often referred to as 'child of the joint'. The idea is that most of the parts of your character are linked to the bone inside them and there will usually be one part of the body per bone. When you select the bone and rotate it, the part of your character that is linked to the bone will move with it. If you have a look at the character that I have built for the exercises in this book, the majority of him is constructed as child of the joint. The upper arm is a cylinder, the elbow is a sphere, the lower arm is a cylinder and the hand is a box shape. The ball of the thumb is a sphere and the thumb is a shaped box. The advantage of this type of construction is that you don't have to do any weighting and it is simple and quick to put together. The disadvantage is that you end up with a rather blocky-looking basic character.

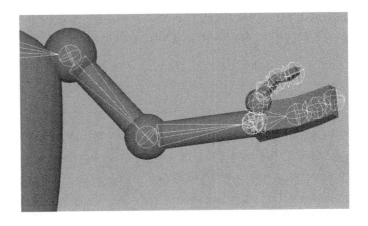

In fact, the man I created has a mixture of skinning and child of the joint. The body is skinned to the six bones of the spine, the neck is skinned to the neck bones, the hands and thumbs are skinned to

the hand and thumb bones and the feet are skinned to the foot bones. The limbs, head, nose and eyes are child of the joint. Most models will be a mixture of skinning and child of the joint.

All of the components mentioned (the polygons and the bones) will appear in the Hypergraph in Maya or Schematic View in 3D Studio Max.

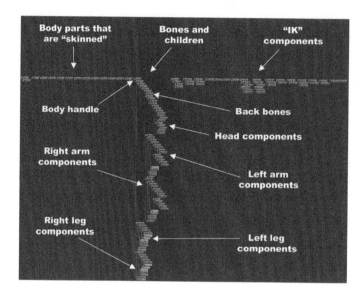

You can select parts of your man within the Hypergraph in Maya or Schematic View in 3D Studio Max when animating (this can sometimes be easier than selecting parts of your man in the view panel).

Planning a Scene

Before animating a scene, it is always a good idea to plan the action with a series of thumbnail sketches. These are simple illustrations showing all the major key poses adopted by your character during the scene. They act as a reference guide and as such are generally small and can be quite rough.

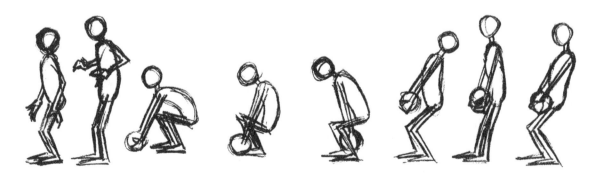

It can be very helpful to have these above the light box as you can often save time by referring to them when drawing the full-size keys. You could even have a go at shooting these thumbnails with your line tester to get a rough idea of the timing.

Sometimes it is helpful to sketch these thumbnails onto your X-sheet, roughly at the frame at which these key poses will occur. To make this easier I've developed a form of the X-sheet called a 'thumb-sheet'. This is an X-sheet with small panels in which you can sketch thumbnail drawings.

THUMB-SHEET 01

ANIMATOR:										
PRODUCTION:										
SEQUENCE NO:	SCENE NO:		LENGTH:				SHEET NO:			
NOTES:										

THUMBNAILS:	ACTION	SOUND	FRM	5	4	3	2	1	BG	CAMERA
THUMB NO:			1							
			2							
			3							
			4							
			5							
			6							
			7							
			8							
			9							
			10							
THUMB NO:			11							
			12							
			13							
			14							
			15							
			16							
			17							
			18							
			19							
			20							
THUMB NO:			21							
			22							

There are blank thumb-sheets in Chapter 3 on the website.

Animating Your Characters (Using the Left and Right Sides of the Brain)

The human brain is divided into two halves. There is a theory that different thought processes are associated with each side of the brain. The left-hand side deals with the logical, practical, analytical, conscious world. It deals with language and speech and the visual interpretation of the world around us. It also deals with the right-hand side of the body.

The right-hand side of the brain deals with the creative, spiritual and

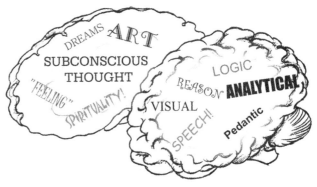

subconscious aspects of us. It's the side that's working when we have a 'feeling' about something. It's also the side of the brain that thinks of the body as a whole.

When you are animating, you should be using the right-hand side of your brain. In order to do this, it is best to work fast and rough. Don't rub anything out. If the lines are in the wrong place, re-draw them until the drawing looks right. Don't be precious about the drawing at this stage. Also, don't think too much, just draw.

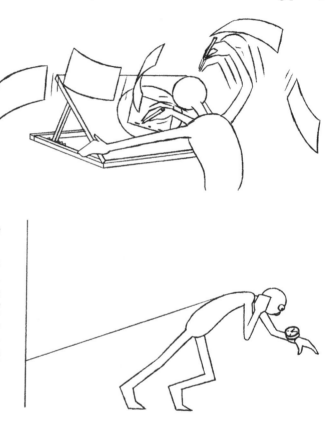

Remember to use a Col-Erase pencil for the rough drawings. You can then mark a clean, correct line with a graphite pencil. Always keep flipping, flicking and rolling.

For this way of drawing to work, you need to have studied the movement beforehand. Get a friend to act it out or watch yourself in a mirror. Study how the limbs move and any twists to the body. Look at the balance and the weight.

While acting out the movement, use a stopwatch to work out the rough timing. If you don't have a stopwatch, it takes about a second to say each repetition of the phrase 'one little monkey ... two little monkeys ... three little monkeys', or about a third of a second to say each of the words. Use this to help with the timing. Then slug out your X-sheet, which uses the left side of the brain.

Exercises

To understand weight and balance, we will animate a human character lifting a heavy ball and pulling and pushing a heavy object. The three exercises are set out step by step as follows:

1. Working out the key drawings. (I've included timing charts with each of the key positions to show where the in-betweens should be placed).

2. Completing the in-betweens.

3. Animating each exercise in the 3D programs covered in this book, using the drawn animation as a guide. Instructions for doing this can be found on the website.

You can follow the exercises I've done or use them as a rough guide and animate something that you've acted out yourself.

The Lift Exercise in 2D

In this exercise we will get our character to pick up a heavy ball. For the majority of the time, the character should be balanced; that is, there should be an equal amount of weight on either side of the imaginary plumb line.

Before you put pencil to paper, act out the movement. Find a reasonably heavy object (I would suggest a bowling ball, but not everyone has one of these lying around) and have a go at picking it up. Remember to lift the ball correctly. Keep your back as straight as possible and bend your legs to bring yourself down to the ball. When you pick up the object, use your legs to provide most of the momentum (the largest muscle in the body is at the top of the leg) and keep your back straight.

By acting out this sequence, you should have an understanding of the movement, which will begin to make the different stages clear in your head. I have provided some thumbnail sketches but use these as a guide. Use your own research to guide your animation for this sequence. This will influence the way you animate the scene, bringing something of you to your animation.

When you act the sequence, exaggerate the weight of the object you are picking up. This will help the animation to work better. Exaggerating the weight of the object makes the action more clear to the audience.

It can also help to study mime artists. These performers are trained to give the illusion of acting with props that don't exist. In animation, the props exist but they have no substance.

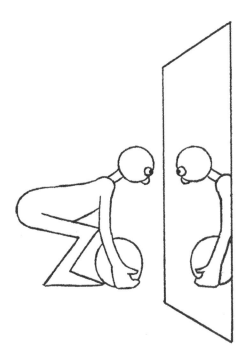

Working Out the Key Positions

The first stage is to draw the key positions and then shoot them on a line tester. There are 10 key positions for this sequence and the sequence is 100 frames long. (Remember to have a go at 'slugging out' the X-sheet. That is, fill out a description of all the key positions in the 'Action' column of the X-sheet.)

The first key position is at frame 1. Begin with your character standing over the ball. Make sure the ball isn't too far away; otherwise, as the character bends, he will end up having to reach too far forwards.

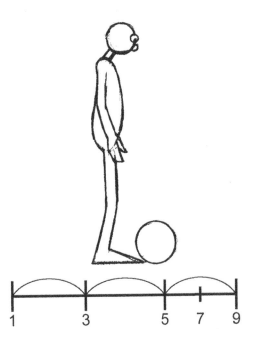

The second key position is at frame 9. Move your character up slightly. This is the anticipatory move (more about anticipation in the next chapter).

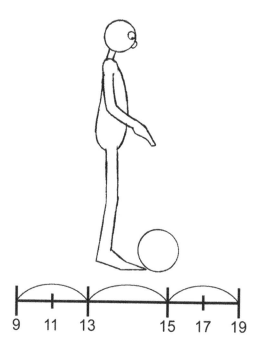

The third key position is at frame 19. This is where our character is grabbing hold of the ball. The hands should be placed on the lower part of the ball.

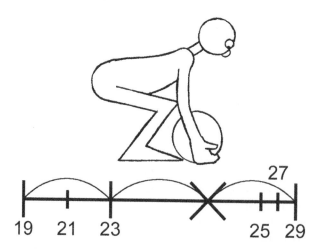

The fourth key position is at frame 29. As the character starts to pick up the ball, his body leans back and his bottom goes down. The weight of the ball causes the arms to become straight and even stretch a bit.

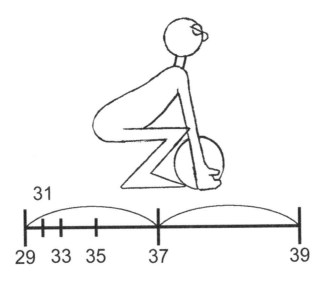

The fifth key position is at frame 39. As the weight of the body is moved backwards, the arms straighten and the ball leaves the ground. The ball swings between the character's legs. Think of the arms being straightened by the weight of the ball and swinging like a pendulum. As the ball travels between the legs, it crosses the plumb line and causes the character to lean forwards.

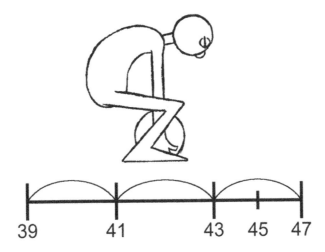

The sixth key position is at frame 47. As the body is raised further, the ball swings further between the legs of the character, causing the body to lean backwards.

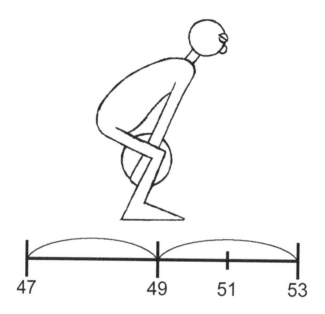

The seventh key position is at frame 53. The character slows down as he goes onto his tiptoes. This is the overshoot position (more about overshoot in the next chapter).

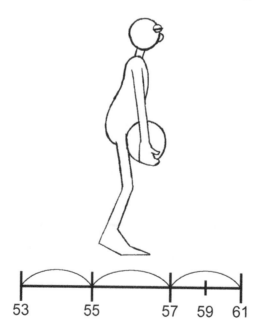

The eighth key position is at frame 61. As the character starts descending towards the resting position, the ball keeps moving upwards. This is because the ball contains momentum from being picked up and wants to keep going.

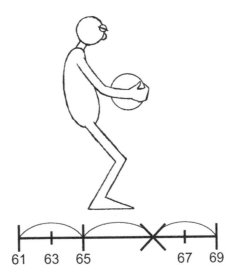

The ninth key position is at frame 69. Our character has moved up slightly from the last key position and the ball has fallen down against his legs.

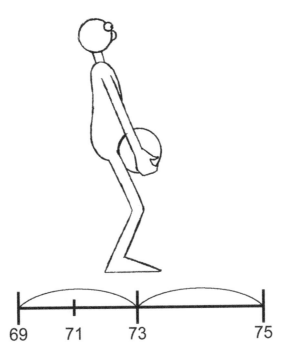

The tenth key position is at frame 75. Here the character has dropped down slightly and is leaning back and bending his legs to take account of the weight of the ball.

When you've drawn these key positions, shoot them on your line tester (see chapter 3 'lift_2D_keys.avi' on the website to see how the animation should look).

In-Betweening the Key Positions

When we were animating the bouncing balls we could stick quite closely to the timing charts. With a human being it's not that simple. The timing charts should be regarded as a rough guide or reminder to you of where the in-betweens should go. You may find that you will have to make some parts of the character's body move faster than others or leave other bits behind in order to make the movement more believable.

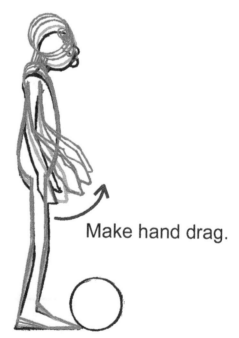

Make hand drag.

Between the first and second key positions (frames 1 and 9), make the hands 'drag' a bit to make the wrist movement seem more fluid.

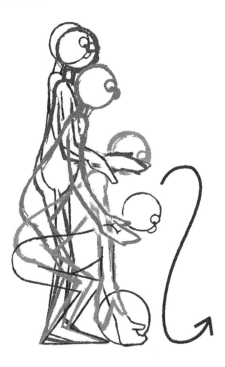

Between the second and third key positions (frames 9 and 19), make the hand flail upwards as it moves out of the second key position. As the hand goes downwards towards the ball, make it move outwards (towards us) to give the idea that it is going to grasp the ball.

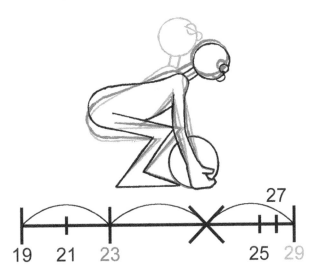

Between the third and fourth key positions (frames 19 and 29), the first bit of the movement is quite slow (19, 21 and 23 are close together) and then there is a sudden movement as the arms become taught (a big gap between 23 and 25). At the very end of the movement there are three drawings very close to the fourth key position to give the impression of rapid deceleration (frames 25, 27 and 29 are very close together).

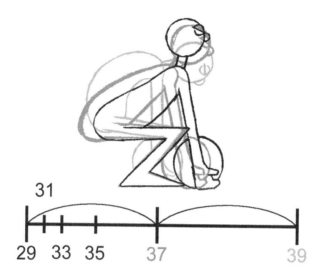

Between the fourth and fifth key positions (frames 29 and 39) there is slow movement until the halfway point (frames 29 to 37) and then a sudden movement as the heavy ball 'gives' (frames 37 to 39). At frame 37 the body is positioned half way between 29 and 39 but the ball is positioned about a third of the way between 29 and 39. This will give the impression of the ball being heavy.

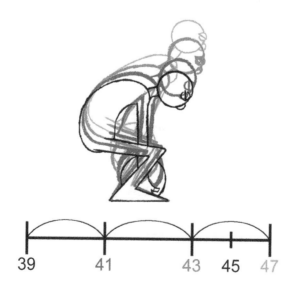

Between the fifth and sixth key positions (frames 39 and 47) the ball swings between the man's legs and slows as it reaches the end of its swing to the left (43, 45 and 47). The arms stay straight and they swing like a pendulum.

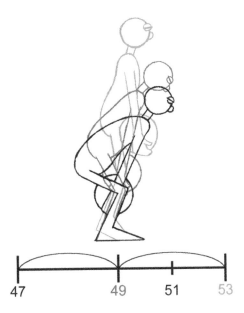

47 49 51 53

Between the sixth and seventh key positions (frames 47 and 53) the man reaches his highest position and the ball swings slightly to the right as it is picked up. The arms stay straight and the man goes up onto his toes. He slows down as he reaches this position (49, 51 and 53).

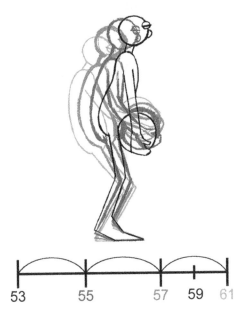

53 55 57 59 61

Between the seventh and eighth key positions (frames 53 and 61) the man comes back down to earth but the ball continues moving upwards, slowing at its apex (57 and 59).

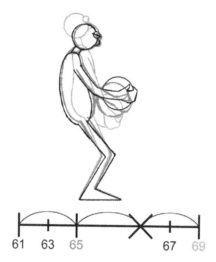

Between the eighth and ninth key positions (frames 61 and 69) the ball falls to a resting point against the man's tummy with the arms at full stretch. The ball comes out of its apex slowly (drawings 63 and 65), falls quickly (gap between 65 and 67) and then slows into the next key (69). This slowing down is caused by the body moving upwards and the arms stretching slightly, with the body slowing to its highest point at key nine (69).

Between the ninth and tenth key positions (frames 69 and 75) the man comes down to his final resting position, moving slowly out of key nine (the drawings between 69 and 73 are closer together).

Have a look at 'lift_2D.avi', Chapter 3 on the website.

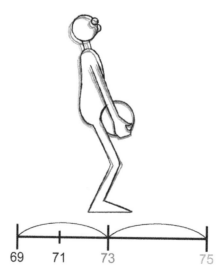

The Lift Exercise in 3D

OK. Let's get animating in 3D. This scene is 100 frames long. Take all your lift animation drawings and arrange them in a nice pile next to your computer so you have a reference for each of the key positions. Pin your X-sheet where you can see it so you know the frame number that corresponds with each of your key positions.

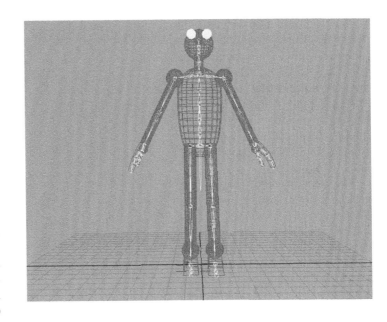

Open up the simple man model that I've built that is appropriate to the program you are animating with. So that's 'mayaman.mb' for Maya and 'maxman.max' for 3D Studio Max in the 'man_model' folder, Chapter 3 on the website. (There are also .pdf files on how to build a basic human in both programs. These are in a folder called 'making man' and are called 'building a man in Maya.pdf' and 'building a man in 3D StudioMax.pdf'. Have a go at animating with the model I've provided first and then if you are interested have a go at building your own person.)

This man consists of a 'skin' made of primitive objects and a set of bones inside that are connected to the skin. The majority of the movement that we are going to do involves selecting these bones at various points and rotating them into the desired position.

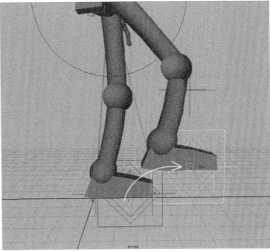

The legs and the arms of the man have been set up with inverse kinematics (IK). This means that you can grab the lower part of the leg (or a handle that is connected to it) and move the entire leg. This can make walking and positioning the feet on the ground easier (but sometimes it causes more problems than it solves).

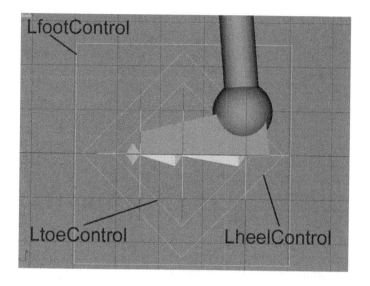

The feet have three handles attached: one square and two diamonds. The square (called 'LfootControl' or 'RfootControl' depending whether it is the left or right one) controls the movement and rotation of the foot. The outer of the two diamonds (called 'Rheel-Control' or 'LheelControl') controls the rotation of the heel. The inner of the two diamonds (called 'Rtoe-Control' or 'LtoeControl') controls the rotation of the toe.

Create a sphere 1.3 units in diameter in Maya or 13 units in diameter for 3D Studio Max and place it at the feet of your character in the same position as key 1 of the drawn animation (in Maya, about 3.5 in X and 1.3 in Y; in 3D Studio Max, about 35 in X and 13 in Y).

(We also need to make a second ball to attach to the hand of the man. The reason for this is that, if you try to get your man to pick up a loose ball, it slops all over the place in his hands. The first ball

will stay on the ground all the way through the scene. At the point that the man grabs the ball it will come invisible. The ball attached to his hand has been invisible up to that point and will then become visible. This all happens at frame 29.)

You then need to move your man into each of the major key positions at the appropriate frame numbers and tweak the way the computer does the in-betweens, either by adding extra key frames (breakdowns) or by manipulating the animation curves appropriate to your program.

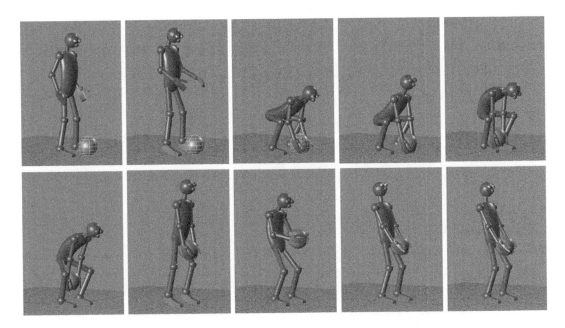

As with the drawn animation, you will need to add some extra key positions to improve the animation. Set these extra key positions at the equivalent of the breakdown positions of the drawn animation.

Between key position one and key position two, make the hands 'drag' a bit to make the wrist movement seem more fluid.

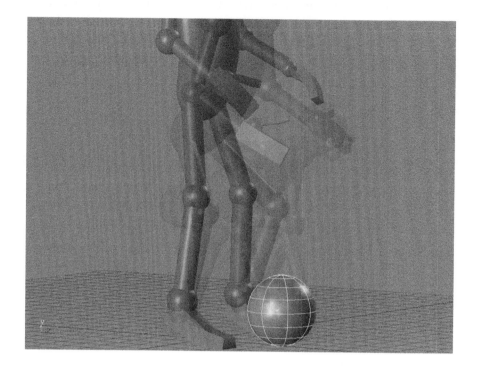

Between the second and third key positions, make the hand flail upwards as it moves out of the second key position. As the hand goes downwards towards the ball, make it move outwards (towards us) to give the idea that it is going to grasp the ball.

Draw your previous key positions on an acetate sheet stuck on your screen as a guide to your animation.

Have a look at 'lift_3D.avi', Chapter 3 on the website.

The Lift Exercise in Maya

Copy the folder 'mayaman' onto the C: drive of your computer (or wherever you want to put it). Open up Maya, go to the main menu and select **File > Open**. In the 'mayaman' folder, find 'mayaman.mb' (if you have Maya 2010 or earlier) or 'mayaman-circles.mb' (Maya 2011 onwards). Highlight it and click the **Open** button.

Select a view where you have a side view of the character that is similar to your drawings (or the drawings in the illustrations of this book).

So that we can select parts of the body more easily, we need to open the Hypergraph, which is a window that shows all of the components of the 3D man in a graphic form. To open the Hypergraph click on **Window** on the main menu and then click on **Hypergraph: Hierarchy**.

You will be confronted with a window that has a large number of small boxes, some connected to each other, others on their own. (If you can't see all of these boxes, just press **A** on your keyboard and they will all come into view.) You can zoom in and out and pan around the Hypergraph in the same way that you move around the view panels of Maya.

It all looks rather confusing, because the display consists of many 'nodes' that represent different parts of your man. However, there are only two areas of the Hypergraph to worry about. The first is the tall, connected hierarchy (a hierarchy is a collection of nodes joined together) in the middle of the Hypergraph window. This represents the skeleton of your man. You can select individual nodes of this hierarchy, which will in turn select individual bones in your man's skeleton.

At the very top of this hierarchy is a handle (called 'BodyHandle') connected to the base of the spine. If you select this you select the entire skeleton and can move the man as a whole or rotate him at the base of the spine. (On the man the handle appears as a circle that runs through the middle of his body.)

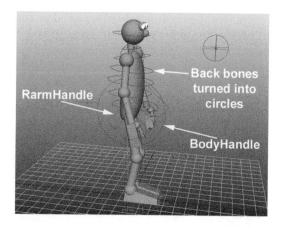

The second area of the Hypergraph to concern us is the collection of smaller hierarchies to the right of the skeleton hierarchy.

The hierarchy labelled 'EyeHandle' on the top node controls the eyes. The six hierarchies labelled 'IK Handle' at the top are to do with the construction of the articulation of the inverse kinematics of the leg and can be ignored.

The nodes that do matter are the hierarchies labelled 'RightFootControl' (right foot control) and 'LeftFootControl' (left foot control).

The foot has a square and two diamond handles attached to it. The square is the node 'RightFootControl' (or 'LeftFootControl') in the Hypergraph and is used to control the whole foot. The bigger of

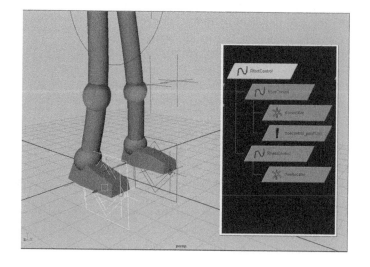

the two diamond handles is 'RightHeelControl' (or 'LeftHeelControl') and controls the rotation of the heel. The smaller of the two diamonds controls the rotation of the toe. Have a go at rotating the heel and the toe.

The arms are much simpler: you can control the positions of the hands by selecting the diamond shapes located at the wrists. These are called 'LeftArmControl' and 'RightArmControl'.

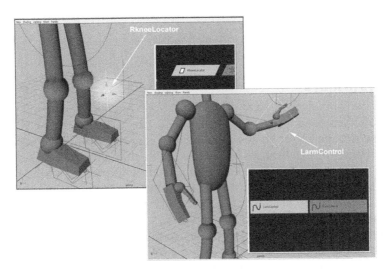

The other four handles worth knowing about are 'rkneelocator', 'lkneelocator', 'relbowlocator' and 'lelbowlocator'. These can move the knees and the elbows of your man from side to side. You will have to keep moving these locators from one key position to the next, otherwise they get left behind.

As a general rule, *move* (translate) locators and IK handle controls and *rotate* the individual joints of the skeleton. If you try to rotate a locator or IK handle, nothing will happen. If you try to move (translate) a joint, it ends up doing some very strange things.

Before we start animating, the last thing we need to do is to switch off all of the selection buttons except the **Handles**, **Joints** and **Curves** buttons. This will prevent you selecting anything that you don't want to select. Just click each of the buttons in turn to switch them off.

OK. Let's start animating.

Setting the Keys in Maya

Create a sphere 1.3 units in diameter and place it at the feet of your character in the same position as key 1 of the drawn animation.

First we need to set a key position at frame 1 (make sure the Time Slider is set to frame 1). In order to do this we have to get your man into a position that roughly imitates key position 1 of our drawn animation (see the drawn animation section relating to picking up the ball). Arrange the Hypergraph as a floating window so that you can select the sections of the hierarchy (and therefore pieces of the skeleton) that you need to move, and make your view panel full screen. (Remember that you can change the viewing position at any time by quickly depressing the space bar, moving the mouse pointer over one of the four view panels and then pressing the space bar again).

Decide whether you want to save keys as you go along (by pressing **S** on your keyboard when you want to save a key) or if you want Maya to set keys for you automatically (select the **Auto Keyframe** toggle at the bottom right of the screen). Using **Auto Keyframe** can be more confusing when you begin but, when you are used to it, your work will be much quicker and you won't ever forget to key something important.

Spread your man's legs by selecting 'RfootControl' with the **Move** tool and dragging the foot in the Z plane. Set a key.

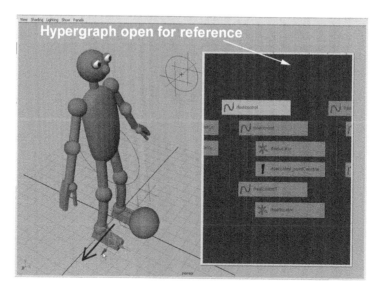

Repeat this procedure for the left leg (select 'LfootControl' in the Hypergraph window) so that the legs are behind and to either side of the ball. Set a key.

Now we need to sort out the top part of the body. Select 'BodyHandle' (either by selecting the 'BodyHandle' node in the Hypergraph or by selecting the circle in the view panel). Select the **Rotate** tool and rotate the body slightly forwards by clicking and dragging on the yellow circle (this will rotate the body in the Z axis). You may want to translate the body back a bit. If so, select the **Move** tool button and translate the 'BodyHandle' backwards. Set a key.

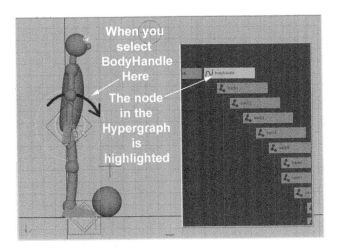

Now we need to angle the head and move the eyes so that your man is looking at the ball. Select the bone 'neck1' (either the node in the skeleton hierarchy or the circle that is around his neck in

the View panel) and rotate the neck forwards in the Z axis. Then select the 'head1' node and rotate that slightly forwards in the Z axis. Finally select 'EyeHandle'. You will notice that this selects a circle that is floating in front of the man's head. This is a 'locator' and the eyes always look at it. By moving it you move the eyes. Select the move tool and move the 'EyeHandle' locator down to a point just above the ball. Set keys.

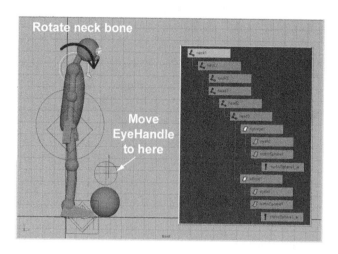

Lastly we need to select the arms and move them to a position that is close to our drawn key 1. Select 'RarmControl' (the IK controller for the right arm) and move the arm into position. You can adjust the elbow by selecting 'RelbowLocator' and moving it. Do the same for the left arm by selecting 'LarmControl' and 'LelbowLocator' and moving them into position. Set keys.

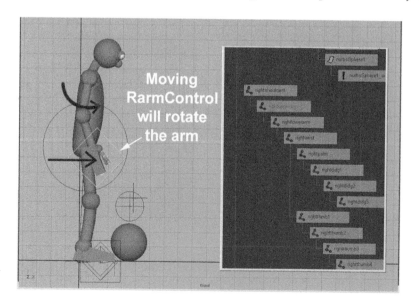

We are now at key position 1.

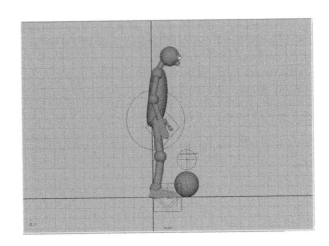

If you have been setting keys as you have been going along (or if you have been using **Auto Keyframe**), you have now saved a key at frame 1. If not, select the elements you have moved and press **S** on your keyboard for each one to save a key. It would also be a good idea to set a key on all the back, neck, shoulder, wrist, finger and thumb bones.

One key position down, nine more to go!

The second key position is on frame 9 and is the 'anticipation' position. The body, arms and head are raised slightly.

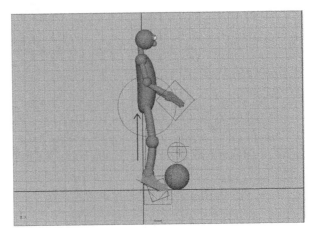

Move the Time Slider to frame 9. Select 'BodyHandle', click the **Move** tool and move the body upwards slightly. Press **S** to set a key. Select 'RarmControl' and 'LarmControl' to move the arms up (set a key). Keep referring to your drawn animation (or the illustration in the 2D lift section) for the position of your man. You can also keep playing back your animation by clicking on the **Play** button or by scrubbing your mouse backwards and forwards over the view panel with **K** pressed on your keyboard. Think of this as being like flipping, flicking and rolling. Always make sure you are back on the correct frame before you set a key!

Select 'leftwrist' and rotate the wrist until you get a position similar to the key drawing (set a key). Do the same for 'rightwrist' (set a key).

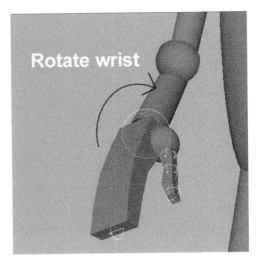

Rotate wrist

If you make a mistake and set a key that you don't want, just right click on the key position in the Time Slider and select **Delete**. Select the bones you haven't moved and set keys on them (the back bones, neck bones and so on).

Move the Time Slider to frame 19 so you can do the third key position (take a look at the illustration above).

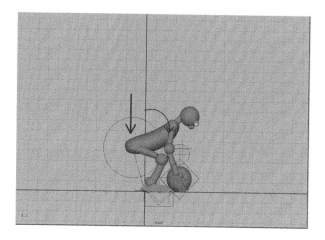

Select 'BodyHandle' and move your man down. The knees should bend nicely with the feet staying in place on the floor. Then rotate his body so he is almost parallel to the floor. Don't select and move the joint 'back1'. Strange things happen when you try to animate it.

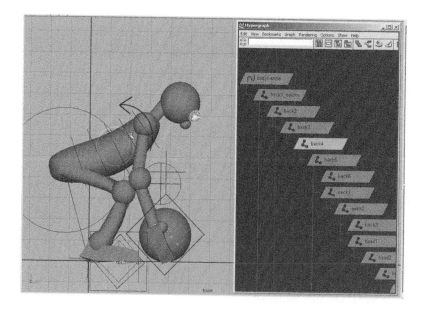

To bend the spine you can either select the nodes in the Hypergraph or the rings that surround the body that relate to the bones. Select the joint 'back2' and rotate it slightly upwards. Then select and rotate 'back3' (you can move your selection of 'back2' to 'back3' by pressing the down arrow on your keyboard). Select and rotate 'back4'. Continue along the spine until it looks like your drawing. Select 'neck1' to rotate the head upwards and then select 'head 1' and rotate the head down so it is facing the ball. Rotate the upper arm joints and the lower arm joints so they are positioned correctly in relation to the ball.

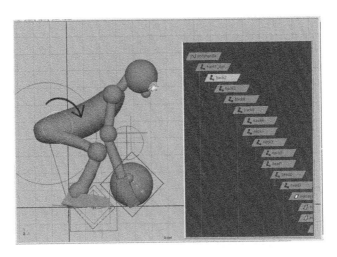

Remember to set a key after each item you've moved, especially if you want to scrub through or play your work.

You can move your man's knees outwards slightly by selecting either 'rkneelocator' (for the right knee) or 'lkneelocator' (for the left knee), selecting the **Move** tool and translating the handles outwards.

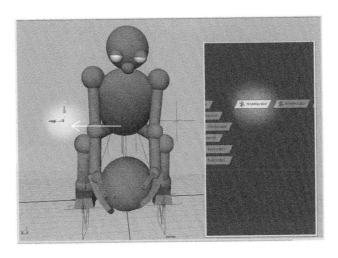

One useful tool that you can use is 'ghosting'. This is where Maya shows you the previous key position on the same view panel as the new key position you are creating. To activate ghosting select part of your man (in this case I've selected his body) and click on **Display** on the main menu. Then select **Object Display** and **Ghosting**. This will show the position of the body at the previous key.

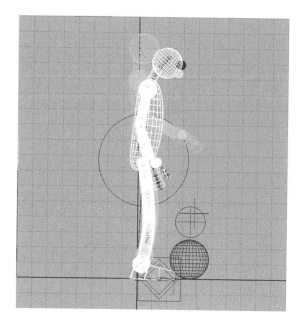

This can be very memory-intensive so you may only be able to select one or two of the body parts to ghost if you computer slows down too much. A less memory-intensive way to mark the positions of keys 1 and 9 is to draw on an acetate sheet stuck on your screen.

At frame 29 (the fourth key position; have a look the 2D section) create a NURBS sphere with a radius of 1.3 (just like your first sphere). Move it to exactly the same position as your first sphere (in this case 1.3 in Y and 3.5 in Z). Attach it to the 'rightwrist' node in the Hypergraph. This is done by opening the Hypergraph window and selecting the **Toggle Freeform/Automatic Layout Mode** button at the top of the Hypergraph. This makes the nodes in the Hypergraph a complete mess but it does mean that you can now move the nodes around. Click and drag the node that is your new ball (hopefully called 'nurbSphere2') and bring it near to the 'rightwrist' node.

You now need to parent the 'nurbsSphere2' node to the right wrist. In the Hypergraph, select your second ball ('nurbsSphere2') node and then middle mouse click and drag to the 'rightwrist' node and let go. There will now be a line linking the two nodes. The ball will now attach itself to the hand in the position you have placed it.

Continue through your key positions, moving any parts necessary in order to make your key position look like the equivalent key position of your drawings (or look at the illustrations below) and remember to save a key on all the nodes in the Hypergraph. Make the final key position at frame 100; this will be identical to the key position at frame 75.

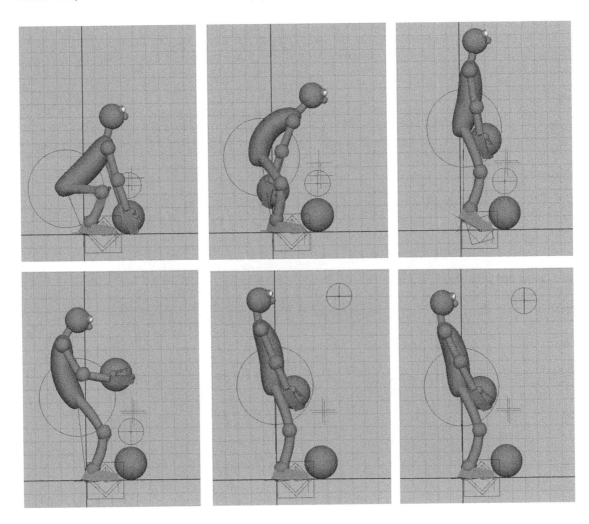

Once all these key positions are worked out, do a Playblast. Hopefully it should look something like 'lift_3D_loose.avi', Chapter 3 on the website. I call this it a 'loose' lift because all the basics are there but the man isn't quite doing what we want him to do. His hands go through the floor and

the ball just before he picks it up, there is a strange wobble on his left arm, there is a strange evenness to the movement and there are two balls! We haven't given the computer enough information to in-between the keys properly. Now we need to do the major in-betweens (otherwise known as the breakdowns).

Open up the Graph Editor (**Window > Animation Editors > Graph Editor**) and then select every node in the Hypergraph. In the Graph Editor window will appear a large number of animation curves. So that we can view the animation without the computer in-betweens, we need to convert these animation curves from 'spline' to 'stepped' (this is the same as viewing the keys of our drawn line test). This means that when the animation is playing the curve will run horizontally from one key frame to the next and then run vertically up it. Your animation will become a series of key positions that jump from one to the next. To convert the curves, in the Graph Editor go to **Tangents** in the menu and select **Stepped**. All of those wavy animation curves become nice and neat and straight!

The first thing we can do is sort out the visibility and the invisibility of our two balls. Deselect everything (by clicking away from the man in one of the views) and then select the ball on the ground ('nurbsSphere1'). Open up the Graph Editor and you will be confronted with the animation curves that refer to the movement of the ball. Under the word 'nurbsSphere1' in the explorer part of the Graph Editor window, select **Visibility**. This will show a black line with a value of 1 and

several dots on it (the keys) in the graph part of the Graph Editor. Of all the key positions, the only three that we need are those at frames 1, 29 and 100. So, delete keys 9, 19, 39, 47, 53, 61, 69 and 75. You can do this by selecting the relevant dots on the animation curve in the Graph Editor and pressing **Delete** on your keyboard, or by selecting the keys in the Time Slider with the right mouse button and choosing delete. You should now have an animation curve that has three keys on it. In the Graph Editor select the key at frame 29. In the two **Stats** boxes at the top of the Graph Editor will be the numbers '29' (for frame 29) and '1' (value of 1). Change the value from 1 to 0. This will make this key position dropdown to 0 on the graph. When the visibility value of the ball is at 1 we can see it; when the visibility is at 0 we can't! Repeat this procedure for the key at frame 100. Because you selected stepped keys earlier, the animation curve has a sharp 'stepped' look.

We need to do the same thing for the ball attached to your man's hand, but now the ball should be invisible from frames 1 to 28 and then visible from frames 29 to 100. All you have to do is delete the irrelevant keys and make the value of the key at frame 1 zero.

Make a Playblast of the animation to view it at the correct speed. It should look something like 'lift_3D_keys.avi', a 3D version of your 2D keys linetest.

Setting the Breakdowns in Maya

Go to frame 1 of your animation on Maya and take out drawings 1 to 9 of your drawn animation. The breakdowns (the major in-betweens) for this section are on frames 3 and 5. The timing chart for the in-betweens between these two keys shows that drawing 3 is one third closer to drawing 1 and two thirds further away from drawing 9 (see the earlier illustration of the timing chart). We need to move your man into this position on frame 3.

In the view panel menu set **Shading** to **Wireframe**. In the Hypergraph select all the nodes and then ghost your animation (on the main menu, **Display > Object Display > Ghosting**). You should now see the first two key positions displayed in your view panel.

Move the Time Slider to frame 3 and move your man to the same position as drawing 3 (between positions 1 and 9). You may find that ghosting everything will gobble up large amounts of memory, making moving your man tricky. If so, try ghosting only one part of his body or drawing on an acetate sheet stuck on your screen. If you need to work out the in-between for the body, select the body and apply ghosting. With the Time Slider on frame 3, move the body of the man (by selecting the 'BodyHandle' node) and move it to the same position as your drawing.

As you do the breakdowns, the computer returns the animation to being evenly in-betweened (the animation curves return to 'spline'). You can either leave this or select all the nodes and then go into Graph Editor and convert to stepped tangents.

If the animation jumps between one key position and the next, it means that the animation curves are still 'stepped' (i.e. there are straight lines between the two key positions in the Graph Editor). To remedy this, open up the Graph Editor and select every node in the Hypergraph. This will show all of the animation curves in the Graph Editor. Don't worry about the multicolored spaghetti; we are only concerned with the curves between frames 25 and 33. Make sure you can see all the curves by having the pointer in the Graph Editor box, pressing **A** on your keyboard and with the left mouse button drawing a box around key positions 25 and 33 on the animation curves. With these key positions highlighted, make the curves between them Spline by going to the Graph Editor menu and selecting **Tangents** and then **Spline**. The frames between keys 25 and 33 should now be evenly in-betweened.

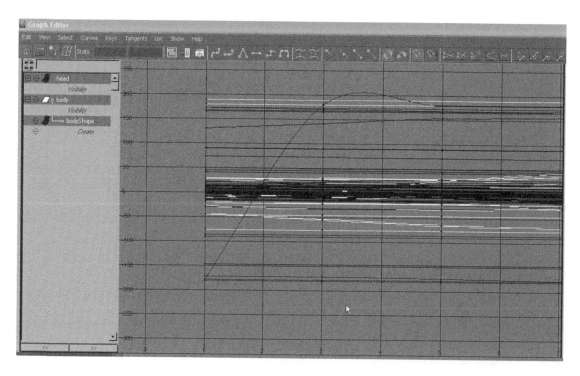

Go through the entire sequence, placing the breakdowns between the main key positions (have a look at the illustrations in the 2D section or, better still, your own drawings). Once this is done, you should have something like 'lift_3D_breakdowns.avi' in Chapter 3 on the website. As you can see, we are almost there. In the breakdowns I've made sure I've put in some life by dragging the head and the arms on the way down and on the way back up again. But it's still a little ragged. The left arm wobbles slightly as the ball is picked up and the right hand wobbles just before it grabs the ball. We also need to close the eyes at the point where the man is straining to pick up the ball. It's now a case of adjusting the animation curves at each of the points where you're not happy with the movement. Choose one section at a time and change the angles of the curves as you did with the bouncing balls in the last chapter. Experiment!

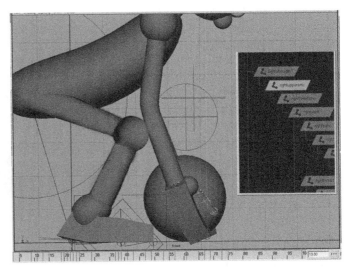

Another method of correcting a part of the animation that you aren't happy with is to put in a key at every frame. For example, at the point where the hand first touches the ball and wobbles around (between frames 19 and 29), go in as close as possible to the hand touching the ball and select 'Larm-Control'. At frame 19, draw an outline of the hand on an acetate sheet stuck on your screen. Then scrub along the timeline to the first breakdown position (frame 23) and rotate the 'LarmControl' joint until the hand is in the same position as the drawing on the acetate sheet and set a key. Then go to the next breakdown (frame 25) and rotate 'LarmControl' until the hand is in the same position as the drawing on the acetate sheet and set a key. Keep scrubbing backwards and forwards, rotating 'LarmControl' and setting a key at various frames in order to keep the hand in the same spot.

Repeat this same technique to sort out any other wobbles. Remember that you can change the position of a key by moving or rotating any part of the character and saving a key in the new shape by pressing **S** on your keyboard.

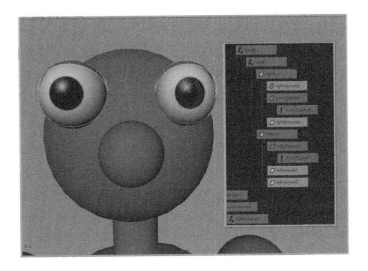

To do the blink, you will need to select the nodes 'righttopeyelid', 'rightboteyelid', 'lefttopeyelid' and 'leftboteyelid'. They are in the middle of the tall hierarchy in the Hypergraph.

On the Time Slider delete (right click on each key frame or select the keys in the Graph Editor and press **Delete**) all the key frames apart from frames 1 and 100. With the four eyelid nodes still selected, set a rotation key frame at frame 23. Set a key at frame 25 and a key frame at frame 67.

We now need to set a key at frame 27 with the eyelids closed. Select the 'righttopeyelid' node and in the Channel Box type −80 m in **Rotate in Z**. This will make the top eyelid shut. Set a rotation key. (The open eye settings for the rotation in Z are 0 for the top eyelids and 50 for the bottom eyelids.)

Repeat the same process for 'lefttopeyelid' and set a key. Then select 'rightboteyelid', change the rotation in Z to 80 and set a key. Repeat this process for 'left-boteyelid'. If you play back your animation you will find that your eyes close quickly between frames 25 and 27 and open very slowly between frames 27 and 67. In order to keep the man's eyes shut we need to set a key at frame 66 with the eyes shut. Select frame 66 in the Time Slider, repeat the process above to close his eyes and set a key. His eyes will now close at frame 27 and pop open at frame 67.

Hopefully you will now have something like 'lift_3D.avi', in Chapter 3 on the website.

The Lift Exercise in 3D Studio Max

Copy the folder 'maxman' onto the C: drive of your computer (or wherever you want to put it). Open up 3D Studio Max, go to the main menu and select **File > Open**. Find 'maxman. max', which is in the 'maxman' folder. Highlight it and click the **Open** button.

Click the **Time Configuration** button and in the window that comes up have the **Frame Rate** set to 'PAL 25 fps' (if you

are in Europe; in the USA, select 'Film 24'). Set the **Start Time** to frame 1 and the **End Time** to 100. Load 'maxman.max' or 'maxman-fins.max' into your scene and rename the scene 'lift.max'.

The man has a circle coming out of his tummy. This is the 'BodyHandle' and controls movement of the body. It can be rotated or moved.

Emerging from his eyes are two long stalks with a handle at the end called, 'EyeHandle'. This can be moved in all directions and the eyes will follow it.

At each wrist there is a diamond. These are called 'RarmControl' (right arm control) and 'LarmControl' (left arm control). These control the movement of the arms and should only be selected and moved (not selected and rotated). Behind each of the elbows are two point helpers (3D crosses) called 'RelbowPoint' (right elbow point) and 'LelbowPoint' (left elbow point). These control the positions of the elbows.

In front of the knees are two point helpers ('RkneePoint' and 'LkneePoint'). These control the positions of the knees.

On each foot are one square handle and two diamond handles. The square handle ('RfootControl' and 'LfootCotrol') controls the position of the feet. They can be rotated and moved. The outer of the two diamonds ('RheelControl' and 'LheelControl') controls the rotation of the heel and should only be rotated. The inner of the two diamonds ('RtoeControl' and 'LtoeControl') controls the rotation of the toe and should only be rotated. Have a quick fiddle with these to get an idea of how they work!

All the other bones have 'Fins' added to them (if you are using 'maxman-fins.max'). You can select these to rotate bones.

Create a sphere (**Create > Standard Primitives > Sphere**) 13 units in diameter and place it at the feet of the man (X = 35, Y = 0 and Z = 13). Next you need to spread your man's legs. Select the 'RfootControl' handle (the square that surrounds the right foot) and drag it to −20 units in Y. You can do this by clicking onto the 'RfootControl' handle and dragging in the view panel or by typing into the numeric boxes at the bottom of the screen.

When you click on an object, the numeric boxes tell you where its position is in relation to the center of the selected viewpoint. When you click and drag on the object, the numeric boxes tell you the movement of the object in relation to its original position. All the figures I will be quoting are in relation to the center of the viewpoint.

Setting the Key Positions in 3D Studio Max

Click the **Auto Key** button at the bottom right of the screen. Make sure that the Time Slider is at frame 1. The first key frame should be set at frame 1 (make the position the same as at frame 1 of the drawn animation). Move your man into a position like the first key position of your drawn animation (or see the illustrations of the lift in the 2D section). Use a combination of selecting and rotating or moving the handles and selecting the individual bones or fins and rotating them (you should only rotate the bones; don't select the skin of the man – you'll end up with a skinless skeleton).

For the first frame you will need to set keys manually for everything you move. So, when you have moved something, click the **Set Keys** button (the one with the big key on it).

When it comes to selecting the handles, you can select them in the viewpoint but selecting the bones is trickier. Open up Schematic View and you will see many nodes that relate to your man.

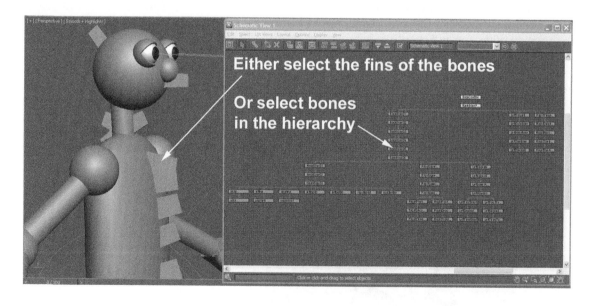

You can select the bones individually in Schematic View by double clicking on them; however, finding them can be difficult! The large hierarchy is the skeleton of the man, so zoom into this (use the buttons at the bottom right of the **Schematic View** window) and select the bones you wish to rotate. (You can use the **Page Up** and **Page Down** keys on your keyboard to move through the selection of the bones.) You could select the fins on the bones if you are using Max 2011 and the model 'maxman-fins.max'.

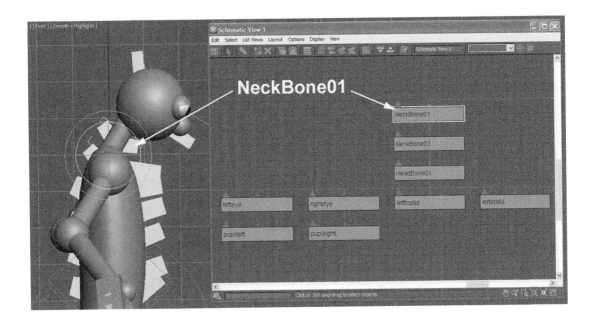

Remember, don't set a key on the skin. If you set a key on the skin it does some very strange things and starts slipping off the skeleton.

Now we need to create the second key position. This is at frame 9 so move the Time Slider to frame 9 (and take a look at the illustration in the 2D section).

You could use 'ghosting'. This will show an image of the previous positions of any selected object. Click on the main menu and select **Views > Show Ghosting**. If it doesn't show the earlier images that you want, click on the main menu again and select **Customize > Preferences** and up will come the **Preference Settings** window. Select the **Viewports** tab and adjust the number of frames of ghosting you want to see and whether you want to see them before or after the current frame.

Alternatively, you could draw on an acetate sheet stuck on your screen. Draw the outline of key position 1 on your monitor screen so you can refer back to the first position.

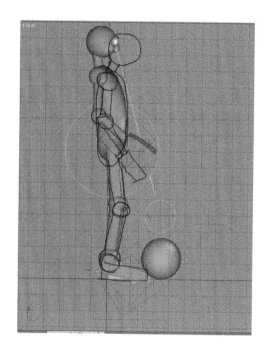

Start moving your man into the second key position by rotating the heel controls around Z slightly, to lift the heels off the ground. Then select the body handle and move it up in Y. Select the arm control handles and move the arms upwards, then rotate the wrists slightly. As you start moving pieces of the man, 3D Studio Max will automatically set a key for you for the piece of the man you have just moved. Once you are happy with the position of the man, it's a good idea to save a key on all the bones and on all the feet and arm controls. If you double click on 'BodyHandle', all the bones in the body will be selected. Create a key by clicking the **Set Keys** button. Then you can select all the controls by clicking on all of them individually with **Ctrl** pressed on your keyboard. Create a key for these. We basically need to create a key on all the moveable parts without selecting and saving keys on the skin. If you find that the skin starts slipping off the bones of your man, it's because the skin is animating independently of the bones and somewhere there are keys that apply to the skin.

As you move your man, 3D Studio Max will automatically set a key for you on the Time Slider on the object that you are moving at the time.

When it comes to the third key position (frame 19 of your drawings or the 2D lift section of this chapter) we need to get a good arching of the back. Select each of the fins on the back bones and rotate them. Or, in Schematic View, select each of the back nodes in turn (press **Page Up** or **Page Down** on your keyboard to move the node up and down) and rotate.

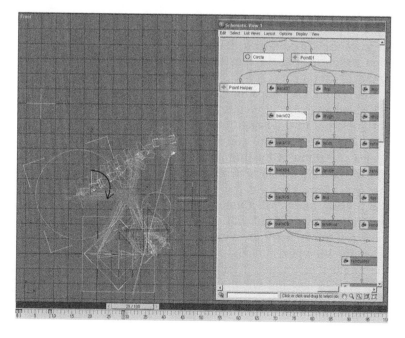

Make sure you spread the man's legs by selecting and moving the knee point helpers in Y.

At the fourth key position (frame 29; take a look at the illustration in the 2D section), manipulate your man into the same position as drawing 29 of the drawn animation. Create a second ball exactly the same size as our ball on the ground (with radius of 13). The easiest way to do this is to click the first ball while pressing the **Shift** key on your keyboard. Up will come the **Clone Options** window asking you whether you want to make a copy of the ball. Click **OK**. You should now have a second ball in exactly the same position as the first.

This new ball needs to be linked to the 'RighthandBone' node in Schematic View. In Schematic View, drag the 'Sphere02' node so that it is next to the 'RighthandBone' node (which is part of the skeleton hierarchy). Make sure that the 'Sphere02' node is selected (it should be white), then click on the **Link** button. Click on to the 'rwrist' node. The 'Sphere02' node is now part of the hierarchy.

If you play back your animation, you will see that there is now a ball on the ground and a ball attached to the man's right hand. Later we are going to make the ball in the hand invisible until frame 29 and then make it visible. The ball on the ground will be visible until frame 29 and then become invisible. The reason for this is that, when it comes to picking up an object, it's far easier to have it attached to the character rather than moving independently.

Continue through your scene, copying each of the key positions from your drawn animation (or have a look at the illustrations in the 2D section). When you're done, switch off the **Auto Key**

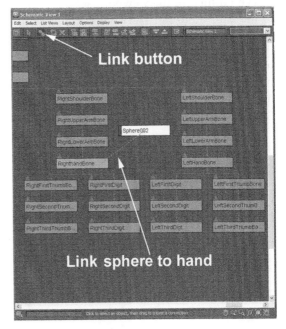

button and render a preview (on the main menu select **Tools > Grab viewport > Create Animated Sequence File**). Then have a look at 'lift_3D_loose.avi', Chapter 3 on the website. Your animation should look something like this. At this point, the animation is very rough: the hands go through the floor, there are two balls, the character's eyes don't close when he's straining and the timing's not so hot.

Setting the Breakdowns in 3D Studio Max

In order to sort out the timing, we now we need to set keys at the breakdowns (the major in-betweens). The basic problem with the timing is that the computer has evenly in-betweened the key positions and we need some light and shade. Take out drawings 1 and 9 (the first two key

positions). The two breakdowns between these key positions are 3 and 5 (see illustration of key position 1 for the timing chart). Draw positions 1 and 9 onto an acetate sheet stuck on your screen (or use ghosting). Move the Time Slider to frame 3 and move the man's body to a position between positions 1 and 9 that is one third closer to position 1 and two thirds further away from position 9. Have the head and neck bend downwards slightly to give the impression that they are dragging. When it's in position, select everything in the skeleton hierarchy and save a key. Move the Time Slider to frame 5. Move the man so that he is in a position that is half way between those of frames 3 and 9. Select everything and save a key. Continue through your animation like this until you reach the end, positioning the breakdowns as per the timing charts of your drawn animation (or have a look at the illustrations in the 2D section).

To make the scene look like it only has one ball rather than two, we need to make the ball attached to the hand (Sphere02) invisible *until* frame 29 and the ball on the ground invisible *from* frame 29. Open up the **Track View** window (on the main menu, **Graph Editors** > **Track View – Curve Editor**). In the viewport, select the ball. In the Track View you will see the curves relating to the ball. Go to the Track View main menu and select **Tracks** > **Visibility Track** > **Add**. You will now have a dotted line that relates to the visibility of the ball in the Track View.

Add a key to this 'track' at frame zero by clicking the **Add Keys** button and then clicking in the visibility track at frame zero (on the far left of the track). Repeat this procedure and place a key at frame 29 and then one at frame 100. On the visibility track, right click on the first key frame and up will come the **Sphere02\Visibility** window.

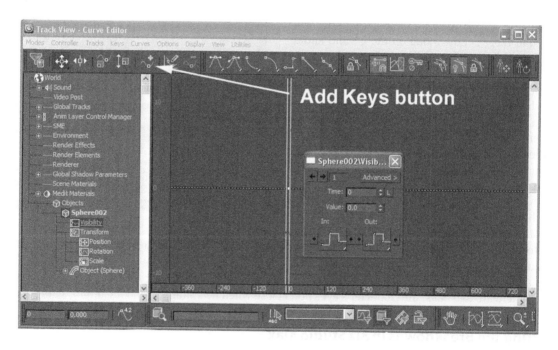

Specify a value of zero (invisible) in the **Value** box and make the **In** and **Out** buttons 'stepped'. Move to key 2 (the one at frame 29), specify a value of 1.0 (visible) and set the **In** and **Out** buttons

to 'stepped'. Do the same at key 3 (frame 100). In the view panel the ball attached to your man's wrist should now be invisible until frame 29.

We now need to sort out 'Sphere001' (the one on the ground). Scroll all the way down to the bottom of the **Hierarchy Tree** window and click 'Sphere001' to select it. Give it a visibility track and give it three key frames at frames 0, 29 and 100. On the first key frame specify a value of 1.0, and on the second and third key frames (frames 29 and 100) specify a value of zero. Make sure all the **In** and **Out** buttons are set to 'stepped'. In the view panel we should now have just one ball throughout the scene.

When you are done, render a preview (on the main menu, go to **Tools > Grab viewport > Create Animated Sequence File**). Have a look at 'lift_3D_breakdowns, Chapter 3, CD_ROM. Lots better! We've got rid of that 'evenness' that you get with computer animation. Now we just need to tweak a few things. We do this by using the function curves. There may be several things that you want to sort out. What I'll do is go through how to fix one thing and it's up to you to change the rest.

In the version of the lift that I did in 3D Studio Max, at the point where the man first starts picking up the ball I want the ball to drag along the ground for as long as possible and then lift up in a pendulum-like ark. This is between frames 29 and 37. The computer has got the man lifting up the ball between these two frames. To make the ball drag along the ground, I need to adjust the function curve that relates to the ball's up and down movement. This is the movement in Z.

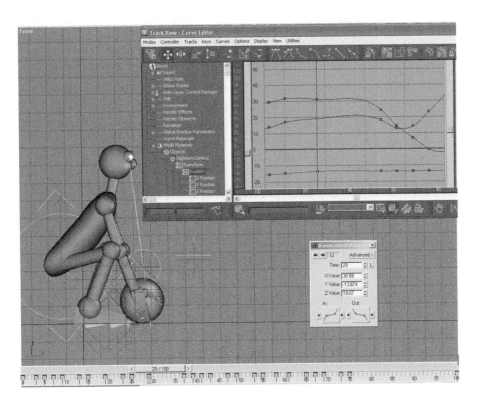

In the **Hierarchy Tree** section of the **Track View** window, expand 'RightArmControl' (click on the circled ' + ' next to 'RightArmControl'). Click on **Z Position**. Find the key frame at frame 29 on the Z (blue) function curve. Zoom into it. Right click on this key position and up will come the **RightArmControl\Z Position** window.

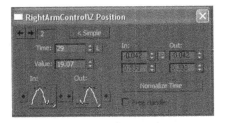

Set the **In** and **Out** buttons to 'Handles' (as shown in the illustration). Click the **Advanced** button to reveal several number boxes relating to the X, Y and Z positions. Click the padlock button next to the Z **In** and **Out** boxes. In the **Function Curve** section of the **Track View** window, click and drag the handle emerging from the right-hand side of the key position at frame 29 on the Z function curve to adjust the curve between the key positions at frames 29 and 37. Keep scrubbing the Time Slider backwards and forwards to see how the ball is moving and keep adjusting the curves from the key positions at both frame 29 and frame 37.

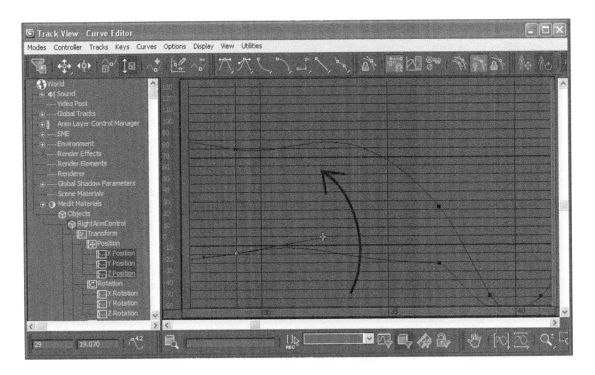

Keep adjusting the curves until the ball picks up nicely. Repeat this procedure for any other irritating areas (fingers going through the ball, hands going through the floor or the ball not following a smooth trajectory).

The last thing to sort is the eyes closing as the man strains to pick up the ball (between frames 25 and 67). In the Track View, click on the **Edit Keys** button. In the hierarchy tree find and expand (click ' + ' sign) 'rightbotlid' (this is part of the 'BodyHandle' branch, so expand 'BodyHandle').

Click 'rightbotlid' to highlight it. Then click the **Delete Keys** button. Up will come a **Delete Keys** warning window; click **Yes**. Repeat this procedure for 'leftbotlid', 'righttoplid' and 'lefttoplid'. This will delete the key positions from all four eyelids.

Drag the Time Slider to frame zero, select all the eyelids in turn and set a key at frame zero (right click on the Time Slider and click **OK** in the **Create Key** window). Drag the Time Slider to frame 23 and create a key for all the eyelids on this frame. Drag the Time Slider to frame 25 and rotate each of the eyelids in Y so that the eyes are shut. This should automatically set a key; if not, create the keys yourself. Drag the Time Slider to frame 66 and create a key at this frame with both the eyes shut. Drag the Time Slider to frame 67, open the eyelids by rotating in Y and create a key there. When you play this back, the eyes will be opening and closing all over the place. Again, the computer has in-betweened the animation, but not as we would like it.

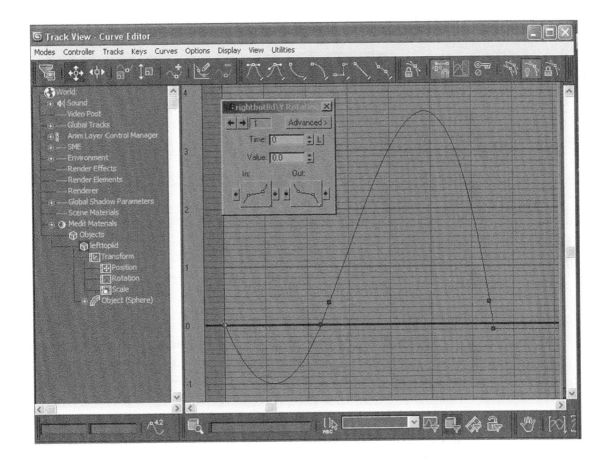

Open up the Track View and click on the **Function Curves** button. Expand 'rightbotlid' in the hierarchy tree and select **Y Rotation: Bézier Float**. This will bring up the function curve for the

eyelid. The computer has made the curve sweep down out of the first key position. It then swoops back up through the second and third key positions and then down again into the fourth key position. We need to adjust the curve so that the curve is straight between keys one and two, has a slight curve upwards between two and three and is straight between three and four. Right click on the first key on the function curve and up will come the **rightbotlid\Y Rotation** window. At the first and third key frames (frames 1 and 25), set the **Out** button to 'stepped'. This should produce a nice, straight line at the correct points. (For some reason we have to repeat this for rotations in X and in Z, although we have only rotated in Y, to get the eyelids to do what we want them to do.)

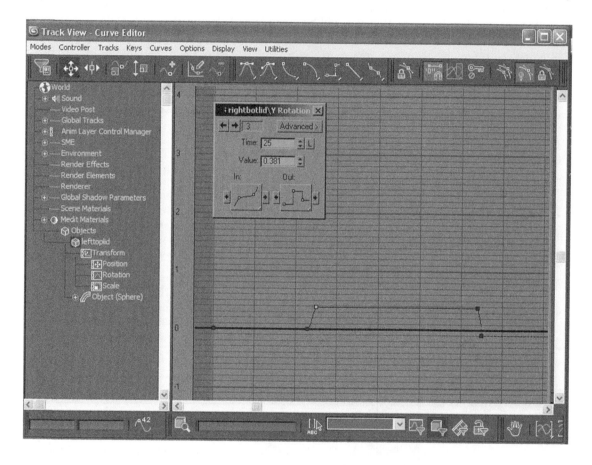

Repeat this procedure for 'leftbotlid', 'righttoplid' and 'lefttoplid'.

Render a preview but without the handles (when the **Make Preview** window comes up, un-tick **Helpers** and **Shapes**). Take another look at 'lift_3D.avi, Chapter 3 on the website. Hopefully your animation looks something like this!

The push and pull exercises can be found on the book's website, www.charactermation.com.

FOUR

Timing, Anticipation, Overshoot, Follow-Through and Overlapping Action with an Animated Character

Chapter Summary

- Timing
- Anticipation
- Follow-Through

- Overlapping Action, or Overshoot
- Vibration
- Exercises

Timing

Timing is probably the most difficult thing to teach and learn about in animation. Timing makes a movement witty or touching or relevant. It is central to any form of film making, whether live action or animation. It runs through all elements of visual moving imagery. Every chapter in this book is about timing.

Timing is about conveying information to your audience so they can follow the action. I always think that good timing is the minimum period you give your audience to understand what is happening. If you make a move or a pose too quick, they won't follow what's going on. Make a move or a pose too slow and the audience will be bored. Timing controls how your audience reacts to what they see. Sometimes you will make your audience wait for the action, or lead them to expect one thing to happen but make another happen (surprise is the basis of a lot of humour). You can lull your audience into a state of complacency through repetition, and then make your character do something different. These are only a few examples of the use of timing but you can see what I mean about it being difficult to teach.

I touched on timing in Chapter 1 and I have been through the basic stages of working out timing during the exercises in Chapters 1, 2 and 3. To recap, these are as follows: first, draw the key positions (making sure they are as clear as possible) and shoot them on a line tester for the required

amount of time (see Chapter 1). Then vary the number of frames each drawing is held for until you have a series of stills that express all the information needed for the scene. Show this to as many people as possible and ask them if they can understand the scene. If all or some of the drawings flash past and no one understands the action, give the offending drawings more frames. If your audience does understand what's going on, well done, but make all the drawings play back for a shorter amount of time. Show this to your audience and see if they still understand it. Keep everything as tight as possible. Never be happy with something that will just do. Always keep pushing your audience and keep experimenting with what you can get away with. Having said this, you must allow for movement between your key positions. Err on the side of being slightly too slow. You can always take out the in-betweens later.

Once you have a sequence of key positions that you are happy with, you can work out how many drawings to do as in-betweens and where they should be placed (mark these up with timing charts at the bottom of every key). The best way to work out the position of the keys is to act out the movement of your character in front of a mirror. Using a stopwatch to time this is very helpful. If you don't have a stopwatch try saying 'one little monkey, two little monkeys, three little monkeys' ('one little monkey' takes about a second to say; 'One little' and 'monkey' each take about half a second; 'one', 'little', 'mon' and 'key' each take about a quarter of a second). Of course, acting out a scene in front of a mirror while saying 'one little monkey, two little monkeys' will make you seriously question your sanity. Don't worry! This is the first part of the process of becoming an animator. Get used to working things out this way. Keep thinking of the minimum that the character needs to physically do in a scene. Never try to fit too much information into too short a period of time. Keep things simple.

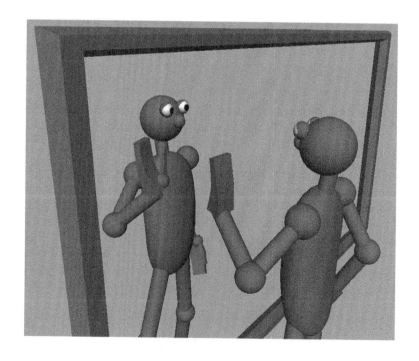

As you watch yourself, make thumbnail sketches showing the progression of the movement. This way you don't forget the sequence when you get back to your desk. Act out the scene until the movement becomes second nature and you can 'feel' what's happening at all points as you draw or move the scene on your computer.

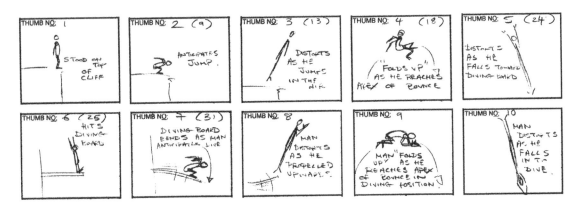

Observing other people acting out a scene or going about their daily lives will also help with your understanding of timing. Watch people and become familiar with how they're moving and how long it takes them to do certain actions. When you're sat at a table outside a coffee bar or pub, watch the people walking by. When watching them, use a stopwatch to time how long an action takes. You could say 'one little monkey, two little monkeys...' (although not too loud). Also think about what's going through their minds. Are they moving slower because they're depressed or because they're contemplative? Are they moving faster in order to get somewhere quickly, or do they need to get away from something?

Timing comes with experience. Experience comes by doing lots of animation and showing it to as many people as possible. Don't be afraid of asking for advice, be big enough to take criticism and always think of your audience.

Anticipation

Every action initiated by a 'living' creature (humans, animals or inanimate objects that have a 'character') will look better if you use an anticipatory movement prior to the main movement. An anticipatory movement is one that precedes the main movement your character will make and follows a path that is in the opposite direction to that main movement.

Anticipation serves two purposes. It communicates to the audience that the character is initiating a major movement. It's as if the character is 'winding itself up' prior to making the move. It also alerts the audience to the fact that something is going to happen and makes sure they are looking at the right place on the screen to see that movement. It's all very well animating a movement that will surprise an audience, but if they aren't looking at it they won't see it and consequently won't be surprised. Following are some examples of anticipatory movements.

If somebody is going to bend down to pick something up, they will make a slight movement upwards (in the opposite direction to the main downwards movement), before bending over.

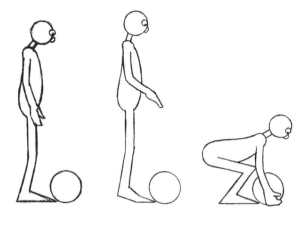

Before walking in one direction, they will pull themselves back (in the opposite direction) before taking the first step.

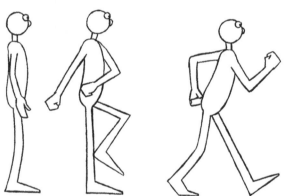

If somebody is going to jump up over something, they will bend their knees and body down into a crouch (bending their arms upwards and backwards) before they jump.

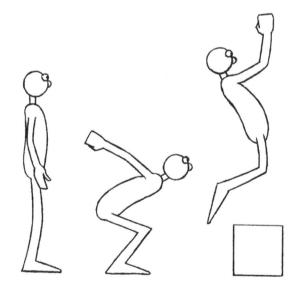

Before throwing something, they will pull their arm back (and lean their body back) in order to put as much energy as possible into the throw.

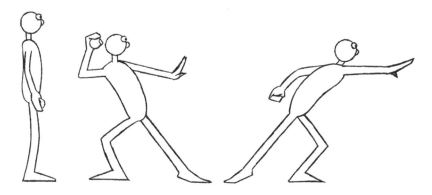

If someone is about to faint and fall to the ground, they will straighten up before falling.

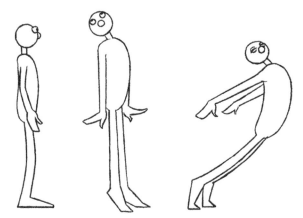

If a character is flying through the air and they suddenly fall (Icarus losing the ability to fly, for example), they will flinch upwards before falling out of the screen.

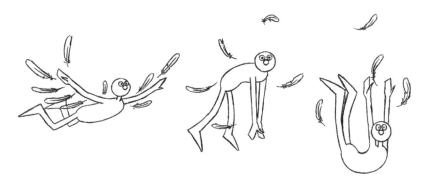

The main circumstance in which you wouldn't use anticipation is when animating an inanimate object affected by gravity and you don't want to give the impression of the object being alive.

How Much Anticipation?

The amount of anticipation to animate depends on a number of factors:

1. How much force is being put into the movement.
2. How fast the movement is.
3. How much you want to surprise the audience.
4. Whether the anticipation is taking place during a movement or is initiating a change of direction during a movement.
5. Whether the movement is anticipated by part of the person's body or the whole body.

Force

Following are examples showing how force affects anticipation.

If somebody wants to throw a relatively light ball a long distance, they will lean right back in anticipation of the throw. They will pull back with the ball into the extreme position relatively slowly and accelerate out of the extreme position quickly.

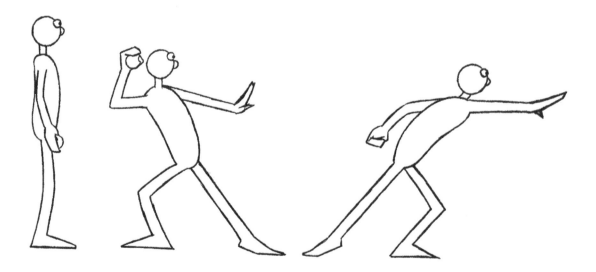

If they are throwing the same ball a short distance and trying to hit a target with accuracy, the extreme position will not be as far back. They will move slowly backwards into the extreme position and accelerate slowly out of it, making a quick movement at the end of the throw with a flick of the wrist.

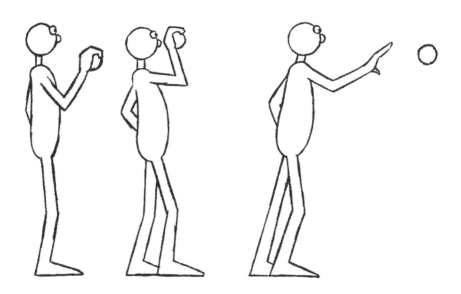

If somebody is trying to throw a heavy ball, they may not be able to lean back very far without unbalancing themselves. In this case the ball would be kept fairly close to the body. The body would be used more in the throw, bending down at the knees and swinging the arms (if they are both holding the ball), just far enough backwards to prevent themselves from over-balancing. They could perhaps take a step back or part their legs further in order to keep their center of balance above and between their legs.

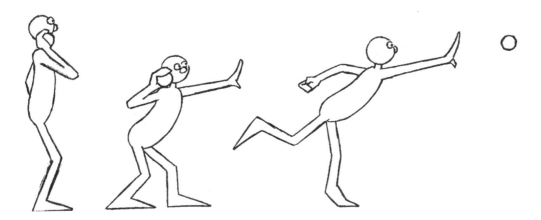

When jumping, the weight that the person is trying to move is themselves. A heavier person will need to anticipate more than a lighter person in order to jump into the air!

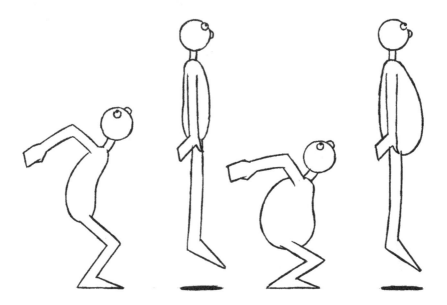

When jumping upwards, the direction of the anticipation is straight down. The higher somebody wants to jump, the further down a body will have to crouch in anticipation.

If somebody wants to jump a long distance, they will pull themselves backwards and downwards in anticipation. The amount they will pull themselves backwards and downwards depend on the angle at which the person will jump. They will anticipate downwards for height and backwards for distance. One leg will take a stride backwards rather than the feet staying together.

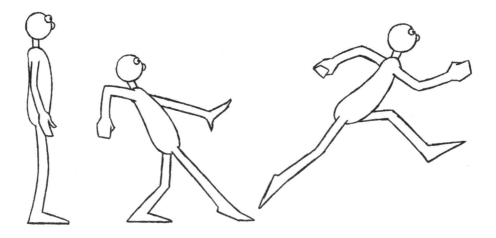

Acting and Anticipation

When it comes to acting, the way a character moves when changing position will influence how extreme the anticipation is. A slow movement could have a small movement of anticipation. A fast, violent movement would need a larger movement of anticipation. A sudden movement would barely have any anticipation at all. Added to this is the frame of mind the character is in together with their surrounding environment. Usually there will be an anticipatory position before or during any movement.

One way to carry this out is to have a small anticipatory movement of the head in the opposite direction to the major movement. Make the eyes move in the direction of the major movement first. If a character is going to look screen right, the eyes will look screen right first, while the head does a small anticipatory movement to the left. The head will then turn to face screen right, following an arc.

Sometimes anticipation in acting can be as small as a slight roll of the eyes; sometimes it can be as huge as a full-blown double take.

Double Takes

The classic example of anticipation is the 'double take' (called this because it involves a character looking at something twice – 'take'-ing something in twice). This is when a character catches sight of something (perhaps out of the corner of his eye) but does not take in the significance of what he has seen. This first look would be followed by an anticipatory movement. This could lead to the character almost screwing themselves up (in the opposite direction to the major or 'take' movement). This anticipatory movement is followed by the second look. The second look can be as extreme as to include the eyes popping out of their sockets and a huge mouth with a large, wagging tongue. Watch any Tex Avery film if you want to know how to do an over-the-top double take correctly.

Double takes don't have to be as extreme as this. They can be as subtle as a small nod of the head from the first look to the next. This gives the suggestion that the character has seen something, is slightly surprised by what they've seen and needs to see it again to make sure their eyes are not deceiving them.

Speed and Surprise

If a movement is quick or is made suddenly, it's best to use a small anticipatory movement. Having said that, much depends on the force and the speed of the movement. Somebody running fast will start with a big anticipatory movement.

To shock your audience with an unexpected action, you may think there would be no anticipatory movement. However, if this was left out, the audience could miss the main action because they may not be looking at the right place. Have a small and very quick anticipatory movement (just enough to catch your audience's eye) and then do your sudden movement.

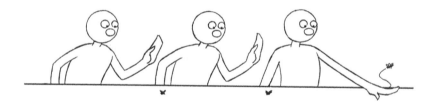

Another way of giving a hint that something is going to happen is to make another part of the body do the anticipatory movement. In the example in the illustration (right), the character points with his right arm. When the arm moves suddenly away from the body, the rest of the body is thrown back first and then dragged forwards by the arm.

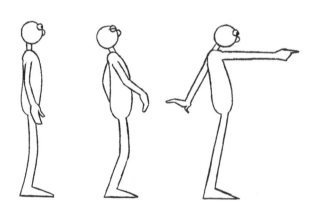

This relative flinging of the body backwards acts as an anticipatory movement and gives the audience something to latch onto prior to and during the major movement.

Anticipation During a Movement

As with the sudden movement discussed above, anticipatory movements don't have to happen before a movement; they can happen during a movement as well.

If somebody is moving their arm to pick something up, as the hand approaches the object it may pause and pull back slightly, opening its fingers just before it grabs the object. The arm as a whole is moving all the time, but the hand relative to the arm is moving backwards (anticipatory movement) and then forwards (major movement).

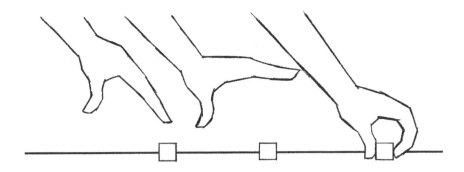

If a character is running and wants to change direction, he could twist away, still running, before executing the main turn. I always think of this in relation to driving a car and making a tight turn. In order to do this you have to initially steer outwards in order to increase your turning circle. The same is true of a four-legged character like a horse or a dog.

When walking or running around a corner, the head will always turn into the corner first, followed by the body.

This helps with creating momentum and it alerts the audience to the fact that the character or animal is going to make a turn.

If a character is tripping up, you can always make it look better by having a very slight pause at the first point of the trip (to get the audience wondering whether the tripper will fall over or not). Use a few frames (six to eight), then, as gravity takes hold, part of the body (led by the stomach, the center of gravity) will start to fall toward the ground. Have the arms, the head and the legs thrown back slightly in the opposite direction to the fall before following the rest of the body.

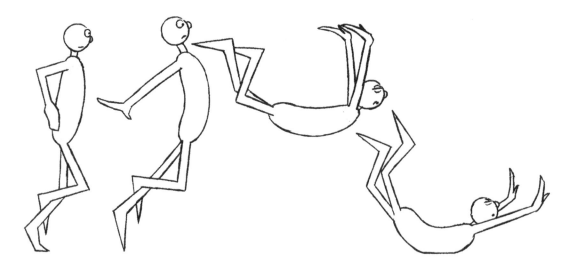

This is a very cartoon-like trip and, hopefully, will make an audience laugh. A more naturalistic trip will look something like the illustration below. An audience seeing this trip will not laugh – they will think 'ouch'!

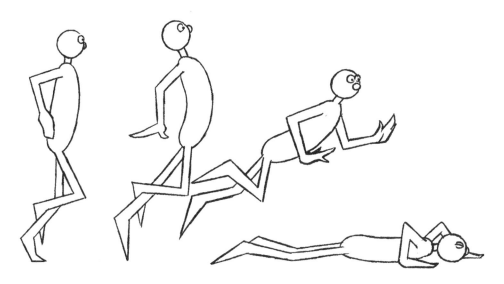

Varying the Amount of Anticipation

This is to do with the amount that the body anticipates a given movement over the movement's entirety. If a character is going to point with its arm, the arm is going to pull back in anticipation by a large amount. The body will pull back by only a small amount and the head (especially if the character is looking at something intently) may move by an even smaller amount.

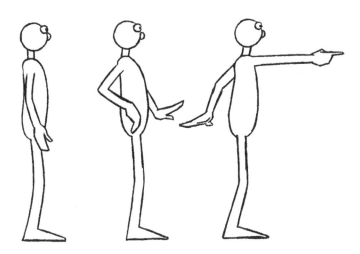

If a character is going to make a movement that uses the entire body, the whole body will do an anticipatory movement. Any variation across the body will be relatively smaller.

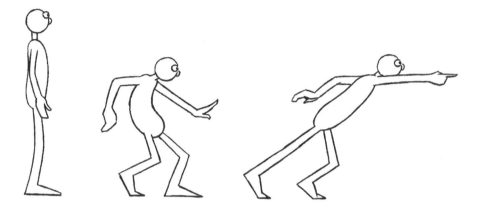

When animating a scene in which there will be several anticipations, try to think of different ways of doing each anticipatory movement. If they are all done in the same way, your animation will look very mechanical and repetitive.

Other Ways of Using Anticipation

Anticipation can also be used with special effects animation. When something is struck by lightning, the clouds that generate the flash should light up at different patches. This will let the audience know that something is about to happen. Just before the bolt of lightning appears, have a white flash frame. Otherwise the audience misses the bolt of lightning.

Somebody hit on the head by a rock will 'bounce' up straight into the air before falling over, anticipating the fall.

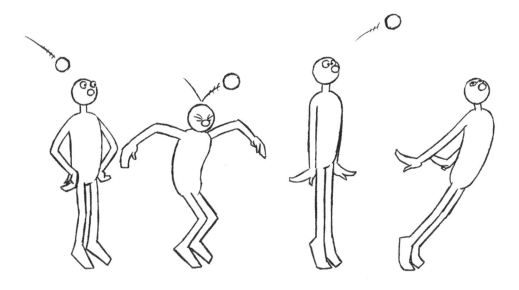

Follow-Through

When a character initiates a movement, follow-through is the movement by additional matter that follows the major anticipation and overshoot movement. This follow-through movement is made by the extremities of the body, such as the hair, ears or tail, and also ancillary items such as clothing and general drapery.

Follow-Through of Inanimate Objects

This is the animation of hair, manes, coat tails, ties, sleeves, strings, general drapery, and so on. Generally, inanimate objects connected to your character will follow a path similar to the part of the character they are attached to. Depending on the size and flexibility of the object, it will flail out from the end of this path to varying degrees.

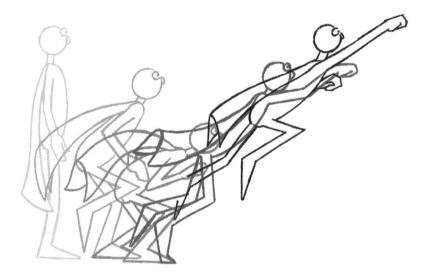

Depending on the 'stiffness' of the object, you will get a slightly different type of follow-through. Generally a piece of drapery will demonstrate a wave running along its length as it is pulled through the air. At its most simple, this is like a flag cycle. See 'flag_cycle.avi', Chapter 4 on the website.

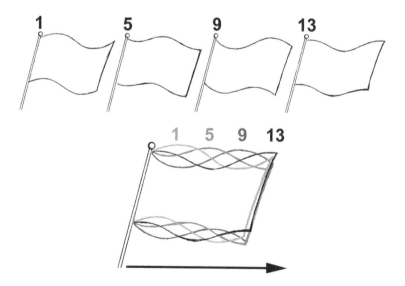

A flag cycle consists of a piece of cloth that has a wave running through it. Each crest of the wave on one drawing becomes the crest of the wave on the next drawing. The first key drawing (number 5) is the mirror image of the first key position (number 1) and the fourth key drawing (number 13) is the mirror image of the second key drawing. These key drawings need in-between-ing. You should shoot these drawings as follows: 1, 3, 5, 7, 9, 11, 13, 15, 1, 3, 5, 7, 9, 11, 13, 15, etc.

Imagine a piece of cloth being pulled through the air. The cloth will drag behind the point where it is being held by the hand, flailing outwards at the end. If the hand slows down or stops, the cloth will catch up with the hand and start to move ahead.

A piece of string or rope will act in a similar way but, because it has greater flexibility than a piece of cloth, it will flail out of the path set by the character to a larger degree.

A steel chain will do something similar but will always be affected by its weight, falling faster but not swinging as far.

If the object holding the cloth speeds up, the cloth straightens as it is left behind. Just give it a very tight wave running along its length.

Follow-Through of Animate (Living) Objects

This is the animation of ears, tails, breasts and beer bellies and, to a lesser extent, arms, legs, the neck and the head. In other words, anything that at certain times moves loosely on the body. Rather than following the path of the character, these body parts have a life of their own. They follow the pattern of cloth or string but can be more exaggerated.

Tails are extensions of the backbone and as such have a particular movement. Always think of them as part of the backbone and as resembling a chain of joints.

 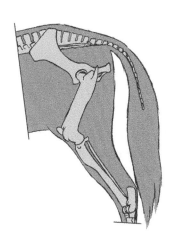

It's worth knowing how much of the tail is backbone as it varies from animal to animal and will affect how the tail moves. A horse's tail is a relatively short stump of bone with a large amount of long hair attached to it. A cat's tail is backbone along its entire length.

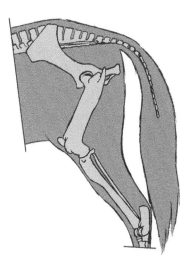 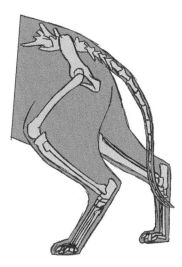

In the same way that a piece of string will, to a certain extent, follow a path led by the part of the body that initiates the movement, the same will happen with the tail. This time the movement is led by the animal's bottom.

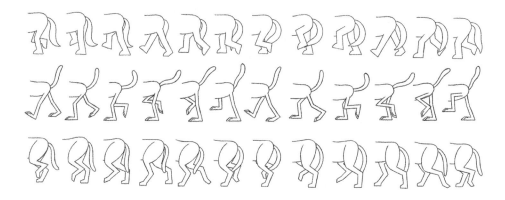

Occasionally the animal will initiate a slight movement through the tail itself. So, for most of the time the tail will follow a cycle but occasionally it will give a twitch and do something slightly different. The tail will then return to the cycle.

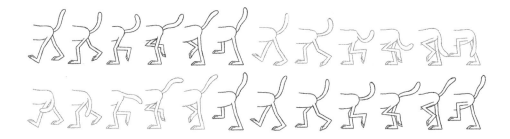

Think about how much of the tail will be following through and how much is initiated from within. Some of the movement results from the animal's bottom moving and some results from the animal moving its tail.

Ears move slightly differently. As with the tail, the make-up of the ear varies from animal to animal. This affects the movement during follow-through. With dogs ears, for example, a spaniel's ears will move in a much more floppy way than a terrier's ears. This is because a spaniel's ears are larger and softer and a terrier's ears are shorter and stiffer.

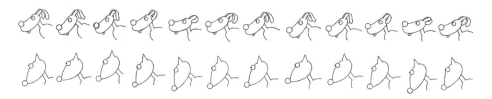

Any sort of hair will move more like an inanimate object because hair consists of a huge number of individual strands. On their own they would move like a piece of light string, but collectively they have a firmer quality. It is always a good idea to simplify a clump of hair to an outline with a few individual strands highlighted. To draw every single hair would take a very long time. In 3D, whole sections of animation programs are dedicated to the animation of hair and to a certain extent will do a lot of the work for you. However, it is always a good idea to have some understanding of how hair works.

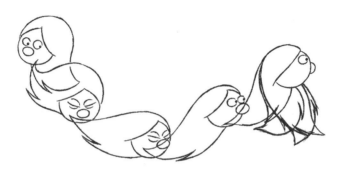

As with the previous examples, the level of follow-through depends on how extreme the movement is. Take as an example a head moving from side to side: as the head moves from one side, the hair fans out close to the scalp. It then starts to taper towards the tips before pinching up thinner at the extreme of the movement.

With 3D computer animation, it depends how naturalistic you want to be. Keep in mind that the more realistic your design, the more realistic the audience expects it to move.

The limbs of a character will demonstrate follow-through during a movement. The amount of follow-through is dictated by the nature of the action. An animated arm that accurately follows the true movement of the limb may look ungainly to an audience. When you animate a sequence like the one shown below, it can look jerky and not flow nicely.

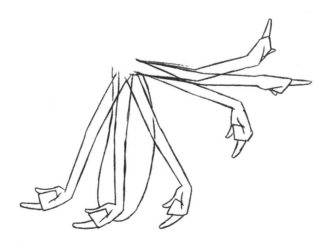

The arm should be re-drawn so that it 'flows' with the movement. Achieving a graceful movement as the arm moves into a resting position may require the bending of joints into impossible positions. This way of achieving fluidity by 'cheating' is often called the 'breaking of joints'. Imagine that the arm is a length of rubber hose and will follow through the movement initiated by the hand. This will look fluid but will also look odd, as though it's lost the elbow and the wrist joint. To make it more convincing, take this piece of animation but add the elbow and the wrist joint to it. Bend the elbow or wrist joint in such a way that it follows the general bend of our rubbery arm. Don't worry that the joints do something impossible. As long as the arm moves nicely, it doesn't matter!

You can take this idea further when any of the limbs are moving at a very fast speed. The arms can lose their joints altogether and even be distorted along the length of the movement to suggest speed. This is referred to as 'smearing'.

What is happening is that the movement is so fast that each individual shot frame is not fast enough to catch a sharp image of a particular bit of the movement.

A similar thing happens in live-action film making. If you look at the individual frames of a live-action sequence that shows a fast movement, the image will be distorted.

The leading part of the moving limb will be fairly sharp but the trailing part will be blurred. You can replicate this in your animation in a number of ways. These include 'smearing', adding whiz lines and (in 3D) motion blur.

Smearing and whiz lines tend to be more cartoon-like, whereas motion blur tends to be more realistic. All of these techniques should only be used at the appropriate time. If you use them to slow a movement, you end up with a mutant limb. You should never actually see any of these distortions but you should miss them if they are not there. Only ever use them with a fast movement.

If a character is moving so fast that they cannot control their limbs, we will get the most distorted follow-through. This will happen, for example, when a character is falling through the air or is being pulled out of screen.

Generally, it's a good idea to animate the follow-through of these parts of a character after you've done the main animation. Follow-through always works better if you animate straight ahead, so take your completed rough animation and put the additional followed-through bits on afterwards.

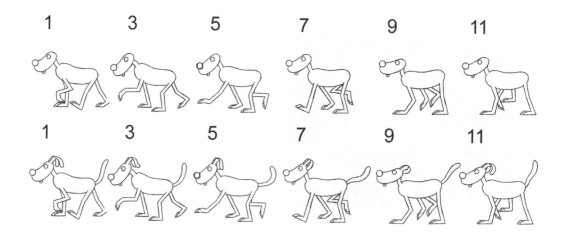

Overlapping Action, or Over-shoot

When a character makes a movement and then comes to a stop, it's always a good idea to make individual parts of that character come to a stop at different times. This gives the impression of a character that is alive. Having a character come to a dead stop makes a character look just that – dead! A good way of doing this is to give your character overlapping action. This means making your character go slightly beyond the position it will come to a stop in and then going back to this position – it 'overshoots' its final position. A good example of this is at the end of the lift sequence in the last chapter. The man moves upwards after he's picked up the ball and then settles down at the end.

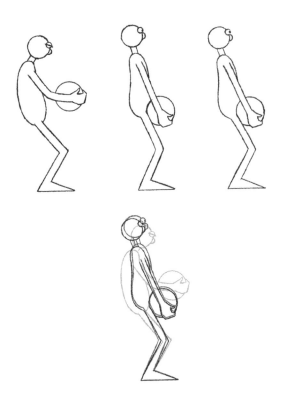

As another example, when a person lands on the ground after jumping, the legs will bend as the knees take the weight. The arms will 'flow' forwards in an arc and be pulled back as the body unbends. The head will be tilted backwards as the body falls and be dragged back up as the body straightens. When the body comes to a stop, the head will go slightly beyond its final resting place and then come back to a stop. This is what overshoot is. Extremities of the body go beyond the body's final resting place and then come back to rest.

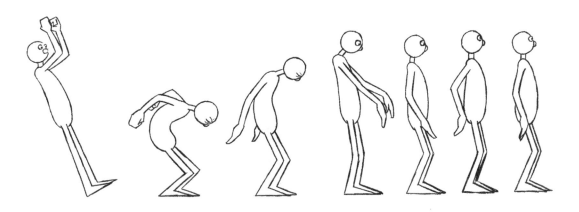

When somebody points, the finger doing the pointing will go slightly beyond its final resting position. You could even lose the joint and make the arm perfectly straight at the most extreme position, or even try stretching the arm as well.

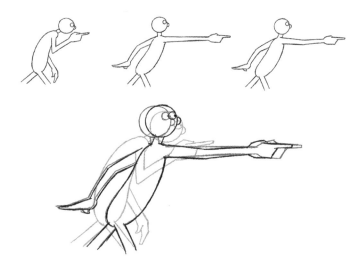

When a head moves from one side to another, it will go slightly beyond its final resting position and then move back to a stop. The hair continues to move, as do the jowls, earrings and any other loose items. The hair, being lighter, will go further beyond the stopping position; the earrings, being heavier and more solid, will not go as far. The jowls will only go beyond their resting position a small amount before coming to a stop. Both the hair and the jowls will come back to a final resting position but at slightly different times, with the hair coming to a stop last.

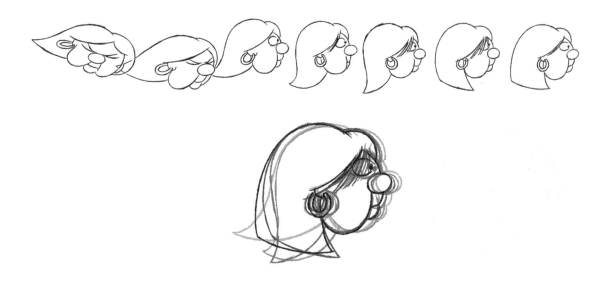

Drapery will move beyond the character's final resting position and then flow back to a graceful stop.

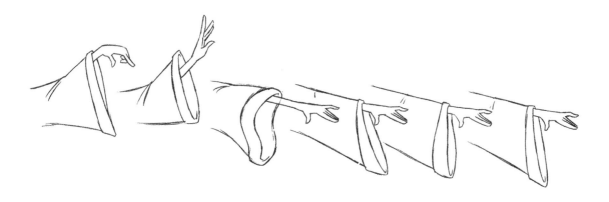

Making parts of your character come to a stop at different times always improves your animation.

Vibration

When we have a stiff object that can show a small amount of flexibility, like an arrow, a plank of wood or a fishing rod, we will get a certain amount of vibration with its follow-through and over-lapping action.

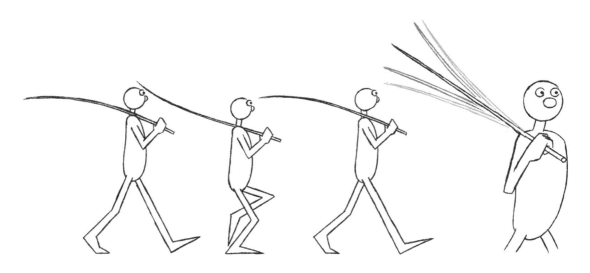

When an object like this comes to a sudden stop or is bent and then released, we get a vibrating movement, as shown in the illustration below.

When organising these drawings onto an X-sheet, put drawing 1 at frame 1, drawing 5 at frame 2, drawing 2 at frame 3, drawing 8 at frame 4, drawing 3 at frame 5, drawing 7 at frame 6, drawing 4 at frame 7, drawing 6 at frame 8 and finally drawing 5 at frame 9.

Exercises
The Stick and String Exercise in 2D

For this exercise we will animate follow-through using a piece of string attached to a stick. Imagine the stick being waved through the air by someone's hand and the string trailing after it. The stick will move forwards in an arc, stop and then move back again, dragging the string behind it. When the stick reaches the end of its arc, the string overlaps. The stick is then moved through an arc back to the first position, the string being dragged and then overlapping. This action is repeated a second time and then the stick comes to a stop at the same position as frame 1. The piece of string overlaps and comes to a rest. This scene is 100 frames long.

First animate the stick, without the string. For the first key position draw your stick at a jaunty angle.

The stick is going to move forwards in an arc to an angle that is a mirror image of the first position. This is key 2 and will be at frame 17.

Bring the stick back to the same position as key 1 (this is the third key position and will be at frame 33). Draw the stick at the same position as key 2 for the fourth key position (this is at frame 49). Finally draw the stick at the same position as key 1 for key position 5 (this is at frame 65). Have a look at 'stick_2D_keys.avi' in Chapter 4 on the website to get the idea.

In-between the key positions by accelerating out of one key position and decelerating into the next.

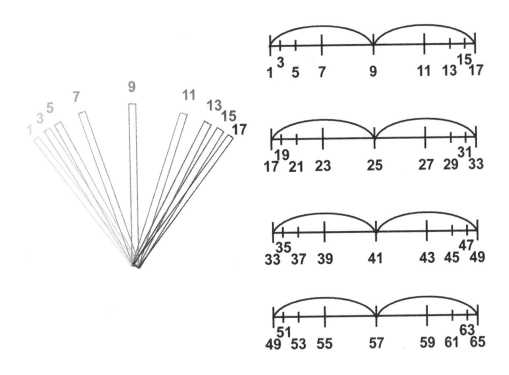

Have a look at 'stick_2D.avi', Chapter 4 on the website. This is the stick waving backwards and forwards.

Now animate the string as straight-ahead animation, drawing on top of your stick drawings. Start with the string hanging down from the end of the stick on frame 1. As the stick moves forwards to the next drawing, the string will be pulled through the air and will follow through the shape of the previous drawing.

When the string reaches the second key position (the point where the stick comes to the end of its arc), the string will keep going forwards and be pulled in the opposite direction as the stick moves back through its arc.

When the stick reaches the end of the second arc (key position 3), the string will keep going forwards and then be pulled in the opposite direction as the stick moves back through its arc.

When the stick reaches the end of the third arc (key position 4), the string will keep going forwards and then be pulled in the opposite direction as the stick moves back through its arc.

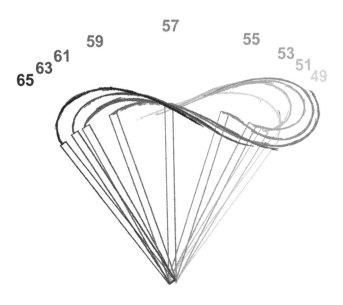

When the stick reaches the end of the fourth arc (key position 5), the string will keep going forwards and then be pulled in the opposite direction as the stick moves back through its arc.

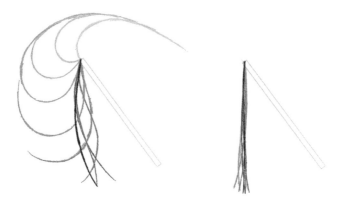

When the stick comes to a stop, the string will swing over and sway to a stop. Take a look at 'stick_ string_2D.avi', Chapter 4 on the website.

The Stick and String Exercise in 3D

First we need to build our stick and string. Create two cylinders, arrange them in a position that resembles the first position of the drawn animation and put bones into them.

Animate the stick rocking backwards and forwards, then animate the string every other frame at a time, copying the illustrations above showing the drawn animation.

The Stick and String Exercise in Maya

Building the Stick and String in Maya

Make the view panel a Front view. Create a polygon cylinder by clicking the **Polygonal Cylinder** button at the top of the screen, or by going to the main menu and clicking **Create > Polygon Primitives > Cylinder**.

In the Channel Box rename 'pCylinder1' to 'stick'. Under **Inputs** click 'polyCylinder1' and the **Input** boxes will open up. Make **Radius** 0.4, **Height** 16, **Subdivisions Axis** 20, **Subdivisions Height** 1 and **Subdivisions Caps** 1.

Create a second polygon cylinder and call it 'string'. Make it **Radius** 0.1, **Height** 16, **Subdivisions Axis** 20, **Subdivisions Height** 16 and **Subdivisions Caps** 1.

Rotate 'string' 90 degrees in Z and move it 9 units in Y and −8 units in X. This will put it 1 unit higher up than the stick.

Now we need to put some joints through the 'stick' and 'string' and 'bind' them together. Go into Animation mode by selecting **Animation** from the dropdown menu in the **Modes** box. Open up the Hypergraph (on the main menu, select **Window > Hypergraph**). This will help when selecting different parts of the skeleton and the stick and string. Click the **Snap to grids** button and then click the **Click to place IK joint** button or go to the main menu and click **Skeleton > Joint Tool**. Click at the center of the base of 'stick' and then at the center of the top of 'stick'. Press **Enter** on your keyboard to leave Joint Tool mode. This will put a joint up through the stick. Select

the **Click to place IK joint** button again and click at each of the subdivisions along 'string'. When you've reached the end of 'string', press **Enter** on your keyboard to leave **Joint Tool** mode. This will put 16 joints along the length of your string.

Select joint three and move it down by one unit by typing 8 into the **Translate Y** box in the Channel Box. Select 'string' and move it down by one unit by typing 8 into the **Translate Y** box in the Channel Box. The string and its joints will now be at the top of the stick.

To connect the joints to the cylinders, click 'stick' and then, with **Shift** pressed on your keyboard, click 'joint1' and 'joint2' so that they are all selected. In the main menu, click **Skin > Bind Skin > Rigid Bind**. The two joints ('joint1' and 'joint2') running up the stick are now attached to the stick.

Attach the joints in the string, by clicking 'string' and, with **Shift** pressed on your keyboard, clicking each of the joints running along 'string' (from 'joint3' to 'joint18') to select them all. In the main menu click **Skin > Bind Skin > Smooth Bind**. All the joints running along the string should now be attached to the string.

Next we need to parent the joints in the string to the joints in the stick. In the Hypergraph select 'joint3' and then middle click it, drag it to 'joint2' and let go of the mouse button. You should now have a line linking 'joint2' to 'joint3'.

Test your model by selecting (clicking) the joints and rotating them (don't move them; this will distort the model). After you've tested each joint, put the stick and string back to their original positions. Do this by going to the main menu and clicking **Skin > Go to Bind Pose**. The stick and string will return to the pose they were in when they were first bound to the joints.

Animating the Stick and String in Maya

Get out your drawn animation. The first thing we need to do is to set the keys for the waving of the stick.

Open the **Preferences** window by clicking the **Animation Preferences** button at the bottom of the screen or, in the main menu, clicking **Window > Settings/Preferences > Preferences**. Select **Settings** from the **Categories** list and in **Working Units** set the **Time** to 'PAL (25fps)' from the dropdown menu.

The scene is 100 frames long so make sure the **End Time** box is set to 100 (this is the default setting so you may not have to do anything).

Move the Time Slider to frame 1 and select 'joint1' (the joint in the stick) and rotate the joint in Z by 35 degrees (in the Channel Box, in the **Rotate Z** box type 50). Set a key position by pressing **S** on your keyboard. Move the Time Slider to frame 17 and set the second key position of a rotation of − 35 degrees. Move the Time Slider to frame 33 and set the third key position to a rotation of 35 degrees. Move the Time Slider to frame 49 and set the fourth key position to a rotation of − 35 degrees. Move the Time Slider to frame 65 and set the fifth key position to a rotation of 35 degrees.

Make a Playblast of your animation (**Window > Playblast**) and then take a look at 'stick_3D_ keys.avi', Chapter 4 on the website. We now have a waving stick with a stiff piece of string.

Move the Time Slider to frame 1 and select 'joint3' in the Hypergraph by clicking on it. Rotate 'joint3' so that the string is hanging down. Select all the bones in the string by drawing a box around them in the Hypergraph (they should all turn yellow) and set a key.

Put a sheet of acetate onto your screen and draw the position of the string at frame 1 with your trusty whiteboard pen and then move the Time Slider to frame 3. Select 'joint3' and each of the subsequent joints in the string and rotate them into a shape that resembles drawing 3 of your drawn animation (or have a look at the illustration in this book). When you rotate a joint, make sure you save a key each time.

Move the Time Slider to frame 5 and repeat the process. Continue through your animation, copying every drawing from your drawn animation (or the illustrations in the book) onto the computer. When you are done, have a look at 'stick_string_3D.avi', Chapter 4 on the website.

The Stick and String Exercise in 3D Studio Max

Building the Stick and String in 3D Studio Max

Make the Perspective viewport full screen. Create a cylinder by selecting the **Create** tab in the Command Panel, then selecting 'Cylinder' in the **Object Type** section. In the **Keyboard Entry** section type 8.0 in the **Radius** box and 320 in the **Height** box. Click the **Create** button. Rename the cylinder 'stick'.

Create a second cylinder with a radius of 2.0 and a height of 320. In the **Parameters** section type 16 into the **Height Segments** box. Rename the cylinder 'string'.

Make the Left viewport full screen and click the **Select and Rotate** button. In the **X** numeric box, at the bottom of the screen, type − 90. This should rotate the string to the side by 90 degrees.

Click the **Select and Move** button and in the **Z** numeric box type 160. This should make the string move to the top of the stick, jutting out to one side.

We now need to put a bone through the stick and 16 bones through the string. Make sure the **Snap Toggle** button is selected. In the Command Panel, with the **Create** tab selected, click the **Systems** button and click the **Bones** button. In the left viewport click the mouse pointer at the base of the stick and draw a bone up its length. Then click at the top of the stick. This will create the first bone. Draw 16 bones along the string by clicking at each of the string's segments. When you get to the end of the string, right click to take you out of the Bone Creation mode. This will create one further bone.

Select the stick, go to the main menu and click **Modifiers > Animation Modifiers > Skin**. In the **Modify** area of the Command Panel, click the **Add Bone** button and up will come the **Select Bones** window. Select 'Bone01' and press **Enter** on your keyboard. The bones should now be attached to the stick.

Select the string, go to the main menu and click **Modifiers > Animation Modifiers > Skin**. In the **Modify** area of the Command Panel, click the **Add Bone** button and up will come the **Select Bones** window. Select 'Bone02' to 'Bone18' and press **Enter** on your keyboard. The bones should now be attached to the string.

Animating the Stick and String in 3D Studio Max

Get out your drawn animation so that you can copy it. The first thing we need to do is to set the keys for the waving of the stick.

The scene is 100 frames long so open up the Time Configuration window (click the **Time Configuration** button at the bottom of the screen) and make sure the **Length** box is set to 100 in the **Animation** section.

Make sure you are still in the left viewport and open up Schematic View by clicking the **Open Schematic View** button at the top of the screen. Click the **Animate** button (in 3D Studio Max 5 press the **Auto Key** button) and click the **Motion** tab in the Command Panel.

Move the Time Slider to frame zero and select 'Bone01' (the bone in the stick). In the **Motion** area of the Command Panel go to the **PRS Parameters** section, click the lower **Rotation** button to put us into rotation mode and then click the **Rotation** button in the **Create Key** section. This will create a key at frame zero. In the **Key Info (Basic)** section type − 125 into the **Value** box and press **Enter** on your keyboard. You should now have a stick that is leaning to one side with a stiff piece of string.

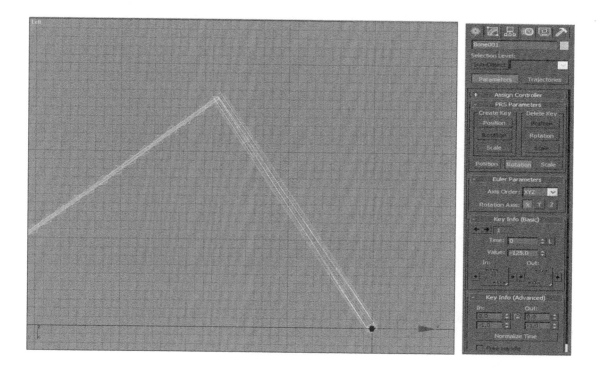

Move the Time Slider to frame 17 and set the second key position by clicking the **Rotation** button in the **Create Key** section, within **PRS Parameters** section on the Command Panel. Then in the **Value** box of the **Key Info (Basic)** section type − 55 and press **Enter** on your keyboard. As you scrub the Time Slider back and forth, the stick should move through an arc from key 1 (frame 0) to key 2 (frame 17). Move the Time Slider to frame 33 and set the third key position to a rotation of − 125 degrees. Move the Time Slider to frame 49 and set the fourth key position to a rotation of − 55 degrees. Move the Time Slider to frame 65 and set the fifth key position to a rotation of 125 degrees.

So that the stick waves from side to side correctly – by accelerating from each of the key positions and then slowing down to the next key position – open up the Track View (click the **Open Track View** button at the top of the screen). Then open the function curve editor by clicking the **Function Curves** button at the top of the **Track View** window. In the explorer section of the **Track View** window, select **Bone01 > Transform > Rotation > Y Rotation**. This will display the Y function curve in the Track View.

Right click each of the key positions on the function curve in turn and give them handles by selecting the handles button below **In** or **Out** in the **Bone01\Y Rotation** window that comes up. To get the handles to work independently of each other, click the **Advanced** button and click the button with a padlock on it. Shape the curves as per the illustration. This will give us a nice pendulum-like movement of the stick.

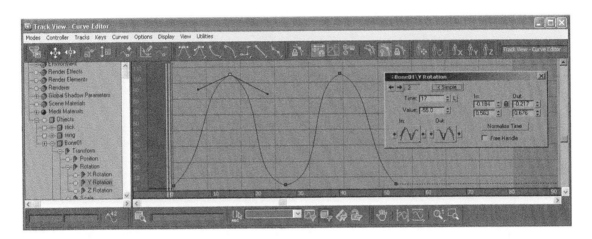

Render a preview of your animation (on the main menu, select **Animation > Make Preview**) and then take a look at 'stick_3D_keys.avi', Chapter 4 on the website. We've now got a waving stick with a stiff piece of string.

Move the Time Slider to frame zero and select 'Bone02' in the Schematic viewport by double clicking it. Rotate 'Bone02' so that the string is hanging straight down, as in frame 1 of your drawn animation (or the illustrations in the 2D section of this chapter).

Put a sheet of acetate onto your screen and draw the position of the string at frame zero on the screen with your trusty whiteboard pen and then move the timeline to frame 3. Select 'Bone02' and each of the subsequent bones in the string and rotate them into a shape that resembles drawing 3 of your drawn animation (or have a look at the illustration in this book). Each time you rotate a bone, make sure you save a key (the default setting on 3D Studio Max is to set a key automatically whenever you move something).

Move the Time Slider to frame 5 and repeat the process. Continue through your animation, copying every drawing from your drawn animation (or illustrations in the book) onto the computer.

When you are done, have a look at 'stick_string_3D.avi', Chapter 4 on the website.

The Dive Exercise in 2D

We will animate a character diving off a cliff, then bouncing off a diving board and finally splashing into the sea. This scene is 70 frames long.

During this scene the diver is distorted on certain frames to emphasise the movement. The diver should never be distorted for more than one frame at a time and should only be distorted at the fastest point of any movement.

First draw your background on a piece of paper. Use the illustration below for reference. On a separate piece of paper draw the diving board. This will animate when the diver hits it, but will be still at the start of the scene. Drawing it on a separate sheet will save you having to draw it on every drawing of the diver.

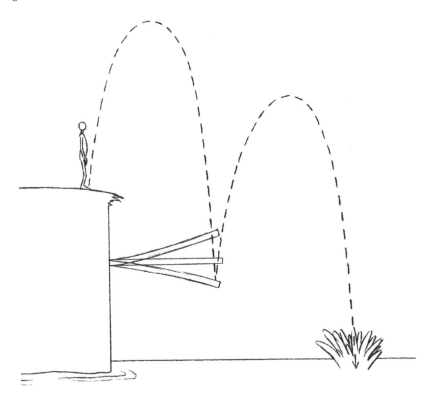

When it comes to putting this information on an X-sheet, the background will be on the lowest layer (call it 'BG1'), the diving board on the middle layer (these will be called drawings 'D1' to 'D9') and the diver on the top layer (call his drawings 'M1' to 'M59').

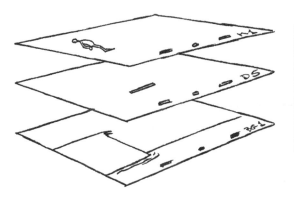

	LEVELS								
FRM NO	6	5	4	3	2	1	B.G.		CAMERA
1					M1	DS	BG1		
2									12 F¢
3					M3				
4									
5					M5				
6									
7					M7				
8									
9					M9				
10									

Draw and number the diving board as in the illustration below. The drawings are numbered by the drawing instead of the frame. Have diving board 'D5' at the start of the scene (the straight diving board).

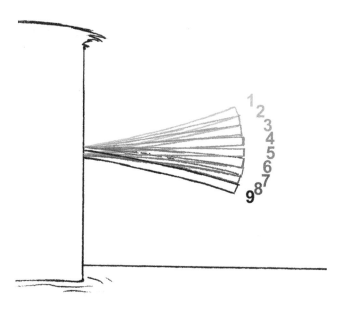

Start by drawing the key frames. In the following illustrations I've included the breakdown positions (the major in-betweens) as well. Do these after you've drawn all the key positions.

Have your diver stand at the top of the cliff and anticipate the jump. He bends down and throws his arms out at the back. These are the first and second key positions, which are at frames 1 and 9 with the breakdown (the major in-between) at frame 3.

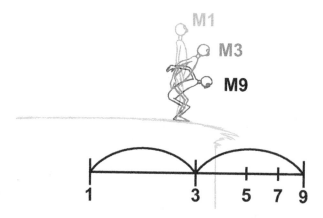

When our diver takes off, distort him as far as you possibly can up to the apex of the jump. At the apex have him regain his original shape. These are the second and third key positions, which are at frames 9 and 13 with the breakdown on frame 11.

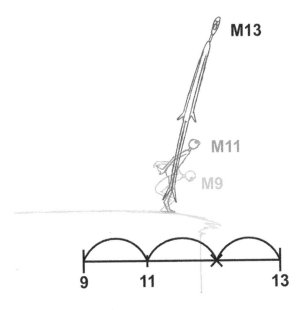

The character will follow an arc through the air similarly to the balls we animated in Chapter 2. These are the third and fourth key positions, at frames 13 and 18, the breakdown being at frame 14.

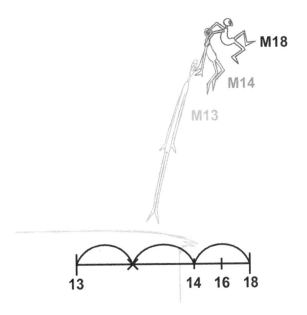

As our diver falls, make him distort again in the direction of the fall before he hits the diving board. These are the fourth and fifth key positions, at frames 18 and 24 with the breakdown at frame 22.

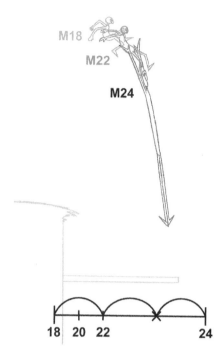

The diving board will bend as it is hit. At this point it will move with the diver. These are the sixth and seventh key positions, at frames 25 and 31. The breakdown position is at frame 27. Diving board D5 goes with man M25, D7 goes with M27, D8 goes with M29 and D9 goes with M31.

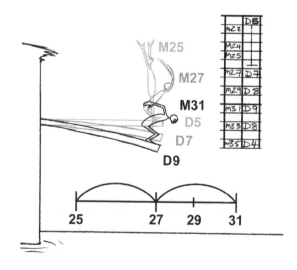

After the diving board bends down, the diver bounces up from the board and is stretched along the second arc of his dive. These are the seventh and eighth key positions and are at frames 31 and 35. The breakdown position is at 33. Diving board D9 goes with man M31, D8 goes with M33 and D4 goes with M35.

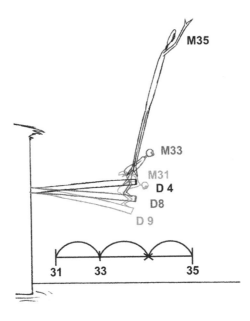

At the apex of this arc, the character slows down and regains his shape. These are the eighth and ninth key positions, at frames 35 and 40, the breakdown position being at frame 36. D4 goes with M35, D1 goes with M36 and D1 goes with M40.

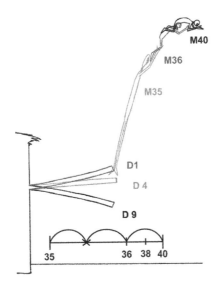

The diver will then fall into the water, distorting at the fastest point. These are the ninth and tenth key positions and are at frames 40 and 46. The breakdown position is at frame 44. D9 goes with M40, D3 goes with M44 and D3 goes with M46.

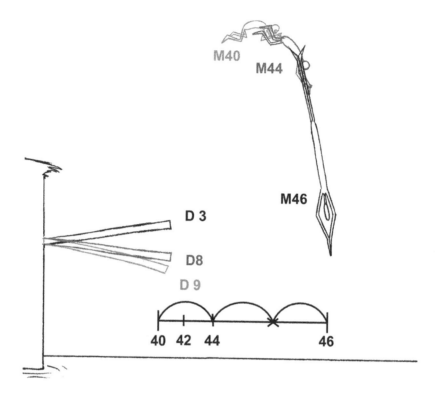

Then there will be a splash as the diver falls into the water.

The diving board will then vibrate to a stop. Draw the following positions and then shoot them in the order shown. This will produce the effect of the diving board vibrating and gradually coming to a stop.

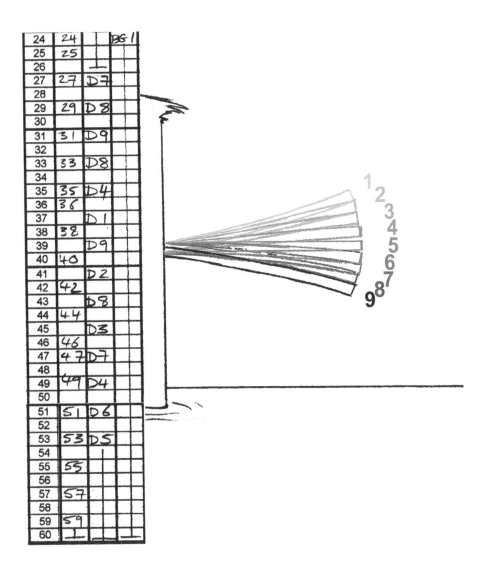

When you've completed all of these key positions, try shooting them with your line tester. I've included the rough timing and the timing charts with this exercise.

Take a look at 'dive_2D_keys.avi', Chapter 4 on the website. You could also take a look at my rough X-sheets, called 'dive_X-sheet_1' and 'dive_X-sheet_2' (available as .pdf and .jpg files), Chapter 4 on the website.

Once the key animation looks OK, in-between the keys, following the timing charts. Do the breakdowns first and then the in-betweens. Make sure that the man's body returns to its proper shape immediately before and after the points at which it's distorted. Take a look at 'dive_2D.avi', Chapter 4 on the website.

When you're happy with your drawn version, have a go in 3D!

The Dive Exercise in 3D

To do the dive exercise in 3D, we need to do the following things:

1. Build a cliff, a diving board and the sea.

2. Place our man at the top of the cliff.

3. Animate him through the key positions.

4. Get the diving board to vibrate.

5. Distort our man at the necessary frames.

It helps to put in some 'nulls' (or any other non-rendering objects) at the apex of each bounce and at the point where the man hits the water. When you are zooming in and out of the scene and animating at the same time, you can refer to these objects as guides.

For the key positions, follow your drawn animation (or the illustrations in the 2D section), but when sorting out the keys don't put in any distortion of the body at frames 18, 24, 35 and 46. Just move the man to a rough approximation of the distorted position.

At the first key position (frame 1), we need to have our man standing at the top of the cliff in a relaxed pose.

At the second key (frame 9), the man bends down into the position that anticipates the jump.

At the third key (frame 13), the man is distorted on the way up to the apex of the first bounce. When just putting in the key positions, we want to move the body to a point half way between the man's anticipation position at frame 9 and the apex of the first bounce, without any distortion.

At the fourth key (frame 18), the man is at the apex of the bounce. Move him into the same position as the fourth drawn key position (drawing 18).

At the fifth key (frame 24), the key position should be distorted but, as for the third key, just move the man to a rough approximation of the correct position.

At the sixth key (frame 25), the man first comes into contact with the diving board. Move the man down to a point where his heels are just touching the board. Select all the bones in the diving board and set a rotation key.

At the seventh key (frame 31), bend the diving board by rotating each of the bones in the hierarchy progressively more so that you get something that looks like the drawn animation. Then move our man down into an anticipation position.

At the eighth key (frame 35), the man should be distorted on his way up to the apex of the second bounce. At the moment, put him in a position that approximates this position undistorted.

The ninth key (frame 40) is the apex of the second bounce so position the man curled up with his arms in a diving position.

The tenth key (frame 46) is where the man distorts as he falls towards the water. Put our man undistorted into this position.

The eleventh key (frame 47) is where the man has hit the water.

Once the key positions are done, it's time to sort out the details – putting in the breakdown positions, distorting the character at frames 18, 24, 35 and 46 and making the diving board vibrate. The programs do this in a slightly different way.

The Dive Exercise in Maya

Open 'mayaman.mb'. We'll be doing most of the animation from the **Front** view panel, so enlarge this (hover the mouse pointer over this view panel and then press the space bar on your keyboard quickly).

Building the Background in Maya

To create the cliff the man stands on, make a polygon cube by clicking the **Polygonal Cube** button (or go to the main menu and select **Create > Polygon Primitives > Cube**). In the **Inputs** section of the Channel Box, make the cube 40 units in width, height and depth. Translate it − 14 in X and − 20 in Y. Give it the name 'cliff'. Your man should now be standing on top of your cliff.

To create the sea for the man to dive into, create another cube and give it a width of 160, a height of 0.1 and depth of 160. Translate it 46 in X and − 40 in Y. Give it the name 'sea'.

To make the diving board, create a cube and give it a width of 28, a height 0.5 and a depth of 8. Set **Subdivisions Width** to 8. Translate it 20 in X and − 15 in Y. Save object as 'diving_board'.

Next we need to put some joints through the diving board so we can get it to bend when the man lands on it and vibrate when he bounces off. Zoom in to the diving board. Click the **Snap to grids** button. Click the **Click to place IK joint** button and make seven bones by clicking at the point where the diving board meets the cliff and then moving along the diving board, clicking at each of the subdivisions. When you are done, press **Enter** on your keyboard.

To bind them together, select the diving board and all the joints within it with the **Shift** key pressed. Then go to the main menu and click **Skin > Bind Skin > Rigid Bind**.

As a guide to the height the man is going to jump up to, put a locator (on the main menu select **Create > Locator**) at the apex of each bounce and at the point where he hits the water. The apex of the first bounce is half way between the man's standing position at frame 1 and the end of the diving board. The bounce is approximately the same height again, into the air, as the height of the cliff (about X = 17 and Y = 40). The apex of the second bounce is half way between the end of the diving board and the point where the man hits the water, and about two thirds the height of the apex of the first bounce (about Z = 50, Y = 30). The point where the man hits the water is approximately the same distance from the diving board that the man is from the diving board in frame 1 (X = 67, Y = −40).

Now we're ready to animate.

Animating the Dive in Maya

Take out your animation drawings (or have a look at illustrations in the 2D section of the exercise) and copy the key positions at the same frames into the computer.

At the first key position we need to have our man standing at the top of the cliff in a relaxed pose. Select the 'BodyHandle' handle with the left mouse button and, with the **Move** button selected, translate the body so that it is in the correct position. Set a translation key (press **S** on your keyboard). Select the arms individually and translate them to positions by the sides of the body. Set a translation key. Select each of the elbow, knee, foot and eye controls and set a translation key. When the man is at a position that you like, select everything in the skeleton hierarchy of the man in the Hypergraph and set a rotation key. Select all the bones in the diving board and set a rotation key.

At the second key (frame 9), the man bends down into the anticipation position of the jump. Middle click 'BodyHandle' to translate the body down and rotate it forwards. Rotate each of the backbones to arch the back. Translate the arms up behind the body. Save translation keys on the foot, elbow, eye, knee and arm controls and finally save a rotation key on the entire skeleton hierarchy.

The third key (frame 13) is the position where the man is distorted on the way up to the apex of the first bounce. At the moment we just want to move the body to a point half way between the man's anticipation position at frame 9 and the apex of the first bounce, without any distortion. Straighten the man's back by middle clicking and selecting and rotating each of the bones and setting rotation keys. Select the 'BodyHandle' handle by clicking it and translating it up to a point half way between the previous key and the locator at the apex of the bounce and set a translation key. Translate the arm, foot, elbow, knee and eye controls to 'catch up' with the position of the body and save translation keys. Select the skeleton hierarchy and save a rotation key on it.

For the rest of the key positions, follow the illustrations in the book. At the seventh key (frame 31), the diving board has to bend when the full weight of the man comes to bear upon it.

Take a look at 'dive_3D_keys.avi', Chapter 4 on the website. It is all too even and there's no distortion yet. Additionally, the board only vibrates once, the feet sink into the cliff at the start, the feet sink into the diving board and there's no splash (we will not be animating the splash).

Adjust the feet sinking into the cliff by flattening out the function curves in X and Y between frames 1 and 9 of the foot controls ('RfootControl' and 'LfootControl') in translation and rotation. To do this, open up the Graph Editor (on the main menu, select **Window > Animation Editors > Graph Editor**) and select a foot control. Back in the Graph Editor in the explorer section, select **Translate X** and its curve will be shown in the Graph Editor. Click the key point on the curve at frame 9 and click the **Linear Tangents** button. This should flatten the curve between frames 1 and 9. Repeat this procedure with the rotation in Z and then with the other foot control.

At each of the breakdown positions (the major in-betweens), move your model to a position similar to the equivalent drawing and set a key. Have a look at the illustrations in the 2D section of the exercise.

To adjust the diving board, bend it (by rotating the bones inside it) so that on each frame where the man's feet are in contact with it the feet are not sinking into the board. After the man has bounced off, vibrate the board by following the illustrations in the 2D section of the exercise.

Once all of the breakdowns are done, take a look at 'dive_3D_breakdowns.avi'. It is much better but we need to distort our man along the arcs at the fastest points of each bounce.

Middle click 'BodyHandle' and select the **Scale** tool in the **Transform** section of the Command Panel. We need to scale the shape of the man to make him distort and set a scale key, but we need to set a scale key without any distortion on the frames before and after.

Take out your drawn animation (or look at the illustrations in the book) and find the key drawing where the man distorts and the drawings before and after it. The first distorted man occurs on frame 13, so take out drawings 11, 13 and 14. Move the Time Slider to frame 11 and, without any scaling, set a scale key. Move the Time Slider to frame 14 and, without any scaling, set a scale key. Finally move the Time Slider to frame 13 and scale 'BodyControl' using the Z (blue) handle. You may have to alter the legs to make him look correct. Repeat this procedure with all the other positions where the man distorts (frames 24, 35 and 46).

Take a look at 'dive_3D.avi', Chapter 4 on the website. Don't worry about animating a splash (this is character animation we're doing, after all).

The Dive Exercise in 3D Studio Max

Open 'maxman09.max' and save the scene as 'dive.max'. For this exercise we will be mainly using the front viewport, so enlarge it.

Building the Background in 3D Studio Max

To make the cliff the man stands on, create a box (on the **Create** tab of the Command Panel, select **Box**) and, in the **Keyboard Entry** section of the Command Panel, make it 400 units in length, 400 units in width and 400 units in height and click **Create**. Click the **Select and Move** button and move the box − 140 in X, 200 in Y and − 200 in Z. Give it the name 'cliff'. Your man should now be standing on top of your 'cliff'.

To make the sea for the man to dive into, create a box and make it 1.0 units in length, 1600 units in width and a 1600 units in height. Move it to X = 450, Y = 800 and Z = 400. Give it the name 'sea'.

To make the diving board, create a box and make it 10.0 units in length 280 units in width and a 80 units in height. Move it to X = 200, Y = 40 and Z = 400. Make its **Width Segs** 7. Give it the name 'diving_board'.

Because the diving board has to bend and vibrate, we need to put some bones in it. Zoom into the side of the diving board in the front view. Make sure the **Snap Toggle** button is on. Go into Create Bones mode (on the **Create** tab of the Command Panel select **Systems > Bones**) and draw seven bones

along the length of the diving board. Right click twice to leave bone creation mode.

To skin the bones with 'diving_board', select 'diving_board' and then **Modifiers > Animation Modifiers > Skin**. In the Command Panel click the **Add Bone** button and in the **Select Bones** window select 'Bone01' through to 'Bone08' then click the **Select** button.

We now need to change the 'weighting' of the bones. Weighting is the amount of influence that an individual bone has on the skin it is attached to. Arrange the diving board in the perspective view. In the **Parameters** section of the Command Panel click the **Edit Envelopes** button. Select a bone in the box below this button and a strange device will appear around the bone. Select the outer squares of this device and move them outwards to enlarge it. As you do, the points on the diving board will change color. The more red they are, the more they are affected by the bone's movement. You will need to do this with all the bones. Extend the device so that it goes to the far end of the board on each bone. Experiment with it until you have a diving board that bends nicely. To leave this mode click the **Edit Envelopes** button again.

As a guide to where in the air the man is going to jump up to, create three 'dummies' (on the **Create** tab in the Command Panel select **Helpers > Dummy**) and put one at the apex of each bounce and one at the point where the man hits the water. The apex of the first bounce is half way between the man's standing position at frame 1 and the end of the diving board. It is approximately the same height again, into the air, as the height of the cliff (about $X = 170$ and $Z = 400$). The apex of the second bounce is half way between the end of the diving board and the point where the man hits the water, and about two thirds the height of the apex of the first bounce (about $X = 500$, $Z = 300$). The point where the man hits the water is approximately the same distance from the diving board that the man is from the diving board in frame 1 ($X = 670$, $Z = -400$).

Animating the Dive in 3D Studio Max

Take out your animation drawings (or have a look the at illustrations in the 2D section of this exercise) and copy the key positions at the same frames into the computer. Make sure you have selected the **Motion** tab in the Command Panel. Make sure the Time Slider is at frame zero and click the **Animate** button (in 3D Studio Max 5, press the **Auto Key** button).

At the first key position (which is at frame zero), we need to have our man standing at the top of the cliff in a relaxed pose. Click the **Select and Move** button and select the 'BodyControl'. Move the body so that it is in the correct position, and create a position key by clicking the **Position** button in the **Create Key** area of the Command Panel. Select the arm controls individually and move them to positions by the sides of the body and create a position key. Select each of the elbow, knee, foot and eye controls and set a position key. When the man is at a position that you like, select everything in

the skeleton hierarchy of the man in Schematic View by double clicking 'BodyControl' twice. Set a rotation key (right click on the Time Slider and in the **Create Key** window check just the **Rotation** tick box and click **OK**). Select all the bones in the diving board and create a rotation key.

At the second key (frame 9), the man bends down into the anticipation position of the jump. Select 'BodyControl' and move the body down and rotate it forwards. Rotate each of the backbones to arch the back. Translate the arms up behind the body. Save position keys on the foot, elbow, eye, knee and arm controls and finally create a rotation key on the entire skeleton hierarchy.

The third key (frame 13) is the position where the man is distorted on the way up to the apex of the first bounce. At the moment we just want to move the body to a point half way between the man's anticipation position at frame 9 and the apex of the first bounce, without any distortion. Straighten the man's back by selecting and rotating each of the bones and creating rotation keys. Select 'BodyControl' by clicking it and moving it up to a point half way between the previous key and the dummy at the apex of the bounce and create a position key. Move the arm, foot, elbow, knee and eye controls to 'catch up' with the position of the body and create position keys. Select the skeleton hierarchy and save a rotation key on it.

For the rest of the key positions, follow the illustrations in the 2D section of the exercise. At the seventh key (frame 31), the diving board has to bend when the full weight of the man comes to bear upon it. Select the bones in the diving board and rotate them to bend the board.

Take a look at 'dive_3D_keys.avi', Chapter 4 on the website. It is all too even and there's no distortion yet. Additionally, the diving board only vibrates once. The feet sink into the cliff at the start, the body drops too far, the feet sink into the diving board and there's no splash (we will not be animating the splash).

Adjust the feet sinking into the cliff by flattening out the function curves in X and Z between frames 0 and 9 of the foot controls ('RfootControl' and 'LfootControl'). To do this, open up the Track View and the function curves, and select a foot control in the explorer section of the Track View. Open up the foot control, select **Position** and the three function curves that relate to the position of the foot control will appear in the Track View. Right click the first key point on the X or Z function curve and up will come the **RfootControl position** window. Specify a liner curve into the key position and a liner curve out by selecting the buttons below **In** and **Out**. At frame 9 (the second key position), specify a liner curve into the key position and a curved curve out.

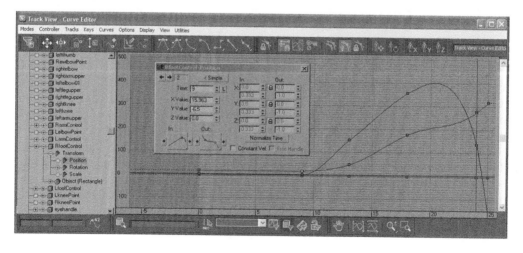

To sort out 'BodyHandle', open it in the explorer of the Track View and select **Position**. Flatten out the curves between frames 0 and 9. Use the Bézier spline buttons below **In** and **Out** in the **BodyHandle\position** window.

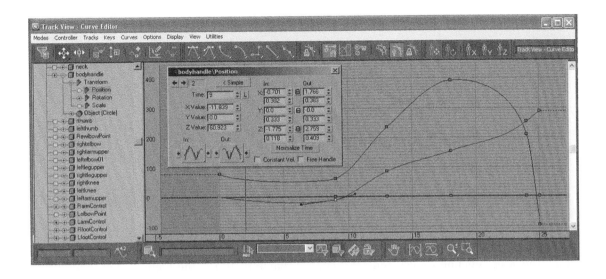

At each of the breakdown positions (the major in-betweens), move your model to a position similar to the equivalent drawing and set a key. Have a look at the illustrations in the book.

When it comes to the diving board, bend it (by rotating the bones inside it) so that on each frame where the man's feet are in contact with it the feet are not sinking into the board (adjust the function curves for the foot controls). After the man has bounced off, vibrate the board by following the illustration of the vibrating diving board in the 2D section of the exercise.

Once all the breakdowns are done, take a look at 'dive_3D_breakdowns.avi'. It is much better but we need to distort our man along the arcs at the fastest points of each bounce.

Click 'BodyHandle' and click **Select and Squash**. We need to scale the shape of the man to make him distort and set a scale key, but we need to set a scale key without any distortion on the frames before and after.

Take out your drawn animation (or look at the illustrations in this book) and find the key drawing where the man distorts and the drawing before and after it. The first distorted man occurs on frame 13, so take out drawings 11, 13 and 14. Move the Time Slider to frame 11 and, without any scaling, create a scale key by clicking the **Scale** button in the **Create Key** section of the Command Panel. Move the Time Slider to frame 14 and, without any scaling, set a scale key. Finally move the Time Slider to frame 13 and scale 'BodyHandle' using the Y handle.

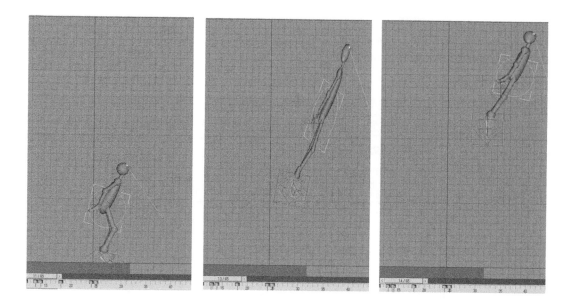

The problem with this is that the man distorts before frame 11 and after frame 14. We need to flatten the scale function curves and set them to a value of 100 at the points, where there is no distortion in the animation. Open up the Track View and open up the function curves. Open the curves that relate to the 'BodyHandle' scale and make the curves between 0 and 11 linear.

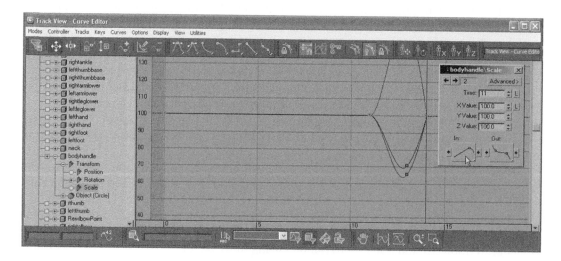

Repeat this process for the other key positions in your animation where the man distorts (frames 24, 35 and 46).

Take a look at 'dive_3D', Chapter 4 on the website. Don't worry about animating a splash (this is character animation we're doing, after all).

CHAPTER FIVE

Animation of Human Walks and Runs

Chapter Summary

- Walk Cycles
- Pace
- Walking Mechanics
- Walk Cycles Displaying Different Moods
- External Influences
- Two People Walking Together
- Running
- Exercises

A human walk can be a difficult sequence to animate believably. This is because your audience are walking experts! They have been walking since they were about a year old and see people walking around them all the time. Consequently, they can judge whether your walk is convincing. If it's not so good, they stop believing in your character.

Walk Cycles

A walk cycle is a piece of animation in which a character walks on the spot (similarly to walking on a treadmill) and the background pans past them. It consists of two strides that are repeated.

The one thing to remember about walk cycles is that they are, by nature, repetitive. When we see someone walking along, we are observing a living, breathing person who is taking in the world around him or her. What we see when watching a walk cycle are the thoughts and actions of the character during those two strides, repeated continually. Consequently, when you animate a walk cycle of somebody in a certain mood, it can seem false, over the top or repetitive.

I've found that walk cycles tend to work better if you make them slightly stylised. I think this is because if you

deliberately make the design more artificial your audience will forgive the artificial movement. The more realistic you make an animated character, the more the audience expects it to move in a realistic way.

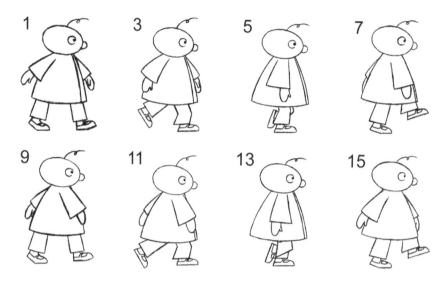

Take a look at 'stylised_walk.avi', Chapter 5 on the website.

Walk cycles tend to be used in television series and computer games. The reason for this is that a walk cycle produces a lot of screen time for a small amount of work (and money). You rarely see walk cycles in feature films. In a feature film an animator will usually animate a character walking from A to B in its entirety. This will produce a walk that is more believable. Only background characters will be doing any form of cycle in a feature film.

Pace

When animating a character walking from A to B, pace must be taken into account. Everybody has a natural pace they are comfortable walking at. Think of the pace of your character's walk as the number of frames it takes for that person to take one stride.

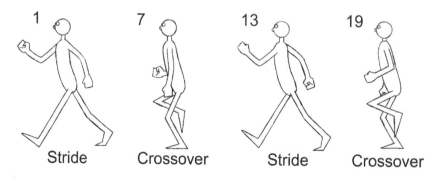

| Stride | Crossover | Stride | Crossover |

A walk cycle will consist of two major key positions. These are referred to as the 'stride' positions, each with a different leg leading. The breakdown (major in-between) positions between these keys are referred to as the 'crossover' positions. This is where the trailing leg is picked up and crosses over to be placed in front of the (previously) leading leg. Most people take a stride about every half a second. So, at 25 frames per second, that's a stride every 10 to 16 frames.

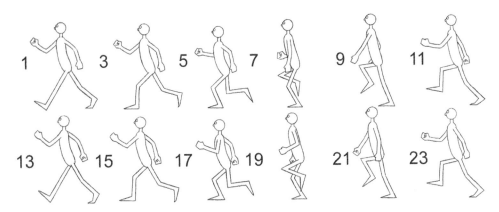

The pace of each stride varies depending on many outside influences. As they are strolling along, someone's walking speed will change. It can be affected by things they see, obstacles they have to negotiate or whether they are on their own or are in company. Frame of mind will also contribute – if they are feeling happy or sad or one of a million other moods.

Remember that all the joints of your character will move in arcs in relation to each other. Take a look at 'basic_walk_2D.avi', Chapter 5 on the website.

When a character slows down or speeds up during a walk the same pace – of around half a second a stride – will be maintained. A character slows down by making the stride shorter and speeds up by making the stride longer. He will still be making each stride roughly every half a second.

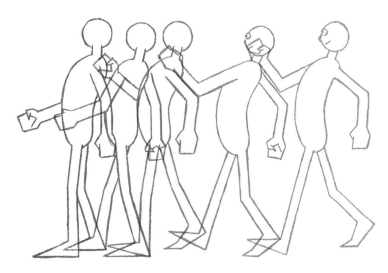

Walking Mechanics

The four basic positions of a walk are the two stride positions and the two crossover positions.

The Stride Positions

The two basic keys of a walk are at the extremes of each stride. To complete a walk cycle you need two strides. The exact arm and leg positions will be dependent on the emotions of your character and the external influences on them. However, one thing that is generally true of these stride keys is that the shoulder of the leading arm will be twisted forwards of the shoulder of the trailing arm, whereas the hip joint of the leading leg will be twisted forwards of the hip joint of the trailing leg. In other words, opposite shoulders and hips lead.

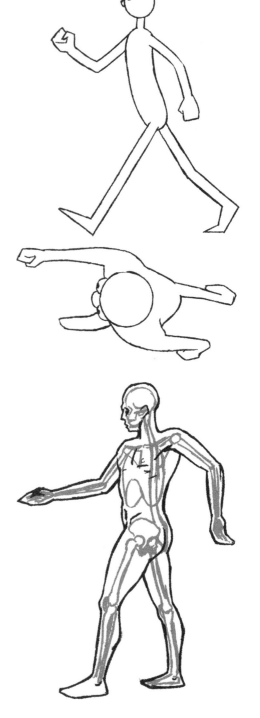

A large amount of the twisting that happens in the body occurs at the base of the spine. This is the most flexible part of the spinal column.

The twisting of the shoulders is dealt with by the movement of the shoulder blades and the collarbone. The shoulder joint of the arm is pushed forwards or backwards in order to balance the top part of the body.

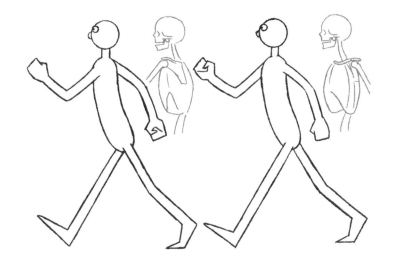

The hips twist in the opposite direction to the shoulders, the leading hip being attached to the leg that is forwards.

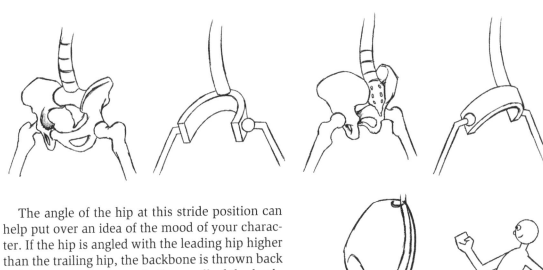

The angle of the hip at this stride position can help put over an idea of the mood of your character. If the hip is angled with the leading hip higher than the trailing hip, the backbone is thrown back and increases the curve in the small of the back. This gives a 'positive' feel to the way your character holds itself. Moods such as happy, determined and laid back will have a hip positioned like this at the stride position.

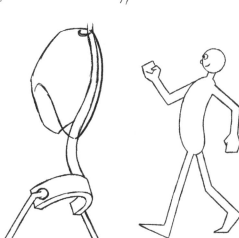

If the angle of the hip has the trailing hip higher and the leading hip lower, the spine curves forwards, giving a 'negative' angle to the body. Depression, misery, goofiness and tiredness are suggested by this hip angle.

Of course, there are lots of other things that will suggest the mood of your character (which we'll go into later), but the angle of the hips and the body gives the basics of emotion in a walk.

The Crossover Positions

The breakdowns to sort out are the crossover positions. These are the drawings where the raised leg crosses over in front of or behind the leg that is still in contact with the ground.

A leg that is picked up high during the crossover looks light. The hip of the raised leg will be higher than the other hip.

These are the key drawings that give the audience a clue to the character and mood of your animation. A leg that drags along the ground when crossing over looks heavy. The hip connected to the raised leg would be lower than the hip of the leg touching the ground.

229

Shoulder Movement

With the stride key drawings, the shoulder opposite the leading leg will be forwards. The other shoulder will be trailing. Because the shoulders can move independently of each other, the leading shoulder can be higher, lower or level with the trailing shoulder.

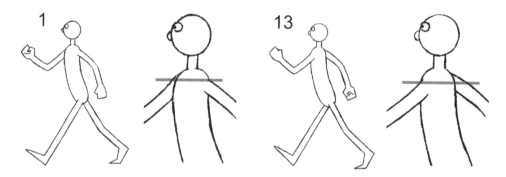

If the leading shoulder is angled higher than the trailing shoulder, the top part of the body looks as if it is pulled back. This gives an up-beat, positive feel.

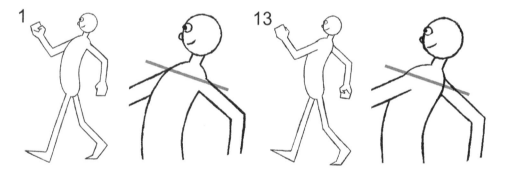

If the leading shoulder is lower than the trailing shoulder, the top of the body has more direction, giving determination to the character. The character is leaning towards what it's walking to.

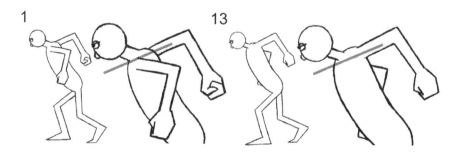

How you draw the crossover key positions for the shoulders will also give a guide to character. If the shoulder of the arm coming forwards moves up (in an arc) and the shoulder of the arm travelling back moves down (also in an arc) – creating a rolling of the shoulders towards the front of the body – the impression is given of someone who is pushy, determined and knows what they want: perhaps something of a gangster's walk. The effort is being put into pushing the arms forwards.

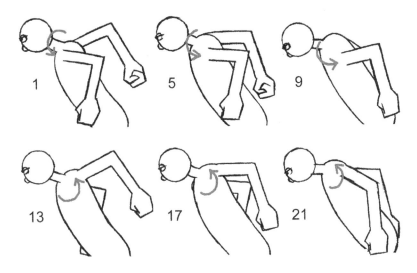

If the shoulder of the arm that is moving forwards dips down (in an arc) and the shoulder of the arm travelling back moves up (in an arc) – creating a rolling of the shoulders towards the back of the body – the impression is given of someone who is happy and positive. The effort is being put into pulling the arms back.

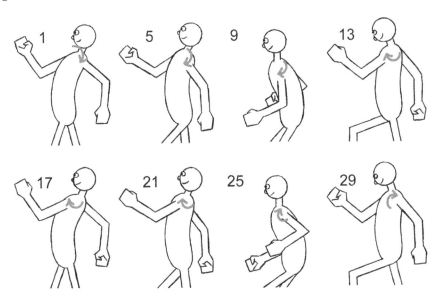

If both shoulders dip down when moving forwards and backwards, the appearance is given of lethargy and depression.

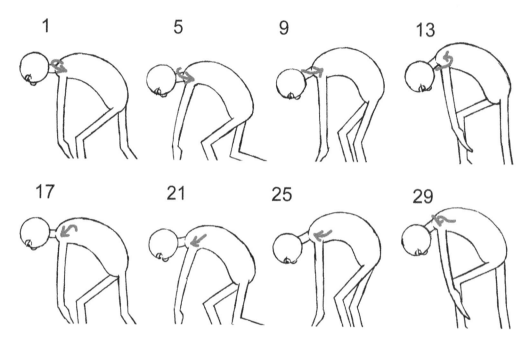

Arm Movement

At their most basic, the arms will swing like pendulums. They will accelerate out of the extreme positions at the strides, moving fastest when they are near to the body. They will then decelerate as they reach the next extreme key position, at the next stride.

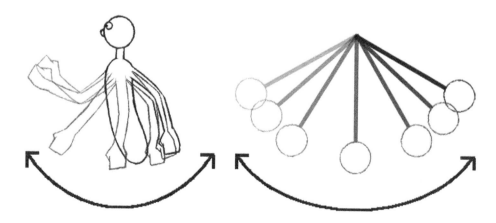

The movement of the arms is affected by which joint in the arm is initiating the movement. If the shoulders initiate the movement, the arms flail out from the shoulders down, following through the movement of the shoulders.

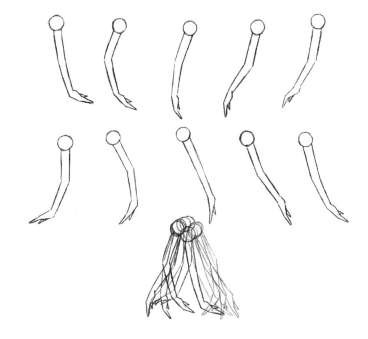

If the elbows initiate the movement, the arms flail out from the elbows down, following through the movement of the elbows.

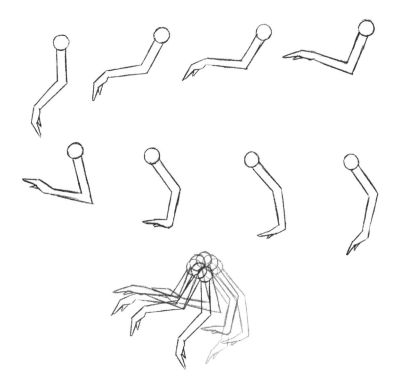

If the wrists initiate the movement, the hands flail out from the wrists down, following through the movement of the wrists.

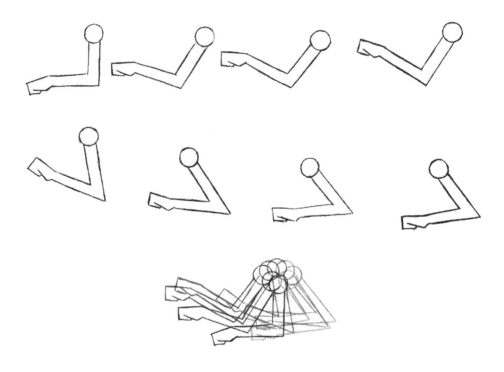

Up-and-Down Movement of the Body

As a person walks, their body bobs up and down. Depending on the mood of your character, this will happen at different places.

During a basic walk, the body will bob down at the point when all the weight goes on to the one foot. It will lift up at the point where the foot is brought over, between the crossover position and the stride position.

Making the highest point of the walk at the crossover will give a resentful, depressed, negative feeling. Animating the crossover at the lowest point of a walk will make the body bounce up and down further and give more positive feel.

Walk Cycles Displaying Different Moods

It has to be emphasised that all the following examples of walks are stereotypes and as such are at the extreme cartoon end of the animation spectrum. The reason why I give these examples is that it is usually better to exaggerate real life, in order for your animation to look more convincing. If you try and make the animation look naturalistic (especially when you are learning to animate),

it will always end up looking stiff and wooden. It's better to think of all your animation as having more in common with theatrical stage acting than with real life. When animating, I've often found that it's better to 'ham up' a scene at first and then go back and tone the animation down if it's too over-the-top (it rarely is).

The mood or character of a person will affect the way they walk. If a person is depressed they will drag their feet and slouch forwards with droopy shoulders. Their inner turmoil will result in them putting as little effort into their forwards progression as possible so they can concentrate on being depressed. Every movement is an effort. A good depressed face and a head hung low will be the main signs to an audience of what is going on in the head of your character. The shoulders follow up and down arcs (the shoulder is at its highest point at each stride). Have a look at 'depressed_walk_2D.avi'.

A not-so-clever person will move in a similar way to a depressed person, but this time the reason why the person finds movement such an effort is that they find walking intellectually difficult! If this dragging of the feet with droopy shoulder movement is topped with an erect head with a stupid grin and half-open eyes (too much effort to open the eyes fully), your character has a goofy look. Have a look at 'not_so_clever_walk_2D.avi'.

An angry person has something they are angry at, focussing their attention/gaze on the object of their anger. They will stamp their feet and clench their fists, holding their body at a stiff angle forwards, maybe fixing their gaze toward the thing they are angry at. Their shoulders roll over the top as they move forwards. Have a look at 'angry_walk_2D.avi'.

A determined person will move in a similar way but with smaller movements and emphasis on the body angle. Everything about this person is pointing toward the goal that they want to achieve. Their head is down like a bull that is about to charge and they keep their leg and arm movements small so that nothing gets in their way.

A happy person will walk with a spring in their step, perhaps putting a double bounce into their stride at the point where all the weight is on one foot. The strides will be light and the arms will swing with a snap (much slower at the extremes). It's as if they are full of energy and are putting the excess into their walk. Their shoulders roll underneath as they move forwards. Have a look at 'happy_walk_2D.avi'.

If somebody wants to be quiet when walking, they could tiptoe. This involves talking little steps on the tips of the toes. See 'tip_toe_2D.avi'.

If someone wants to be really quiet (or is walking over a pond of ice, testing the surface), they could sneak. This involves placing the feet slowly onto the ground to test whether it will make a noise or break. When the character knows the surface is OK, they move forwards and take the next step.

If somebody is cool and laid back, they will adopt a laid back position when they walk. The whole point of this type of walk is to give the impression that as little effort as possible is being put into it. The body is angled back and the legs are bent to help with balance. As the legs are picked up, the body will slowly lower and then rise as the legs are kicked forwards. See 'sneak_2D.avi'.

A dreamy person will float along, giving the impression of being very light. It is as if they are being carried along by their thoughts, the movement being like a leaf falling off a tree. Make them cushion themselves with their extended toe at the start of each stride. See 'dreamy_walk_2D.avi'.

The double bounce walk is a type of walk used by a lot of cartoon characters. It involves having a dip of the body at the point where the front foot comes into contact with the ground and a second dip of the body as the rear foot leaves the ground. See 'cool_walk_2D.avi'.

A walk can emphasise the sexuality of the walker. In a man this will involve a laid back top part of the body combined with a pelvic thrust at the lower part of the body with every stride. See 'macho_walk_2D.avi'.

A female catwalk model's walk involves pushing out the hips sideways at each stride position. The small of the back is very curved and this pushes out the breasts and the bottom. The walk is on tiptoe (or high-heeled shoes). Because of this, during a walk it is difficult to bend the knee while all the weight of the body is moved over the leading leg. This results in the leg locking straight and the hip being pushed out to take the weight. Placement of the feet in a central line in front of each other accentuates this. See 'model_walk_2D.avi'.

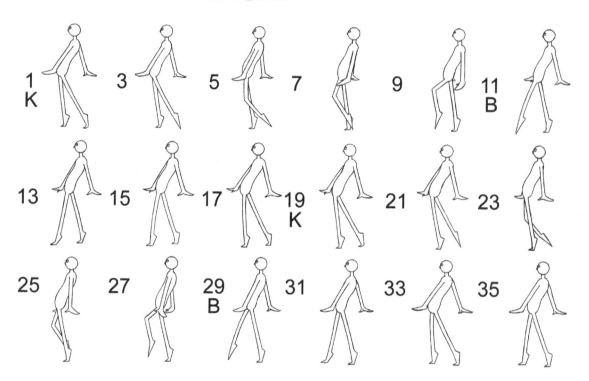

External Influences

When somebody is walking along, not only will they have these internal influences, but they will have to contend with external ones too. Is the person carrying or pulling something? If so, they will be straining to hold, pull or carry the object they are interacting with.

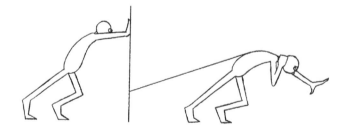

Are they walking up or down something (a ramp, a hill, stairs, etc.)? What's the temperature (somebody who is hot will seem exhausted)? Is the wind blowing (the character will have to push against the wind)? Is the surface they are walking over smooth or rough? Somebody picking their way over a rocky landscape will be watching their feet, making sure they don't trip up).

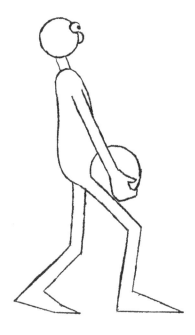

Do they have to step over something (again, they will have to look down in order to see where their feet are stepping) or is their attention taken by something that they are looking at (e.g. a poster or cars, when they are crossing the road)? Are they eating chips or talking on a phone?

Two People Walking Together

When two people interact, they do something called 'mirroring'. If you watch two people sitting in a pub together, they will often sit in a similar position to each other. They will take drags from a cigarette or sips from a drink at roughly the same times, and scratch their heads or fold their arms in approximate unison. The amount of mirroring will vary depending on how well people know each other. Those who are good friends 'mirror' more. Married couples who are used to each other's company (perhaps they are even bored with each other) tend to mirror less, depending on how much they want to emphasise their personality, but will return to mirroring at certain points during their interaction. The same can be said of two people walking together. They will often speed up or slow down their walk (or shorten or lengthen their strides) so

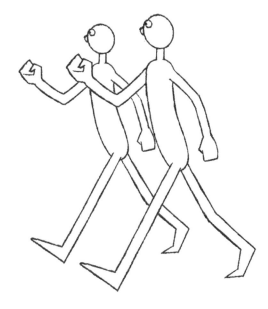

they take steps at roughly the same times, especially if they are talking together. If their attention is taken by something else (a poster, for example) they will revert to their natural walking pace (as they look at the poster), regaining their 'unison' walk when they have each other's attention.

Running

The main point of a human running is to get from A to B as fast as possible. This is achieved not by making the strides quicker (this results in a fast walk) but by making the strides longer. Each stride is basically a jump, with both feet off the ground. Each crossover point is the squash down following the jump, combined with the anticipation for the next jump. The twists in the body will be an exaggerated version of a walk cycle. The line of balance is pushed forwards as if our character is falling forwards – this gives more momentum.

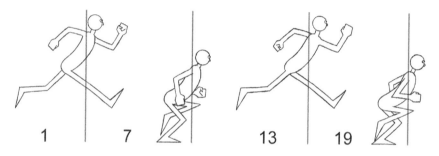

There are four basic key drawings to a run cycle:

1. Near-side leg leading a stride and the far-side leg trailing.

2. Near-side leg impacting the ground and bending as the far-side leg crosses over.

3. Far-side leg leading the stride and the near-side leg trailing.

4. Far-side leg impacting the ground and bending as the near-side leg crosses over, and so on.

When in-betweening these key positions, remember to bring the foot up and over from the stride position to the crossover position. Have a look at 'run_2D.avi' and 'run_3D.avi'.

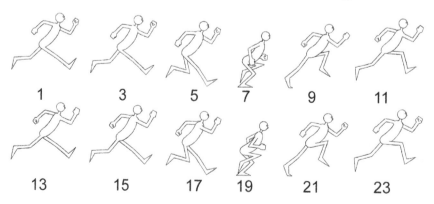

Of course, because the stride is a jump, the squash is much bigger than during a walk cycle. The difficult bit is putting some character into your run.

If your character is running away from something, it's as if the legs are running away with them. The legs could drag the body. See 'run_away_2D.avi'.

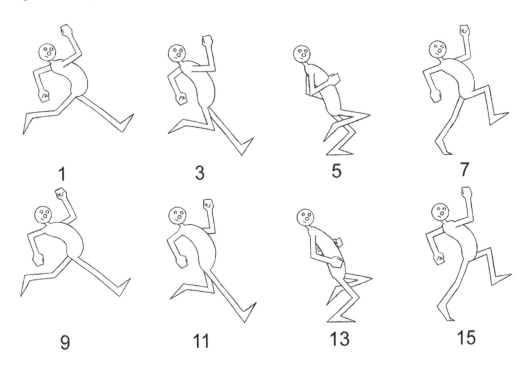

If somebody is running towards something, they will lean towards what they are chasing, be it something that is moving or the finishing line. See 'run_toward_2D.avi'.

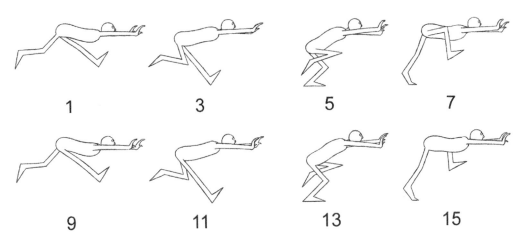

A good way of helping a run cycle to work is to add whiz lines, smear the arms and legs and also, if it's on singles, offset the legs slightly so that they don't 'strobe' (this is when the stride positions look so similar that your audience can't tell the difference between them when the sequence is played). See 'fast_run_2D.avi'.

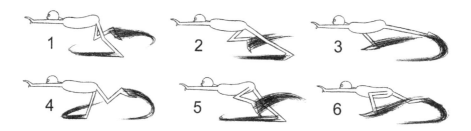

A skip is a kind of run that involves a floating stride position and landing on the rear foot. See 'skip_2D.avi'.

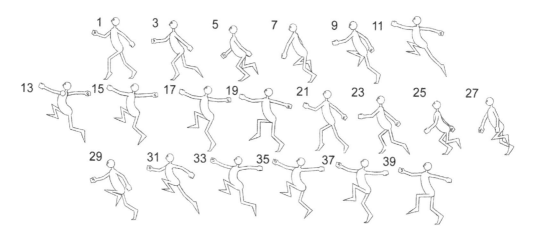

Exercises

The Walk or Run Cycle Exercise in 2D

Take any of the illustrated examples of walk cycles or run cycles and have a go at a character walking or running on the spot. In order to do this, think of your character walking on a treadmill.

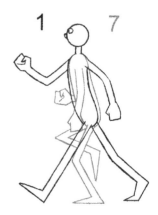

Think of the body staying in the same position on the piece of paper: it can go up and down but not backwards and forwards.

Start with the two stride positions. They are basically mirror images of each other. Make sure that you take into account perspective when you draw each of these. This will prevent the character from strobing.

Take a look at any of the '...walk_2D.avi' files in Chapter 5 on the website. Have a go at animating several of the different walk cycles.

The Walk or Run Cycle Exercise in 3D

Because there is nothing new to learn in either of the 3D computer programs covered in this book, I will only give a very general guide as to how to animate a walk cycle in 3D.

Take out your animation drawings for the walk or run cycle (or refer to the relevant illustrations in this book). We

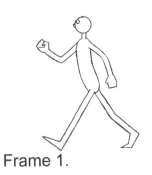

Frame 1.

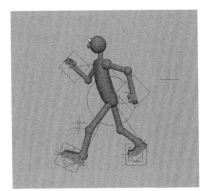

are only going to animate two strides (one complete cycle) and then loop the animation on playback. Our man will be walking on the spot, sliding his feet backwards along the ground and then picking them up to cross them over and bring them forwards.

In order for this to work correctly, we need to set the length of the scene to one frame longer than the drawn walk or run cycle. For example, if we are animating 'basic_walk_2D.avi', which is 24 frames long, we need to set the length of the animation on your chosen computer program to 25 frames.

Load your man model and move him into the first key position at the first frame of your animation. This will be a stride. Set a key for this position. Go to the last frame and, without moving anything, select your model (or the individual sections that you moved at the first frame) and set a key.

Move to the frame of the next stride key position and move your man into the position of this stride, setting keys as you do so. For example, in 'basic_walk_2D.avi', this will be at frame 13.

Playing the animation will give the impression of a man sliding his feet backwards and forwards on the floor.

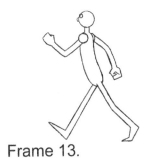

Frame 13.

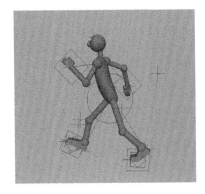

At each of the frames where the crossover breakdown positions occur, move your man into a crossover position and set a key. For example, in 'basic_walk_2D.avi' these will be at frames 7 and 19.

Add extra key positions or manipulate the animation/function curves in order to stop the feet from sinking and sliding in the wrong places.

If you want to add whiz lines, make a sphere, distort it so it looks roughly like the shape of your drawn whiz line and place it behind one of the legs. Change the shape of the distortion for each frame, matching your drawn animation, and render it as semi-transparent. Do the same for the other leg.

When it comes to rendering your animation, don't render the last frame. For example, in 'basic_walk_2D.avi', only render 24 frames. This will prevent a jump at the point where the animation loops.

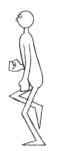
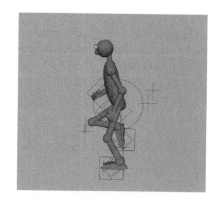

Frame 7.

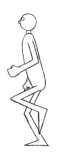

Frame 19.

Changing the Pace and Mood in a Walk Exercise in 2D

The illustration (right) shows the background for the exercise we are going to do.

The idea is to have a character that walks into the scene from screen right, slows down to look at the sign (by taking shorter strides) and then, as a result of reading the sign, walks out screen left displaying a different emotion. Our character will be walking along the floor this time, rather than sliding its legs back, as in the walk cycle exercise.

Below are the key positions for a character walking into the scene happy, slowing to see the sign and walking out unhappy as a result of seeing what is written on the sign.

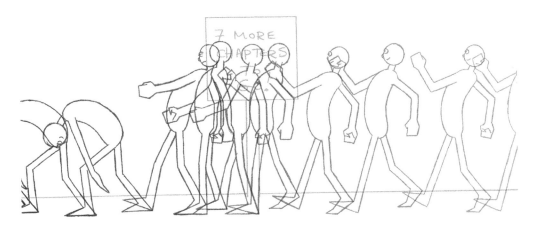

First work out the stride positions all the way through the scene. Once these are done and you are happy with the pace, put in the breakdowns. These are the crossover positions. Take a look at 'walk_by_2D.avi', Chapter 5 on the website.

You don't have to follow this scenario. You may want to have a sad person becoming happy, a miserable person becoming dreamy or a stupid person acquiring some intelligence. Just make sure your audience understands it.

Changing the Pace and Mood in a Walk Exercise in 3D

Start by building a floor for the man to walk on. Make it out of a grid, plane, box or cube. It should be about 100 units wide for Maya or 1000 units wide for 3D Studio Max and 30 units deep for Maya or 300 units deep in 3D Studio Max. Don't make it any taller than 1 unit in Maya or 10 units in 3D Studio Max. Position it so that the majority of its length is in front of our man.

Make a sign for our man to read by creating a post out of a box or cube

and making it 15 units high in Maya or 150 units high in 3D Studio Max, and 1 unit wide and deep or 10 units wide and deep in 3D Studio Max. Position it 30 units in front of our man and 15 units to the side in Maya, or 300 units in front of our man and 150 units to the side in 3D Studio Max. Make the notice board to attach to the post by creating a box or cube 10 units tall and wide and 1 unit deep in Maya, and 100 units tall and wide and 10 units deep in 3D Studio Max, and position it at the top of the post.

Using your animation drawings (or copying illustrations from the 2D section of this chapter), work out the basic stride key positions of the entire sequence. This time the man will be walking along rather than having his feet slide back as they did in the walk cycle exercise.

One thing that can help is to put a block/cube/box at each of the points where the heel of the man touches the ground. This can act as a permanent marker for where the man is going to put his heel at each stride. Each stride during the happy part of the walk is 8 units long so place the blocks 8 units apart. At the point where the man is looking at the sign the strides are about 5 units apart so place the blocks 5 units apart. During the depressed walk part of the scene the strides are about 7 units apart so put the blocks 7 units apart. When your animation is done just delete the blocks!

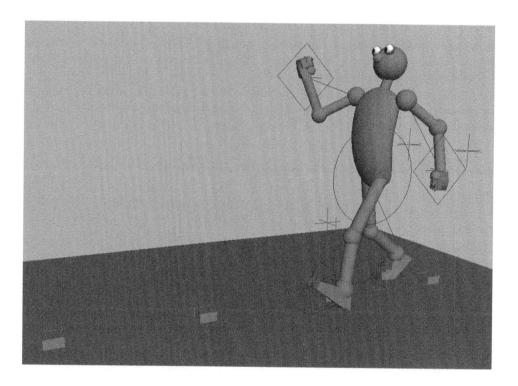

Once the key positions are done, go back and sort out the crossover breakdown positions. To stop the feet slipping and sinking into the ground, make sure that the rotation and translation animation curves that relate to the foot controls are flat at the points where the feet touch the ground.

Tweak your animation as needed and hopefully you will end up with something like 'walk_by_3D.avi', Chapter 5 on the website.

Animation of Animal Walks and Runs

Chapter Summary

- The Four Types of Animal Locomotion
- Construction of an Animal
- Animal Leg and Foot Construction
- Animal Runs
- Exercises

The Four Types of Animal Locomotion

There are four kinds of gait (types of locomotion) adopted by animals. These are walking, trotting, cantering and galloping. Before covering these we have to understand how different types of animal used in animation are put together.

Construction of an Animal

The best way to get an idea of how four-legged animals move is to go out and sketch some. Go to a zoo or a farm or just to the local park and draw animals. Don't worry if your drawings don't seem that good. The whole point of sketching is to make you look at your subject for long periods of time and to assimilate how they are constructed and how they move.

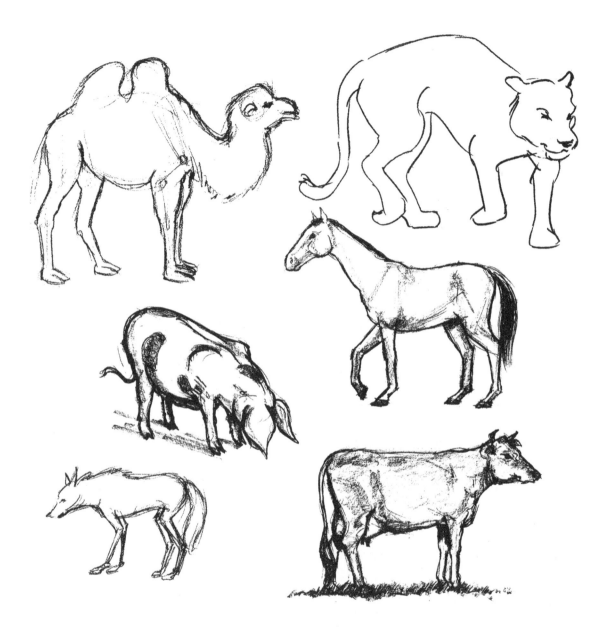

There are three ways to construct a four-legged animal. These are 'pantomime horse', 'cartoon four-legged' and 'correct four-legged'.

Pantomime Horse Construction

Pantomime horse construction involves constructing your four-legged animal like two actors in a horse suit.

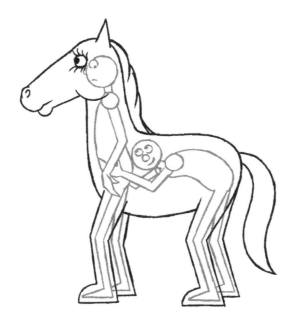

When the two actors walk in unison they will probably do something like the illustration below: both pairs of legs doing a basic human walk.

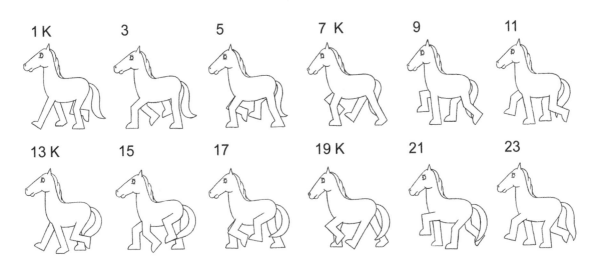

The walk consists of the four major key positions. The first key position is at frame 1: stride at the front, crossover at the back. The second key position is at frame 7: stride at the back, crossover at the front. The third key position is at frame 13: stride at the front, crossover at the back (mirror image of the first key position). The fourth key position is at frame 19: stride at the back, crossover at the front (mirror image of the second key position). This means that there are always at least two legs touching the ground and, in order to maintain a 'tripod' of balance, three legs will remain on the ground for as long as possible.

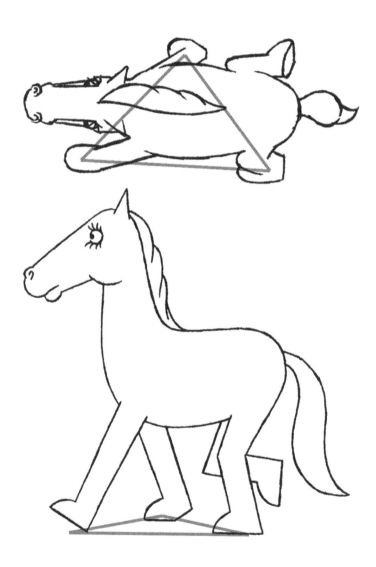

The stride at the back is the same length as the stride at the front and the foot of the leading leg at the rear will step into the footprint of the trailing leg at the front.

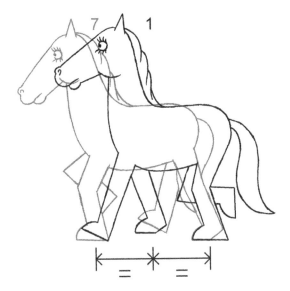

This is a very unrealistic walk for a four-legged character to do. The construction is entirely wrong, but it can be quite effective. It tends to look better when you are animating a toy-like character. Bullseye in *Toy Story 2* walks like this.

I've included a basic animation – 'panto_horse.avi' – in Chapter 6 on the website.

Cartoon Four-Legged Construction

For this type of character think of a man on all fours.

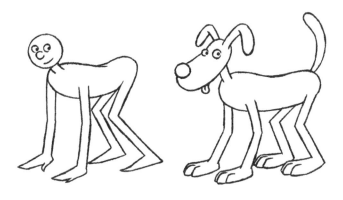

The rear legs of our character are like the legs of a human. The front legs of our character are like the arms of a human. This is much closer to the way that a four-legged character is realistically constructed but is still a simplified cartoon version.

The way to animate a walk with this character is to do something similar to the walk made by our two men in a pantomime horse but to make sure that the legs bend in the correct way. The stride of the back leg will be the same length as that of the front leg. The legs will still maintain the 'tripod' of balance.

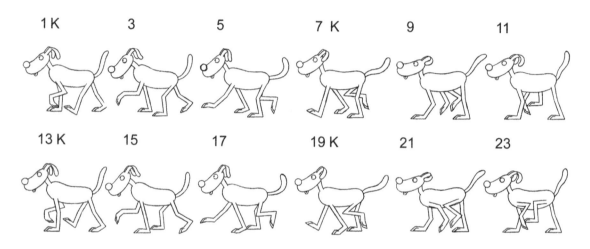

The first key position is at frame 1: stride at the front, crossover at the back. The second key position is at frame 7: stride at the back, crossover at the front. The third key position is at frame 13: stride at the front, crossover at the back (mirror image of the first key position). The fourth key position is at frame 19: stride at the back, crossover at the front (mirror image of the second key position). Also, as the front leg at positions 2 and 4 comes down to touch the ground, the rear leg at the back of the stride will be picked up. Again, this leaves the three legs in contact with the ground for as long as possible.

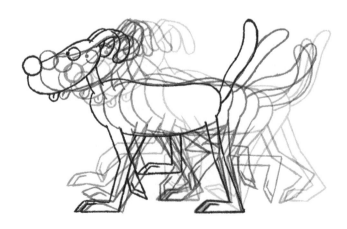

As with the pantomime horse walk, the tripod of balance will be maintained for as long as possible and the foot of the rear leading leg will step into the front trailing leg's footprint.

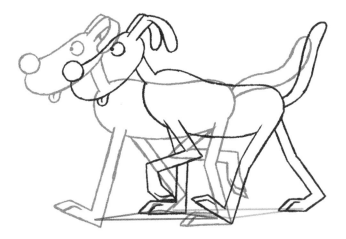

This kind of walk and construction is suited to the types of animal character that jump up and become more human-like and characters that talk and gesticulate with their front legs. Examples include Tom and Jerry and Bugs Bunny.

I've included a basic animation – 'cartoon_dog_2D.avi' – in Chapter 6 on the website.

Correct Four-Legged Construction

This is a four-legged animal that is constructed like a real quadruped. Still think of your animal as a human on all fours, but, rather than standing with the feet and the hands flat on the ground, the feet are articulated differently depending on the animal. The rib cage on the animal is elongated downwards whereas a human rib cage is flat. The shoulder blades on an animal are on the sides of the rib cage whereas on a human they are on the back.

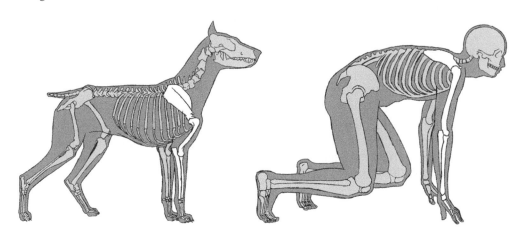

Unlike humans, these animals do not have a collarbone. This allows the shoulder blade to rotate and move up and down more freely. It is as though the shoulder blade of a four-legged animal has a sliding pivot point that can move up and down the side of their rib cage. When all the weight is on one of the front legs, the body will drop in relation to the shoulder, making the top of the shoulder blade stick out at the top of the body.

Animal Leg and Foot Construction

The construction of the legs and feet of a four-legged character influence the way in which they walk.

Animals with Paws

This category includes cats (big cats as well as domestic cats), dogs (all breeds as well as wolves and wild dogs), rodents (although they vary enormously) and some marsupials.

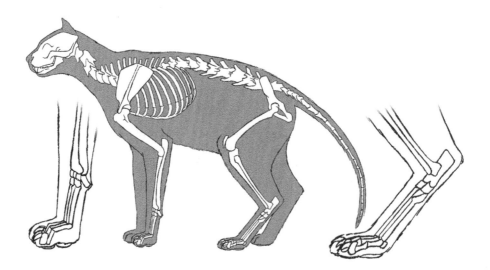

Notice how the length of all four feet has been elongated and how the animal balances on the last two digits of the toes. The animal also walks on pads, giving it lightness as it walks on the ground. The legs remain fairly straight. Bend the legs when you want to suggest an animal is crouching in order to jump or is sneaking along.

The rear leg is similar to the leg of a human, but again the feet and toes are elongated. The rear leg will always have a shape like a straightened 'S' – a 'dog leg' shape!

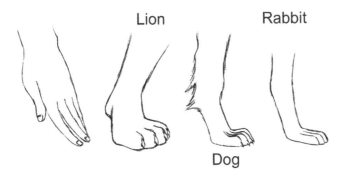

Whatever position the leg is in, the foot and the thigh will stay in parallel with each other (with the exception of frames 9 and 21, where the foot drags).

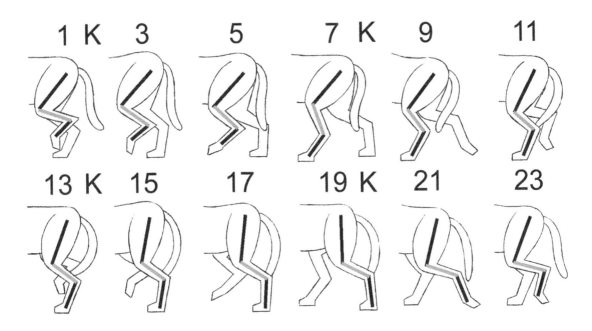

When animating a basic, 'naturalistic' animal walk, it's a good idea to think of the same sort of 'tripod' walk that we saw with our pantomime horse and our human on all fours.

A Dog Walk

A dog has a very solid, eager walk that displays a lot of weight. Have a look at 'dog_walk.avi', in movies006, Chapter 6 on the website.

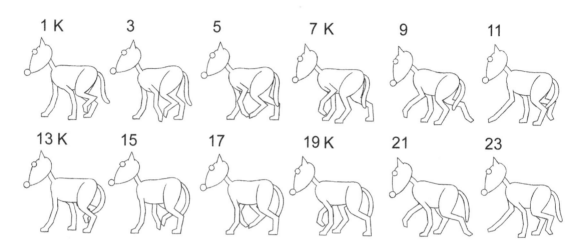

The backbone of the dog will be level at the stride and crossover key positions (frames 1, 7, 13 and 19 of the above illustration). Between frames 1 and 7, as the dog moves forwards, the front part of the body dips down as the weight goes onto the forwards leg of the stride. The back part of the body rises to accommodate the rear leg being brought up and over, out of the crossover position. From frames 7 to 13, the rear part of the body dips down as the weight goes onto the leading leg of the stride and the front part of the body rises to accommodate the front leg being brought up and over. Between frames 13 and 19 the back does the same thing as between frames 1 and 7, and between frames 19 and 1 the back does the same thing as between frames 7 and 13. The illustration below shows the first half of the cycle, which will be repeated by the back in the remainder of the cycle: 13 is the same as 1, 15 is the same as 3, 17 is the same as 5 etc.

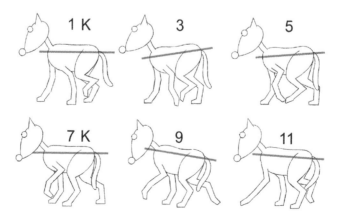

The other thing to take into consideration (especially if animating a rear or three-quarter view) is the twisting of the hips and the shoulders as the animal moves forwards. The illustration below shows the first half of the cycle. In the remaining part of the cycle the hips do the same thing, but as a mirror image: 13 is the mirror image of 1, 15 is the mirror image of 3, 17 is the mirror image of 5 etc.

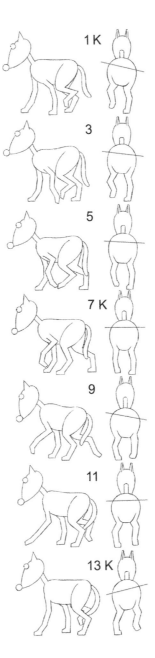

At the stride position, the hips are level. As the animal moves forwards, more weight is placed on the leading leg. Less weight is placed on the trailing leg and that side of the hip drops as a result. As the trailing leg is picked up and goes into the crossover position, the hip is raised to stop the leg dragging on the ground. Finally this leg reaches the next stride position and the hips are level.

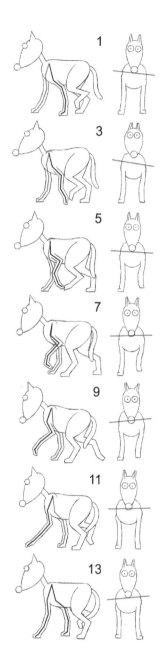

At the front, most of the twisting is made by the movement of the shoulder blades, with only a small amount of rotation through the rib cage.

Generally at the stride position the shoulders and rib cage are slightly angled, the shoulder of the leading leg being slightly higher than the shoulder of the trailing leg. The leading leg's shoulder blade is facing forwards and the trailing leg's shoulder blade is facing back. The illustration below shows the first half of the cycle. In the remaining part of the cycle the shoulders do the same thing, but as a mirror image: 13 is the mirror image of 1, 15 is the mirror image of 3, 17 is the mirror image of 5 etc.

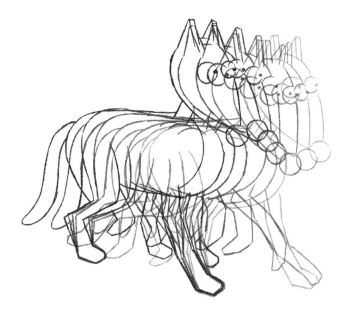

As the dog moves forwards, the rib cage twists away and downwards from the leading leg and the shoulder blade of the trailing leg drops. The shoulder blade of the leading leg (the leg in contact with the ground) sticks up through the top of the body as it takes all the weight. The illustration below shows the first half of the cycle.

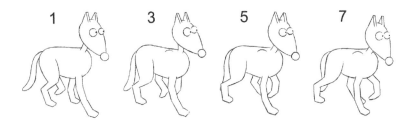

As the trailing leg moves to the crossover position, its shoulder blade is higher than the shoulder blade of the leg in contact with the ground.

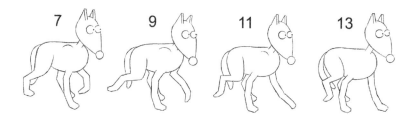

Finally we get back to the next stride position. The remaining drawings in the cycle will do the same thing but on the opposite sides. The two previous illustrations show the first half of the cycle. The remainder of the cycle will do the same thing but as a mirror image: 13 is the mirror image of 1, 15 is the mirror image of 3, 17 is the mirror image of 5 etc.

From the top, the spine will twist from side to side in order to accommodate the stride positions.

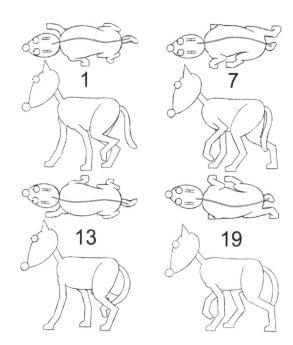

Take a look at 'dog_walk_2D' and 'dog_walk_3D.avi', in the animations006 folder in Chapter 6 on the website.

A Cat Walk

Where dogs are quite solid and resilient in the way they move, cats are rather floppy and nonchalant. Have a look at 'catwalk.avi' in movies006, Chapter 6 on the website.

In comparison to dogs, cats tend to have longer back legs but the strides their front and back legs take will be of the same length. Cats are more likely to hold their bodies lower to the ground and tend to pick up their legs slightly slower than a dog does. A cat's hips will move in a similar way to the hips of a dog. The noticeable difference in movement is at the shoulders.

To give a cat that 'can't-be-bothered' feel to their walk, the rib cage should always be suspended lower between the shoulder blades than a dog's rib cage is. This makes the shoulder blade of the leg in contact with the ground stick up through the top of the body. The leg that is picked up to cross over will drop, leaving the shoulder blade lower than the outline of the body. The rib cage drops and twists slightly. The illustration below shows half of the cycle. Frame 17 is a mirror image of 1, 19 is a mirror image of 3, 21 is a mirror image of 5, etc.

At the crossover position, the rib cage remains dropped (although slightly raised, compared with the stride position) and the shoulder blade of the leg in contact with the ground remains visible through the top of the body.

The raised leg then moves to the next stride position. The twisting of the spine (from the top view) will be similar to that of a dog.

Take a look at 'cat_walk_2D.avi' and 'cat_walk_3D.avi' in the animations006 folder in Chapter 6 on the website.

Animals with Cloven Feet

Animals such as cows, sheep, pigs, goats and deer walk on the equivalent of two fingers.

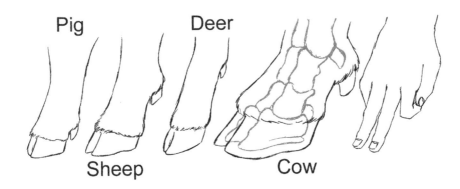

These extended digits are referred to as fetlocks. The lengthening of these digits allows for a longer leg and thus a longer stride, thereby enabling these animals to walk and run faster.

Take a look at 'cow_walk_2D.avi' in the animations006 folder of Chapter 6 on the website.

Animals with Hooves

In hoofed animals such as horses, ponies, donkeys, zebras and giraffes, the fetlock consists of a single elongated digit. If you imagine an extended finger, the bone at the end of the finger is the equivalent to the hoof. Take a look at the live-action 'horsewalk.avi' in movies006 in Chapter 6 on the website.

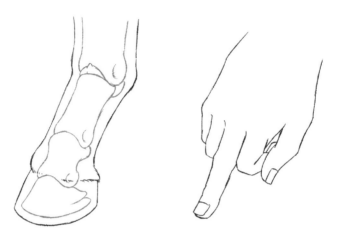

This elongation of the fetlock and the leg as a whole make these animals especially good at running.

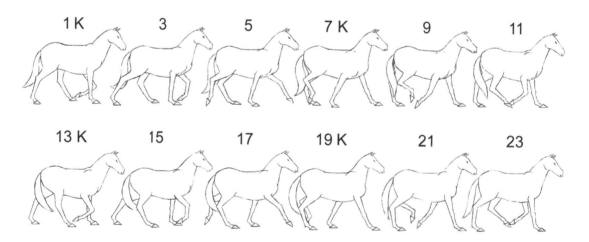

The rules for the four-legged walks discussed above also apply to a hoofed walk. There will be a crossover at the back and a stride at the front and a tripod of balance will be maintained for as long as possible. There will always be at least two legs on the ground. I've included 'horse_walk-2D.avi' in animations006, Chapter 6 on the website.

The movement of the hips and the shoulders is similar to the earlier four-legged walks, but with an animal with hooves these movements tend to be more pronounced because the legs are longer. The head will counteract what the body is doing. The head will be down on the crossover position of the front legs and up on the stride. This head movement tends to be more pronounced in a hoofed walk because the legs are much longer than in the other animal walks.

Flat Feet

Animals such as elephants and rhinos walk on the equivalent of the bones at the very end of human fingers. Imagine the thumb facing backwards and three fingers facing forwards. These digits are very thick and heavy in order to take the large weight of the animal they are supporting. The remaining digits are very short.

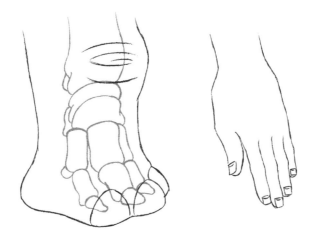

There is virtually no movement of these digits because they are firmly wrapped in flesh, which further helps in supporting the great weight of the animal they belong to. The solidity of the foot gives the appearance of it having one less joint than most animals.

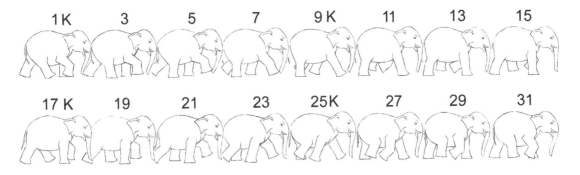

Take a look at 'elephant_walk_2D.avi' in animations006, Chapter 6 on the website.

Animal Runs

Now that we've covered walking, we need to look at the remaining three gaits: trotting, cantering and galloping. I've illustrated each of these gaits with a horse, but something very similar happens with most other four-legged animals.

In order to speed up, an animal, like a human, must lengthen its stride. To do this it needs to change its gait. That is, it must change the way in which it makes the strides.

Trotting

Have a look at 'horsetrot.avi' in the movies folder of Chapter 6 on the website. To move faster than a walk, the legs move as diagonal pairs, as during a trot. This means that the animal is doing a stride at the back and a stride at the front at the same time and a crossover at the back and a crossover at the front at the same time. Add to this a little jump in the air during the stride position and your horse's stride is lengthened.

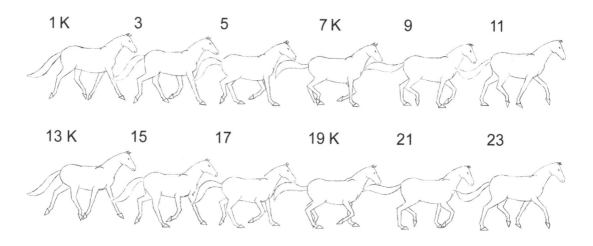

When the horse lands after the little jump, the fetlock absorbs most of the weight, by bending. With each of the strides and crossovers, the back moves up and down in a parallel movement.

When moving your horse from a walk to a trot, pick up one of the legs (it doesn't matter which leg) slightly earlier as it travels from a stride into the crossover. Move it through the crossover position slightly faster than a walk so that it catches up with the crossover at the other end of the animal. Then have it come down to the next stride at the same time as the stride at the other end of the animal. Take a look at 'horse_trot_2D.avi' in animations006, Chapter 6 on the website.

A dog trot will be very similar to that of a horse.

Take a look at 'dog_trot_2D.avi' in animations006, Chapter 6 on the website.

Cantering

Have a look at 'horsecanter.avi', in the movies folder of Chapter 6 on the website. Two legs work in unison as a diagonal pair. The other two legs work independently. The fetlocks now compress more because of the greater force placed upon them as a result of the longer stride achieved.

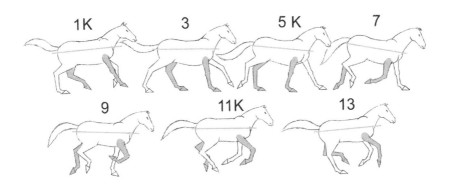

The back is level when the diagonal pair of legs is in contact with the ground. As the two rear legs and the front leg of the diagonal pair lift off the ground, the horse's pelvic region is raised and the spine is tipped forwards. When the front leg leaves the ground and we have all four legs in the air, the backbone becomes level. As the first rear leg touches down on the ground, the horse's pelvic region drops and the spine is tipped forwards. As the diagonal pair of legs touches down onto the ground, the spine becomes level. This gives the back a rocking motion. Take a look at 'horse_canter_2D.avi' in animations006, Chapter 6 on the website.

A dog canter will be very similar to that of a horse.

Take a look at 'dog_canter_2D.avi' in animations006, Chapter 6 on the website.

Galloping

Have a look at 'horsegallop.avi' in the movies folder of Chapter 6 on the website. All four legs touch the ground at different times, but essentially the front two legs work in unison with each other and the rear two legs work in unison with each other. The legs are slightly offset from each other.

The spine extends and stretches as much as possible at the point where the rear legs are in a stride position and the front legs are just about to touch down on the ground. At this point the front part of the body is at its highest. As the front legs leave the ground (when the rear legs are in the air and trying to come as far forwards as possible), the spine arches and curves over. At this point the horse's pelvic region is at its highest. Take a look at 'horse_gallop_2D.avi' in animations006, Chapter 6 on the website.

A dog gallop will be very similar to that of a horse.

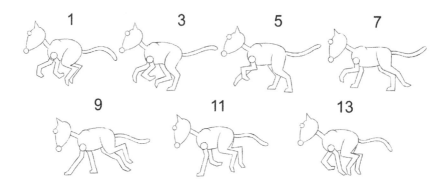

Take a look at 'dog_gallop_2D.avi' in animations006, Chapter 6 on the website.

Transverse or Rotary Gallops and Canters

During a canter or a gallop, depending on whether front and rear legs on the same side lead or the front and rear legs on the opposite sides lead, the gallop or canter can be referred to as 'transverse' (same-side) or 'rotary' (opposite).

According to the experts, dogs and deer tend to do the rotary kind of canters and gallops while most other animals do the transverse form. However, having watched a few animals galloping and cantering in my time I can swear that I have seen horses and dogs doing both transverse and rotary gallops. The same can be said of most animals.

That being said, the whole visual experience of watching an animal gallop is so complicated that only an expert is going to question whether you have done the correct sort of gallop or canter for an individual animal.

Exercises
The Dog Walk Cycle in 2D

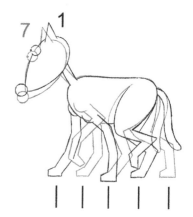

Take a look at the illustration of the dog walk cycle above and have a go at animating the dog walking or running on the spot.

First sort out the first two stride and crossover positions (for the dog walk these are 1 and 7). It can help to mark on paper the positions where the feet will touch the ground. The stride at the back legs should be the same as the stride at the front legs.

At the front of the dog, from frames 1 to 7, the foot in contact with the ground will slide back to a point that is half way between the front legs at frame 1. At the back of the dog, the leg that is in the air will be put down onto the ground and the leg in contact with the ground will slide back into a stride.

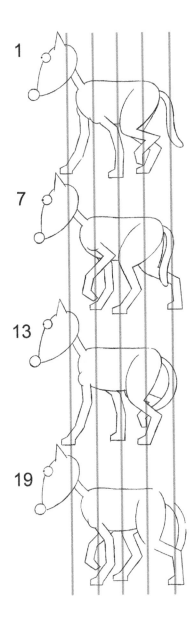

The next two key positions to sort out are on frames 13 and 19. The drawing at frame 13 is a mirror image of the drawing at frame 1 and is placed in the same position. The drawing at frame 19 is a mirror image of the drawing at frame 7 and is placed in the same position.

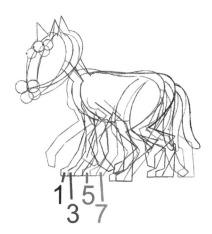

Next sort out the in-betweens. These should have the feet sliding back at a constant rate against the ground. Take a look at 'dog_walk_2D.avi', in Chapter 6 on the website.

If you were animating your dog walking across the screen, the key positions would be as shown below.

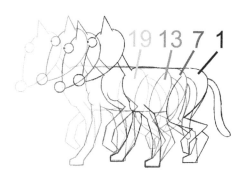

Finally, have a go at animating a dog walking into the screen, seeing something, coming to a stop, and galloping out of the screen as a result of what it's seen.

The Dog Walk Cycle in 3D

Open up your chosen 3D software and load up either 'maya_dog' or 'max_dog' from the 'dog_models' folder in Chapter 6 on the website. With the Maya dog I've converted the bones to rings in 'maya_dog_rings.mb' and in the Max dog I've given the bones fins in 'max_dog_fins.max'.

The 3D dog is constructed in a similar way to the 3D man. There is a circle running through the hips of the dog called 'BodyControl'. This is used to pick up the whole dog or to rotate the hips.

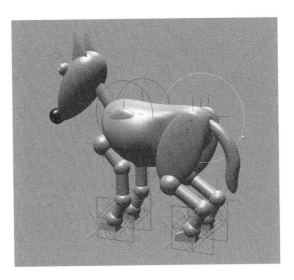

There are a square ('FootControl') and two diamonds running through each foot that control the lifting and rotation of the foot and the rotation of the heel and toe. These are the same as the controls used for the man but there are four of them.

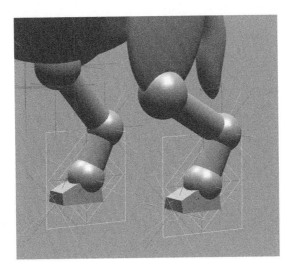

There are two circles running through the shoulders. These control the rotation of the shoulder blades and are called 'LShoulderControl' (left shoulder control) and 'RShoulderControl' (right shoulder control).

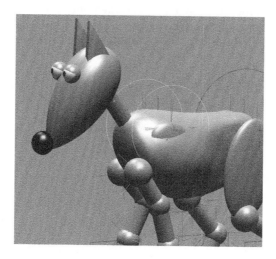

Between the shoulder bone and the backbone there is a rib ('LribBone' or 'RribBone'). This controls the up and down movement of the shoulder bone in order to replicate the sliding pivot effect that you get with shoulder movement.

There are controls at the knees and elbows ('LKneeControl', 'RKneeControl', 'LElbowControl' and 'RElbowControl'). These control the angles of the legs.

You could have a go at building your own dog. The following sections show you how.

The 3D Dog Walk or Run Cycle

Take out your drawings for the 2D dog walk cycle (or have a look at the illustrations in the 2D section of this chapter) for reference.

To help with this exercise, create some small blocks and position them alongside the dog at intervals of 2 units for Maya or 20 units for 3D Studio Max. These will act as markers to guide where the feet will go.

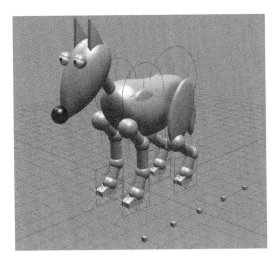

Make the scene one frame longer than the drawn walk or run cycle and make the last key position at the last frame identical to the first key position at the first frame (just like in the man walk or run cycle exercise). The dog walk is 24 frames long so the animation needs to be set to 25 frames. The first frame (frame 1) and the last frame (frame 25) are the same and have a stride at the front and a crossover at the back.

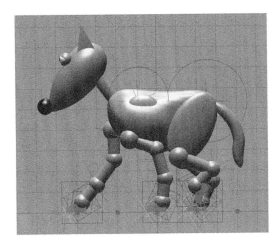

Move the feet forwards, backwards, up or down by using the foot controls and rotate the toe controls, hand controls and heel controls. Remember to set keys on all the key positions.

Next sort out the 'mirror image' key frame at frame 13. There is still a stride at the front and a crossover at the back but the legs are swapped. You can always make a note of the numerical position and rotation of one leg at frame 1 and then paste these numbers onto the opposite leg at frame 13.

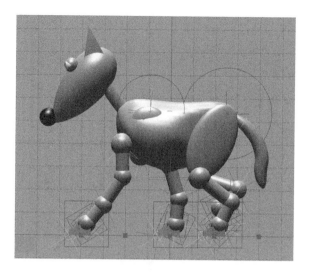

Once these are done, do the other two key positions. These are at frames 7 and 19. They have a crossover at the front and a stride at the back and are the mirror images of each other.

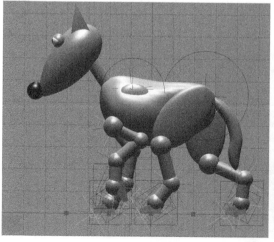 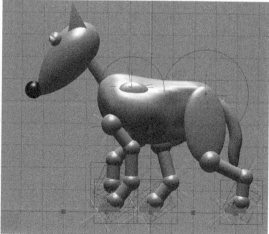

Frame 7 (6) Frame 19 (18)

The computer will in-between the legs reasonably successfully but the back is left ramrod straight. To alter this, do the breakdowns (the major in-betweens). Go to frame 3, select 'Body-Control' and lift the body up. Save a key. Then rotate 'BodyControl' to position the front part of the body lower than the back. If you play back your animation you will have a dog that dips at the front as it puts all its weight at the front onto the leading leg. At the back it raises its bottom. Then go to frame 15. At this frame the body will be positioned exactly the same as in frame 3. So, select, move and rotate 'BodyHandle' so that the body is in the same position at frame 15 as at frame 3.

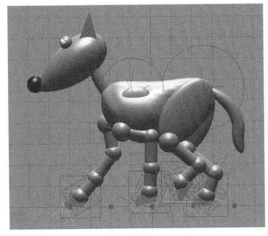

Frame 3 (2)

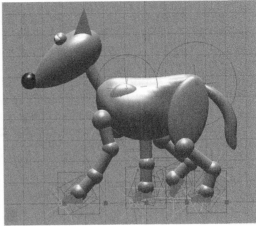

Frame 15 (14)

Next sort out frames 9 and 21, in which the front part of the body is higher than the back. Lower and rotate 'BodyControl' upwards to increase the height at the back.

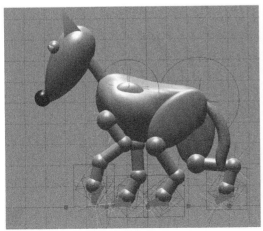

Frame 9 (8)

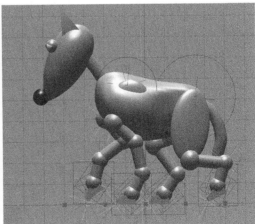

Frame 21 (20)

Once these breakdowns are completed, your dog will be walking, although the movement will probably be jerky. Select 'BodyControl' and go through the piece of animation frame by frame. Draw the position of each key and breakdown on an acetate sheet stuck onto your screen. Make sure that the body moves smoothly between each of these keys by either opening up the rotation animation curves for 'BodyControl' and adjusting them or by moving 'BodyControl' and setting a key on this movement.

If the feet sink into the ground, adjust them by opening up the translation (move) animation curves for the foot controls. Between the key positions, where the feet are touching the ground make the curves straight. Either move the curves with the Bézier spline handles or make the curves linear. You'll probably also need to move the knee and elbow controls outwards to stop the knees and elbows sinking into the dog's body.

When you render a movie of this animation, only render frames 1 to 24 and loop the playback. If you include frame 25, the walk will pause because frames 1 and 25 are the same. The animation will accelerate out of key 1 and slow into frame 24, again causing a pause in the walk. To adjust this, select any of the major components of the dog that are animated and open up the animation curves. Make sure that the curves going out of frame 1 and into frame 25 match each other. Remember that the movement at frame 25 continues on to the movement at frame 1 in a cycle.

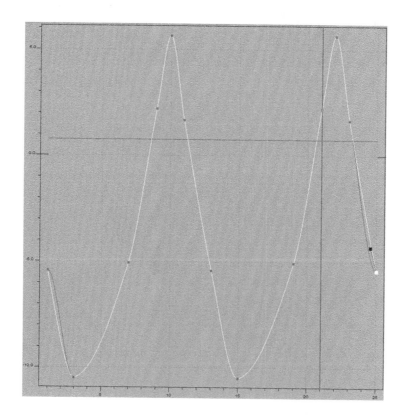

Adjust the tail by setting keys at frames 1 and 25, where the tail has swung out, and then at frame 13, where the tail has swung in between the leg. Go through the animation two frames at a time. Rotate the bones inside the tail to move them into the correct position, according to your drawn animation (or refer to the relevant illustration in this chapter).

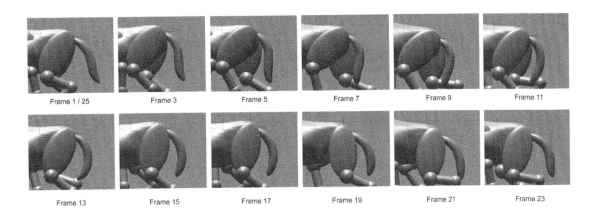

Frame 1 / 25 Frame 3 Frame 5 Frame 7 Frame 9 Frame 11

Frame 13 Frame 15 Frame 17 Frame 19 Frame 21 Frame 23

Adjust the head by placing it at its lowest point just after the front legs cross over and at its highest point just after the stride. Drag the head into higher or lower positions after each crossover and stride to stop it looking too repetitive.

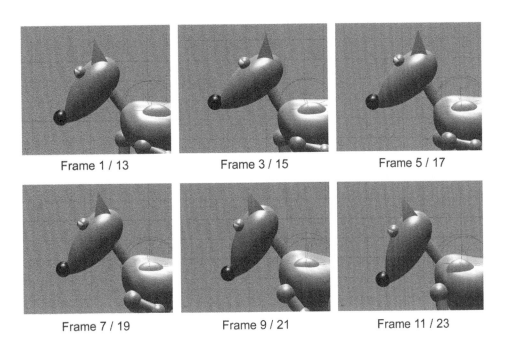

Frame 1 / 13 Frame 3 / 15 Frame 5 / 17

Frame 7 / 19 Frame 9 / 21 Frame 11 / 23

Take a look at 'dog_walk_3D.avi', animations006, Chapter 6 on the website. Have a go at animating a trot, canter and gallop as well and then take a look at 'dog_trot_3D.avi', 'dog_canter_3D. avi' and 'dog_gallop_3D.avi', animations006, Chapter 6 on the website.

If you're feeling very brave, have a go at animating a dog walking past a sign and changing its form of locomotion as a result of what it's seen, just like in Chapter 5.

SEVEN

Animation of Acting – Body Language

Chapter Summary

- Acting
- Consequence
- Emotions
- Introduction to Laban Movement Theory
- General Body Language
- Basic Body Postures
- Basic Modes
- Palm, Hand, Arm and Leg Gestures

- Using Rhythm in Animation
- Acting Out a Scene in Animation
- Using Video Footage to Help Your Animation
- Using Rotoscoping and Motion Capture in Animation
- The Seven Questions of Character
- The Different Types of Animation Acting
- Analysis of a Character
- Exercises

Acting

Developing a sense of the dramatic will help with your ability to depict what you want your character to express. All movement in animation must be exaggerated to make it more convincing, and the same is true of animated acting. I've found that animated acting has more in common with theatrical acting than live-action film acting. Theatrical acting has to be big and demonstrative for the audience to see and understand what's going on. This exaggeration is similar to exaggerated cartoon movement, whereas film acting requires a certain amount of restraint: the camera can cut right up close to the actor's face and a whole range of emotions can be put over with the movement of an eyebrow. This is something that animation finds very difficult to do. The closer you cut close to the face of your character, the more obvious it is that your character is artificial.

There are many theories about acting but I'm going to concentrate on the ones that I've found most useful. These concern method acting and more traditional theatrical acting.

Method Acting

Think of this style of acting as constructing a character from the inside out. Method acting was developed by Constantin Stanislavski (1863–1938), a Russian actor, director and producer of stage plays and a founder of the Moscow Art Theater in 1898. His book *An Actor Prepares*, first published

in 1936, is well worth a read. Lee Strasberg was the first to develop training in method acting, at the Actors Studio in New York from the 1930s onwards.

The basic premise is that an actor lives and breathes the character of the part he is about to play so that when the actor's character is put in a given situation the character will react in a convincing way. This living and breathing of the character is carried out via workshops with other actors, the director making the actor act out spontaneous situations and also by the actor taking his role home with him and acting the character out in real life situations – imagine going out for the evening as Henry VIII!

The actor is meant to use his or her own emotional experience and memory in preparing to live a role. An actor using this method is likely to ask, 'what is my motivation for this scene?'. The idea is that, when an actor comes to reciting his lines, the body language, intonation and facial expressions will come naturally. It is a style of acting that is particularly suited to film. Quite often a camera will be left running while the actor acts out a scene, not knowing exactly how it will end. This 'acting on the hoof' can result in some very powerful performances. It can also end up looking rather ragged and messy, depending on the actor's ability and plain good luck.

In animation, the method acting technique is useful for working out how your character would act in a given situation. Act out what your character would do in front of a mirror, then use what you've learnt in your animation.

Theatrical Acting

You can almost think of this form of acting as constructing the character from the outside in. The actor's inspiration for the character is derived from the script. The director and the actor work out a series of positions and facial expressions to adopt while each line is read. Sometimes this form of acting is referred to as 'negative acting'. Depending on the actor's ability, it can seem over the top or it can be breathtaking.

This technique is best used in animation to work out the main poses and facial expressions that your character will adopt during a scene.

Consequence

In real life, any demonstration of an emotion (via body language, facial expression and tone of voice) will be as a consequence of emotions felt internally. In method acting, body language, tone of voice and facial expression are the consequence of genuine (or imagined) emotions felt by the actor, who uses his or her experience and memory to inspire these emotions). In theatrical acting, the actor mimics the body language, facial expressions and intonation that are the consequence of emotions in order to put these over to an audience.

Method actors can be very disparaging of theatrical actors because of this mimicry, whereas theatrical actors can be disparaging of method actors because they can seem unable to act out a scene without knowing everything about the character they are playing.

Animators have to use both acting techniques. They have to understand the characters inside out and know how a character will behave in a given situation (this is where an animator will act out a scene in front of a mirror). The animator then mimics the visible manifestations of these emotions (body language, facial expressions and tone of voice) in their animation.

Emotions

Emotions are the manifestations of conscious and unconscious feelings. They can include a character's affectation, vibes, mood, attitude, state of mind, or a character trait.

Emotions can be divided into three types, each of which has a sliding scale of intensity:

1. *Positive and negative.* These emotions can range from happiness and enthusiasm (positive) to anger, sadness or boredom (negative).

2. *Engagement and rejection.* These emotions can range from surprise and attention (engagement) to disgust and contempt (rejection).

3. *Neutrality and high intensity.* These emotions can range from calmness (neutrality) to excitement (high intensity).

Each of these three groups of emotions can be intermixed: for example, anger combined with contempt (negative and rejection).

Emotions can be experienced very briefly (for only a few seconds or fractions of a second) or for a long time. A mood could last for a couple of hours or for several days. An attitude or state of mind could last for a very long time. A character trait will be a part of the character's emotional make-up and will give a clue to the character's outlook on life. For example, if a character is constantly miserable, they may have a sad or angry look on their face. Their shoulders may be stooped and their motions may be laboured.

Acting is the bodily expression of these emotions.

Introduction to Laban Movement Theory

One of the most useful things you can do as an animator is to take some drama classes. Actually learn about acting and movement and get somebody who knows what they are doing to teach you. A lot of animators dismiss this approach, saying that you don't need to leap about and make a fool of yourself in order to animate. All I can say is that my animation has improved incredibly as a result of acting classes and any animator who doesn't try this is missing out.

Of all the drama techniques that I've studied, I found the most useful to be Laban movement theory. This approach to acting and dancing was developed by Rudolf Laban (1879–1958). Laban not only was a choreographer, dancer and actor but also was interested in all forms of movement. He was involved in time and motion studies for industry and applied his theories using mathematics, geometry and drawing.

I won't even try to cover all aspects of Laban's movement theory and will only review the absolute basics. The best thing you can do is to try and find a Laban movement class locally and do some exercises. Failing that you could look up the Laban Center web site (www.trinitylaban.ac.uk/Laban) or buy the book *Laban for Actors and Dancers* by Jean Newlove (1993). However, remember that nothing beats doing the movement yourself to really take it in.

The great thing about Laban movement theory is that it makes you very body- and movement-aware. Through a series of exercises you become familiar with the way the body moves and how external and internal influences can affect it. The theory also ascribes movements to things like character and emotion.

Kinesphere

Think of this as an area of personal space around the body, a bit like a large bubble. Within this the body can move forwards, backwards, up and down, left and right, and diagonally. Diagonal movements are furtive because they unbalance the body and either have to be completed quickly or some sort of counter balance will have to come into play. There will always be a specific reason for a diagonal movement or stance, for example to balance yourself while holding an object or pointing at something. Standing on one leg and adopting the necessary diagonal posture to remain balanced makes a person look vulnerable, but it can also give a feeling of confidence to that person. It would be easy to push the person over, but the character is confident enough to know that that is not going to happen. Asymmetrical postures are always more interesting to look at than symmetrical ones, so use them as much as possible.

Space, Time, Weight and Flow Continuums

Anything we do involves the movement of our body through space. Often, in life drawing a tutor will refer to the model as occupying space, and it's that bit of space that you are drawing. When we leap about or pull a facial expression or just breathe, we are moving in space.

Time should not only be understood as the amount of time it takes for an audience to understand a certain point you want to put across. It can also be the changing of the seasons, the phases of a humans life, the fast-moving modern world or the idealised idea of a slower-moving bygone age.

The depiction of weight is one of the fundamentals of producing a convincing piece of animation. A balanced person will look right when planted in the middle of your screen. An unbalanced person will look as if they are going to fall over, and if they don't fall over or correct their balance they will start to unnerve an audience. Within this you can also think about the other 'weight' a person may be carrying: the weight of responsibility, guilt or misery. They could also be affected by the lightness of relief, of a lack of responsibility or of being in love.

Flowing movement can be said to be the continuous movement of one action into another. If your animation has too much flow it is difficult for an audience to define each of the individual movements and what they mean. Conversely, a series of movements that stop and start could be described as jerky and, again, can be off-putting to an audience. It's always best to use a mixture of approaches.

Eight Basic Efforts

Laban movement theory divides movement into eight basic 'efforts'. One way to give the scene you are animating more depth is to determine which of these efforts applies to the personality of your character and the situation that they are in within the scene. Then have a go at physically doing these efforts yourself. Subconsciously you will take on board the movement required to do these efforts and this will be reflected in your animation.

It would be a good idea to practice each of these following movements, individually and in combination, just so you get a feel for them.

Pressing

This movement is direct, sustained and strong. It could be pushing or pulling something, or lifting or leading something. It suggests a character that is determined and indefatigable. This movement could be applied to a determined person who has a definite goal.

Flicking

This movement is flexible, sudden and light. It could be delicate movements of any part of the body, for example flicking dust off clothes or suddenly moving the head round to something that is heard. This perhaps suggests a more nervous person, twitching and reacting suddenly to things that happen to them.

Wringing

This movement is flexible, sustained and strong. It can be a movement such as wringing out wet clothes but could also be interpreted as gut-churning internal emotions within somebody who is frightened or embarrassed. This suggests somebody in inner turmoil or somebody who is worried about something.

Dabbing

This movement is direct, sudden and light, a bit like flicking but with a directness to it. An example is poking somebody on the shoulder to get his or her attention. This movement could be applied to a busybody-type person, bossing other people around.

Slashing

This movement is sudden, strong and flexible. Imagine slashing a sword in all directions or whirling the arms about to escape from something. This movement could be applied to an angry person who is annoyed by everything and anything.

Gliding

This movement is sustained, light and direct. One example could be a butler gliding silently into a room, very confident and aloof. The movement has a definite direction to it. This movement could

be applied to a quiet, confident person who is in control of themselves and everything else (or who gives a good impression of being so).

Thrusting

This movement is direct, sudden and strong, a bit like slashing but with a definite direction to the movement. An example could be one person punching another or somebody punching the air. This movement could be applied to a person who exists on short bursts of energy, either aggressive or delighted in nature.

Floating

This movement is flexible, sustained and light and has a more dreamy feeling, like thistledown drifting in the air or a cork bobbing on the ocean. This perhaps suggests somebody dreamily skipping through the woods, at one with nature.

Have a look at the rather amusing movies I shot of myself doing these actions in Chapter 9 on the website.

Of course, all the examples of characters I have given here are very one-dimensional. Have a go at mixing and matching these efforts in order to define your character. For example, a character displaying both pressing and wringing efforts gives the impression of somebody who has a depressive personality. Have the character display pressing and floating and they seem rather dumb.

Once you've worked out a collection of efforts for the basic personality of your character, think of what efforts can be layered over the top for the individual scene that you are going to animate. Then try acting out what your character does, keeping these actions in mind.

As I said above, doing this on your own, without the benefit of a drama or Laban coach, will be something of a shot in the dark. Sign up for some classes and see how much they improve your animation.

General Body Language

Sorting out the body language is the first thing you should do when animating a character. If you can put over what a character is thinking, looking at or doing just using body language, you are doing very well. When you add the facial expressions to your animation it will only get stronger.

We look at other human beings every day and we try to read from their facial expressions and body language what that other person is thinking and feeling. We've done this almost every day of our lives and have become remarkably good at it – so good, in fact, that a large amount of this information is taken in subconsciously. We've all been in a situation where we've met someone who is all smiles and bonhomie but there is something not quite right about them – something a bit false, a bit dodgy. You could say that some door-to-door salesmen fit into this category. There must also have been times, for example at an interview, where you have not been able to come across as you would have liked. It may have been down to the fact that you were nervous and didn't come over as someone in control and confident. In order to animate subtlety, we need to become anthropologically minded, with a deep interest in all human beings.

A lot of puppet animation (and puppetry in general, for that matter) relies purely on body language. The faces of puppets can't change expression to the same degree as drawn animation or 3D computer animation, but puppet animation and puppetry can be just as expressive (if not more so) as any other sort of performance. Watch puppet shows like the *Muppets* and animated films like *The Nightmare before Christmas* and see how the characters express themselves.

This is not to say that facial expressions are not important. Humans have the most expressive faces of any animal and one of the main reasons for this is to facilitate communication with other human beings. I like to think of the face as a canvas that different expressions are painted onto (more about faces in Chapter 10).

One amazing thing about human beings is their ability to lie. This ability to lie is at its most refined in the face. We can be feeling miserable but still say that we are OK and have a smile on our face. As we move down the body this ability to lie weakens. To put it bluntly, our bodies are more honest. So, if we are feeling miserable, we can put on a happy face and may be able to hold our shoulders up when we want them to droop, but there will be a strange strain to the position – perhaps the shoulders are slightly too high and are stiff in their movement. Further down the body, the arms and hands may hang in a way that suggests that any movement is an effort, the small of the back may tend to bend outwards and, if the character walks, the feet may drag. Very corny, I know, but all these little things can add up to telling your audience what a character is feeling.

Basic Body Postures

From the moment we wake up to the moment we go to bed, we are spending our day reacting to things that we are presented with. Whether people, ideas, situations or problems, smells or sounds, everything we do is a reaction to something else. How we react to these situations is reflected in the body language we adopt. There are a huge number of signals that can be given off by the positions adopted by different parts of the body. These postures can complement or contradict each other, depending on the situation. In the example above of a character who is depressed and openly expressing this, although some of the signals given off by parts of the character's body will say something else, the majority of the signals say 'depressed' and so the observer will still get an overall feeling of depression.

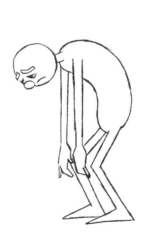

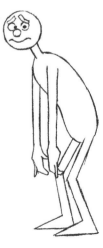

Generally there are four basic forms of body language posture: open, closed, forwards and backwards. We use a combination of these postures to give out signals to other people. Remember, acting the emotion that your character is feeling in front of a mirror is always the best way to make the action clear to yourself. In order to keep things clear I have deliberately made the following illustrations as simple as possible.

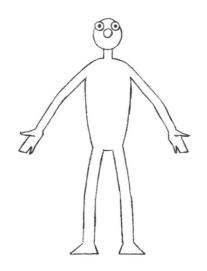
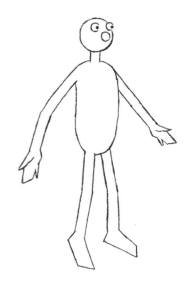

Open Body Postures

In these postures the arms are apart, the hands are open, the legs are apart with the feet planted on the ground and the body is fully facing the object of interest. These postures show that your character is reacting positively to the messages they are receiving.

Closed Body Postures

In these postures the arms are folded and the legs are crossed (if seated). The body may be turned away from the object of interest. The head might be lowered. These postures show that your character is rejecting the messages they are receiving.

Forwards Body Postures

In these postures the character is leaning forwards and pointing toward something with a fist or a finger. They indicate that a character is actively accepting or rejecting a message given to them. They are involved, absorbed or passionate about what they feel.

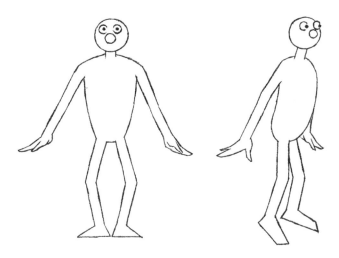

Backwards Body Postures

In these postures the character may be leaning backwards, looking up at the ceiling or engaged in some other activity such as cleaning glasses, winding a watch or doodling on a pad. They indicate that a character is passively involved or ignoring a message given to them.

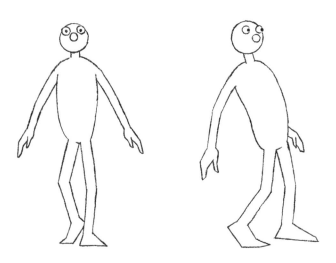

Basic Modes

The previous four postures combine to create four basic modes: responsive, reflective, combative and fugitive. Following are some suggestions for body postures and actions during a range of emotions. Remember, nothing is better than working out these postures by acting the emotions in front of a mirror.

Responsive

When a character is reacting responsively they will display a combination of open and forwards postures. The moods covered by this include happy, interested, engaged in and occupied with something, in love, wanting something, eager, and liking something.

The different types of responsive body language and the moods that trigger them are as follows:

1. When a character is happy, the body could be angled forwards and the head held up. The legs could be apart and the arms and hands open.

2. When a character is interested, engaged or occupied with something, the body will be held forwards and the head even more so. They may be standing on tiptoes, putting the head to one side.

3. When a character is in love, they will have very open body postures and the body will lean towards the object of their affection. The arms will fall loose and be uncrossed, with the palms turned forwards. The head could be tilted to one side.

4. When a character is eager, they will lean forwards and be on the edge of their seat (if they are seated). They could grip something like the edge of a table or a pencil. Their head may be jutting forwards and their legs kept apart.

5. When a character likes something, think of your character doing a down-played version of being in love.

6. When a character wants something, they could put their head on one side, put out their arms with the palms upwards, lean forwards and open up the body.

7. When a character is listening, they could lean the body forwards, tilt the head, raise the arm to cup the ear and have the head nod occasionally.

Reflective

When your character is in a reflective mood, they should display open and backwards postures. Your character may be considering something, thinking and evaluating, or feeling perplexed.

1. When a character is thinking and evaluating, they may do any of the following: lean the body back, suck a pencil, stroke the chin or scratch the head. The head position may be angled to one side or looking up to the heavens (often to the right). The legs could be crossed with the ankle on the knee (if sitting).

2. When a character is feeling perplexed, this usually involves a contradiction of body postures. Have the top part of the body open and similar to the thinking posture but have the lower part of the body closed. Have the legs crossed and the feet occasionally moving on tiptoes.

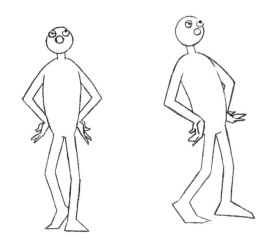

3. A raising of the shoulders and an opening of the arms and palms produces a shrug. This says 'I don't know'.

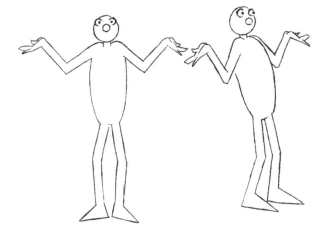

Fugitive

When your character is in a fugitive mood they will display closed and backwards postures. Your character may be feeling any of the following: rejected, bored, sad or miserable, in denial, not quite sure of themselves, lying, wanting to get away, or resisting an idea.

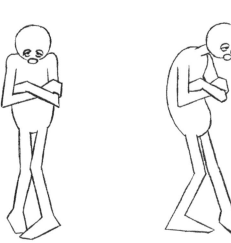

1. When a character is feeling rejected or dejected, the body could be leaning back and slumped forwards, arms folded, legs crossed with the thigh on the knee (if sitting) and the head down.

2. When a character is bored, the body could
 be slumped or angled back with the head
 staring into space. The character may
 be stifling yawns, tapping their feet or
 fingers, doodling with a pen, or looking
 around for something interesting.

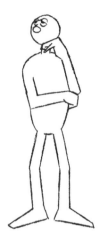

3. When a character is sad or miserable, the
 body will be very slumped. The arms will
 hang lifeless. The head will be hung low.
 Everything will seem to be an effort and
 difficult to do.

4. When a character is in denial, angle the body
 backwards and have the arms sweep across
 the body as if pushing something away.
 Have the hands form a fist or a pointing
 finger. Make the neck tense and hunch the
 shoulders.

5. When a character wants to get away, angle the body towards the main route of escape (usually away from the thing that they want to avoid). They will be looking around for a means of escape.

6. When a character is resisting an idea, the body language will depict rejection of the idea: the head will be shaking and lowered.

Combative

When your character is in a combative mood, they will display closed and forwards postures. Your character may be angry or defiant, may wants to put over a point forcefully, or want to have or be having an argument.

1. When a character is angry the body will be leant forwards. Hunch the shoulders and tense the neck. The arms will hang straight down or will be folded. The hands can form fists or a clenching shape. Tap the toes or stamp the feet.

2. When a character is putting over a point forcefully, they will point with the hands and lean forwards as if they are putting themselves forwards.

3. When a character is being defiant, they will pull themselves up and cross their arms. The head will be held up high and angled back.

4. When a character is having an argument, they will lean forwards, wave their fists, strike things, hunch their shoulders and gesticulate wildly.

5. When a character is listening to something that they disagree with they will partly cover their face with one hand, which could have a single upturned finger. The other arm will cross over the body. If seated, the legs will be crossed.

Palm, Hand, Arm and Leg Gestures

The hands and arms play a crucial part in our communication with other people. The postures adopted by the legs reinforce these gestures.

Palm Gestures

The palm can be used to suggest openness and honesty or the lack thereof. Honesty and submission are suggested by a character gesticulating with open palms facing upwards or away from the character's body and towards the person to whom they are gesticulating. You will see this sort of palm signal when people are shrugging and when they are happy, eager, interested or contemplating something.

Dishonesty and dominance are suggested by the palms being open but facing downwards or towards the character's body. You will see this when people are defiant, bored, sad or annoyed. When you see the open body language associated with a responsive body posture but the palms are facing downwards or towards the character, something doesn't seem quite right and you tend not to believe the character. This could suggest that the character is lying.

The closing of the palm suggests anger and aggression or exaggerated dominance. You will see this form of display if somebody is aggressively pointing while talking or chopping the hand across the body. Examples of this type of palm signal will be seen when a character is angry, trying to put a point over, disagreeing with something or being argumentative.

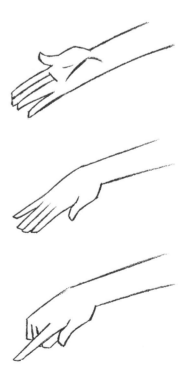

Hand Gestures

Rubbing the palms together suggests eagerness, excitement and expectation. Rub your hands together before you say something such as 'we're going to make a lot of money on this' and it suggests to an observer that they should be eager and excited too. However, rub your hands together *as* you are saying the same phrase and you will come over as too eager about what is going to happen – you will seem to be pulling a fast one on the observer.

Clenching the hands together by interlocking the fingers suggests frustration and that the person is holding back negative feelings. The hands can be clenched together in front of the body at different positions. If the hands are higher it suggests increased levels of frustration.

When thumb and all the fingertips of each hand are pressed together and the hands are held upright, this gives an impression of superiority. It is usually done when the character is talking, or, more accurately, pontificating. It's a bit smug and suggest that the character is a 'know it all'. When somebody is listening attentively to something the thumbs and fingertips can be pressed together but the hands will be held downwards.

Rubbing the thumb and fingers together suggests money!

Prominent thumbs suggest confidence, dominance or coolness.

Pointing with the thumb suggests a derogatory manner.

Arm Crossing

Hiding behind something is a way of protecting ourselves. If a character crosses their arms in front of them it's as if they are hiding behind their crossed arms. They may do this because they disagree with something that has been said or are comfortable with the situation they are presented with.

Clenching the fists while crossing the arms gives a hostile signal.

Gripping the arms tightly with the hands while the arms are crossed suggests nervousness and stress.

Partially crossing the arms shows a lack of confidence (e.g. in a situation where the character is with a lot of strange people).

Crossing the arms at the hands suggests humility.

Leg Crossing

Leg crossing gives off a similar signal to arm crossing but is far less strong. A basic crossing of the legs can give the impression of defensiveness, but could actually have been adopted by a person trying to make themselves comfortable.

Combine a leg cross with an arm cross, a backwards body posture and a sour look on the face and you get a strong impression of displeasure.

Crossing the leg with the heel at the knee gives a competitive, aggressive impression.

Crossing the legs at the ankles gives a 'prim and proper' look.

Entwining the legs around each other gives the impression of a lack of confidence or of nervousness. This can be done both sitting and standing.

Crossing the legs when standing reinforces the closing off of the body.

Remember, all of these body positions and gestures can be mixed and matched to produce a convincing over-all body posture, but nothing beats acting it out in front of a mirror.

Using Rhythm in Animation

All animation has rhythm. Think of it being like a dance or a poem. It's not realistic and spontaneous like real life and, as such, celebrate that fact. If all your key positions hit the timing of a catchy rhythm that you can tap out on a desk with your fingers, you know you can't be far wrong. Look at good pieces of animation or sequences in a well-choreographed action movie on the television or your computer. Try tapping out the rhythm of the sequence. You'll soon see that there is a rhythm to life. There is a whole bit of our brain that delights in rhythm. Without it we wouldn't enjoy music or dance or the movies.

Acting Out a Scene in Animation

I tend to think of straight-ahead animation being more like method acting and key-to-key or pose-to-pose animation having more in common with theatrical acting. Straight-ahead animation can throw up some interesting, spontaneous touches but can get out of control, whereas pose-to-pose animation allows more control but can sometimes seem wooden and clunky. Ultimately you should use a combination of the two.

Work out your character by acting out a scene yourself. It doesn't matter if your acting is not particularly good. Do it in front of a mirror in the privacy of your own home. Think how your

character would behave in a given situation. How does your character think? This will govern the way it moves. Note all this down.

When it comes to animating a scene, act it out first then sit down and work out a series of thumbnail sketches. Think of the minimum your character has to do in a scene to make sure an audience is going to understand what is going on. Make sure you have good, strong silhouettes. One thing to avoid is something called 'twinning'. This is where the arms (for example) do exactly the same thing at the same time. If the arms are doing a sweeping gesture downwards, offset one arm slightly from the other (if you act everything out thoroughly, you tend to avoid twinning anyway).

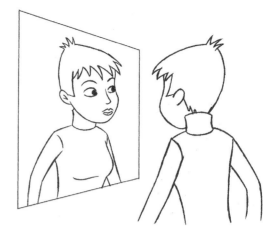

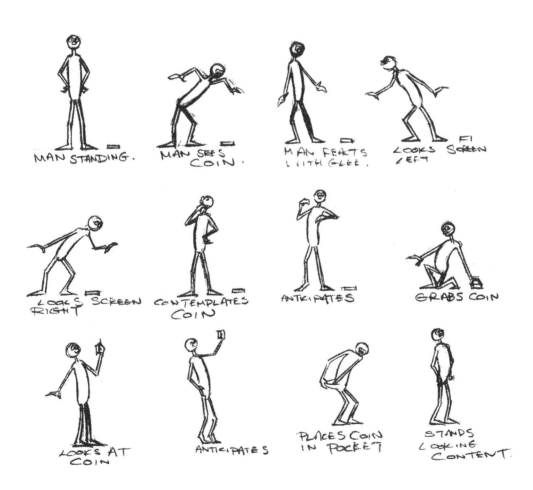

MAN STANDING.

MAN SEES COIN.

MAN REACTS WITH GLEE.

LOOKS SCREEN LEFT

LOOKS SCREEN RIGHT

CONTEMPLATES COIN

ANTICIPATES

GRABS COIN

LOOKS AT COIN

ANTICIPATES

PLACES COIN IN POCKET

STANDS LOOKING CONTENT.

When you've completed your thumbnails, shoot them with your line tester and play about with the timing. It doesn't matter if the sizes of the character change – all you are doing is feeling your way through the scene.

You can now re-draw the thumbnail sketches onto full-size paper, modifying them as you go along (alternatively, you could always blow them up on a photocopier). The idea is to retain the spontaneity of the thumbnails in your animation. Shoot these to the same rough timing as your original pose test with your thumbnails, making sure that nothing is bouncing about too much, for example feet touching the ground or hands touching the scenery. This test should consist of the major key positions.

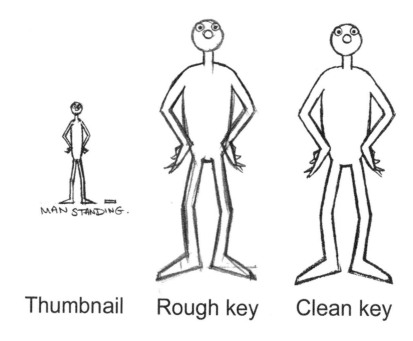

MAN STANDING.

Thumbnail Rough key Clean key

After this, sketch in the minor key positions (all the anticipations and overshoots) and some of the major in-between drawings (the breakdowns). Shoot it again. Keep flicking, flipping and rolling all the time.

Generally, the way we move in both real life and when acting is to shift from one major pose to another. When we reach each of these poses we keep moving but make only minor movements. If you want to see a good example of this, just fast forwards a feature film and watch how the actor will move quickly from one position to another and then stay put for a short period of time.

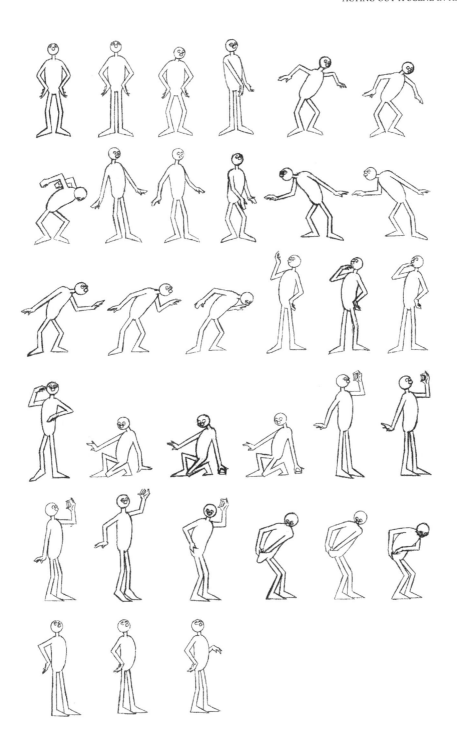

Once you've worked out these major poses and the minor key positions (the anticipations out of a position and overshoots into a position), think about things that you can get your character to do while in those poses. Move your character through a pose in such a way as to emphasise what the character is doing. If your character is looking off to screen right, move the character into that position and then move them slowly forwards a small amount while looking.

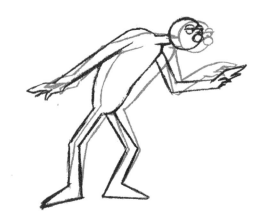

Think of the most extreme position as being one key position and the position that the character moves to as another key position. Do some timing charts to work out where to place the in-betweens and then complete the in-betweens.

Make sure that when you do the in-betweens different parts of your character move at different rates depending on the item you are animating. For example, the drapery will follow through the main movement of the character. One way to do this is to roughly animate one part of the character (e.g. the main movement of the body) all the way through the scene and then go back and animate a different part of the character (e.g. the drapery). This technique is referred to as building the animation up as layers.

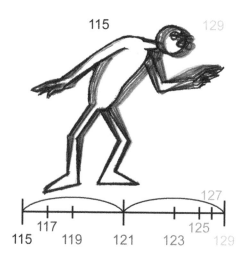

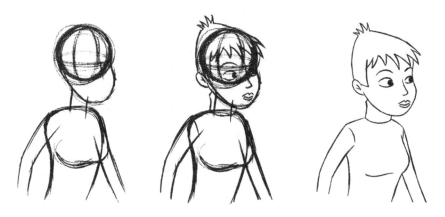

Start with the basics (with your characters as simple ball-like shapes) and then add the details! Keep adding to these layers until your animation is finished in rough. Then, and only then, clean up each animation drawing onto another piece of paper.

Using Video Footage to Help Your Animation

With the advent of small digital video cameras (still digital cameras that take movies and camera mobile phones) it has never been easier to take video footage of the piece of acting that you want to animate as reference. This is something that professional animators have been doing since the 1930s. All of Disney's films had huge amounts of reference footage shot of actors acting

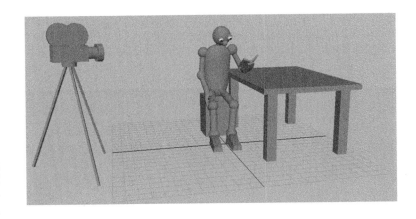

out the scenes that were to be animated. It still happens today. One strange thing that I've come across is that some animators think of it as 'cheating'. All I can say to that is that if something improves your animation it's worth doing and spending a few minutes in front of a camera can really help your work.

You could film yourself or somebody else acting out your scene, load it onto your computer and refer to it while animating. I always think it's better to have a go at acting it out yourself so that you get a better 'feel' of the movement involved. By acting something out, you cause a series of synapses in your brain to form a link that relates to the movement. When you then start animating this movement, your subconscious mind draws upon this information in order to help you animate it. Sports stars do something similar called 'visualisation', in which they sit down and think about the movement they are about to perform in great detail (almost frame by frame). They 'visualise' what they are about to do before they do it, which links up a chain of synapses in

their brain so that when they are performing that triple axial somersault or that impossibly high jump over a bar their subconscious mind will not have to be thinking about the movement while they are doing it. Because of the linking-up of the synapses in their brain, it's as if they have done the movement already.

So, when it comes to animating a scene, write down a basic list of what's going to happen (e.g. man sits reading book, man

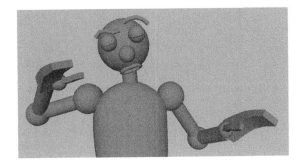

glances up, man does a double take and looks up in a more exaggerated way). Act it out yourself a few times until you think you've got it how it needs to be, then act it out in front of somebody else. Get their comments on what you've done. Do they understand it? Does the movement fit in with what they understand as the personality of the character? When you've taken all of this on board and re-acted it a few times so that it feels natural, get somebody to film you with a digital camera. Act a few versions, using different timing and mannerisms. One thing you will find is that you will start putting things in that you never would have thought of if you had just started animating straight onto the computer. When you've seen the footage, you may find that you need to re-shoot. For example with the first video that I shot, I felt that the first look off screen was too subtle (have a look at 'vid-ref01.avi' in the movies folder of Chapter 9 on the website). So, I shot it again with a bigger 'look' off screen at the start ('vid-ref02.avi').

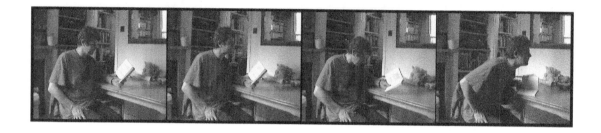

Download the movie(s) from the camera onto your computer and watch them a few times. Try to remember how it 'felt' to do the movement. If you did several 'takes', watch them all and take the best bits from each movie to apply to your piece of animation. The most important thing is not to slavishly copy the footage. Take the essence of it. You may have to change the timing (you will usually have to animate things a bit slower than real life). You may also need to exaggerate each of the poses as well as the anticipation, the movement itself, and the overshoot and overlapping action.

Once you have watched the footage over and over again (almost until you are sick of it), do a series of thumbnail sketches for you to stick on the wall to refer to. This will also make it a lot clearer in your head what you will need to do once you are animating.

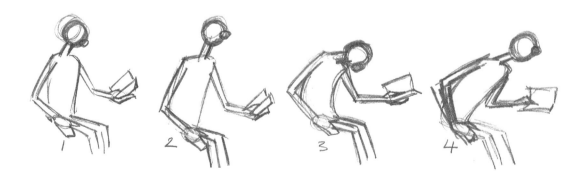

Finally, after all of this research, get on with animating the piece, constantly referring to the video footage, thumbnails and your own experience of doing the movements.

By the way, never think of this process as a replacement for having a mirror on your desk to help you with facial expressions (as well as using it as a reflection of your screen to make sure that your key positions are 'balanced').

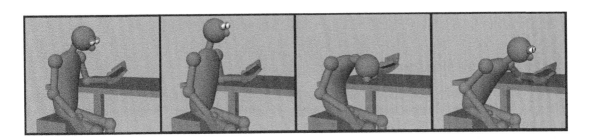

I found in my example that I added a small glance of the eyes before I did the first 'look' off screen. I also added a bit of breathing and the eyes reading the book at the start. I then speeded up the anticipation into the double take and added a bit of breathing to the hold at the end to make it seem less static.

Take a look at 'reading-book.avi' in the movies folder of Chapter 9 on the website.

Using Rotoscoping and Motion Capture in Animation
Rotoscoping

Rotoscoping is where a piece of live-action footage is traced frame by frame onto paper (or digitally into a computer program). This will give a very realistic look to the animation. When rotoscoping, the main things to worry about are the performance of the actors and the quality of the drawings produced from the acting.

The old-fashioned way of doing things is to use a rotoscope machine. The shot film is projected onto the glass plate of a light box. A piece of paper is placed onto a peg bar on the glass plate and the image can be traced onto the piece of paper. Do this for every frame and you will soon have a short sequence.

The modern way to do this is to take your footage into a program where you can draw over video. Adobe's After Effects, Photoshop and Flash are all perfectly usable. Alternatively, you could use DigiCel FlipBook. To do so, open up a new scene in FlipBook. Make sure it is set at the correct number of frames per second for the .avi you are importing and also make sure you have three levels. Select level 1 in the X-sheet, go to the main menu and select **File > Import > AVI**, select the .avi you want to import and then click **OK**. Your movie should now be in level 1 frame by frame. Select level 2, open the drawing tools and draw over your movie one frame at a time. When it comes to exporting your rotoscoped movie, select just layer 2 to export.

Motion Capture (Mocap)

Motion capture, mocap and motion tracking are terms used to describe the process of recording action and transposing these actions on to a computer-generated model. The technique can be used in medical applications, entertainment and sports analysis. In movie making, it refers to recording the movement of human actors and using that information to animate computer character models in 3D or 2D digital animation.

During a motion capture session, the movements of an actor are sampled many times per second, but only the movement – not the way a person looks. Consequently, the movement of a human actor can be used as the action of an animal or fantasy creature.

The main strength of motion capture is that it can turn out a lot of very realistic movement very quickly. However, the quality of the movement is only as good as the actor doing the moving. The actor has to take into account the fact that the model they are moving may be a totally different shape to the actor, otherwise parts of the model's body can intersect other parts. These are referred to as 'artefacts'. Usually most motion capture requires some cleaning up and fixing by an animator afterwards to make it more believable to an audience. Anticipation, overshoot, squash and stretch and other cartoony effects have to be added later by an animator. It can also be very expensive to set up a motion capture studio (although there are now some affordable options available).

There are two main ways of doing motion capture: via optical systems and via non-optical systems.

Optical Systems

This is where the actor dresses in a suit with lots of special markers on it and cameras arranged around a large room register the movement of the markers. This data can then be applied to the model in the computer program. Obviously all of these cameras, a large room to put them in and all the data crunching software add up to a very big outlay before you have produced any animation at all (way out of the scope of individual animators and small animation studios).

Non-Optical Systems

This is where the movements of the actors are detected mechanically either by gyros or potentiometers (complex switches). Usually these are arranged in a suit or on an exoskeleton that has sensors attached to it. These sensors then send the data to a computer either through wires or wirelessly.

The main advantages of these systems are that they are portable and can be used anywhere near a computer. They are also relatively inexpensive, costing about the same amount as the cost of a full licence for Maya or 3D Studio Max.

A company called Animazoo, situated in Brighton in the South of England (www.animazoo.com), makes a product called Gypsy 7. I was lucky enough to be given a chance to use the system and was amazed at how quickly it was possible to start producing data, which can then be brought into your chosen 3D software as animation. Gypsy 7 consists of an exoskeleton that is worn by the actor and the movements are interpreted by Animazoo's own piece of proprietary software, which does a lot of the cleaning up of the movement automatically.

In Chapter 9 on the website you can find a movie of me making a character move by wearing the Gypsy 7 exoskeleton. The digital files produced by Gypsy 7 have a .bvh extension, and other motion capture devices use other extensions (e.g. .bip, .fbx and .htr).

How to Import Motion Capture into Maya

BHV files are not native to Maya, so you need to acquire a BHV importing plug-in. To do this you will need to go to a website such as www.creativecrash.com, where I found a plug-in called 'BVH File Import Export'. Download this plug-in and put it into your Maya plug-ins folder. In Maya, load a character and select the root (the first part of the hierarchy in the Hypergraph). Then go to the main menu and select **File > Import**. Browse to the BHV file and click the **Import** button. Not that your character *must* be built in the same way as the character in the BHV file. Go to www.animazoo.com to see how their characters are rigged.

How to Import Motion Capture into 3D Studio Max

BVH files can be imported into 3D Studio Max and applied to one of their pre-built 'CAT' rigs. To create a CAT rig go to the **Create** tab in the Command Panel and click **Helpers > Choose CAT objects** and then under **CATParent** select a CAT rig from the **CATRig Load Save** roll down menu (e.g. 'Base Human'). Then click and drag in a viewport to create a human. To load your motion capture onto this model, select a limb on your base human. Right click and from the menu that comes up go to **Tools 2 > File IO > Import BVH**. Browse to your .bvh file and click **Open** in the window. Then, in the **Import BVH** window that comes up, click **OK** and your motion capture will be imposed onto your CAT rig. Have a go with the .bvh files in Chapter 9 on the website.

The Seven Questions of Character

Ask yourself seven basic questions about the personality of your character. From the answers you can build a solid, defined character that everybody should understand.

This is a very useful thing to do when working out what your character is like. It establishes where they have come from, where they are going and how they would react in a given situation. It should be done particularly thoroughly on a movie, where several animators may be animating the same character. Often I've seen the same character animated by several animators in several different ways, leading to a degree of confusion on the part of the audience!

So, before you do anything (storyboarding or even scriptwriting, let alone animating) ask yourself the following seven questions about your character:

1. Who am I? (Name, age, temperament etc.)

2. Where am I? (In a bedroom, up a tree etc.)

3. When am I? (Present day, seventeenth century, in the future etc.)

4. What do I want? (Money, power, a simple life etc.)

5. Why do I want it?

6. How will I get it?

7. What is stopping you getting it?

These are standard questions that any actor would ask himself or herself when establishing a character for a play or film. You don't have to slavishly stick to these questions but this seven questions do act as a firm foundation, enabling you to get your character clear in your head and explain your character to other people (producers, directors, clients, an audience or other animators).

You will find a .pdf form of these seven questions that you can print out and write on in Chapter 9 on the website. When you have filled it out, stick it up on the wall above your desk and keep referring to it!

The Different Types of Animation Acting

Depending on the budget, time scale and type of production, most acting in animated films tends to fall into the following categories.

Animated Radio

Also known as limited animation, this form of animation is a series of pictures that illustrate the script. This is probably the simplest form of animated acting. It is frequently used in low-budget television series. The characters move as little as possible and tend to be flatter in design to save time and money. When using limited animation your script needs to be as good as possible because you can't use the animation to distract from weaknesses or holes in the plot.

Animators working on these productions have to think far more about the drawings they do and they have to be very good draftspersons. The audience is relying on fewer drawings to convey the story.

Pose-to-Pose Animation Acting

Generally this is the type of acting employed in Hollywood animated shorts. The best exponents of this are Tex Avery (Droopy, Screwy Squirrel) and Chuck Jones (Wile E. Coyote, Daffy Duck, Bugs Bunny).

Pose-to-pose animation involves drawing the poses that best emphasise the central themes of the story line and animating between each as quickly as possible. When your character is in these strong poses you then give them something to do. This type of animation makes a virtue out of the strong poses it uses. It is the kind of animation that expresses a point effectively but won't get in the way of your ideas or gags. It suits fast, aggressive, violent humour.

This kind of animation could not sustain a feature film – the audience would be worn out after 70 minutes. Having said this, it's fast and furious and, if done well, very funny.

Full Animation Acting

This is the kind of animation used in feature films and is probably the hardest to do. It's animation that requires light and shade. You have to spend time with the characters in order to know them well enough to care about them for 70 minutes. In earlier animated feature films the heroes were usually as dull as ditch water but the villains (and the comic relief characters) were really exciting. Nowadays, scriptwriters tend to emphasise the comedy (and the flaws) of the heroes in animated feature films. It's because their characters are flawed that they are interesting.

Full animation uses similar techniques to pose-to-pose animation but the poses won't be as obvious. The movement will be more fluid and continuous. Although an animator will draw the key poses and in-between them (or set keys on his/her computer model in 3D), the animation will not look as if it's moving from one deliberate pose to another. It is a type of animation that has the freedom and fluidity of straight-ahead animation and the discipline of pose-to-pose.

One way to help with full animation is to leap about in front of a mirror and live and breathe the character you are animating. Draw sketches of the movements and poses and shoot them in sequence as a 'pose test'. From here draw the sketches as the key drawings and animate straight ahead between each drawing, aiming roughly at the next key position (use the timing you worked out in the pose test). If, when you reach the next key, your straight-ahead drawings have changed from the original key position, go with it. Continue going through the sequence in this way. Animate straight ahead but use the key drawings as a guide to where and when you will end up during the animation.

One of the main ways in which animation studios make their characters more real and believable is for an established actor to provide the voice. They will also often film an actor performing most of the movements – sometimes the same actor who provides the voice.

The best characters in animated feature films are often the villains. The movement and acting tends to be far bigger and more exaggerated. Because of this, the villains are frequently voiced by stars who can throw themselves into the roles with zeal. Sometimes the heroes can seem rather dull in comparison, and can be more difficult to animate. The acting required is much more subtle. The best way to make heroes more interesting is to emphasise their humorous side.

Fully animated characters should be fairly simple in their design and not have lots of complicated bits and bobs attached to them. The more complicated the character, the more awkward it is to animate and the more awkward it is for an audience to watch.

When using full animation, some actions are more difficult to animate than others. The subtle movements made when somebody is sitting down and doing nothing other than thinking can be difficult to animate well. Animating a swash-buckling sword fight is much easier to do because of the complexity and speed of the action. There's only one thought going through the head of a sword fighter – 'how do I swing at my opponent again?'. However, a character who is falling in love has hundreds of thoughts going through their head. To convey these emotions and thoughts you've got to animate them all bubbling to the surface. Similarly, it's much easier to act out a sword fight in front of your full-length mirror than it is to portray a believable love scene. This is because complex action is very different from complex acting.

Full animation also demands good use of timing and a sense of design for the overall screen image. For this kind of film making you not only have to know when to slow your animation down and when to speed it up but also when to hold back with your background animation and when to exaggerate. It's all very well having the most brilliant animation in the background but if it distracts the eye from the main purpose of the scene it's worse than useless.

Mime

It is worth looking at and studying mime artists. If they are performing well, they have amazing control of their bodies and are able to convey emotions with the smallest gesture. The whole body can portray emotion. For example, a head hung low, shoulders drooped, body bent over and legs dragging the feet suggest depression. Folded arms and legs suggest somebody that is lying or feeling uncomfortable. Somebody who is happy will walk with a spring in their step and their movements will be quicker and quirkier.

Mime is used in a lot of European animated films. Mute films can be viewed by a larger global audience, which is why they are so popular around the world.

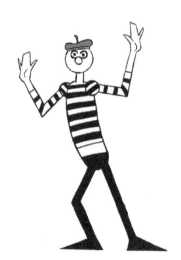

Analysis of a Character

The basic idea is to live and breathe your character – act out everything your character has to do and present it to an audience so they understand what makes that character tick. One of the best things to do before you start animating is to write down a list of the main character traits of the character you are about to animate. On a professional animation project, your director has, hopefully, already done this and will be able to brief you before you start animating. When you're working on your own project you'll have to do it for yourself.

MY CHARACTER IS:
GREEDY.
A COWARD.
THE KIND OF PERSON DISASTERS HAPPEN TO.
SELFISH.
(MY GOD! IT'S ME!)

Make sure you also have a good collection of model sheets to work from. A model sheet is a collection of drawings on one page (or several pages) that show front, back, side and three-quarter views of the character. It could also include head shots of the face showing different emotions.

Finally, remember that actors have drawn inspiration from animation, as well as the other way round. Laurence Olivier based his portrayal of Richard III, in the film of the same name, on the wolf in Disney's *Three Little Pigs*.

Exercises
Animating Acting in 2D

In the exercise below, the character spots a coin on the floor, looks around and quietly pockets the money. As with all the exercises, this is only a guide to follow – other possibilities include picking an apple out of a tree, a book off a shelf, a cake off a plate or even picking somebody's pocket. The aim is to have a character see something, covet it and sneakily take it.

Have a character standing in medium shot, slightly to one side of the screen. To the character's side on the ground is a coin. The character is going to see the coin, sneakily look from side to side, pick up the coin, look at it and then pocket it. Act the sequence out in front of a mirror and draw a series of thumbnail pose sketches of the major key positions (or have a look at the illustrations below). Shoot the thumbnail sketches as a basic line test, then take a look at 'coin_thumbs.avi' in animations009, Chapter 9 on the website.

Once you're happy with the timing of the thumbnails, draw them full size and think about the minor key positions. These are the smaller movements your character makes when in a pose. They are also the anticipatory movements out of one position and the overshoot positions into another. Remember to slug out these actions in the action column on your X-sheet.

Between the equivalent of the first thumbnail sketch (character standing) and the second thumbnail sketch (character looking at coin), have the character straighten up, glance down at the coin, do a double-take and then do a big look at the coin. Key 1 (frame 1) is basically the same as the first thumbnail sketch: the character is standing center screen. Key 2 (frame 11) is at the highest point of the straightening up. Key 3 (frame 33) is at the point where the character finishes glancing at the coin. Key 4 (frame 37) is at the anticipation of the second look. Key 5 (frame 45) is the big look at the coin and is the equivalent of the second thumbnail sketch.

Between the equivalent of the second thumbnail sketch (key 5, frame 45) and the

311

third (character standing back and looking at the coin with glee (key 8, frame 69)), have the character looking at the coin as it moves closer to the coin and do an anticipation into the look of glee. Key 6 (frame 57) is at the end of the movement forwards as the character is looking at the coin. Key 7 (frame 63) is the anticipation position, which then leads the character to move into the look of glee (key 8, frame 69).

Between the equivalent of the third thumbnail sketch (key 8, frame 69) and the fourth (character looking screen left (key 11, frame 93)), have the character move forwards as it is looking with glee and then do an anticipatory move into the look screen left. Key 9 (frame 81) is at the last position where the character has moved forwards. Key 10 (frame 85) is an anticipation position, which then leads the character to the look towards screen left (key 11, frame 93).

Between the equivalent of the fourth thumbnail sketch (key 11, frame 93) and the fifth (character looking screen right (key 13, frame 115)), have the character lean forwards in the direction that it is looking. Then have it move quickly into the look towards screen right. Key 12 (frame 107) is

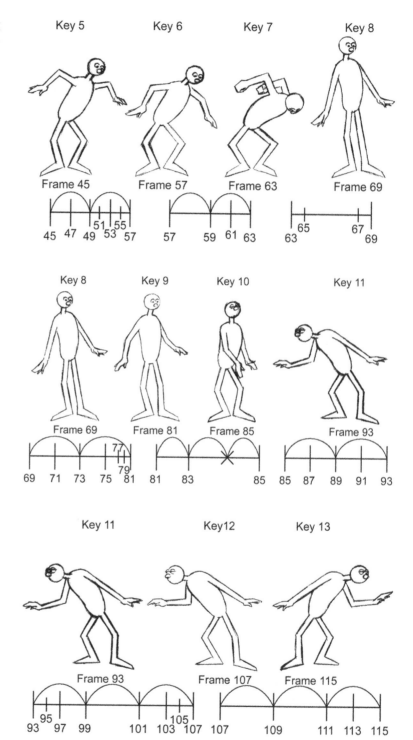

the last position where the character has lent forwards before moving to key 13 (frame 115), where the character is looking screen right.

Between the equivalent of the fifth thumbnail sketch (key 13, frame 115) and the sixth (character pondering coin (key 17, frame 145)), have the character move in the direction of the look off screen right, then anticipate the movement up into the pondering position, overshoot and go back down into the pondering position. Key 14 (frame 129) is the last position of the move towards the look screen right. Key 15 (frame 133) is the anticipation position. Key 16 (frame 141) is the overshoot position, which then leads back down to key 17 (frame 145), where our hero is pondering the coin.

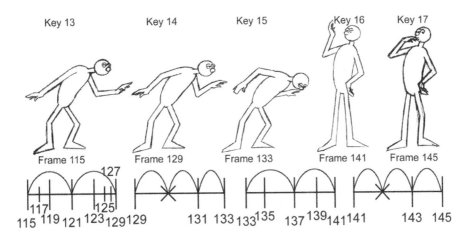

Between the equivalent of the sixth thumbnail sketch (key 17, frame 145) and the seventh (character anticipating grabbing the coin (key 19, frame 163)), have the character straighten up slightly while pondering the coin. Key 17 (frame 145) is the first position of the character pondering the coin. Key 18 (frame 159) is the last position of the character pondering the coin, having straightened up slightly. Key 19 (frame 163) is the character moving up and anticipating moving down to pick up the coin.

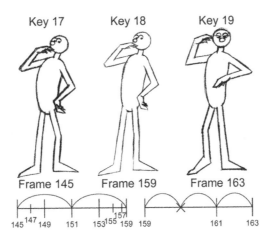

313

Between the equivalent of the seventh thumbnail sketch (key 19, frame 163) and the eighth (key 21, frame 173), have the character overshoot the coin-grabbing position with its fingers outstretched and then bring the character up slightly as it grabs the coin. Key 20 (frame 169) is the overshoot position. Key 21 (frame 173) is the coin-grabbing position.

Between the equivalent of the eighth thumbnail sketch (key 21, frame 173) and the ninth (character holding up coin and looking at it (key 24, frame 187)), have the character, while it is still grabbing the coin, move down slightly and then move up to and overshoot the position where it is looking at the coin. Key

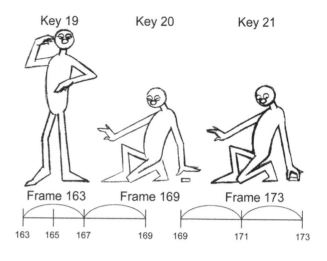

22 (frame 177) is where the character has moved down a little. Key 23 (frame 183) is the overshoot position. Key 24 (frame 187) is the point at which the character looks at the coin.

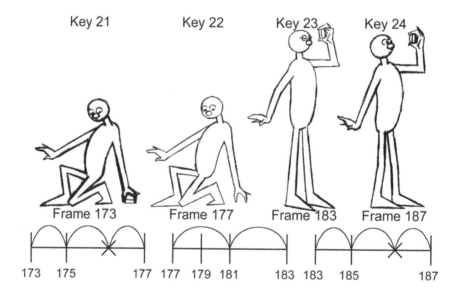

Between the equivalent of the ninth thumbnail sketch (key 24, frame 187) and the tenth (where the character has moved its body and arm up in anticipation of putting the coin in its pocket (key 26, frame 205)), have the character move slightly as it looks at the coin and then lift the arm up as an anticipation position. Key 25 (frame 201) is where the character is still looking at the coin

but has moved its arm outwards a bit. Key 6 (frame 205) is the anticipation position of the arm going up before it is plunged into the pocket.

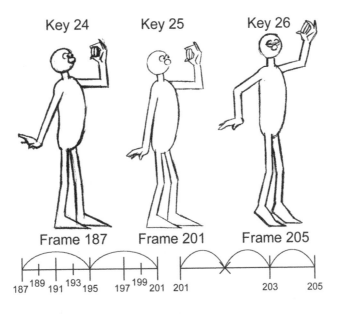

Between the equivalent of the tenth thumbnail position (key 26, frame 205) and the eleventh (character with hand plunged in pocket (key 28, frame 215)), have the character grab its pocket at key 27 (frame 211).

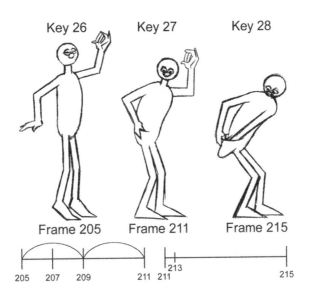

Between the equivalent of the eleventh thumbnail position (key 28, frame 215) and the twelfth (character standing looking innocent (key 32, frame 243)), have the character pull its hand out of its pocket and put its hand on its hip. In key 29 (frame 221), the character still has its hand in its pocket. Key 30 (frame 227) anticipates the character popping up. Key 31 (frame 235) is where the character overshoots into the hand-on-hip pose, which is key 32 (frame 243).

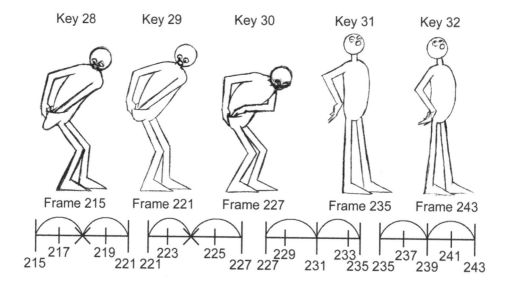

At the end, the character is still but brings up its arm. Take a look at 'coin_2D.avi' in Chapter 9 on the website.

Animating Acting in 3D

Load your character onto your program and at the first frame set the character up so it is stood exactly like frame 1 of your drawn animation. Make the length of the scene the same length as your drawn animation (in this case 252 frames long).

Make some ground for the character to stand on by creating either a grid or a very short, wide and deep box, and place it under the character's feet. Make a coin by creating a cylinder with a radius of 0.5 units and a height of 0.2 units in Maya or a radius of 5 units and a height of 2 units 3D Studio Max. Place the coin on the ground to the right of the character, about 5 units from the center in Maya or 50 units in 3D Studio Max. Create a second coin and parent it (attach it) to the hand that will pick the coin up. Make the coin in the hand invisible until the hand grasps the coin on the ground. At this point make the coin on the ground invisible for the rest of the scene (just like the ball we picked up in Chapter 3).

Go through the sequence copying each of your drawn animation key positions onto your 3D program (or copy the illustrations in the 2D exercise section).

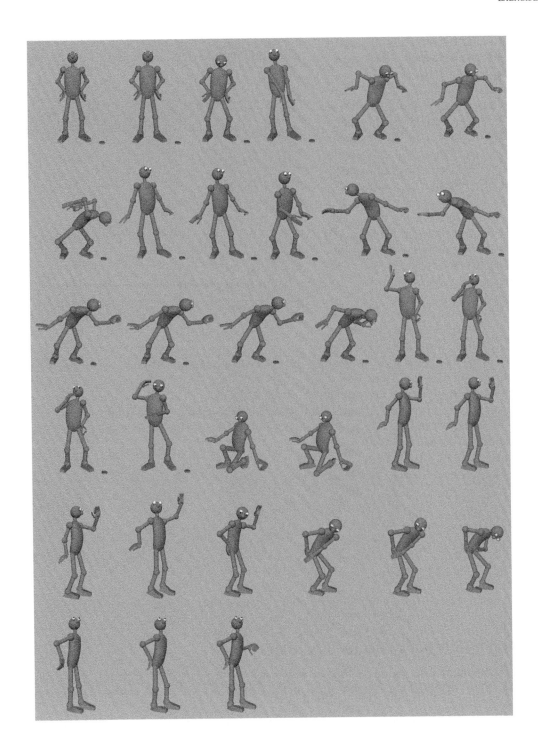

Take a look at 'coin_keys_3D.avi' in Chapter 9 on the website. The movement during the sequence is close to being as it should. However, there are some important faults. The movement/dynamics throughout the scene is slightly too even and the character seems to sway around at the points where it should be making only a small amount of movement (e.g. where the character looks off screen and at the point where it looks at the coin). The legs also act very strangely. Go through the animated sequence inserting further keys at the positions of the breakdowns (the major in-betweens), between the keys you have already set.

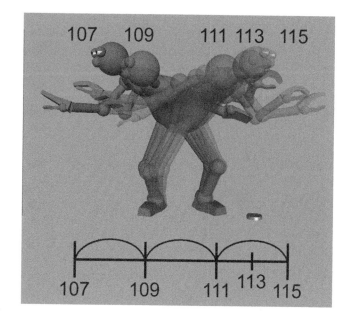

At the points in the animation where the character should only move slightly, flatten out the animation curves to make them linear. This will take out the swaying motion. Finally, when this is working, go back and animate the hands and fingers, the eye blinks and the swivelling of the feet on the ground. It's often best to animate the hands straight ahead.

You could even have a go at making a pocket out of a sphere. Shape it like a cup and make it appear as the character opens its pocket. Scale it as the coin is thrust into it and make it disappear as the character's hand lets go of it.

Take a look at 'coin_3D.avi' in animation009, Chapter 9 on the website.

Building a More Sophisticated Character

Because modelling and rigging a more sophisticated character is quite difficult, I've stuck to the fundamentals. You should be consulting the manual that came with your software while constructing your character.

I've built a character called Jenny, who you can open up in Maya or 3D Studio Max and have a go at animating. Video tutorials on the website show how to build her. I've also supplied a headless version of her, so you could just build a head and stick it on her body.

The first thing to do when building an animated character is to think about what motivates the character. So, work through the seven questions of character and work out which Laban 'efforts' suit the character and list those as well. Then work out the practicalities. Think about what your character will need to do during the piece of animation that you are going to create and make sure the character is going to be able to do it. For example, if your character needs to reach up to a high shelf, will their arms raise above their head? Are the arms long enough to reach? Will the hands be able to pick up the thing they are trying to reach? Make lots of lists.

Next, put together a mood board. A mood board can be the cork board above your desk or a bit of cardboard with things stuck to it that will inspire you in the creation of your character. These could be illustrations from magazines, postcards, photocopies, printouts from web sites or fast food paper bags – anything! As well as the shape of your character, you need to think about the colors, textures and feel of the character and the movie they are going to be in. It's always better to have all this reference stuff where you can see it all the time, rather than on a computer where you will have to go to a certain amount of trouble to open up a file and you won't be able to see everything at once.

Then, draw, draw, draw. Fill up sketchbooks. Draw on paper napkins at restaurants. Have a sketchpad with you when you go to bed so that, if inspiration does strike, you can jot it down. Drawing this character in every shape, form, mood and position you can think of. Live and breathe the character. Do a drawing as if your character is drawing it. The clearer idea you have of what your character looks like and how they are made up mentally and emotionally, the better your model of that character will be. Don't worry if a lot of your drawings are no good. The sooner you get the bad drawings out of the way, the sooner the good ones will turn up!

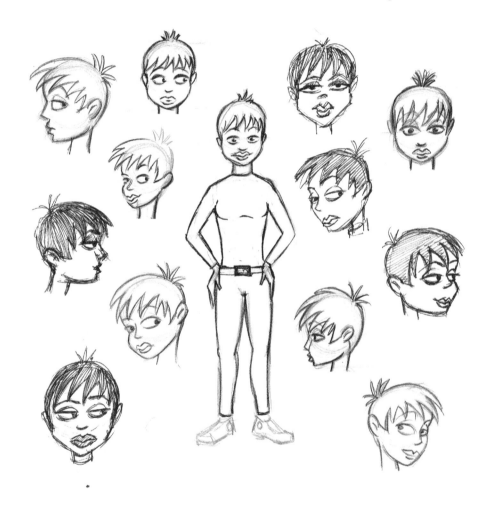

Have a go at making your character in modelling clay. A 3D model will give a better idea of what kind of silhouettes the character will produce and also help you iron out any awkward shapes. Rounded shapes seem to move better through space than angular shapes and tall, thin characters tend to produce better silhouettes than short, fat ones. Bear in mind that most of the

best 3D animated characters you have seen in movies would have been sculpted in clay first and then scanned into the computer. They would then have been 'cleaned up' and tweaked to make them look better.

Finally, draw up a plan and elevation diagram of your character – straight-on front and straight-on side views. We are going to scan this into the computer as a .jpeg and set it up in the 3D environment. It will then be used as reference for your model. Stick the arms out to the side (all 3D models seem to be built this way).

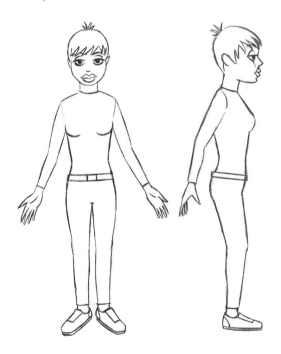

Make sure that the plan and elevation views of your character match up correctly. The top of the eye, the bottom of the chin, the bridge of the nose, the arms, the legs and so on should line up.

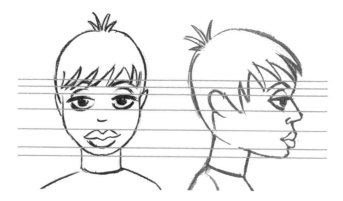

Next learn some anatomy. Look at how a face is constructed in terms of muscles and bones.

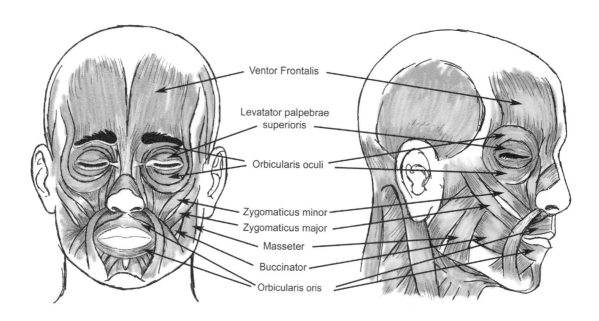

You then need to draw the structure on your character in the form of four-sided shapes (quads) within a wireframe (also known as the topology). This is so that, when we start creating a model, we know where to position the mesh. You need to follow the natural creases of the face and body

and take into account the muscles underneath the skin. You only need to do this for the front of the face, but put some creases on the side of the face as well. You will need to work out the front, back and sides of the body.

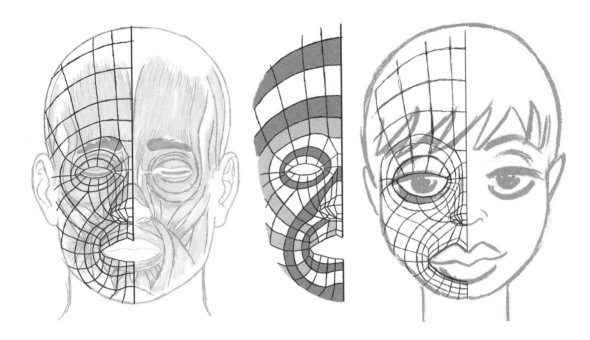

After all of this, you can finally switch on your computer. When building your character think how you can divide it up into bits. It's always going to be a lot easier to work on small bits one at a time rather than a whole character. So, the head can be one part of the model, the torso another, the arms another and so on. Think of them like those children's toys that have one piece of colored plastic for the head, another piece for the hair and so on.

The reason why this makes life so much easier is that you can apply a texture or color to each individual component, rather than having to paint a huge complicated texture map to apply to the whole character.

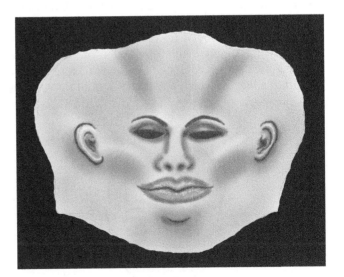

Scan in your plan and elevation drawings. Import them into your program and arrange them just off the center of the screen so that you can build your model in the middle.

When it comes to building your character it's probably best to start with the head. This is the part that will require the most time and patience to get right and it's also the most important part for your audience. Although the body is the most important part in terms of conveying the general mood of the character, the face tends to be the part we are all drawn to look at to get an idea of what is going

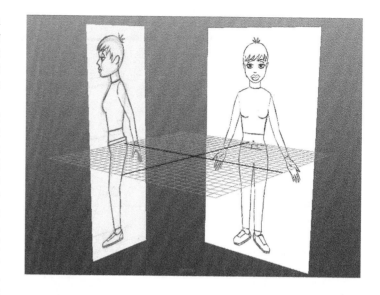

in the character's head. So, it's a good idea to get it right. The minimum we need to get over all the emotions that are possible is two eyes (with eyelids), two eyebrows and a mouth. Of course, it's also nice to have a nose that can be moved a bit, cheeks to help emphasise expressions, a forehead that will produce good frown lines and a moving jaw to help with bigger expressions. However, I would always keep everything as simple as possible to make life easier for you and your audience. The more detail there is, the more work there is for you when modelling and animating and the more chance that your audience will get confused by the complexity.

To create the head, you have two options. Either use a sphere and pull and push points around until you have a shape that resembles your character's head or use 'patch' modelling. Patch modelling is where you build up the shape of the character's head one line or one square at a time. Starting with a sphere tends to be better for more simple, cartoon-type characters that have simple expressions. Patch modelling is better for more realistic characters as it allows you to take into account the way in which a real face is built up with the muscles under the skin.

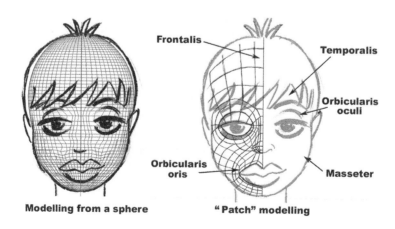

Modelling from a sphere "Patch" modelling

You will need to push a certain amount of the mesh inside the head to create a mouth. Within this you could put a separate tongue and teeth and link them to the head (make them children of the head).

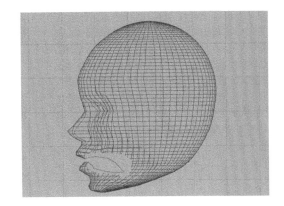

Once the head is done, think about whether you want to put on the eyebrows as part of the mesh and paint them on the texture map that you apply to the head, or whether you want to make them as separate shapes and link them to the head. The eyes can be created simply as white spheres with squashed black spheres attached to them for pupils. Alternatively, if you want something more realistic, get a sphere and squash one side of it flat. On this place a disk that is colored or has a texture map on it, which will be the iris. On top of this place a small black disk that will be the pupil, and finally on this place another

smaller sphere that is squashed flat at the side for the lens. Have it so that this sphere is rendered see-through. You can control the size of the pupil by scaling the back disk bigger and smaller. Make all the parts children of the larger white sphere and in turn make this a child of the head.

When it comes to the body, try to think about where it can be divided into bits. You will have to model the torso, the arms and the legs as two halves (back and front) and join them together (the arms and legs can be separate from the torso and, if your character is wearing a t-shirt, the seam at the sleeve could be where they join). The top could be sleeveless and the arms join at the shoulders. If the shirt has long sleeves, don't go to the trouble of making an arm to go inside. Just make a sleeved arm and then build a separate hand to pop in the bottom of the sleeve. The more you plan these things out at the start, the easier it will be when it comes to modelling. Model the skirt, trousers or shorts separately from the top and model the legs (however much you are showing of them) separately as well.

If you want to make a model with complex topology, draw out the quads of the mesh first on your design and then create the mesh on top of your design in Maya or Max. It's a good idea to create one mesh for the front of the body and one for the back and then join them together.

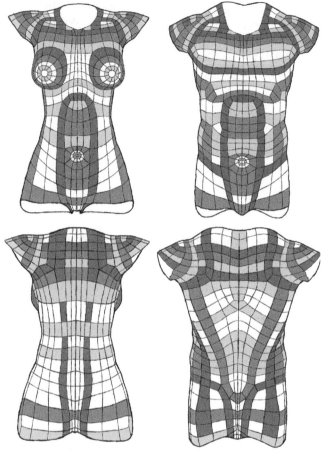

Make the topology as simple as possible and construct it as parts that can be joined together like a plastic model kit.

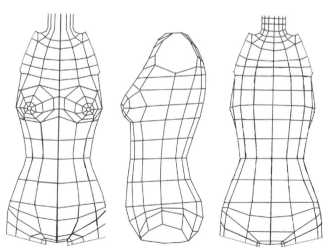

Great care has to be taken when sorting out the elbows and knees. It's at this point that the limbs will bend and, in order to avoid that bent hose pipe look, you will have to make sure that there is plenty of mesh at these joints and that you have weighted all the points correctly when you rig the model.

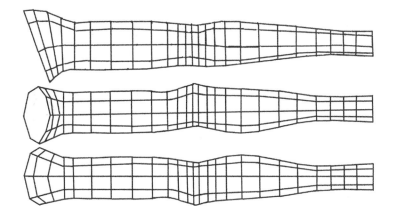

If your character's feet are in shoes, just model a shoe and stick it on the ankle.

When it comes to the hands, as always, simplicity is the key. You may have noticed that in a lot of drawn cartoons the characters only have three fingers and a thumb. The main reason for this is that it's less work to draw three fingers than four and also you can do anything you want with only three fingers (two fingers looks weird). In the 3D world you can make a character with four fingers (and a realistic three-fingered human character would look rather odd) but it will be more work to model and animate. In my example I've kept the fingers separate from the palm of the hand to make life easier with modelling and weighting.

When it comes to rigging your character, again keep it as simple as possible. You could copy the basic rig I did for my man character. All I would change is to make the joint for the ankle a bit higher (because this joint is not flat on the ground in a human being). Add some more bones for the fingers and I would also add some handles to each of the backbones, the neck joints, the head joint, the eyelids and the shoulder joints, just to make them easier to select on the screen.

You could have a go at scripting and expressions and stuff like that (programming that can help with some movements), but that is a path I have chosen not to go down (I want to be an animator not a technical director).

Always test your character out on a couple of scenes before you start animating in earnest and be prepared for it to fall to bits at any time. I will go into more sophisticated facial expressions in Chapter 12.

Take a look at the Chapter 9 folder on the website. I have included some movie tutorials on how to build a head and body and there is also a model for you to play with.

It is possible to download a lot of excellent models from the Internet these days, all for free. If you want to learn how to animate, it might be better to stick to animating a downloaded model rather than spending a lot of time building one.

Specific exercises on building a more sophisticated character in Maya and 3D Studio Max can be found on the book's website, www.charactermation.com.

Animation of Acting – Facial Expressions

Humans have the most expressive face in the animal kingdom. With a combination of eight basic expressions we can pull around 5000 different faces, all with slightly different meanings. The majority of these expressions are universal to all human cultures.

The face is used as a signpost to other people. It shows how we are feeling and what we want, or can be used to mask the way we feel. Almost half of our brain is concerned with seeing and almost half of this part of the brain is dedicated to recognising human faces and facial expressions. When we look at someone, we study the face. We look at the eyes, the eyebrows, the lips and the forehead. They give out a combination of signals that provides us with the information to form an opinion as to what the owner of the face is thinking.

When animating your character, because facial expressions can be very ambiguous and misleading, it is always best to work out the body language first and then add the facial expressions. I have deliberately kept the illustrations and examples in this chapter as simple as possible. It's up to you to act out these emotions in a mirror to elaborate on them.

Emotions

Facial expressions are the ultimate demonstration of our emotions. We use the face to broadcast and communicate our emotions. Facial expressions are caused by the contraction and relaxation of the facial muscles.

Facial expressions result from somebody hearing something, seeing something, smelling something, tasting something, feeling something or thinking something. As a character goes through a

scene, the facial expression will change depending on these stimuli. Think of each facial expression as a key position and animate between them and hold them as necessary.

On the most simplistic level, there are eight basic emotions: happiness, sadness, surprise, fear, anger, disgust/contempt, interest and pain.

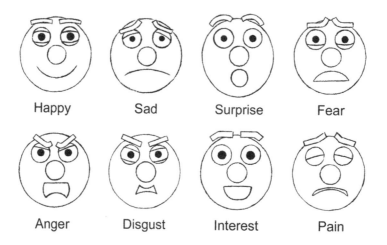

These are inherited, not learnt. Each of the basic emotions has an appropriate facial expression to display it. These are common to all human cultures. Some variations of these expressions are culturally specific and learnt.

A combination of these basic facial expressions can appear on the face at the same time, for example happiness and surprise. All of the basic facial expressions can also be varied, depending on the intensity of the emotion portrayed.

The design of a character could emphasise a certain emotion. A down-turned mouth will make your character look morose, sad, angry or irritable. Heavy-set eyebrows can produce the same effect. When this character displays an emotion other than the overriding emotion suggested by the design, the new emotion must be exaggerated to make up for the character's design.

True facial expressions are involuntary and display the emotion being felt by the character. They tend not to be held for long periods and flit across the face as the person changes mood. False expressions convey something other than how the character is feeling. Actors, liars, con artists and sales people, for example, use false expressions to varying degrees. These false expressions can take the form of a character putting on a neutral face when a deep emotion is felt: for example, a poker face when holding a royal flush!

Another example of a false expression is an emotion that is simulated when none is felt: for example, the sincere face of a used car salesman.

One further example of a false expression is one that covers up the true emotion felt underneath: for example, smiling when you want to cry.

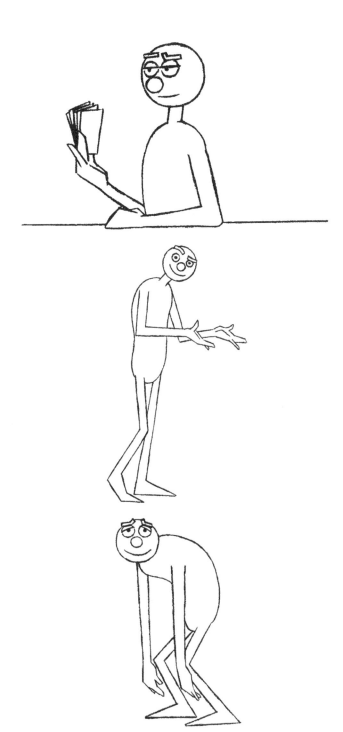

Sometimes in animation we tend to only include 'readable' or 'appealing' facial expressions; however, it's useful to include neutral – almost undistinguishable – expressions to complement these.

The Eyes

It is commonly said that the eyes are the windows of the soul, and the main feature that makes a character seem alive is its eyes. If the eyes are not focusing on something, your character will look like a groggy doll. Always give your character something to look at, either on screen or off. The only times your character will not be looking at something are when their eyes are glazed and looking into the mid distance or they have crossed eyes (when they are thinking or have been drugged or knocked out and are dazed).

The eyes will lead all movement of the face and body. When a character looks off screen, the eyes move first, then the head, then the shoulders and then the body will twist at the waist.

Following are some examples of emotions and the different looks connected with them. When a character is thinking, they could look heaven-ward for inspiration or down at the ground when searching for an idea.

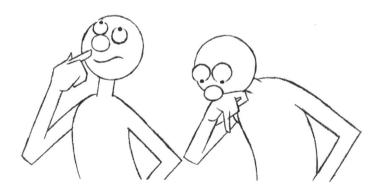

When a character sees something that they like or love, the pupils of the eyes will dilate (they will get bigger). This will also make the character look more attractive or cute.

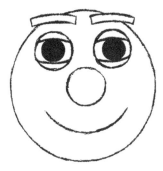

When a character is frightened, the pupils will contract into tiny pinpoints. This also happen when a character is evil, hates something or is untrustworthy.

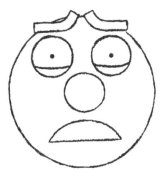

When a character is surprised, the eyes will bulge, emphasising the whites of the eyes.

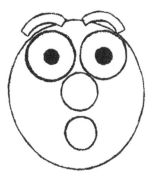

When a character is shifty and evil and appears to be happy, smiling and laughing, the eyes will narrow, reducing how much of the white of the eyes are visible.

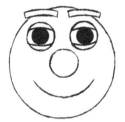 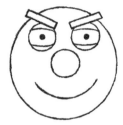

When a character is feeling sexy and wants to give a sexy look, the upper eyelid is lowered and almost cuts the eye in half. The head is usually turned away from what it is looking at. Combine this with fully dilated pupils for maximum affect.

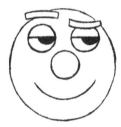 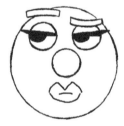

The two main functions of a blink are to clean the eyes and to protect them from danger. When we blink we shut our eyes in different ways to portray different emotions. A baby will blink infrequently and with a slow opening and shutting of the eyes. The opening and shutting will look very deliberate. Combine this with a direct stare and large pupils and you have a cute, loving look. This can be replicated by adults that are in love with the object they are looking at.

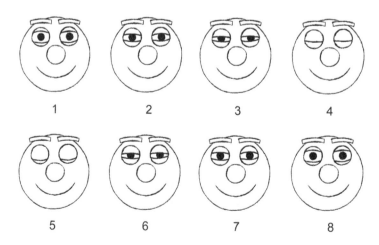

With a standard blink, the eyelid will close slowly and open quickly. By making the eyelids pop open quickly, the character looks alive and awake.

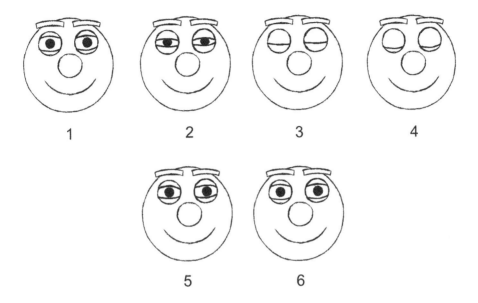

When somebody is sleepy or not very bright, the eyelids will shut slowly and open very slowly, with a lot of drag on the lids. This gives the impression that opening the eyes is a huge effort.

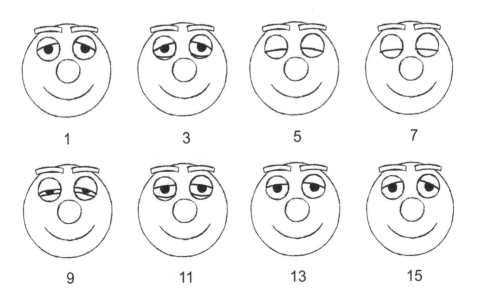

A real cliché when it comes to blinking is the fluttering of eyelashes. This happens when a feminine character tries to look attractive and get the attention of another character. The eyelids will open and close quickly with the (elongated) eyelashes following though in an exaggerated manner.

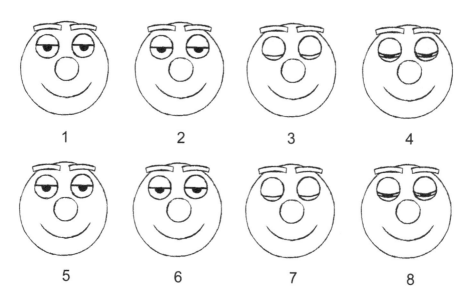

When drawing the eyes (or building them in 3D), make sure you take into consideration the fact that the pupil and the iris have a convex lens in front of them called the cornea.

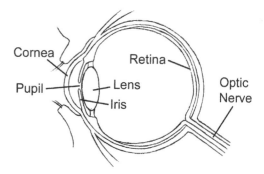

To illustrate this in drawn animation, when your character is looking to the side (for example), draw the pupil slightly through the outer line of the eye rather than on the inside of it. This will give more 'direction' to the look and make the eyes seem more 3D. The exaggeration will also make the drawing look more cartoon-like.

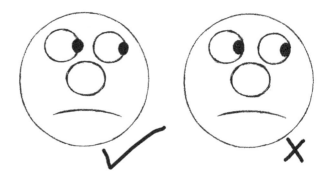

Facial Expressions

The facial expressions that portray the eight basic emotions are happiness, sadness, surprise, fear, anger, disgust/contempt, interest and pain.

Happiness

There are different degrees of happiness, ranging from mild amusement through to ecstatic laughter.

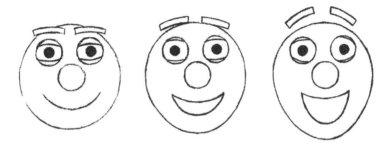

Smiles

The eyebrows on a normal smile will be raised evenly. The corners of the mouth will be raised, symmetrically, into a smile. This can be with the mouth open or closed. With the mouth closed, the lips narrow and are stretched over the teeth and gums. With the mouth open, the teeth can be closed, exposing the teeth and gums, or open, with the jaw dropped. Each of these mouth positions makes the emotion expressed more intense. The gap between the top lip and the bottom of the nose narrows. The lips become thinner as they are stretched.

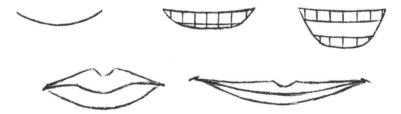

Furrows appear between the corners of the mouth and the nostrils on either side of the face, making the cheeks puff upwards and outwards. Depending on the width of the smile, a furrow can form between the corners of the mouth and the chin on both sides of the face.

Crow's feet form on the outside of each eye. A muscle around the eye contracts, making the skin underneath it puff out. This narrows the eyes. The pupils dilate to suggest that the character likes what they are seeing or feeling. The ears can also move upwards.

In a false smile, the lips and eyebrows may be slightly asymmetrical. The muscles around the eyes don't contract so there are no crow's feet and no puffing of the skin under the eyes. It's a good idea to use asymmetrical facial expressions, to make the face seem more believable. This is commonly forgotten by some animators, especially students.

If the eyebrows are angled downwards and inwards, you get an evil smile. With this smile you could contract the pupils to make the character look more sinister.

If you angle the eyebrows downwards and outwards, you get a forlorn, 'sad' smile.

Sadness

Sadness can range from disappointment through to crying with despair.

The inner ends of the eyebrows will be raised and the outer ends lowered. This pushes the outer edge of the eye socket over the eyes. The upper eyelids may drop slightly. There will be concave furrows on the forehead.

The corners of the mouth will be turned down, causing two furrows to run downwards from the nostrils to the chin via the corners of the mouth. The lower lip could be pushed upwards and outwards, increasing this downturn. This can be accompanied by a depression immediately under the lip. This is particularly apt for the face of a sad baby.

The jaw can be dropped while the lips are still shut, giving your character a 'long face'. The mouth could open, especially during crying. Another thing that looks good is to make the bottom lip quiver.

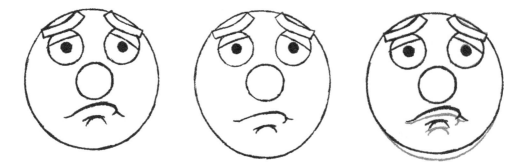

When a character is sad, the eyes may look downwards. During crying, the eyes will be closed or almost closed. If a character looks to one side when sad, the pupils could move slower.

False sadness could be given away by a slight curling up of the corners of the mouth, crow's feet appearing at the outer corners of the eyes, puffy bags at the bottom of the eyes and an irregularity of the eyebrows.

Surprise

Surprise can range from slight surprise through to amazement. If the mouth has a smile, you get a look of delight.

The eyebrows will be raised high above the eyes and the forehead will be furrowed. The eyeballs will bulge out, making the eyes look bigger. The eyes tend to stay fixed on the object that has surprised the character.

The mouth will usually be open with the jaw dropped, and will take on an oval or round shape. When the character is first surprised there will be an anticipation move and then a rapid movement of the head back and a blinking of the eyes. The head may also shake from side to side.

False surprise will be similar to the above but the movement will be slightly delayed. There may first be a slight look followed by the reaction. When animated, the surprised look could be held slightly too long. The mouth could be squared off, as if it's being held open deliberately, and the eyebrows could be uneven. The pupils will not be able to keep their look fixed on the object of the surprise.

Fear

Fear can vary from apprehension through worry to shock and plain terror. The mouth will be open with the jaw dropped and the corners of the mouth pulled outwards and downwards.

The eyebrows will be drawn together and raised and vertical lines will form on the forehead. Both the upper and lower eyelids will be raised, the lower eyelid being tense, pulling it straight across the eye. The pupils could be dilated and the eyes will tend to be locked onto what they are frightened of.

Generally there will be a large amount of movement of the body and head through the main fear pose. Mock fear could involve an 'over the top' face and body pose but the character staying still. The eyes may move more erratically.

Anger

Anger can range from slight irritation to blind fury.

The inner ends of the eyebrows will be pulled inwards and downwards. There will also be a fold of skin between the eyebrows. The eyebrows will press down onto the eyes. The eyelids could narrow or the eyes could bulge. The pupils could be contracted into tiny pinholes.

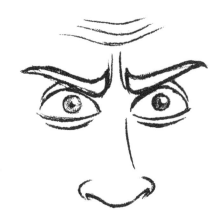

The nostrils can get bigger and flare out, and the baring of the teeth is considered a sign of aggression. The mouth could be closed with the lips pressed hard together and the mouth narrow. This tends to suggest suppressed anger. The mouth could be open with the teeth clamped together and the mouth squared off or in a frown shape. The jaw could also be dropped with the teeth apart.

343

Sometimes it can be effective to make the character's face and body vibrate or shake, as if with suppressed rage. This can be done with the head either staying on the spot or following a path up and away from, or down and towards, what the character is looking at. Draw two key positions and in-between them evenly. Stagger their shooting.

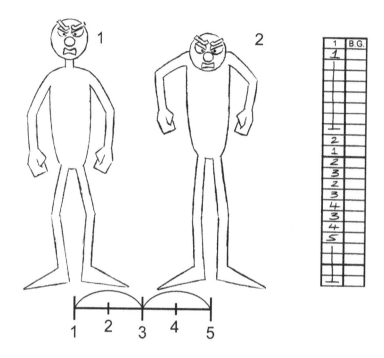

A false display of anger will involve this expression being 'forced' onto the face. The mouth and eyebrows may be crooked. The character won't be able to keep this face up for long and, hopefully, will collapse into a fit of giggles or a big smile.

Disgust and Contempt

Disgust and contempt can range from dislike through to nausea.

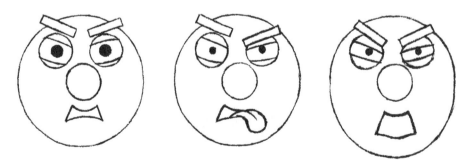

The head will be pulled away from the object of disgust with the chin tucked into the neck or body. The eyebrows will be lowered and pulled together horizontally. This causes wrinkles to form around the bridge of the nose and on the insides of the eyes. The eyes are narrowed and the pupils are contracted.

One or both corners of the upper lip can be raised (raising one corner of the lip gives a more contemptuous look). This makes the furrow between the nose and the chin take on a squared-off shape. If the mouth remains closed, the lips will be pressed tightly together.

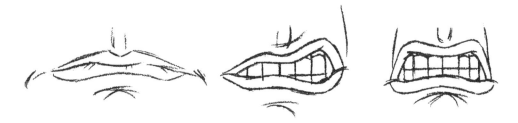

With a false look of contempt, the character needs to occasionally slip slightly out of the contemptuous look.

Interest

Interest can take many forms: alertness, attentiveness, expectancy or anticipation. It's really an elaboration of other expressions, and interest and excitement are usually accompanied by another facial expression, such as surprise or happiness.

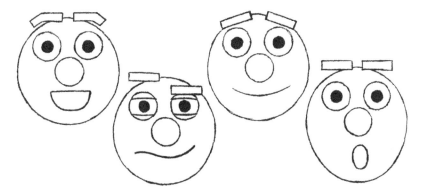

The eyebrows can be raised, producing a furrowed forehead, and they could be brought together. One of the eyebrows could be higher than the other. The pupils could dilate and will always stare unblinkingly at the object of interest. The eyebrows are positioned similarly to the surprised facial expressions but the mouth usually has a smile.

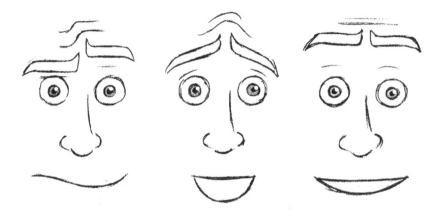

The head could be brought forwards and even put onto one side.

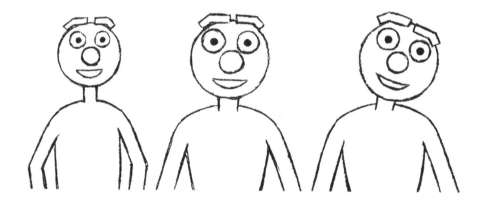

The opposite of interest is boredom. The face becomes relaxed and unanimated: the eyes droop and look up or straight ahead, not focusing on anything. The whole upper body may lean forwards until the character catches themselves and moves suddenly back to an upright position. The character could also fiddle with things to occupy them. Yawning is a good sign of boredom.

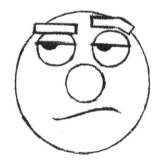

Somebody feigning interest will hold any of the poses described earlier but occasionally lapse into boredom, making any of the boredom-type gestures for a short period and then reverting to the positions of interest.

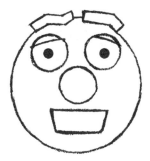

Pain and Distress

Pain and distress can range from discomfort through to extreme pain.

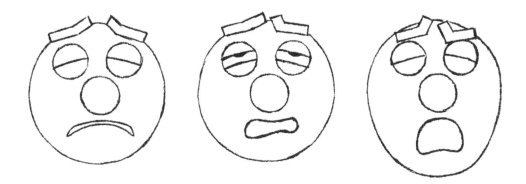

The mouth could be open and squared off, with the jaw open, or shut with the jaw tightly clenched.

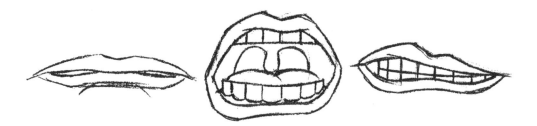

The eyebrows will be drawn together with the inner ends up and the outer ends down, or they may switch to be the other way round. The eyes will be shut for most of the time.

Generally the face will be screwed up and will move from one configuration to another while the character is feeling pain or distress. The look is almost a cross between sadness and anger. When somebody is putting on pain, they will recover remarkably quickly. Somebody in real pain will feel it for a long period of time.

Combination of Facial Expressions

As mentioned above, there are any number of combinations of these basic facial expressions happening at any one time. The illustration (on next page)shows a few examples deliberately drawn as simply as possible to allow you to see the basics of the facial expressions. The best thing to do is to watch yourself in a mirror pulling the expression you want to animate. To reinforce the point: there is nothing better than acting and observing the emotions you want to express in animation. So get acting! Don't be self-conscious. Don't worry if people think you are mad. If an audience understand your animation, you have done a good job. If it has people rolling on the floor with laughter at you, so be it!

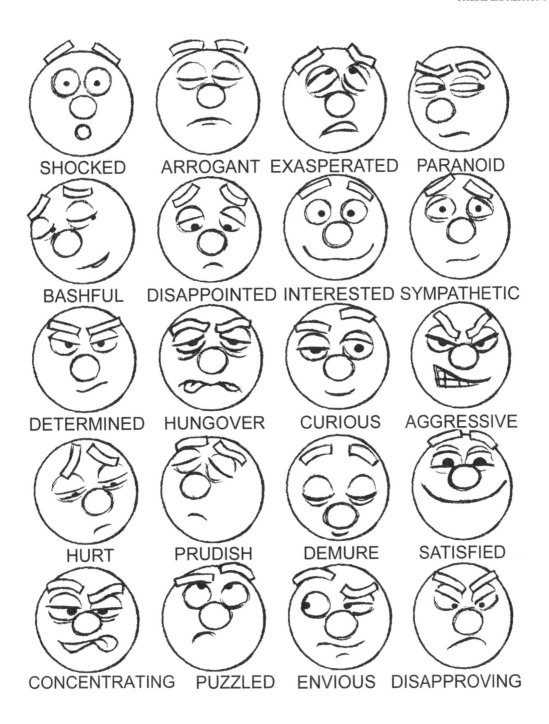

SHOCKED ARROGANT EXASPERATED PARANOID

BASHFUL DISAPPOINTED INTERESTED SYMPATHETIC

DETERMINED HUNGOVER CURIOUS AGGRESSIVE

HURT PRUDISH DEMURE SATISFIED

CONCENTRATING PUZZLED ENVIOUS DISAPPROVING

Only rarely will you see a character in an animated film directly face the camera, especially in drawn animation. It's acceptable to hold a straight-on face at the end of a movement, but when doing a head movement from one side to another do not have a drawing or image where the head is straight on to the camera. Make sure all the heads are at a slight angle.

This is because a drawing of a face that is straight on will often look different in character to one that is slightly side on. A view straight on can look open and innocent or intense. A side-on view will seem more guarded. This is also true of both puppet animation and 3D computer animation.

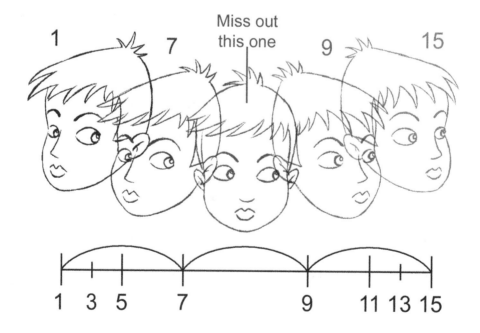

When moving a head quickly, it's fine to distort it along the path of movement, but always keep the cranium the same shape and size. Distort the cheeks, jowls and jaw. Have a look at 'distorted_head.avi', animations010, Chapter 10 on the website.

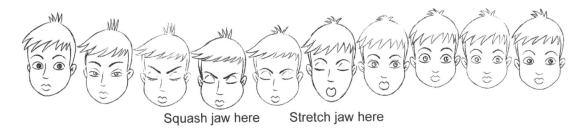

Squash jaw here Stretch jaw here

Head Angle

The head moves in an arc in relation to the neck and shoulders. The expression on the face is important but the angle of the head has to be right. Angling the head forwards but upwards indicates a willingness to engage: either the character is interested in something or wants to challenge it head on. Angling the head forwards and downwards can give an argumentative or determined look It can also give a tired or stupid impression.

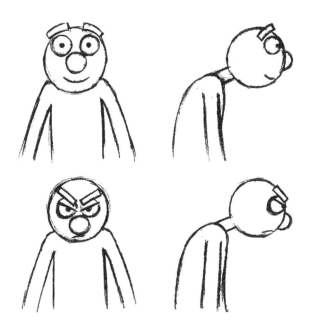

Angling the head backwards and upwards gives an arrogant or snobbish look. Angling the head backwards and downwards gives a frightened or nervous look.

Angling the head to the side can indicate that somebody is looking to one side, if the eyes are looking in the same direction as the head. It can also indicate that somebody is shy of something or interested in something but wants to cover his or her interest. If somebody is attracted to somebody else they will look at this person directly. If the attractive person looks at them they will angle the head away, but sneak a look with the eyes.

Rotating the head to one side while looking directly at somebody is an 'asking' gesture. The person doing this action wants something from the person they are looking at. This is a very deep-seated gesture that is seen a lot in young children.

Hand-to-Face Gestures

People frequently touch their faces. This will take place while they are listening to something, seeing something or feeling something; while talking to somebody during a conversation; or when contemplating something. The relevance of these gestures depends on the way they are done and the emotion being felt by the person. These gestures can be divided into the following categories: evaluation, deceit and stress.

Evaluation

If somebody is considering something, they may stroke their chin or support their face delicately.

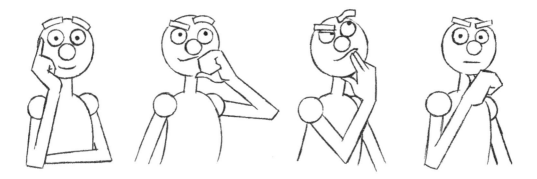

If somebody is bored, they may support their head with their hand as if their head were heavy.

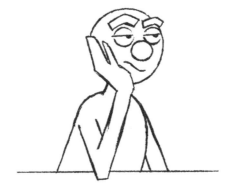

Deceit

When a young child is telling a lie, they will often cover their mouths involuntarily, as if they are trying to cover up the lie they are saying. Adults will do a similar action but will try to disguise it but turning the gesture into something else. Touching the nose or cheeks gives the impression of somebody who is being economical with the truth.

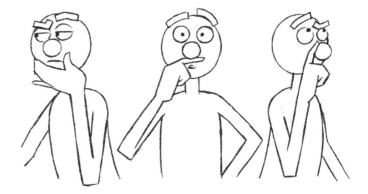

Strangely enough, if a person is hearing somebody telling a lie they may also do a mouth-cover gesture, giving the impression that they doubt what they are hearing.

If a person is rubbing their eyes, it could be because they are tired, because they want to avoid eye contact with the person they are lying to or because they don't believe what they see. The eyes may also move more erratically.

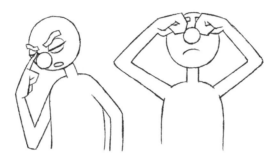

Rubbing or generally fiddling with the ears indicates that somebody doesn't believe what they are hearing or they are telling a lie.

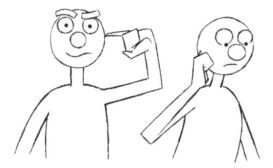

Scratching the neck or pulling the collar indicates that somebody is feeling nervous because they are telling a lie or that they are angry or frustrated.

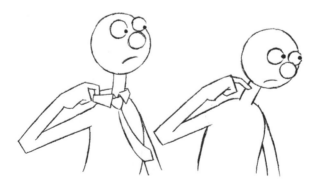

Stress

When somebody is stressed, nervous or frightened, they may stick their fingers in their mouth for comfort. Biting the finger nails is a more complicated version of this.

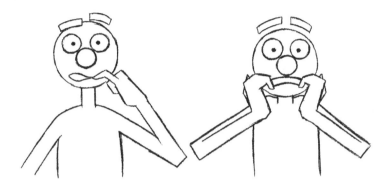

Slapping the front of the forehead, scratching the top of the head or rubbing the back of the neck are also signs of stress or frustration.

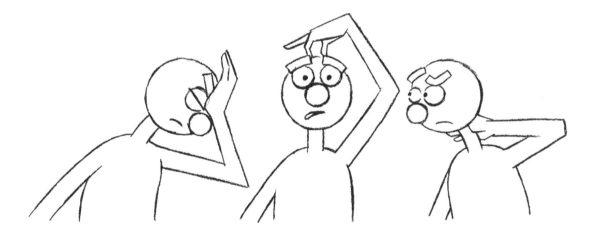

Extreme Close-Ups

In many live-action films there are often extreme close-ups of the main actors, where only the eyes and nose are in screen. These sorts of close-ups tend not to work so well in animation. With drawn animation it's difficult to decide how thick the line should be. Drawing the lines can be problematic because the audience very easily sees any inaccuracy. It is also easy for the lines to wobble and ooze. This makes an audience stop believing in your characters. With 3D computer animation, line wobble is less of a problem but close-ups of polygons, skinning or texture mapping

never look quite right and make an audience uneasy about your characters. If you must do an extreme close-up, keep it quick (less than two seconds).

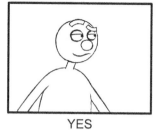 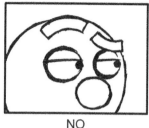

YES NO

How to Animate a Piece of Facial Acting

How do you put all of this information together? How do you make your character live and breathe and express themselves? Well, we as humans look at other people and work out what they are thinking from the signals displayed on their faces and the body language they adopt. Use this with your character. Work out what they are thinking and make their face and body language display this thought. Most of the acting your character does is in reaction to something that happens to them. They may see something, hear something or feel something and the result of that reaction will be seen on the character's face and their body language. The main thing to work out is how long an audience needs to see a facial expression for to understand what the character is thinking. So, think about your character moving from one pose to another (one facial expression to another). Think about how long they adopt each pose for and what they may do while in that pose, and vary the way the character moves into each pose.

First think about what your character has to do in a scene. Think about it for as long as possible. If you can go out for a walk or have a cup of coffee while thinking, do it! Act it out in front of a mirror or videotape yourself (or, if you are very persuasive, somebody else). When you have decided what your character has to do, write it down, in list form, in as simplistic a way as possible. Write down the minimum that your character has to do to make the scene understandable to an audience (when you start animating you can elaborate on it). Make some notes about how many frames each of these poses needs to be seen for. If you're not sure, guess.

1. A character is sat center screen. He has a sad look on his face.

2. He notices something screen right (his eyes look screen right)

3. He looks screen right with a happy look on his face.

4. As he is looking screen right his expression changes to a look of horror and he leans back.

5. He then looks back to camera with an angry look on his face.

You could write this directly onto an X-sheet in the action column, marking the frame where each of the poses takes place. If you're not confident enough with your timing, shoot the drawings first and then make changes. When you are happy with the timing, write everything down on an X-sheet. (Whether you use X-sheets or not, always note down your timings. There is no way that you will be able to keep all this information in your head and animate.) Once you've sorted out this list, do a drawing that illustrates each of the items on the list. Just make these very rough thumbnail sketches.

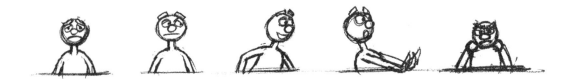

Shoot this collection of thumbnail drawings as a 'pose test' on a line tester (take a look at 'acting072_thumbs.avi' and 'acting073_thumbs.avi', animations010, Chapter 10 on the website). Vary the number of frames that each of the pose drawings is held for until it works as a pose test (i.e. the audience has just enough time to clearly understand what each of the facial expressions is and means). Mark this on an X-sheet (slug it out). Then draw each of the drawings full size (or blow them up on a photocopier). Now you can start animating them. Think about how long the audience needs to register an expression (a minimum of half a second). Always keep thinking of your audience and whether they will understand what is going on. Draw all the key positions. These are the poses where the character adopts a posture and facial expression. Do a key position at the start of these poses and one at the end, just before you anticipate into another pose. If a character does something while in this pose (looking at a watch, for example) sort out key positions for this action. Do the anticipation keys out of a pose and the overshoot keys into the next pose. When they are done, shoot them on a line tester and fiddle with the timing again.

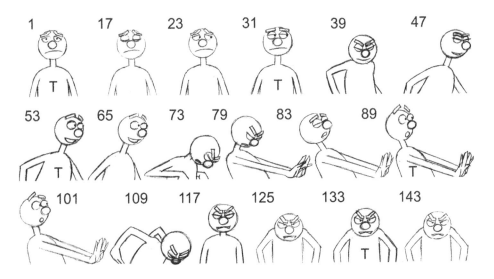

The subtlety of the animation depends on the positions of the anticipation keys and the speed and arcs of the in-betweens. In the illustrations (on previous page and below), I've used the same basic key positions as the thumbnail sketches (those positions marked with a 'T') but changed the number of frames between these major keys. I have also changed the anticipation and overshoot keys. The illustration (on previous page) has quite extreme anticipation and overshoot positions and moves between these positions quickly (fewer frames). As such, it has a sharper 'pose-to-pose' feel. The illustration below has much less extreme anticipation and overshoot positions and the movement between these keys is slower (more frames). This gives it a more 'full animation' look.

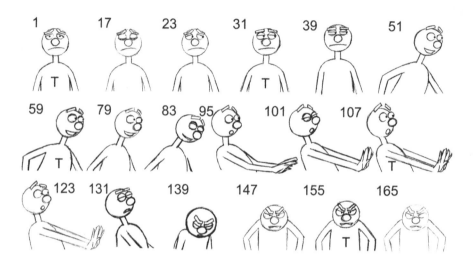

Take a look at 'acting072_keys.avi', animations010, Chapter 10 on the website to see the timing of the first version. Then take a look at 'acting073_keys.avi', animations010, Chapter 10 on the website to see the timing of the second version.

When you reach each of the expression poses, don't just have your character staying stock-still. This will make your character look dead. Give your character something to do when in each of these poses. One of the best things to do

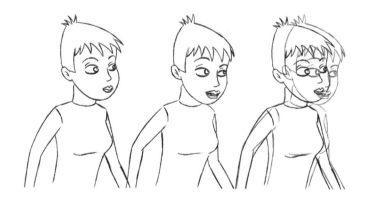

is to slightly change the expression on the character's face. For example, when the character sees something and moves into a pose where they look happy, have the character slowly move forwards slightly and increase the size of their smile.

This technique can be used with all facial expressions within a pose. You could go from a small expression to a larger one, a large expression to a smaller one or from one expression to another.

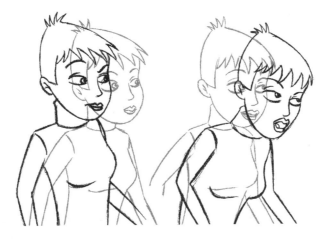

It's always a good idea to move the head and upper body slightly in these instances. Keeping the head clamped to the spot will look stiff and wooden. Remember that almost everything moves in arcs and a lot of the movement of the upper body stems from the base of the spine. Don't just move the head on its own without some shoulder and upper-body movement. In order to compensate for the movement at the top of the body, the legs will have to bend and shift to maintain the correct balance. So, even a simple look to the side of the screen may result in the whole body moving.

In a situation where your character is moving while pulling a facial expression that the audience needs to see, you have to keep the expression the same while the character is moving and hold that expression for longer. Don't try to change the expression on the character's face because there is

already a lot going on and your audience won't register the change. This is called a moving hold. Moving holds aren't limited to the face. The hands could stay in the same position (e.g. when the character is pointing) while the rest of the body is doing something else.

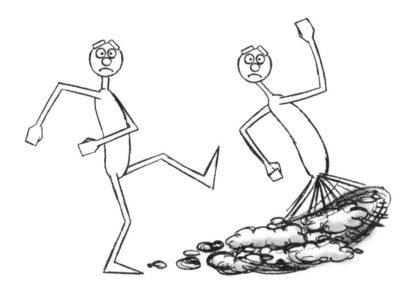

Another way to make sure an audience sees an expression (e.g. when a character is falling out of screen and is looking at the audience) is to move the head slightly as the body moves rapidly. This gives an impression of the head being left behind while the neck stretches. When the audience has had enough time to see the face (8 to 12 frames), it then zooms out of screen after its body.

What happens when your character is constantly moving in a scene and there isn't time to adopt any poses? When you have to cram many facial expressions into a small amount of time, you will need to 'snap' the facial expressions from one to the other as the character moves. You need to ensure the audience has enough time to register each expression during the movement. In simple terms, this uses several moving holds in a row. If you make the character screw their face up from one expression and then pop it out into another, this can work well.

Anticipation and overshoot can be used within the face to get from one facial expression to another. For example, if a character is happy and they see something that makes them sad, their happy expression could first become more happy (bigger smile, narrower eyes, more crow's feet) and then move into a frown. Make the frown slightly more exaggerated to start with and then tone it down a bit during the pose.

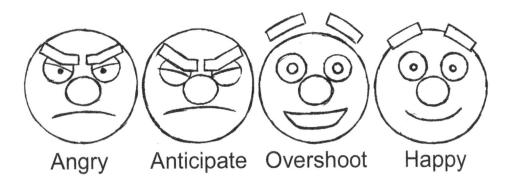

Angry Anticipate Overshoot Happy

One of the main problems with sorting out the poses first and then completing the in-betweens is that you can end up with a rather stiff and wooden, 'clunky' piece of animation. One way around this is to use your pose drawings as a 'marker post' to aim for and animate everything straight ahead, hopefully ending up at points roughly the same as your pose drawings. If the pose drawings have to be changed slightly, so be it. Animate everything in rough first.

Exercises

The Facial Expression Exercise in 2D

One of the simplest exercises to explore facial expressions is as follows: a person is sat center screen, facing towards us, with just his head and shoulders in view. He sees something off screen and pulls a facial expression as a result of what he's seen. He then realises that it's not quite what it seems and changes his expression as a result. He then looks back at the camera with another expression.

Work out a list of what the character will do and then draw a series of thumbnail sketches and test them (as outlined above). Slug out the basic timing onto an X-sheet and draw the thumbnails full size, adding extra key positions for anticipations, overshoots and held poses. Work out the timing charts so you have a reminder of how to in-between the keys. Then complete the in-betweens.

Here is one interpretation of this scenario (I've deliberately made it very 'over the top'). First draw a series of thumbnail sketches. Have a look at the thumbnail sketches and the series of pose drawings (on previous page). The following exercise uses the first set of 18 drawings (on previous page) as a guide.

Start with our character center screen, looking sad. He blinks and glances to screen right.

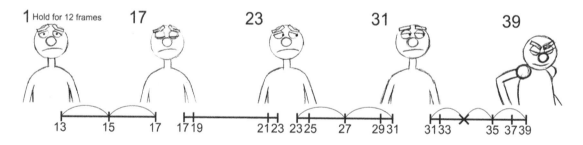

He does a double take and looks screen right with a happy look on his face.

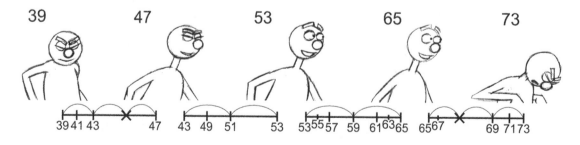

He then recoils back in shock.

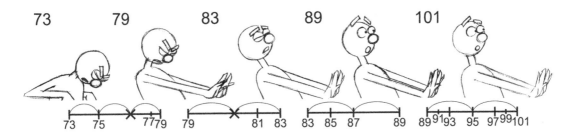

He then turns back towards the camera with an angry look on his face, fuming.

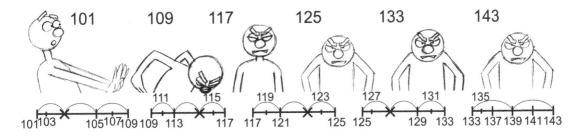

Take a look at 'acting072_2D.avi' in animation010, Chapter 10 on the website.

It may help you to think about what your character has seen and why they have reacted in this way. In the example above, the man has seen an ice cream van and smiled at the thought of getting an ice cream. He then notices the extortionate price of the ice cream and recoils back in horror. He finally looks at us angrily because he can't afford one.

Following are some other suggestions for close-up exercises:

1. A character is sat center screen holding a telephone, listening to the receiver (make it a mobile phone – no wires to worry about). Depending on what the character hears, his or her facial expression changes from one look to another. Do about four facial expressions and use expressive body language to augment these.

2. A character is sat at a table waiting to be served a meal. It is taking a long time to turn up so he is annoyed. He looks to one side to see his plate placed in front of him. He looks down at the plate with a happy expression and licks his lips. He forks up a portion of food and pops it into his mouth with a look of ecstasy on his face and starts chewing. His face turns to one of disgust as he realises that the food tastes awful. He spits the food out and looks angrily in the direction that the food came from.

3. A character tries to attract somebody's attention off screen (make it to one side of the screen or the other – it's much more difficult to do this towards the camera). They may be waving and smiling or looking angry and waving their fist (anything you want). The character is ignored by the person off screen and reacts as a result of being ignored. They may get angry (or angrier) or become sad or nonchalant (again, it's up to you).

4. A character is trying to complete a complicated task, for example build a house of cards. As they place one set of cards against another there is a look of concentration on their face. When they place the final two cards at the top, they have a look of triumph. They might then sneeze and blow the house down and end with a fed-up look on their face. Think about there being three major facial expressions.

5. A character could be sat watching television and react to what they see and hear. Again think of three facial expressions and how to get from one to another.

The Facial Expression Exercise in 3D

There are two ways of animating facial expressions in 3D. You can put bones into the head and make each of the bones operate a distinct feature on the face (e.g. the corner of the mouth). It's as if a bone is replicating one of the muscles of the face. This method can be quite confusing because there is a vast number of muscles in the face and you could end up having hundreds of bones and trying to control them all. I think of this method as being like puppetry, with the bones opening and shutting the mouth like the fingers of a puppeteer operating a glove puppet.

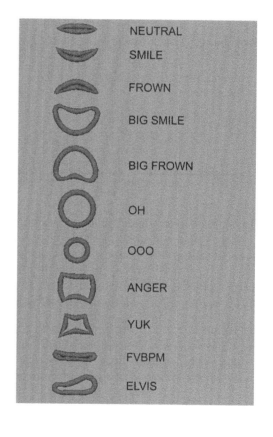

The other method is to build one head (or mouth) and then copy it and re-model it so it is pulling a new facial (or mouth) expression. Save this head, copy the original head and then give this third head another expression. Continue doing this until you have enough facial expressions to do the piece of animation you want to do. You then get your program to 'morph' from one facial expression to another, saving keys as you go. This can make the face look as if it is 'oozing' from one expression to another if it is not done right and if you aren't thorough it is easy to miss one expression. However, this is the most popular method profession-

ally. I think of this method as being similar to model stop-frame animation, in which several heads are replaced one after the other depending on what facial expression is required. It's also similar to clay animation, where each facial expression is sculpted from one frame to the next.

The model on the website is built using the morphing method and in order to keep it as simple as possible it consists of a 'stick-on' mouth that is morphed from one shape to another.

Copy the folder that contains your model ('mayaman_mouth' or 'maxman_mouth') onto the C: drive of your computer. Load up 'mayaman_mouth.mb' (Maya) or 'maxman_mouth.max' (3D Studio Max). These are in the folder 'man_mouth_models', in Chapter 10 on the website.

The model is basically the same as the model of the man we used earlier but with a mouth and eyebrows. The mouth can be morphed to produce different mouth shapes (each program uses a slightly different method) and the eyebrows are moved by bones inside them. I'll go into more detail about how to morph the mouths in each individual program later in the chapter.

The majority of facial expressions can be done with a minimum of 11 basic mouth shapes and variation in the position of the eyebrows. The same basic mouth shapes can be used to speak the majority of words.

These are 'neutral', 'smile', 'frown', 'big smile', 'big frown', 'oh' (as when you say the word 'pot'), 'ooo' (as when you say the word 'pool'), 'anger', 'yuk' (as in disgust or contempt), 'fvbpm' (the bottom lip is tucked under the top lip when you say each of these consonants) and 'Elvis' (one corner of the lip is pulled up).

Take out your animation drawings of your expression change acting (or copy the positions from the illustrations in this chapter). Work out the body language and the eyebrows first by setting keys for the whole body and head all the way through the scene.

The eyebrows have bones (joints) running through them and can be rotated and moved. They can have keys saved on them as with any other bones. They are called 'R_Brow' and 'L_Brow'. The bones within them are called 'R_BrowBone01', 'R_BrownBone02' etc.

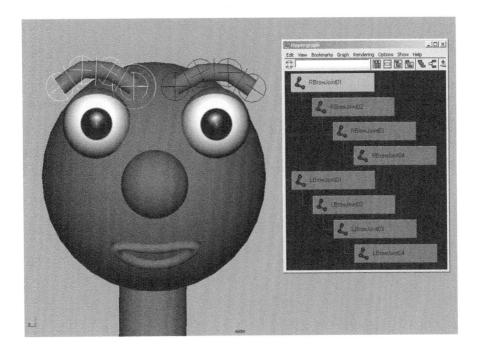

To one side of the man there is a pile of mouth shapes. These are the reference shapes that the mouth on the face of the man can morph to. Always keep them out of scene, otherwise you end up with strange mouths floating around.

For the 'face_acting_3D.avi' example, the mouth shape is a frown between frames 1 and 31. It is then neutral for frames 33 and 35. It is a smile between frames 37 to 41 and then becomes

a big smile between frames 43 and 67. It goes into a frown between frames 69 and 79 and then goes into a cross between the 'oh' and 'frown' shapes between frames 81 and 85. Between frames 87 and 101 it is an 'ooo' shape and between frames 103 and 115 it is in a 'frown' position. For the remainder of the scene the mouth is in an 'angry' position. Hopefully you will end up with something that looks like 'face_acting_keys_3D.avi' in animations010, Chapter 10 on the website.

All that needs to be done now are the breakdown positions to help sort out the way the computer in-betweens the key positions. Follow the four timing charts in the 2D exercise section. Once this is done you should end up with something like 'face_acting_keys_3D.avi'.

Adding a Simple Mouth and Eyebrows to Your Basic 3D Character

If you want to have a go at putting a mouth and eyebrows on to your own man, rather than using the ready-built example, before you animate, here are some basic instructions.

Most expressions carried by the face are produced by a combination of the eyes, the eyebrows and the mouth. It's amazing that so many faces (over 5000) can be produced with such basic raw materials! The basic man that you built in Chapter 3 only has eyes; now is the time to add eyebrows and a mouth.

The Eyebrows

The eyebrows are made from two small cylinders with at least three subdivisions down them (five would be better). This means that when they are manipulated they will produce smooth curves. Put several bones through each eyebrow (at least five). Skin the eyebrow to the bones so that when the bones are moved or rotated the eyebrow will move with them.

Place the eyebrows in an eyebrow-like position above the eyes. They are going to 'float' in this position and be moved in order to pull specific facial expressions. Finally link the first eyebrow bone of each eyebrow to the head bone so that the eyebrows will move with the head.

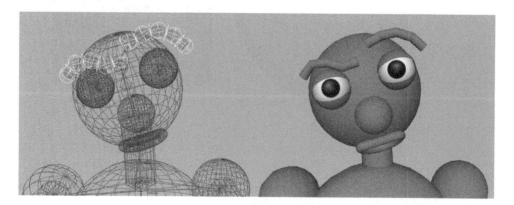

To create an eyebrow position, select each bone in turn within the eyebrow and rotate it. To raise or lower the eyebrow, select the first eyebrow bone and move it up or down.

Making Mouths

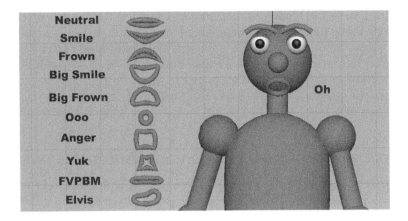

In these notes I will describe as simply as possible how to do animation that involves the changing of a physical shape. You could have a head that is sculpted and manipulated several times rather than just a mouth shape.

To make a mouth, create a torus or doughnut shape and stick it onto the head in the rough position of the mouth. Parent it to the head so that when you move the head the mouth will move with it.

Creating Mouths with Blend Shapes in Maya

Create a torus (on the main menu select **Polygon Primitives > Torus**). This is the base object. Name it 'mouth01'. Parent it to your head (select 'mouth01' then **Shift** + select 'head' and press **P** on your keyboard).

Duplicate it (**Ctrl + D**) and move 'mouth02' to the side. Change its shape by going into **Select by component type** mode (button on top shelf) and moving the points. Then select 'mouth02', **Shift** + select 'mouth01' and go to the main menu and select **Deform > Create Blend Shape**. To open up the **Blend Shape** window go to the main menu and select **Window > Animation Editors > Blend Shape**. By moving the slider, 'mouth01' will change into the 'mouth02' object.

Repeat the process by duplicating 'mouth01', changing the shape of the resulting duplicated shape and making it a blend shape. You will need to create about 10 mouths.

To animate the mouth, move the Time Slider to the correct frame, move the **Blend Shape** slider to the desired amount and set a key (click the **Key** button under the blend shape slider).

Creating Mouths with the Morpher in 3D Studio Max

In the **Create** section of the Command Panel, create a torus (click the **Torus** button and then click and drag twice in one of the views). Duplicate it by selecting it (with the **Select and Move** button clicked) and pressing the **Shift** key while moving the object to one side. Name the new object 'mouth02' (the program may do this automatically).

Select 'mouth02' and from the **Modifier List** select **Edit Mesh** (in the **Mesh Editing** subsection). Change the shape of your torus by selecting the points and moving them. Click on **Edit Mesh** in the Modifier Stack to take you out of this mode.

Select 'mouth01' and in the **Modify** section of the Command Panel open up the **Modifier List** and select **Morpher**. In the **Channel Parameters** section of the Command Panel select **Pick Object From Scene** and select 'mouth02' in one of the views. In the **Channel List** the top 'channel' will change from 'empty' to 'mouth02'. You can change the mouth shape of 'mouth01' by selecting it and increasing the number in the box next to 'mouth02'.

To animate click the **Animate** button, move the timeline to the correct frame and change the percentage in the box next to 'mouth02'. The program will set a key automatically.

Creating Facial Expressions with Your More Sophisticated Character

When it comes to creating facial expressions for the more sophisticated character you created in Chapter 9, you will need to duplicate the entire head (make sure it's separate from the body) and then manipulate the face into each of the mouth shapes. You will also need to do expressions for the eyebrows. Make each eyebrow have a horizontal middle position, a horizontal raised position and a horizontal lowered position. Also have an angled outwards and an angled inwards position. There are some movie files on the website that explain this much better. Have a look at 'expressions-in-maya.avi' or 'expressions-in-max.avi' in the Chapter 10 folder on the website.

Animating Mouths with Blend Shapes in Maya

First animate the body, head, eyes and eyebrows.

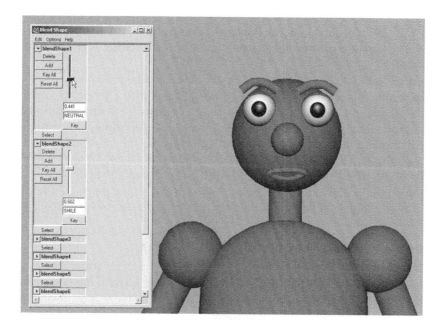

Open up the **Blend Shape** window by going to the main menu and selecting **Window > Animation Editors > Blend Shape**. In the **Blend Shape** window is a series of sections called **blendShape1** through to **blendShape10**. These are the controls that relate to the different basic mouth shapes. They can be maximised or minimised by clicking the triangle next to the particular **blendShape**.

Maximise one of them and you will see that it consists of a slider and several buttons that relate to creating and deleting keys. Move one of the sliders and the mouth on the face of the man will change. We create movement of the mouth by moving the Time Slider to the correct frame and then moving a **Blend Shape** slider to a position where the mouth is the right shape and then setting a key by clicking the **Key** button underneath the **Blend Shape** slider. You can change the value of several of the **Blend Shape** sliders to get almost any mouth shape you could ever want.

Go through your animation and at the appropriate points change the shape of the mouth to suit your drawings (or the illustrations in the 2D exercise in this chapter). Keep experimenting with different mouth shapes until you have something you are pleased with. Then take a look at 'face_acting_3D.avi', animations010, Chapter 10 on the website.

Animating Mouths with the Morpher in 3D Studio Max

First animate the body, head, eyes and eyebrows.

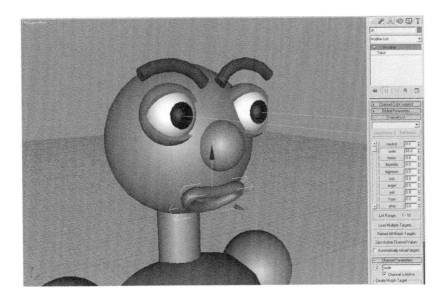

Select the mouth in one of the views and make sure the **Modify** tab is selected in the Command Panel. Make sure **Morpher** is selected in the Modifier Stack. In the **Channel List** there is a list of all the mouth shapes (apart from 'oh', which is the mouth shape you get to start with). Next to each of the mouth shapes are boxes that have percentages in. When you vary the percentage number in the box, the mouth on the man's face will morph into the mouth shape named by the box (0 means 0% of the mouth shape and 100 means 100% of the mouth shape). Have a practice by changing the percentages of one of the mouth shapes.

Go into 'Animation' mode by clicking the **Auto Keyframe** button (the outside of the views will go red), change the mouth shapes as required and keys will be automatically set on the shapes.

Go through your animation and at the appropriate points change the shape of the mouth to suit your drawings (or the illustrations in the 2D exercise in this chapter). Keep experimenting with different amounts of mouth shapes until you have something you are pleased with. Then take a look at 'face_acting_3D.avi', animations010, Chapter 10 on the website.

CHAPTER NINE

Animation of Acting – Two or More Characters

Two Characters on Screen Together

Two characters in a scene together will interact with each other. Even if one is ignoring the other, there will be a certain level of interaction.

When two characters interact, the action should be like a game of tennis. One character will have the audience's attention, then the other character. Divide a scene to make sure the action and events happen at different times. After one character acts, the second character responds to the action. Then the first character reacts to the response. If the two characters do something at the same time it will be too confusing for the audience and they will miss part of the action (though this may be what you want). When one character is performing an action the audience must see, the other character should make a minor movement. This should be just big enough to keep them looking alive, but not so big that they start to distract attention from the action that matters.

Personal Space

People standing or sitting side by side who don't know each other will acknowledge each other's presence. It may not be obvious, but they will acknowledge each other subconsciously. We all have a concept of personal space. That is, we all have an area around ourselves that we consider ours and we only allow people that we are comfortable with into this space. Having said that, we like to feel accepted and to make other people feel accepted. Because of this we won't sit or stand as far away from others as possible. When we sit on a park bench or in a train carriage we sit an acceptable distance away from those we don't know. When in a queue we give each other room to feel comfortable – if we were too close it would make us feel very uncomfortable.

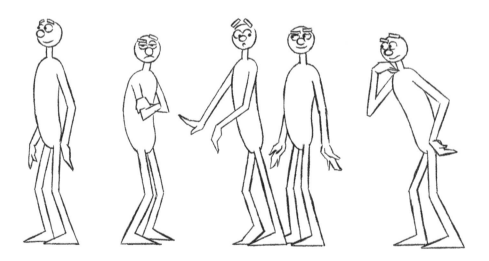

Having said this, there are situations when personal space has to be reduced. A good example is when we are crammed into a tiny space such as an underground train carriage. In this situation people tend to look upwards or shut their eyes in order to avoid eye contact.

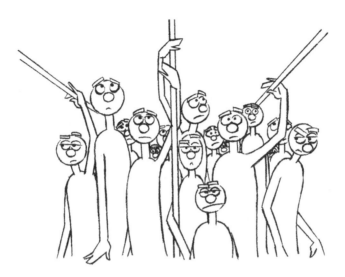

When two people know each other well, they allow each other into their personal space. The degree to which you allow your characters into each other's space gives an audience an idea of how familiar they are. Another indicator is the way your characters touch each other. If people are only acquaintances, they shouldn't go beyond touching the outside edge of the arms and shoulders, or shaking hands. Often touching the outside edge of an arm is used when the person doing the touching wants something from the person being touched. This may be a favour or money or it could be to offer consolation, commiseration or reassurance.

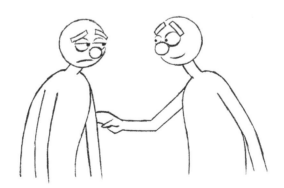

People who know each other better can cuddle, touch the other person on the face, kiss, and touch the other person's hair or the outsides of the legs.

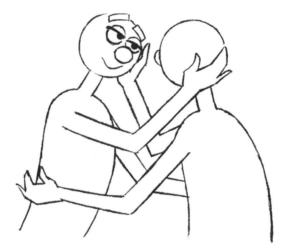

If your characters touch each other more intimately than this they are either lovers or closely related.

Of course, very young children are unaware of these taboos and, in their innocence, move into other people's space freely. When children reach their early teens (or earlier) they shy away from this sort of contact. They are in the process of learning their body language and become more self-conscious. The concept of personal space is learnt and is different depending on differing cultures.

Mirroring

When two people know each other well and are in close proximity (for example, engaged in a conversation), they will 'mirror' each other. That is, they will adopt body language similar to that of the other character. They may cross their legs in the same way, lean on their elbows on the table in the same way or angle their head in the same way. These are only a few examples of the many different ways in which your characters can mirror each other.

The degree to which people mirror each other depends on how well they know each other and also how well they *want* to know the other person. The degree to which your characters mirror each other is an indication to the audience as to what sort of relationship they have. Two teenagers trying to look cool will both adopt postures that suggest boredom. An office junior trying to impress his boss will imitate his body language.

When a couple are on that oh-so-important first date, if they are attracted to one another they will end up mirroring each other's behaviour. They will be trying so hard to mirror each other that their movements may seem forced. They will occasionally slip out of mirroring when they are distracted – for example, when a waiter asks whether everything is OK with their meal – and will act as themselves. To show to the other person that they are attracted to them, the character must learn to mirror.

When couples have known each other for a while, they will mirror automatically and feel at ease in each other's company. Their body language will suggest to the rest of the world that they are together. They will hold hands or hug when they walk.

This may work in the opposite direction, however. When two characters are in a long-term relationship there may be a level of boredom with each other. As a result, they will try to reinforce their own identity. When together they may tend to, almost deliberately, not mirror each other's body language. One may read a newspaper while the other is looking at their surroundings. They will deliberately occupy different poses. When interrupted they will start mirroring each other, because this is their natural state.

When mirroring, people will take drinks from their glasses at roughly the same time and take bites of their food at the same time. When walking along together, their strides will synchronise.

How Characters Look at Each Other

Again, this depends on how well the characters know each other and what their relationship is.

When two characters are in love they will stare directly into each other's eyes. Each character is essentially 'giving' themselves to the other person and not covering anything up, and they will look at each other with a happy, questioning look. Because each character is looking into the eyes of the other person, their own eyes will flick from side to side, with both eyes focusing on one eye and then the other in turn (when animating, make the eyes stay in one position for a second or so and then click the pupils to a second position, repeating at random). This gives a very 'open' look. Combine this with an occasional slow eye blink and dilated pupils.

When characters are staring at each other competitively (staring each other out), the eyes remain locked on one point of the other's face (between the eyes). The eyes will not 'flick'. Each character's eyes will blink as little as possible and the pupils will be contracted.

When two people don't know each other as well as lovers, their eyes will meet only for a short period of time. In some ways, staring at somebody is an intrusion of their personal space as much as is grabbing hold of them. The more confident person will maintain eye contact for longer.

When somebody is attracted to someone, a stare is a way of getting attention. Let's take the very stereotypical situation of a man and a woman who are attracted to each other. The woman will look at the man and, when she gets a look back from him, will look away. If she is happy with the situation, she will steal a look back with her body and head facing away from the man. The man, on the other hand, will continue to stare at the woman. If he receives a positive reaction, it's time to walk over and introduce himself. If he receives a negative reaction, it's time to try something else.

Two Characters Acting with Each Other While Talking

When two characters are talking to each other, depending on what is being discussed, the character talking can often be highly animated. They will look in different directions to emphasise a point and will occasionally look at the listener to check their reactions. The listener will be looking at the speaker (hopefully in rapt attention). When the speaker finishes, they will look at the person listening. This signals to the listener that the speaker has finished and they can reply. When they have replied, the person listening may want to say something further and will adopt a suitable body posture. They may try to interrupt the person talking. Both characters could end up talking at the same time.

First character talking.
Second character listening.

First character looks at second to check his reaction

First character looks away and continues talking.

First character finishes what he says with a look

Now the roles are reversed. The second character is talking, gesticulating and looking in different directions to emphasise different points and the first character will be doing the listening. Should the first character want to butt in when the second character is talking, they will stare more intently and may be on the edge of their seat. They may get the first couple of words of their statement out, depending on how determinedly the other character is talking.

First character listening.

First character not happy.

Second character replying.

Second character checking reation of first.

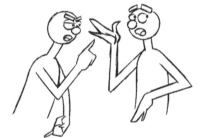
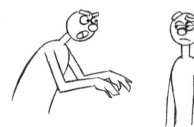

First character tries to butt in.

First character manages to butt in.

Second character continues talking.

Second character butted!

If the listener is bored they will look up or away from the speaker. They will yawn or do anything other than look engrossed in what the talker is saying.

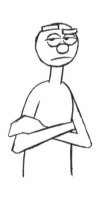

A bored listener who is trying to look attentive will stare rather too intently at the talker, but will occasionally find something else interesting and look away or stifle a yawn.

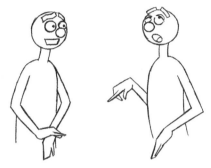

Remember that the interaction of two characters must be like a game of tennis, with the characters alternating as the focus of the audience's attention.

Two Characters: Alternating from One Shot to Another

Animated film making only occasionally has two characters acting in one scene (e.g. when there is physical contact between the two characters or when you need to see the two characters together). More often than not, a basic film-making technique is used in which the camera cuts from one character to the other as the conversation or action continues.

The most important rule to learn is 'do not cross the line'. Imagine that your characters are on stage together and that the camera is the audience. Imagine a line running between each of these characters. The camera has to stay on one side of this line.

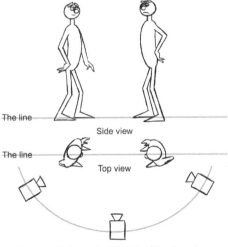

The line — Side view

The line — Top view

Camera will always stay this side of the characters

Start with an establishing shot that shows both of the characters. Follow with a close-up of the first character talking or acting. Follow it with a close-up of the second character replying.

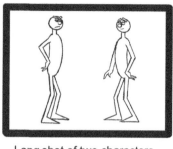

Long shot of two characters.

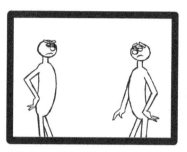

Medium shot of two characters.

Close-up shot of first character.

Close-up of the second character.

Close-up of first character.

Back to medium shot.

When animating your characters in close-up, follow most of the techniques described earlier in this chapter. The difference is that only one character is on screen at a time. Always bear in mind that your character is looking off screen at the other person. Depending on the relationship with the person off screen, the way your character looks at them will change.

To make a character look more dominant, angle the camera to look up at them.

To make a character look more submissive, angle the camera to look down on them.

A Large Group of Characters on Screen at the Same Time

With a large group of characters on screen at the same time, the most important thing is to make sure that your audience is looking at the right character at the right time. This is done in a combination of ways.

The first way is to use focus. If the main characters are in the foreground and the rest of the crowd is in the background, the background characters can be slightly out of focus.

Second, use lighting and color. If the background characters are slightly duller in color or are lit more darkly than your main characters, the audience's eye will be drawn to the characters that matter.

Last but not least, the main way to get your audience to look at the important characters is to make them more animated than the lesser characters. Don't move the background characters around too much because they will be too distracting. Any movement these characters make must be a down-played version of the movements they would do if they were the main characters in the scene.

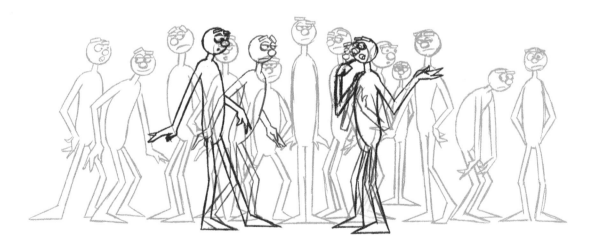

If you watch any film (animated or live action) and look at the characters in the background, they will move in a way that will not be distracting to the audience. In live-action films there is a whole subsection of actors that do nothing other than be extras. It's as though the acting knob has been turned down. Many actors on their way up (and on their way down) get acting work playing

these roles. In animated films this is where junior animators can cut their teeth, because the quality of animation required is not as high as for the main characters.

Exercises
The Double Acting Exercise in 2D

Have two characters in a scene side by side. One of the characters attracts the attention of the other. The other character then reacts. The characters could be sat at a bar, standing at a bus stop, sat on a park bench, waiting in a queue, arm wrestling or anything else. Some possible situations are as follows:

1. Have the passive character occupied with something – reading a book, newspaper or poster, cleaning their glasses or listening to music. Have another character trying to get their attention.

2. One of the characters sees something off screen and tries to get the other character to look at it.

3. One character asks the other character for something – the time, some change, a match or directions.

When animating two characters interacting with each other, always animate the character that initiates the action first and then animate the character that reacts. Keep each of these characters on different pieces of paper. This means that if you need to change the timing of one of your characters you only have to re-draw that character.

Animating It

The first thing to do is to write down what is going to happen in the scene. Then draw some thumbnail sketches and shoot them to get an idea of the timing. In this little scenario we have two characters on a park bench. The first character is sitting staring into the distance and then glances

over and sees the second character reading a newspaper. He leans over and sneaks a look at the newspaper. The second character notices this, scowls and turns away from the first character. The first character looks into the distance despondently, then has an idea. He pulls a pair of binoculars out of his pocket and looks at the second character's newspaper at a distance through the binoculars. Take a look at '2_act_thumbs.avi', animations011, Chapter 11 on the website.

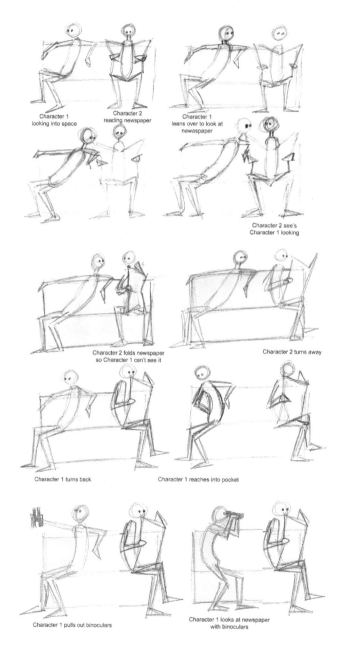

Character 1 looking into space

Character 2 reading newspaper

Character 1 leans over to look at newspaper

Character 2 see's Character 1 looking

Character 2 folds newspaper so Character 1 can't see it

Character 2 turns away

Character 1 turns back

Character 1 reaches into pocket

Character 1 pulls out binoculars

Character 1 looks at newspaper with binoculars

Once this is sorted (and remember always to err on the side of being slightly too slow rather than too fast), draw the thumbnails full size or blow them up on a photocopier. Work out the key positions (the anticipations and overshoots, the follow-throughs and what each character does in each pose), remembering to put each character on a separate sheet of paper. When working out the key positions, start by animating the character that initiates the action. In this case it's the first character. The entire sequence of keys is in Chapter 11 on the website.

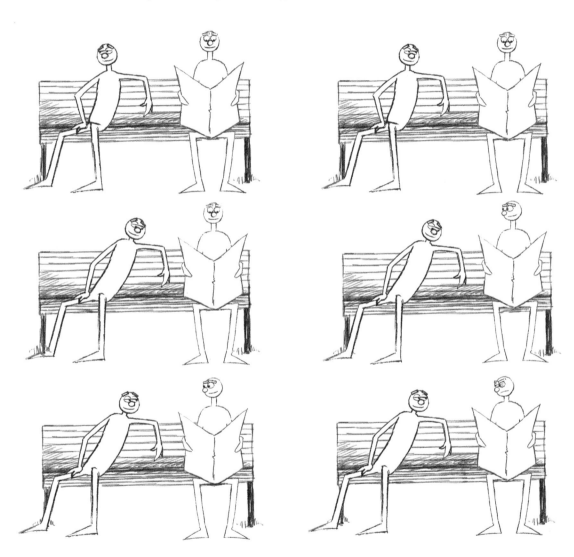

Animate the first character to the point where the attention moves to the second character and work out the key positions for this character.

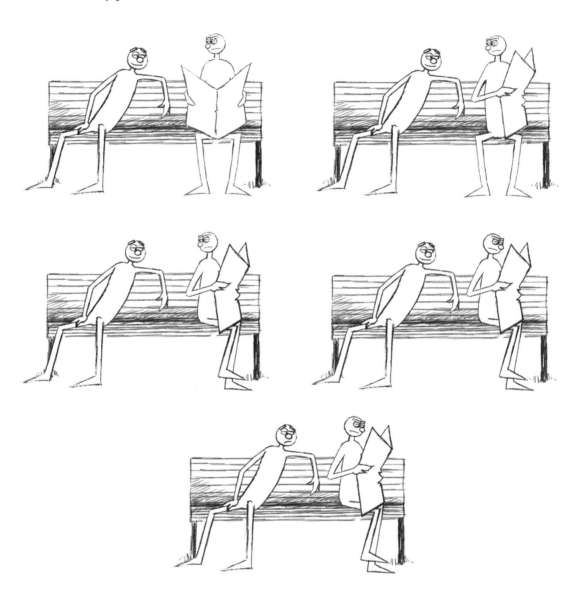

Then, when the attention goes back to the first character, work out the key positions for the first character.

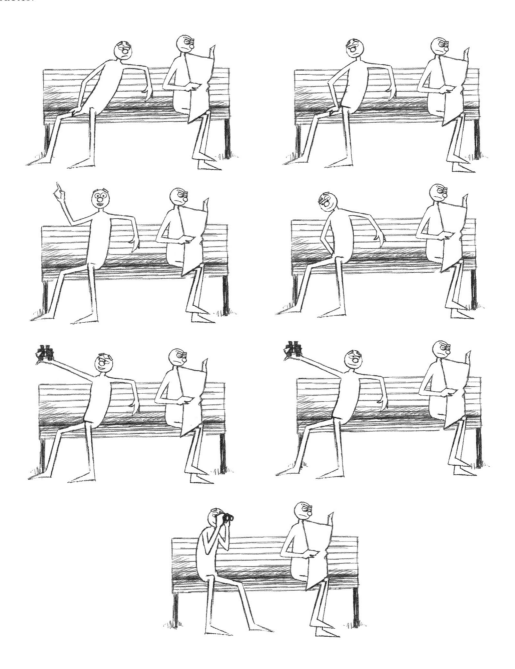

The Double Acting Exercise in 3D

Load your man with mouths and eyebrows from Chapter 10. Once he's loaded you need to duplicate him (there are several ways to do this) so that you have two characters that look exactly the same (you may want to change the color of one). Then build a basic park bench out of simple cubes. Finally, make a newspaper out of a plane.

Loading Two Identical Characters into the Same Scene in Maya

Open up 'mayaman_mouth.mb' and move your character over a bit. Then go to the main menu, click **File > Import** and select the same scene ('mayaman_mouth.mb') in the **Import** window. Click the **Import** button and you should have a second man in your scene. Save this scene as 'double_mayaman_mouth.mb'.

Loading Two Identical Characters into the Same Scene in 3D Studio Max

Open up 'maxman_mouth.max' and move your character over a bit. Then go to the main menu and click **File > Merge** and select the same scene: 'maxman_mouth.max'. Up will come the **Merge** window. Click **All** and **OK**. Up will come the **Duplicate Name** window. Tick the **Apply to All Duplicates** box and then click the **Merge** button. You will now have a second man in your scene. Save this scene as 'double_maxman_mouth.scn'.

Animating It

With both programs, the components will have been renamed, so make a note of the new names so you don't get too confused.

Follow your drawn animation, or at least do some thumbnail sketches (or follow the illustrations in this chapter), working on one character first and then the other as the action passes over. Go back to the first character as the attention moves back to him.

When you have finished, take a look at '2_act_3D.avi'.

Lip-Sync

Chapter Summary

- Recording and Breaking Down a Dialog Track
- How We Speak
- Acting with Dialog
- Mouth Shapes
- Animating the Mouth Shapes Early
- Exercises

Many aspiring animators are slightly afraid of getting their characters to talk. They shouldn't be. Lip-sync is much easier than you think and, as long as you follow a few basic rules, the timing is sorted out for you. Rather than having to guess or rely on your experience to get the timing right, your timing is worked out from the dialog that your character is speaking. The main thing to remember is that the quality of acting by your character is the most important part of lip-sync. The mouth shapes only make up a small part of a lip-sync scene. If the acting is good, you can pretty much get away with murder when it comes to the mouth shapes.

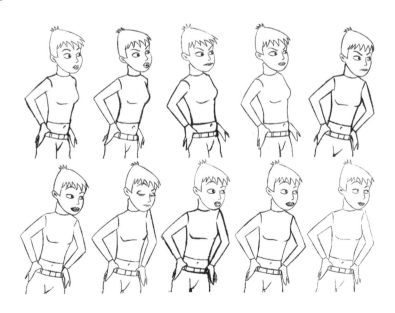

Recording and Breaking Down a Dialog Track

In order to animate a piece of lip-sync, it helps if you first record your dialog (you can take advantage of the dialog to help with your timing and characterisation).

Record a piece of dialog or take a section from a feature film, television show, radio show or CD. You can even download .wav files from the Internet.

If you are recording your own dialog or don't have the sound file on your computer, the simplest way to get it onto the computer is to use the Sound Recorder application. Locate the 'Programs' folder on your computer, find the 'Accessories' folder and open Sound Recorder (this may be in a further folder called 'Entertainment', depending on your operating system). Connect the 'audio out' socket of a video recorder, mini-disk player, CD player or microphone to the microphone socket on your computer. Press play on your sound equipment or speak into the microphone, and press the **Record** button on Sound Recorder. Save the sound as a .wav file.

Sound Recorder does not give the best sound quality and you may want to try a specific sound recording program. There are lots of programs for recording and editing sound available in either shareware or demo versions on the Internet. You may even have one that came with your sound card.

Budget allowing, the best thing to do is to hire a sound studio and record an actor, but this can work out to be very expensive. Alternatively, you could buy or hire a portable sound recorder. A company called Zoom make some very impressive professional sound recorders at a very reasonable cost.

I've included two pieces of dialog on the website in the 'sounds' folder in Chapter 12. They are called 'hello.wav' and 'moment.wav'.

Once you've got your dialog, you need to break it down. That is, you need to work out, frame by frame where each sound of your piece of dialog occurs during the scene that you are animating. This then needs to be marked onto the sound column of an X-sheet.

DigiCel FlipBook can be used to break your sound track down. In fact, you can use any program that divides up your sound track into units of 24 frames per second for film, 25 frames per second for PAL or 30 frames per second for NTSC.

It's best to record your dialog in short pieces (the length of a scene, say, or one person talking) rather than the entire movie at once. This will give you more freedom when it comes to editing your movie. Trim your dialog to the correct length and save what you've recorded as a .wav file.

Now open up DigiCel FlipBook and import your sound track onto an X-sheet (right click on **Sound** on the X-sheet and in the **Sound Properties** window click **Change**; find your .wav file and click **OK**; the sound will now be loaded into the sound column). Scrub through the sound slowly and mark onto a paper X-sheet the frames where each of the sounds of the dialog start and end.

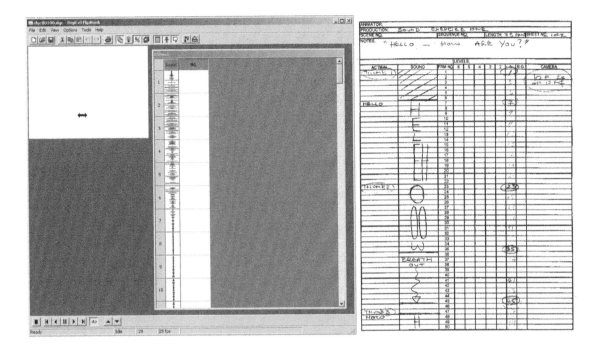

When breaking down a sound track I always play the dialog through a few times and write what is said at the top of my paper X-sheet. When I'm scrubbing through the dialog slowly the first thing I listen for is the silences. These occur between some words and where there are the sounds produced by the consonants that occur when the mouth is shut ('M', 'B', 'P', 'F' and 'V'). Little sound comes out of the mouth when these consonants are spoken and the sound track is quiet or silent at these points.

Then I listen for the 'S' sounds in the dialog, which tend to sound like a 'shhh' or hissing sound. If the hissing sound lasts for three frames, mark it down on your X-sheet for three frames. Keep scrubbing backwards and forwards through your dialog. The next sounds to listen for are 'T' and 'C'. 'T' makes a 'tut' kind of sound and 'C' makes a 'kar' sound. Next listen out for the consonants at the start of each of the syllables of each of the words.

Once these are done, all that remain is the vowels. Listen for the loudest ones first. These will generally be the vowels that are spoken with the mouth wide open (jaw dropped). 'A' and 'O' are the loudest of the vowels and 'I' and 'E' tend to be quieter because the mouth is less open and less sound can come out of the mouth as a result.

How We Speak

Breaking down a sound track like this is a very good way of getting an idea of how we speak. To produce a noise out of the mouth, the vocal cords in the throat vibrate. In simple terms, this causes air molecules to vibrate and they pass this vibration through millions of other air molecules until they, in turn, cause your eardrum to vibrate – that is, the sound is heard. The information gathered by your eardrum is then passed to your brain.

The mouth can open and shut independently of the jaw, but to get the mouth as open as possible the jaw has to be dropped. The more open the mouth, the louder the sound that can come out of it.

Generally, most syllables have a consonant at the start, followed by a vowel (and often another consonant at the end). The consonant at the start gives shape to the sound and the vowel provides the power, so the mouth will usually be more open when it is speaking a vowel.

When we watch somebody speak we see a combination of the mouth opening into different shapes and the jaw opening and closing to augment these mouth shapes. One way to work out where the jaw should open and close is to speak the piece of dialog yourself while holding your index finger on the top of your nose and your thumb under your jaw. As you speak your thumb will be pushed down and up by your jaw.

The most important mouth shapes are the mouth-shut consonants: 'M', 'B', 'P', 'F' and 'V'. At these points during speech, only a small amount of sound (or none at all) comes out of the mouth. 'M' and 'B' produce a humming sound. 'P' produces no sound at all – there is just a slight spitting noise as the mouth opens. 'F' produces a slight escaping of air and 'V' is a combination of a hum and air escaping.

The reason these mouth shapes are so important during speech is that they are highly noticeable to an audience. Before a mouth-shut consonant occurs, the mouth will usually be open and then shut quickly. After a mouth-shut consonant the mouth will open quickly. Most other mouth shapes during a piece of dialog will slur from one to the next. The audience uses these mouth-shut consonants as markers to see whether it is the person they are looking at who is talking.

When writers re-write a script for a foreign-language film that will be dubbed into English, they will do so in such a way that mouth-shut consonants in the script coincide with the mouth shapes being spoken by the characters on screen.

Generally we are quite 'lip-lazy' – our lips don't accurately make mouth shapes but move from one shape to another. Unless you are animating something for effect with very exaggerated mouth

shapes, concentrate on hitting the mouth-shut consonants and the large vowels. The rest of the mouth shapes can be regarded as in-betweens.

Acting with Dialog

When animating a scene with dialog, it's always best to leave the mouth shapes until last and concentrate on the body language and facial expressions first!

Listen to the dialog over and over. It's probably best to do this via headphones if you don't want to drive everybody in the room crazy by playing the same track over and over. Act out the dialog as you play it. Watch yourself in a mirror. Listen to the piece of dialog until you're sick of it. It's at this point that you start living it! You'll notice that there are certain words that are the main emphasis points. At each of these emphasis points, your character should be put into a suitable pose. This technique is called 'phrasing'. You can divide your animation up into major emphasis points and minor emphasis points. The major ones involve a movement of the body whereas the minor ones perhaps only involve a movement of the head. Use the information in Chapters 9–11 to work out the key poses that are appropriate for your dialog.

If a character says 'hello [pause] how are you?', the two major emphasis points are 'hello' and 'how'. The character could lean forwards as he says 'hello' and then put his head to one side to say 'how are you?'. Within this movement you can put in a minor emphasis point on the 'you' at the end of the dialog. So, the head has been put on one side to say 'how are' and then nods on 'you?' while the body stays in the same position. There would also need to be small anticipation positions out of, and overshoot positions into, each of these poses (see the 2D animation exercise below for a full description).

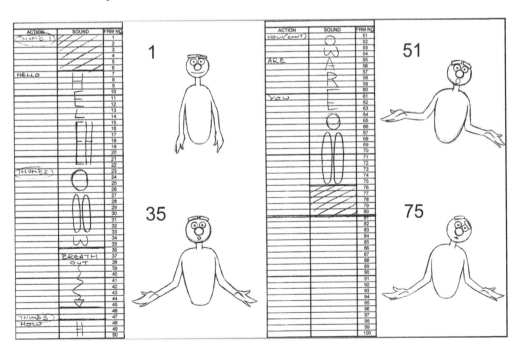

Don't try to put in too many of these emphasis-point poses. At the most, do about one a second. Any more than this and it will look as if your character is shaking violently.

Because your audience has to absorb far more information while watching a character talk than with a mute character acting, you don't want to distract the audience with too much activity. The extremity of each pose depends on the character you are animating and the mood they are in. When your character is in one of the major emphasis poses you still have to give them something to do. Sometimes the minor emphasis points are enough; sometimes you have to put in a bit more.

When you've worked out your basic poses, shoot them on a line tester with the dialog, giving them enough frames to take them to the next pose. How does it look? If some of the poses don't fit the dialog, re-draw them and shoot them again. Are the poses hitting at the right time? If the character is talking enthusiastically or aggressively, it might be best to hit the poses about two to four frames early. If your character is talking in a neutral manner, hit the poses exactly at the same time as they say the phrase. If your character is talking in a relaxed or hesitant manner, hit the poses about two to four frames late. Don't try and be too clever about this. If in doubt, hit the poses at the start of the word at which the pose should start.

Quick from Pose-to-Pose

If a character is angry, excited, nervous or worried they will move quickly from one pose to another and will seethe in each of these poses.

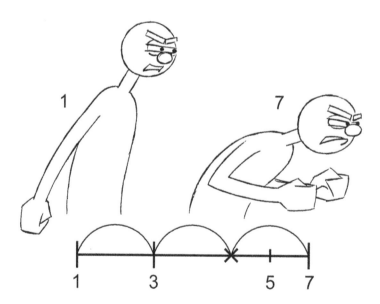

Slow from Pose-to-Pose

If a character is calm, relaxed, happy, moody, sad or sulky they will move from one pose to another in a calm, relaxed way.

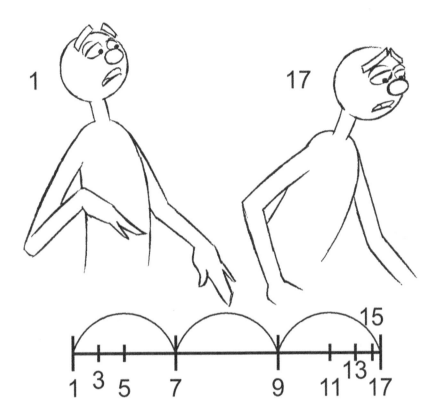

Eractically From Pose-to-Pose

This type of movement is used when the mood of a character changes. For example, they may be talking calmly and then notice something that excites or angers them. They then start moving quickly from pose-to-pose.

Mouth Shapes

Animate the mouth shapes straight ahead rather than key-to-key. This will give the lips a livelier look. As a guide, put in the mouth-shut consonants first and then do the large vowels (where the jaw is open). Always keep mouthing the words to yourself in a mirror.

Mouth-Shut Consonants

Let's start with the most important mouth shapes, the mouth-shut consonants. In order to make sure an audience sees these mouth shapes, hold them for a frame longer than written on the X-sheet. In this case our character is saying 'moment'.

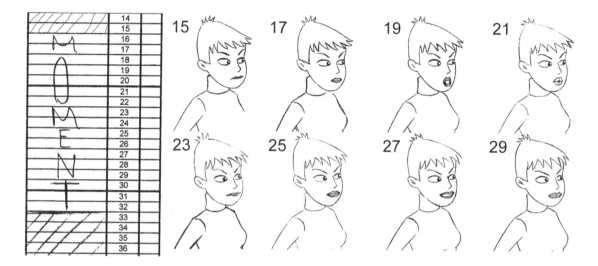

When animating into and out of these mouth shapes, keep the previous mouth shape as one frame and then go into the mouth-shut consonant on the next frame (no in-betweens). When you get to the mouth-shut consonant, the lips will be placed together slightly differently, depending on the sound.

Generally the jaw will be shut when your character is making the sound of a mouth-shut consonant. If the sound after a mouth-shut consonant needs the jaw to be open, the jaw can start opening while the lips are still shut in a mouth-shut consonant shape.

'M'

The lips are shut and a humming sound is produced. Both lips are tucked under against each other, wrapping over the teeth. Animating into and out of an 'M' tends to be slower than with 'B' and 'P'. It takes longer to un-tuck the lips from each other! At the start of your 'M' mouth shape, make the lips squash together. Towards the end of your 'M' shape make a slight movement of the lips opening and then go straight into the next mouth shape.

'B'

The lips are pressed together but not tucked under as much as with 'M'. A humming sound is produced but at the front of the mouth rather than the back. When animating into a 'B' shape, create a small amount of squash in the mouth as it closes. When animating out of a 'B' shape pop the mouth straight open.

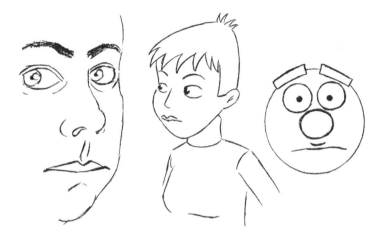

'P'

With a 'P' mouth shape the lips are squashed together and are pushed outwards. When animating into the 'P' mouth shape, move quickly from the previous mouth shape and then show the lips squashing outwards for the first part of the 'P'. When animating out of the 'P' shape, imagine trying to spit some grit off your lips. The mouth opens quickly with the lips pushing outwards and upwards. This jutted-out lip position is reflected in the first frame of the next mouth shape.

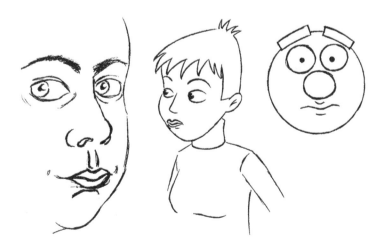

'F'

When the mouth is making an 'F' sound, the bottom lip is tucked under and bitten by the teeth. Most of the sound comes from air hissing out from between the teeth and the lips. The shape of the top lip varies depending on the mood of your character. When he is happy or relaxed, the top lip is relaxed and almost covering the teeth. When he is angry or aggressive, the top lip is tensed up and pulled back to reveal the teeth – for example, when saying a certain four-letter word. When animating into the next sound, the teeth are raised and the bottom lip is flicked forwards and downwards into the next mouth shape.

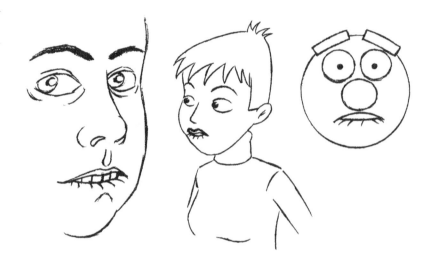

'V'

As with 'F', the bottom lip is tucked under the teeth, but not as much. The sound made is a mixture of hissing air between the teeth and the lips and a humming sound. When animating out of a 'V' sound the bottom lip doesn't pop out as far as with an 'F'.

Vowels

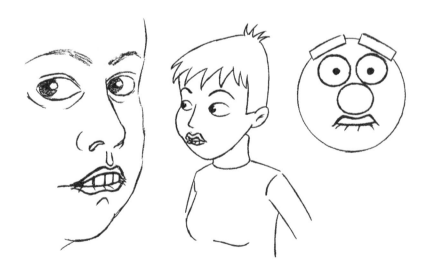

'Ooo'

The next most important mouth shape is 'ooo' as in 'pool'. This is because it takes the lips quite a long time to make an 'ooo' shape and then to pull out of it, so it's a mouth shape your audience notices.

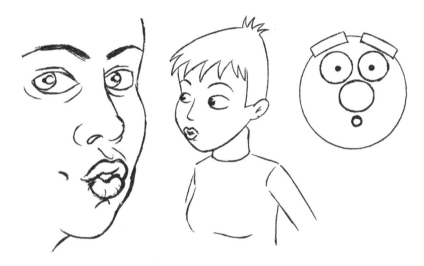

Following on in order of importance, next are the loud vowels. These are the vowels that produce the most noise and when they are animated the mouth should be widely open and the jaw dropped.

'O'

As in 'pot'. A large oval-shaped mouth with the jaw dropped.

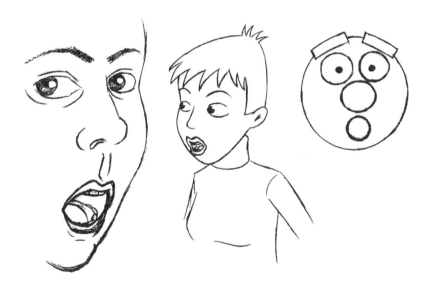

'AR'

As in 'car'. Like 'O' but with a slight smile to it.

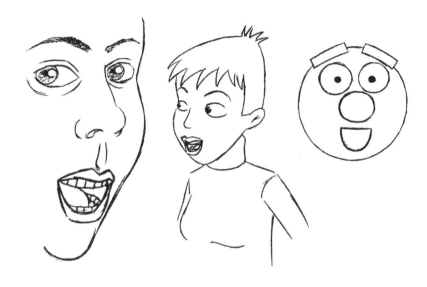

'A'

As in 'dad'. This is a large but narrow smiling mouth shape.

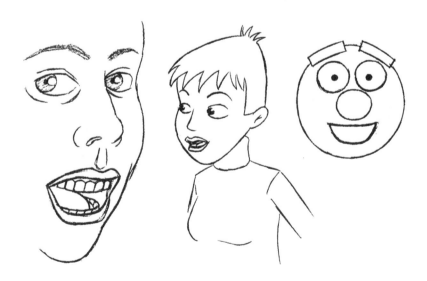

'EH'

As in 'wet'. A large, wide smiling mouth with the jaw dropped, but not quite as dropped as for 'O' and 'A'.

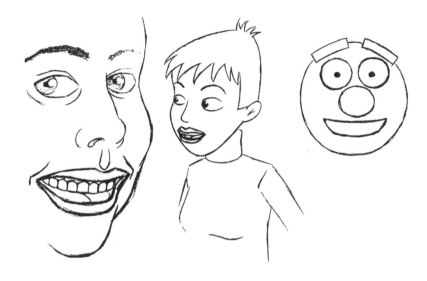

'EEE'

As in 'squeeze'. Still quite loud but the jaw will not be as open as for the other loud vowels. It consists of a wide smile.

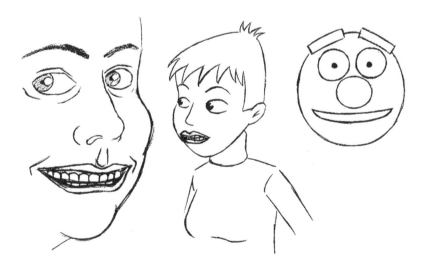

The Quieter Vowels and Consonants

The quieter vowels and the less defined consonants ('C', 'D', 'I', 'K', 'N', 'S', 'T', 'Y', 'Z' etc.) can be considered as in-between shapes that go between the mouth-shut consonants and the loud vowels. The mouth shape can be almost any shape you like: the same sound will come out.

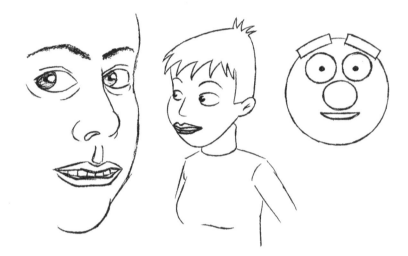

The other thing to remember is that a mouth shape will be influenced by the mouth shapes before and after it. In the 'moment' example, the first 'M' mouth shape will be quite narrow with slightly pursed lips. The mouth then pops open into a larger 'O' and then animates into a smaller 'ooo' shape, before shutting into another pursed-lip 'M' shape. This will animate over two frames to a wide 'M' mouth shape, which in turn pops open into a wide-mouthed 'eee' shape. The mouth pops open slightly for one frame for the 'T' and then return to a wide-mouthed 'eee'. This is why it's often better to animate mouth shapes straight ahead.

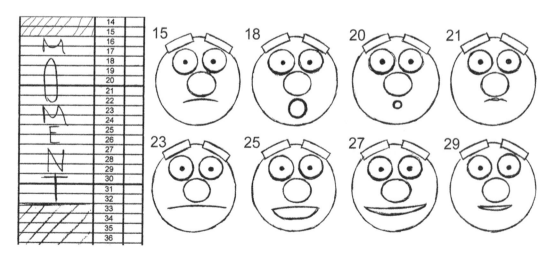

Teeth

If your character has teeth, make sure your audience can see them in the majority of mouth shapes. Otherwise the teeth will keep flashing on and off and can be very distracting.

Animating the Mouth Shapes Early

Sound travels slower than light. This means that you usually see something before you hear it. Some animators animate their mouth shapes one frame ahead of the sound. I've always come unstuck when I try to do this, so I animate with the mouth shape hitting the same point on the X-sheet as the dialog breakdown. Later, if it doesn't appear to fit the dialog or it looks better, I will slip the dialog a frame later when I line-test the animation. Sometimes it works, sometimes it doesn't. As always, don't try to be too clever with the animation until you have a lot of experience under your belt!

Exercises

The Lip-Sync Exercise in 2D

Have a character act out one of the two pieces of dialog supplied on the website ('hello.wav' and 'moment.wav'). Alternatively, you could always break down your own piece of dialog and animate that. You will find copies of the X-sheets on the website ('moment_x_sheet.avi' and 'hello_x_sheet. avi').

The two pieces of dialog are 'hello … how are you' and 'one moment … my good man'. As always, the first thing to do is to write down a list of character traits and from that write down a list of what the character is going to do during the scene. Then work out a series of thumbnail sketches and shoot a pose test with them. With these you should have worked out the main emphasis points (or phrases) of the action. For 'hello … how are you?', the main emphasis points are 'hello' and 'how are you?'.

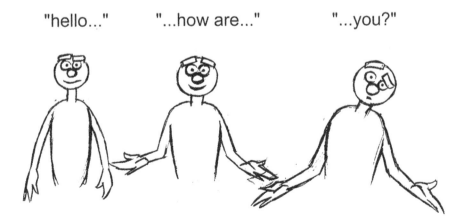

"hello..." "...how are..." "...you?"

Notice that there are only three pose positions for the 80 frames of dialog. For 'one moment … my good man', the main emphasis points are 'one moment' and 'my good man.'

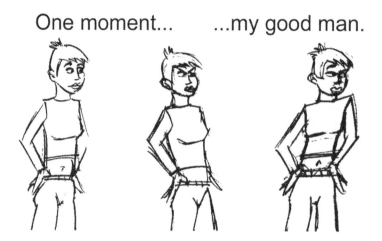

Take a look at 'moment_thumbs.avi' and 'hello_thumbs.avi' on the website.

The next thing to do is to work out the key positions and the in-betweens, making sure the action fits the feel of the dialog. For 'hello … how are you?', we have the character anticipate backwards and then lean forwards on 'hell…'. He then over shoots on the '…o' and comes back to rest on the end of the '…o' sound (it's quite long). In the pause he anticipates his head to screen left. He then leans his head to screen right on 'ho…', overshoots on the '…w', pulls his head back again slightly on 'are' and then puts his head back down again for 'you', over shooting on the '…o…' and coming back up to rest on '…u'. Take a look at 'hello_keys_2D.avi'.

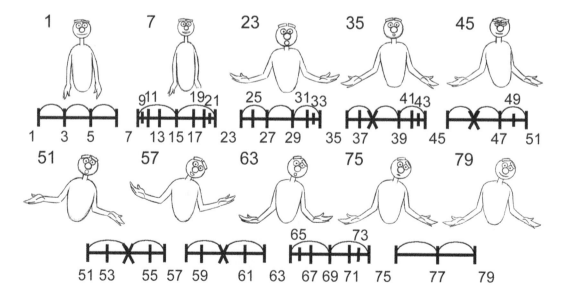

For 'one moment … my good man' (a good chance to do a lot of mouth-shut consonants), the head goes down on 'one' in anticipation of the arm coming up and the body leaning forwards on 'moment'. Have the character overshoot her pointing hand and body on 'mo…' and settle down on '…ment'. She can pull her hand back in anticipation on 'my' and then move the hand forwards on 'good'. Overshoot on 'm…' and come back to rest on '…an'. Take a look at 'moment_keys_2D.avi'.

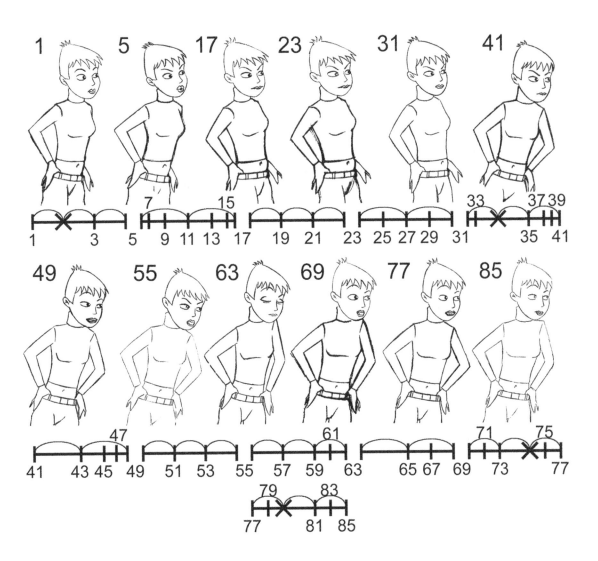

Finally animate the mouth positions by drawing them onto the character's face one drawing at a time. These could be animated straight ahead or you could work out the positions of the mouth-shut consonants, then the 'ooo' shapes, then the big vowels and finally all the other mouth shapes as in-betweens. Make the jaw open and shut on the big vowels. Line-test it to see if it is working. Experiment with slipping the sound up and down on the X-sheet (or by deleting frames or adding them to the drawings). Take a look at 'moment_2D.avi' and 'hello_2D.avi'.

The Lip-Sync Exercise in 3D

Load your man with mouths and eyebrows onto your program.

Importing Sound into Maya

Go to the main menu and select **File > Import**. In the **Import** window, find your sound file, select it and click the **Import** button.

To get the sound to play back in the timeline, right click on the timeline and select **Sound** from the menu that comes up. Follow the arrow next to **Sound** and select the recently imported sound file. The sound file should appear in the timeline as a waveform. If Maya is set to the correct play-back speed when you play the timeline (and when you scrub through it), the sound should play back.

Importing Sound into 3D Studio Max

Right click on the Time Slider and select **Configure > Show Sound Track**. Go to the main menu and select **Graph Editors > Track View**. Click the **Function Curves** button at the top of the Track View in 3D Studio Max 4 or on the main menu select **Bar > Graph Editors > Track View > Open Track View – Curve Editor** in 3D Studio Max 5.

Select **Sound** by clicking with the right mouse button in the hierarchy tree and select **Properties** from the list that comes up. This will open the **ProSound** window. Select **Add** and from the **Open** window find your sound, select it and click **OK**. Click **OK** in the **ProSound** window and you should now have your sound in the hierarchy tree. It should also appear in the Time Slider and in the Track View. If you play back the Time Slider with the playback controls you will hear your sound playing.

Animating the Mouth

By following your drawn animation (or illustrations) and the X-sheet with the dialog, work out the basic body language and facial expressions.

Take a look at 'hello_keys_3D.avi'. This shows the basic body language but without any mouth movement or breakdowns – it's letting the computer in-between the keys. Follow the timing charts in the 'hello … how are you?' illustration (on previous page) and correct the way that our hero moves by adding keys at the breakdown positions.

Take a look at 'hello_mouthless_3D.avi'. This shows the body movement but there is still no mouth movement. Good body language should suggest the dialog being spoken.

Once the acting is sorted out it's time to sort out the mouths. The basic mouth shapes can be made using the mouth shapes that come with the scene.

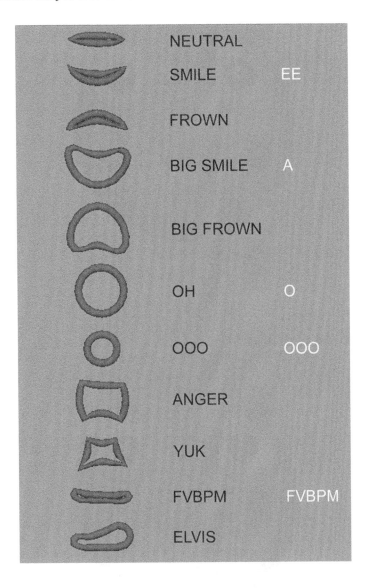

To get the various mouth shapes required, either use these mouth shapes as they are (manipulate the tools in your program so that they are at 100%) or use mixtures of the mouth shapes to get the desired mouth shape. The 'OH' mouth shape is the basic shape with no distortion on it.

Mouth-Shut Consonants

For the mouth-shut consonants, use the mouth shape 'FVBPM'.

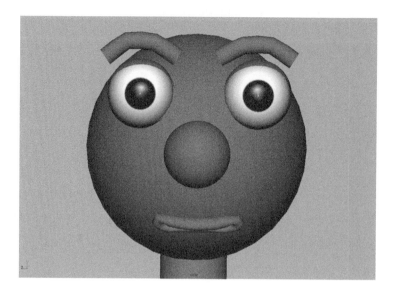

The Vowels

For 'ooo' as in 'pool', use mouth shape 'ooo'.

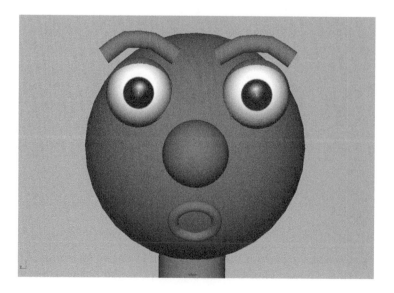

'O' as in 'pot' is a large oval-shaped mouth with the jaw dropped. Use mouth shape 'OH'.

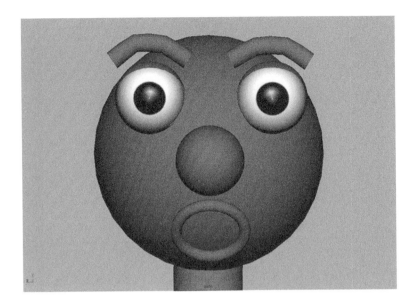

'AR' as in 'car' is like 'O' but has a slight smile to it. Use a mixture of 'OH' and 'big smile'.

'A' as in 'dad' is a large but narrow smiling mouth shape. Use mouth shape 'big smile'.

'EH' as in 'wet' is a large, wide smiling mouth with the jaw dropped, but not quite as dropped as 'O' and 'A'. Mix 'OH' with 'big smile' but don't have the mouth as open as for 'AR'.

'EEE' as in 'squeeze' is still quite loud but the jaw will not be as open as for the other loud vowels. It consists of a wide smile. Use a mixture of 'big smile' and 'smile'.

The Quieter Vowels and Consonants

These are 'C', 'D', 'I', 'K', 'N', 'T', 'Y', 'Z' etc. Use almost any mouth shape you like as long as it in-betweens from one of the major mouth shapes to the next.

Animating the Mouth

Change the shape of the mouth depending on the mouth shape required for the given sound on the X-sheet. Each of the four programs has a slightly different way of changing the mouth shapes and setting keys, so follow the individual instructions for each program outlined in Chapter 10. With the second piece of dialog, try using the more sophisticated character (Jenny). Take a look at 'hello_3D. avi' and the video tutorials in the Chapter 12 folder on the website to get an idea of what to do.

ANIMATION EQUIPMENT SUPPLIERS

Animation Supplies Ltd
Puppet animation supplies.
D4 Yeoman Gate
Yeoman Way
Worthing
West Sussex
BN13 3QZ
UK
+44 (0)844 358 0852
www.animationsupplies.net

Cartoon Supplies
All drawn animation supplies such as paper, peg bars, light boxes and pencils.
36125 Travis Ct.
Temecula
CA 92592
USA
+1 951 693 5165
www.cartoonsupplies.com

Cartoon Colour Company, Inc
All drawn animation supplies such as paper, peg bars, light boxes and pencils.
9024 Lindblade Street
Culver City
CA 90232
USA
+1 310 838 8467
www.cartooncolour.com

Chromacolour UK
All drawn animation supplies such as paper, peg bars, light boxes and pencils.
Unit 5, Pilton Estate
Croydon
CR0 3RA
UK
+44 (0)20 8688 1991
www.chromacolour.co.uk

Lightfoot Ltd
All drawn animation supplies such as paper, peg bars, light boxes and pencils.
36125 Travis Ct.
Temecula
CA 92592
USA
+ 1 951 693 5165
www.lightfootltd.com

Mawaha Engineering
All drawn animation supplies such as paper, peg bars, light boxes and pencils.
27 Picardy Road
Belvedere
Kent
DA17 5QH
UK
+ 44 (0)20 8311 7980

Paper People
All drawn animation supplies such as paper, peg bars, light boxes and pencils.
Slade Farm
Morechard Bishop
Crediton
Devon
EX17 6SJ
UK
+ 44 (0)1271 814300
www.paperpeople.co.uk

Schopman Supplies Europe
All drawn animation supplies such as paper, peg bars, light boxes and pencils.
Pioenstraat 20
2600 Antwerp
Belgium
+ 32 3 13900118

Stop Motion Store
Puppet Animation supplies.
Animate Clay
2612 West Blackburn Drive
Springfield MO 65807
USA
+ 1 636 410 6340
www.stopmotionstore.com

TecnoToon
All drawn animation supplies such as paper, peg bars, light boxes and pencils.
Customer Care Department
TechnoToon
Miami FL
USA
+ 1 (954) 376 8437
www.tecnotoon.com/store.htm

Quickdraw Animation Society
All drawn animation supplies such as paper, peg bars, clear film stock to scratch on and pencils.
Suite 201, 351 – 11th Avenue SW
Calgary Alberta
Canada
T2R-0C7
+ 1 403 261 5767
www.quickdrawanimation.ca/production/animation-supplies.html

Index

Printed and bound by CPI Group (UK) Ltd, Croydon, CR0 4YY

21/10/2024

01777093-0008